Basic Critical Theory for Photographers

Basic Critical Theory for Photographers

Ashley la Grange

Focal Press
Taylor & Francis Group

NEW YORK AND LONDON

First published 2005

This edition published 2013
by Focal Press
70 Blanchard Road, Suite 402, Burlington, MA 01803

Simultaneously published in the UK
by Focal Press
2 Park Square, Milton Park, Abingdon, Oxon OX14 4RN

Focal Press is an imprint of the Taylor & Francis Group, an informa business

British Library Cataloguing in Publication Data
A catalogue record for this book is available from the British Library

Library of Congress Cataloging-in-Publication Data
A catalog record for this book is available from the Library of Congress

ISBN: 978-0-240-51652-3 (pbk)

Contents

Contents

How to use this book

Many people are put off critical theory because they see it as difficult
(often unnecessarily difficult), and cannot see its relevance to their own practical work.
The situation is not helped by the fact that much critical theory is written by
academics, for other academics who are already familiar with the issues, vocabulary
and earlier arguments. The result is that critical theory becomes unnecessarily
elitist and many people who would be quite capable of debating the issues are
discouraged from doing so. The idea behind this book is to draw these disenfranchised
people into some of the debates. Each chapter is followed by a series of
assignments, some theoretical, some practical and some a combination of both,
which should generate critical thinking by the student. The student and/or
institution the student is studying at must decide the range of assignments to be
done and the depth at which they should be done. Many of the assignments can
be used as discussion points rather than for written work.

The selection of areas to include in the book has been very difficult; there are very
important issues and writers that have been ignored. The book does not attempt
to cover all the issues and schools of thought, it attempts to encourage students to
think critically and hopefully they will then apply this type of thinking to other
issues. In part, texts have been chosen that develop arguments or ideas raised in earlier
texts so allowing the student to follow the development of ideas by different writers.
For example, Sontag, Rosler, Solomon-Godeau and Szirtes all deal with the work
of Arbus. The texts have been summarised without editing out issues that some
readers may feel are not key to the main argument. This has been done for several
reasons: to avoid editorialising the summary; to give the reader a better feel of how
the argument developed; and to allow the reader to decide for themselves which
issues are the most important or interesting.

The indexing should prove particularly useful as some of the key texts, Sontag's *On Photography* for example, were not indexed in the first place. All references to photographers by the various writers have been left in and indexed as an aid to research. As a further aid to research, key words that would not normally be indexed, such as 'appearance' and 'reality', are included.

Although the book is illustrated, it would be impossible to reproduce all the photographs required to illustrate all the points of view of the writers. Access to a range of monographs on the work of the photographers is essential to respond adequately to many of the issues raised.

The first chapter is a summary of John Berger's *Ways of Seeing*. It is first for two reasons: it is easy to understand having been written for a general audience and it leads into photography from art. This should help those students who have never studied photography before but, who will be familiar, to some extent, with art. The book is still in print making reference to it easy (it should be referred to as it is extensively illustrated). Although first published in 1972 the issues it raises, like sexism and the effects of advertising, are still relevant today.

The second chapter is a summary of John Szarkowski's *The Photographer's Eye* and Stephen Shore's *The Nature of Photographs*. Unlike the *Ways of Seeing* they were written for a photographic audience but are also clearly written and are very well illustrated. They have been chosen for two reasons; because there is a sense in that whatever else a photograph is, it is at a basic level, what they describe it as; and they, to some extent, can be seen as expressing the views of 'straight' photography, an approach to photography that dominated the twentieth century. *The Nature of Photographs* is still in print so referring to it is easy.

The third chapter is a summary of Susan Sontag's *On Photography*. This collection of essays is undoubtedly one of the most influential pieces of photographic criticism written and is probably required reading in most university courses on photography. It deals with a wide range of issues but many students find it an intimidating read. It is still in print and the summary should be read in conjunction with the full text.

The fourth chapter is a summary of Roland Barthes' *Camera Lucida*. Again this influential book is often found on university courses. Not an easy read, it is an intensely personal search for photographic truth and deals with issues that often arise in photographic criticism. It too is still in print and the original and the summary should be used in conjunction with each other.

The fifth chapter is a summary of the first part of Martha Rosler's essay *In, Around and Afterthoughts (On Documentary Photography)*. This essay picks up issues on documentary photography that had been raised by Sontag, and allows the student to follow the development of arguments by different critics. The essay is not infrequently published in collections of essays on photography, so is relatively easy to find.

The sixth chapter summarises Abigail Solomon-Godeau's essay *Inside/Out*. This essay further develops some of Sontag's and Rosler's arguments as regards documentary photography. Despite the quality of the essay it seems harder to find than the Rosler essay.

Chapter seven is a summary of the first chapter of Clive Scott's book *The Spoken Image* which explores the relationship between photography and language. It has been included to introduce students to some of the concepts in semiology and semiotics. These are philosophies of language that both relate to the work of Barthes and are seen as being important in shaping some contemporary approaches to photography.

Chapter eight is a summary of Andy Grundberg's essay *The Crisis of the Real*. In it, Grundberg explains what post-modernism is. This movement in photography developed in reaction to straight photography and is probably the main alternative to straight photography. Post-modernism is, however, very vaguely defined and Grundberg explains it very well.

Chapter nine is a summary of Raghubir Singh's introduction to his book *River of Colour*. As a leading late twentieth century Indian photographer, his introduction is an example of a non-Western approach to photography. He explains the differences between Indian and Western art and in doing so adds to the debate as to the merits of using colour as opposed to monochrome in photography.

Chapter ten is a summary of a chapter of Bertrand Russell's book *The Problems of Philosophy* and is included to show that issues raised in the criticism of photography are not specific to photography itself.

Chapter eleven is a short story by Italo Calvino. Although not an academic essay it illustrates how photography can be evaluated in other ways and in doing so raises a number of interesting issues. It also relates to summaries in this book.

Chapter twelve contains various poems. The first is by Felix Morisseau-Leroy which again presents a non-Western view of photography. There are also three poems by George Szirtes on the work of Diane Arbus, which relates to summaries in this book.

Chapter thirteen consists of the evaluation of various photographs by a range of writers giving the reader examples of the actual evaluation, 'criticism' of specific photographs.

The appendixes include information on the reproduction of images in books with regard to evaluating photographs, various schemes for criticising photographs and a short list of very useful books.

The glossary includes a wide range of terms, some specialist and some used in everyday English, but which have particular meanings in photographic criticism. It is hoped that this will be of particular use to students new to criticising photographs and those whose first language is not English, but who are studying at English speaking institutions.

The index. As explained above, this should prove a particularly useful aid to research.

The chapters taken together present a range of views from academics, photographers, writers, critics, artists and journalists. It should be noted that the term 'Critical Theory' is not necessarily neutral. The use of it in the title of the book could be interpreted as an acceptance of a range of theories from Marxism to Structuralism, for example. This is not the case, the phrase is used in a very broad way, and the book does not set out to champion any particular theory.

Frontispiece

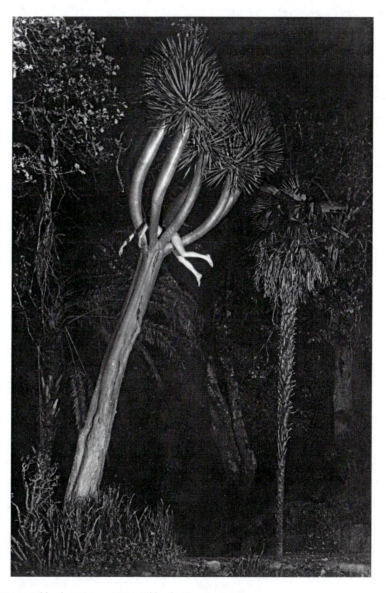

Untitled C 1984 © Ashley la Grange. 1984 Ashley la Grange.

This photograph was originally going to appear on the cover of this book, however it is now being used to show how the meaning of a photograph can be changed by events. It was selected as the cover photograph because its ambiguity seemed to suit the contents of the book. The photograph was never intended to have a clear cut meaning; it is dark, both literally and figuratively; says something about mankind's relation to nature; and although menacing it has a suggestion of humour. It was taken in an inland area of South Africa in about 1984. The devastating impact of the tsunami of December 2004 meant that most people would probably have seen it (initially at least) as a photograph of a tsunami victim. On close inspection it is clearly not a photograph of the aftermath of a tsunami, there is no debris or broken vegetation, for example; however, it was felt that it was now inappropriate for use on the cover.

Foreword

For photographers, the word 'theory' usually conjures up images of scientific formulae or equally impenetrable academic critical writing that features words like 'discursive', 'signifier' and 'intertextual' rather a lot. But this book is obviously not about the former at all, and only tackles the more useful, accessible and stimulating texts of the latter variety.

Some of these texts have been written by photographers whose thoughts on the medium have been informed by first hand practical experience, whilst others contain reflections on the subject from eminent philosophical writers, curators, critics and cultural commentators who have trained their spotlights on photography with increasing enthusiasm over the last thirty years or so.

La Grange, whose years at the chalk face place him in a better position than most to undertake this challenging task, has chosen an eclectic mixture of texts that are on most university, college and school photography reading lists as well as one or two more idiosyncratic choices that spice up an already substantial didactic menu. The selected texts are intelligently written, illuminating, often testing, sometimes highly personal takes on what the Tate Gallery, London calls 'the 21st century's dominant art form'.[1]

As well as being a guide, by placing each text in its right context and clearly explaining the background and the points the writers are seeking to make, the author has set some useful assignments that will help photography students and their teachers explore further the issues raised. In this way theory has been integrated

[1] *Photography as Art*, Tate Modern, London, June/July 2005

with visual practice and not treated as a separate stand-alone discipline. This makes it a uniquely valuable introduction to the role of critical theory and the medium's position in contemporary culture and thought.

La Grange writes in his introduction that much critical theory is written by academics for other academics who have similar backgrounds and ambitions as each other. This incestuous sphere can be difficult for the outsider to penetrate without the right credentials. He has, therefore, chosen the better-written, more accessible, non-jargon-ridden pieces of criticism and theory, where it is obvious that the authors have attempted to enlighten rather than obfuscate.

As I am writing this I have just noticed I have six of the books featured here on my bookshelf a few feet away. These texts have nearly all stood the test of time and many are used extensively by photographic educators and have become vital elements of the their curricula. When I was commissioned by Focal Press many years ago to write an introductory guide *(Approaching Photography)* to 'reading' photographs and the broad variety of motivations of photographers, I took inspiration from these books, not only because of the ideas and information contained in them, but by the way most of them create persuasive narratives that are insightful and eloquent. They helped me understand the medium better and also highlighted the importance of good critical analysis and coherent writing. My book came out at the beginning of the 1980s – a decade when theory flourished. But as a prominent photographic critic and teacher wrote: 'For all its good, Photo Theory did a lot to stifle practice'.[2] It led to theoreticians, not image-makers, becoming the pacesetters in photographic education.

That imbalance has been corrected and today the position and effect of theory has been re-evaluated. Its place is assured and it is a crucial part of most photographic courses whatever the level. That necessary revision and re-evaluation has not been a 'dumbing down' process because, as the content of this book attests, theory and criticism are vitally important components of modern photographic education.

Many theoretical texts can be challenging and complex, whilst others are relatively easy to follow. But the curriculum will always need navigators if students are to get the most out of their studies. This is a user-friendly guide, for the tutor as well as for the student, that can be easily incorporated into syllabi whether at 'A' or degree level. La Grange places each piece in its correct context, unravels and demystifies difficult arguments, communicates well his enthusiasm for the medium,

[2]*Format 05 – A season of photography in Derby*, Mark Durden, Derby, March/April 2005

and offers useful strategies for further learning through the assignments.
The book gives the student essential information on the diverse concepts and
philosophies that underpin many photographic practices. This knowledge should
give them confidence to tackle photographic theory and practical assignments
from an informed critical position that should certainly not stifle creativity and
instinct, but enhance them.

Paul Hill
De Montfort University, Leicester

Acknowledgements

I would like to thank Shirley Read for proofreading the assignment sections; Paul Hill for writing the foreword; Rob Cooper, Don McCullin, Mike Wells and Tom Wood for allowing the use of their photographs; Magnum, and in particular Martin Parr and Fran Morals for their support and help; George Szirtes for allowing the use of his poems; John Baldessari for the permission to use both the photograph and his response to it; Peter Godwin for his response to Rob Cooper's photograph; the Italo Calvino Trust for the use of his short story; the Felix Morisseau-Leroy Trust for the use of his poem; Marie Hooper, Christina Donaldson and Georgia Kennedy of Focal Press for their patience and support; my family, Teral, Kyla and Arran for putting up with the repercussions of my writing the book.

I would also like to thank, Stephen Mears, Martin Pover, Julian Rodriguez, Michael Callahan, Tim Dooley, Marianne Zappen-Thomson, Emma Dykes, the Raghubir Singh estate, Richard Billingham, Tom Hunter, Rebecca Smithers and Eamonn McCabe who have all helped in various ways.

In particular, I would like to thank my colleague, Ruth Fuller who did her best to try to free up time for me to work on the book.

1 John Berger, *Ways of Seeing*

INTRODUCTION

Published in 1972 and based on a BBC television programme of the same name, this is a very influential text on art criticism. Although the book and programme make the same case, they do so in slightly different ways, and the programme is well worth watching. For the photographer, the book has the advantage of putting photography in the context of western art. For the student new to critical theory, it has the advantage of being produced for a mass audience, and has as a central aim the de-mystification of art. These two points make it relatively easy to understand. A further advantage this book has is that many students have not had the opportunity to study photography, but have studied art, and so the book presents a logical progression for them when they start to study photography.

The television programme is divided into four sections and although the book is divided into seven chapters (three being made up solely of images), the book also covers four areas. The summary is of three of the four written chapters.

Chapter 1. In this chapter, Berger points out what is involved in seeing, and how the way we see things is determined by what we know. He goes on to argue that the real meaning of many images has been obscured by academics, changed by photographic reproduction and distorted by monetary value.

Chapter 3. In this chapter, Berger shows how the nude in western art systematically objectified women, and how this tradition has been continued by photography.

Chapter 5. Here, Berger argues that oil painting has, because of its realism, a powerful link to ownership and the buying power of money, and so often celebrates the power of money. This chapter is not summarised.

Chapter 7. In this chapter, Berger further develops the link between ownership and art by critically looking at modern consumerist society and 'publicity' or advertising photography.

WAYS OF SEEING: CHAPTER 1

Seeing

Berger starts by trying to explain the relationship between words and what we see. He points out that seeing and recognition come before words. It is seeing that establishes our place in the world, but we use words to explain this world. Despite this he argues there is always a distinction between what we see and what we know. The example he gives is that of us seeing the sun revolving around the earth but knowing the opposite.

Having established that we see first and then use words to explain the world, i.e. what we know, he then goes on to say what we know or believe affects the way we see things. This makes it a dynamic relationship; it may start with seeing and recognition, but develops into a system in which our past experience or knowledge changes the way we see things. For example, today we would see fire differently from people in the Middle Ages who believed in the physical reality of hell.

The act of seeing is active; it is an act of choice. We see what we look at and so relate to it. We also become aware that we can be seen, and so are aware we are part of the visible world. This results in the understanding that others may see things differently. This two-way (reciprocal) nature of vision comes before dialogue.

The Image

For Berger, 'An image is a sight which has been recreated or reproduced...which has been detached from the place and time in which it first made its appearance...' (p. 9). This detachment can be great or small, but all images, including photographs, involve a way of seeing by the person who has created the image. Further, when we look at someone else's image, our understanding of it depends on our way of seeing.

Berger argues that images were first made to represent something that was not there, and later acquired an extra level of meaning by lasting longer than the original subject. The image now showed how the subject had once looked to other people. Later still, with the increasing consciousness of the individual, the image was recognised as the particular vision of a particular artist. Nothing else documents the past so well, and the more imaginative the work, the more we can understand the artist's experience of the world. Unfortunately, when images from the past are presented as works of art, their meanings are obscured (mystified) by learnt assumptions such as beauty, truth, form etc. Our understanding of history will

always change as we change. However, this cultural mystification results both in making the images seem more remote, and allows us to draw fewer conclusions from history.

When we see art from the past, we have the opportunity to place ourselves in history. The mystification is an attempt to prevent us from really seeing the image and so deprives us of our history. For Berger, this has been done deliberately '... because a privileged minority is striving to invent a history which can retrospectively justify the role of the ruling classes...' (p. 11).

Berger gives as an example two paintings by Frans Hals; one of the Regents and the other of the Regentesses of the Old Men's Alms House. At the time of painting, Hals was a destitute old man dependent on the charity of people whose portraits he now painted. Berger quotes from an authoritative art history that evaluates the paintings purely in terms of their formal elements, using phrases such as '... harmonious fusion... unforgettable contrast... powerful whites...' (p. 13). The history goes further and argues against the viewer thinking they can understand the personalities of the people portrayed. For Berger, this is mystification and he argues we can have an understanding of the personalities '... because it corresponds to our own observations of people... [and]... we still live in a society of comparable social relations and moral value' (p. 14). For Berger, the relationship of the personalities, the destitute old painter and the people on whose charity he depends on is the essence of the painting.

The impact of photography

From the Renaissance onwards, perspective in art converged on the single spectator, who could only be in one place at a time. The implication was that images were timeless. Photography, in particular the movie camera, changed this. What you saw depended on your place in time and space. The camera changed the way artists saw. Impressionists saw the visible in continuous change [as the light changed so did the appearance of the object] and Cubists no longer recognised a single vantage point [so, for example, they would paint a face with an eye seen from one vantage point and the nose from another].

A second major impact was to destroy the uniqueness of images. Prior to photography, images were an integral part of a building, and as a result this was a part of the images' meaning. Even if the image could be moved, there was always only one image. By reproducing the image, the camera multiplies and breaks up its meaning. It can be shown on your own lounge wall, on the television, or on a T-shirt.

To argue that the reproductions will always lack something still leaves problems, because the uniqueness no longer resides in the meaning of the image, but in its unique physical existence. Its value lies now not so much in what it says but in its rarity and the price it would fetch. There is a conflict here because art is thought to be above commerce. Those who mystify art respond by claiming that the commercial value reflects the spiritual value; yet in modern society, religion is not the living force it once was. What determines an image's value is not its meaning or quality of painting, but its uniqueness, and Berger cites the example of two almost identical paintings of the *Virgin of the Rocks* by Leonardo da Vinci. One is at the National Gallery and other at the Louvre. In both institutions, their art historians' prime concern is not the meaning of the image but to prove that their image is the original and the other, the copy. Likewise, certain images take on new importance when their value increases. To hide this link between artistic value and market value, a false sense of religiosity is given to these works, so alienating most people from art.

Reproduction detaches the meaning from a painting, and its meaning is to a greater or lesser degree changed. By selecting a part of an allegorical painting for example, it can be transformed into a portrait. A filmmaker can construct an argument by selecting parts of a painting and presenting them in a particular order. Presented with the painting itself, the viewer takes in the whole image in an instant, and, even when looking at a specific area, can always refer to the whole.

The juxtaposition of words and images also changes the meaning. The meaning of an image will change depending on its context. The image could be used in advertising, often reconfirming the mystification of art, or someone could pin a reproduction on his or her pin-board, seeing something very personal in the image.

Berger still sees a value in the original image. The original is silent and has traces of the painter's actions, creating a closeness between the painter and the viewer, so making the painting, in a sense, contemporary.

Berger feels a total approach to art is needed, one that relates art to everyone's experience, including the innocently spontaneous and that of the art specialists. Art no longer exists as it did. It was once isolated, part of a hierarchy, but now images of art are available and insubstantial. Yet it is still presented to people in a mystified way and so alienates them, cutting them off from their history and making art a political issue.

WAYS OF SEEING: CHAPTER 3, THE NUDE

The social presence of men and women

Berger points out that traditionally, men and women have different types of social presence. Men are measured by the degree of power they offer. The power may be in any number of forms, for example moral, physical, economic etc. A man's presence suggests what he may or may not be able to do to or for you. In contrast to this, a woman's presence indicates what can or cannot be done to her. Every thing she does contributes to her presence. She is born into the keeping of men, and from childhood is taught to survey herself, with the result that her being is split into two, the surveyed and the surveyor. Her own sense of being is replaced by a sense of being appreciated by others – ultimately men. He acts, she appears, and she watches herself being looked at. 'The surveyor of woman in herself is male: the surveyed female. Thus she turns herself into an object – and most particularly an object of vision: a sight.' (p. 47).

The nude in oil painting

Berger points out that women are the main subject in one category of European oil painting – the nude. The nude reveals how women have been seen and judged as sights. The first nudes in this tradition illustrate the story of Adam and Eve, usually as a series of images similar to a cartoon. For Berger, there are two important elements to this story. Firstly, having eaten the apple they see each other in a different way, so nakedness was in the eye of the beholder. Secondly, the woman is blamed and made subservient to the man by way of punishment.

During the Renaissance the story disappeared, and instead a single moment was shown, usually the moment of shame. However, the shame is directed more at the viewer than towards each other. Gradually, the shame became a kind of display. Even when secular subjects began to be used, the implication that the woman was aware of being seen by the spectator remained. As a result she was not naked in her own right but naked as the (male) viewer saw her.

Berger gives a range of examples. Nudes looking at the viewer looking at them; of women looking in mirrors joining in the spectacle of themselves; or of looking into mirrors and being accused of vanity, when in reality they are only satisfying men's desire to see them naked; and of women's beauty being judged. Common to all of these images is the sense of the woman being watched; by men in the painting; by herself; by the spectator towards whom her body is often turned.

Often, she looks at the spectator looking at her. Her nakedness is not an expression of her own feelings but that of the male viewer. This is in marked contrast to the art of other cultures where nakedness is not so passive and has a degree of sexual equality.

At the time Berger produced *Ways of Seeing*, the most authoritative study of the nude was Kenneth Clark's *The Nude*. Clark distinguishes between nakedness and nudity. For him, to be naked is simply to be without clothes. It has nothing to do with art. The nude, on the other hand, is an art form. The subject may be naked people, but the way they are painted makes them nudes, i.e. a way of seeing. [Berger does not make it clear, but Clark's main concern was to deny the sexuality of the nude.]

Berger develops this distinction. 'To be naked is to be oneself. To be nude is to be seen naked by others and yet not recognized for oneself. A naked body has to be seen as an object in order to become a nude.'

In the average oil painting of the nude, the main character is never painted; this is the male spectator for whom everything has been done. Berger illustrates this point with the *Allegory of Time and Love* by Bronzino. In the painting, Cupid is kissing Venus, yet the way their bodies are arranged have nothing to do with them kissing. Her body has been contorted to present itself to the male viewer of the painting. The picture appeals to his sexuality, it has nothing to do with hers. The image conforms to another European convention, that of not painting body hair on women. This is because hair suggests power and passion, and the male spectator must feel these are his characteristics.

There are exceptions to the tradition, and Berger points out the characteristics paintings need, to be '...paintings of loved women, more or less naked' (p. 57), rather than nudes. They need to transcend the moment, because for Berger, in a lived sexual experience, nakedness is a process rather than a state, so an image of any instant runs the risk of distortion. The images must be subjective, and finally they must have an element of banality (ordinariness).

European humanism, which entails a strong sense of the individual, was a strong influence on European thinking during this time, yet the nude denied the individualism of the women portrayed. The reason for this was the contradictory interests of those involved in a painting: the patron, the artist and the model. Dürer, for example, believed the ideal nude ought to be constructed out of the parts of various bodies, so denying any sense of the individual at all. The spirit of individualism allowed some artists to resolve this contradiction, but the tradition as a whole did not.

Despite the notion of the ideal nude being broken by Manet's Olympia, and replaced by the realism of the prostitute, the unequal relationship exploited by oil painting is still deeply embedded in our culture and shapes the thinking of many women. Today, the attitudes that created the nude can be seen in the mass media, and '...the essential way of seeing women, the essential use to which their images are put, has not changed' (p. 64). The ideal spectator is still male and the image is designed to flatter him.

WAYS OF SEEING: CHAPTER 7, PUBLICITY

The effect of publicity images

For Berger, the term 'publicity images' has the same meaning as 'advertising images'. He points out that they surround us, and that this is unique to modern society. These visual messages last only for a moment, both in terms of how long we look at them and in terms of how frequently they need to be updated. Despite this, they do not refer to the present but to the future.

We see these images so frequently we now take them for granted. Although we usually pass these images, we have the sense of them continually passing us, so they are seen as dynamic and we seem static.

These images are justified in terms of an economic system that, in theory, benefits the public (the consumer), by stimulating consumption and as a result, the economy. Although tied to the concept of free choice, the freedom to buy this brand or another, the whole system of publicity is based on one proposal: that we can change our lives for the better if we buy something. Despite having spent our money, our lives will be richer by possessing more.

Envy, glamour and publicity

Berger sees a relationship between envy, glamour and publicity. Publicity shows us people whose lives have been transformed by consumption and so have become enviable. Being enviable makes the person glamorous, and publicity manufactures glamour.

Publicity starts by working on the natural appetite for pleasure, something that is real. It does not, however, offer the pleasure as it is. Rather it promises happiness, happiness gained by being envied by others, and this is glamour. It is not therefore offering the pleasure in itself. The better the publicity, the more the spectator is aware of what they are missing. Yet this glamour is very solitary.

Being envied depends on your not sharing your experience with those that envy you. This explains the impersonal and unfocused look of many glamour images.

The buyers imagine themselves transformed by buying the product and envy this transformed self. In effect, the publicity image has lowered the spectators' self-esteem and offers it back if they buy the product.

The relationship between oil painting and publicity images

There is a direct relationship between oil painting and publicity images, which has been obscured by cultural prestige. Publicity images often make direct reference to past art, either by copying it in some way, or by incorporating the art into the publicity image. This 'quoting' of art achieves two things. Art is associated with wealth and beauty, and the publicity image benefits from this. Art also has cultural authority, which makes it superior to mere materialism. This use of art allows the publicity image to promote two almost contradictory things, spiritual or cultural refinement and consumerism. Publicity understands the link in oil painting between the work of art and the spectator-owner and uses these to flatter the spectator-buyer.

There is, however, a much deeper link to oil painting. The composition and visual signs used are very similar. Berger cites a list of examples:

The models' gestures

The romantic use of nature with connotations of innocence

The use of the Mediterranean

Stereotypical women, e.g. serene mother (madonna), hostess (spectator-owner's wife), sex-object (Venus)

Materials indicating luxury (metal, fur, leather etc.)

The frontal arrangement of lovers for the benefit of the viewer

The sea, suggesting new life

Wealth and virility conveyed by the stance of men

Perspective used to offer mystery

Drinking equated with success

The mounted knight as motorist.

For Berger, publicity is the culture of the consumer society and there are reasons why it draws on oil painting:

Firstly, oil painting celebrated private property; it expressed the idea that you are what you have. For this reason, publicity has not replaced post-Renaissance art, it is an extension of it.

Secondly, it is nostalgic because its references to quality are bound to the past and the traditional. If it spoke in contemporary terms it would be neither confident nor credible.

Thirdly, it exploits the traditional education of the average spectator-buyer. Publicity does not need to make specific or accurate historical references; in fact it is preferable that it does not.

Fourthly, colour photography and oil painting are very similar in their ability to produce a sense of tactile reality to the spectator, reinforcing the sense of actually owning the thing (in the case of the spectator-owner), or the possibility of owning it (in the case of the spectator-buyer).

There is a fundamental difference between oil painting and publicity. Oil painting starts with facts, i.e. he already owns what is shown. It confirms the status of the spectator-owner and boosts his ego. Publicity diminishes the spectator-owner's ego, it makes him dissatisfied with his life (but not society). The spectator-owner made money out of the market, the spectator-buyer is the market and has money made out of him at two levels, as a worker and then as a buyer.

Publicity works on the fear that if you have nothing you are nothing. To overcome this anxiety, the consumer must have money. 'Money is life...in the sense that it is the token of and key to every human capacity. The power to spend money is the power to live.' (p. 143).

Oil painting gave a permanent record of a real, successful present to be passed down to future generations. For publicity, the present has to be insufficient. The short-lived publicity image claims not that you are desirable or successful, but that you will be. Sexuality is used, either explicitly or implicitly, by publicity to sell things. The message it conveys is that being able to buy is the same as being sexually desirable, or loveable.

Function of publicity

How does publicity remain credible if it never delivers happiness? It does so by being relevant to the fantasies of the spectator-buyer, so again it is divorced from reality.

Berger returns to the notion of glamour, which he states is a modern invention. In the past, there were notions of grace and elegance etc. but these were in essence different. People portrayed with these characteristics were not dependent on other people's envy to have these characteristics.

For glamour to exist, envy needs to be a widespread emotion. Berger argues that the industrial society creates the right conditions for this to happen, as it is not yet fully democratic. It recognises the right of individuals to pursue individual happiness, yet it creates a situation where the individual feels powerless. The individual is trapped between what he is and what he would like to be. There are two responses to this: the individual remains subject to envy and feelings of helplessness and escapes by day dreaming, which is exploited by publicity; or the individual becomes politically active and tries to overthrow capitalism.

Berger sees publicity as a substitute for democracy. Instead of making significant political choices, the individual asserts their individuality by choosing what to buy. This compensates for, and hides the lack of democracy in society. Publicity is a kind of philosophical system, as it explains things in its own terms.

Publicity and the world

The whole world is a setting for publicity, and it is a world beyond conflict, able even to translate revolution into its own terms. Yet there is a harsh contrast between the real world and publicity's world. At times, this becomes very obvious and Berger cites the example of a magazine using harsh images of third world poverty alongside publicity images. This raises a number of issues, among them the cynicism of the culture that shows these images alongside one another. Berger does not wish to emphasise the moral shock. He points out that even advertisers recognise it and tone their images down as a result.

Berger argues that the contrast between the news or feature photographs and the publicity images would be just as great if the former were about a happy event. What provides the contrast is that 'Publicity is essentially *eventless*... situated in a future continually deferred.' (p. 153). It replaces events with tangibility, and everything it shows is waiting to be acquired. This power to acquire is all that publicity recognises. In capitalism, all hopes are mixed together and simplified. The spectator-purchaser is offered vague but magical promises that these hopes will be met through purchases.

Without publicity, capitalism would not survive, and it can only survive by forcing the majority of people, '... whom it exploits, to define their own interests as

narrowly as possible . . . by imposing a false standard of what is and is not desirable . . .' (p. 154).

ASSIGNMENTS/DISCUSSION POINTS

The impact of photography

1. Berger argues that it is not the quality of a painting or its meaning that determines its value but its uniqueness. In photography, unlike painting, it is possible to make many absolutely identical copies. Many would argue that this is one of the essential characteristics of photography and one that makes it a democratic medium. However, collectors of photography will always pay more for a 'vintage' print (one made when the photograph was taken) than for an identical one printed later. This higher price is justified by claiming that the vintage print will better reflect the photographer's original vision. Many photographers print limited editions of their work, and by ensuring a degree of rarity increase the value of the prints. Others, Edward Weston and Mario Giacomelli, for example, were happy to re-print images at later dates. Weston's son Brett, however, destroyed all his own negatives to prevent any posthumous printing of his own work. Sherrie Levine (see Chapter 9) photographs reproductions of famous photographers' work and claims the resulting prints as her own work. For Berger, the commercialisation of paintings because of their uniqueness clearly corrupts their meaning. Explore the notion of uniqueness, value and meaning in photography with regard to the points raised above.

2. Find a photograph you feel has a clear meaning, study it with a view to selecting parts of it which, when seen in isolation, or in conjunction with other parts would result in a different meaning. Make a good photocopy or scan of the original, cut it up and present the parts to illustrate the new meaning(s). Do this first without captions and then with captions. Evaluate the impact the captions have.

The Nude

The social presence of men and women

1. Select three magazines, one aimed at women, one at men and one at a mixed audience. Analyse the advertising and editorial images in each to see if what Berger says about the social presence of men and women is still true today.

Is there any difference in the depiction of men and women in the different magazines, and within each magazine between the advertising and editorial depiction. See if you can find any similar magazines from earlier decades, and see if you think there have been any significant changes in the way men and women are depicted.

The nude in oil painting

1. It could be argued that in fine art, there has been an enormous change in the way the nude is depicted, exemplified by the work of such artists as Stanley Spencer, Lucian Freud and Jenny Saville. Likewise in photography, it could be argued that there is no longer a dominant convention with such photographers as Jo Spence, Sally Mann, Arno Minkkinen and John Coplans, exemplifying the changes in photography. The nude is increasingly being used in advertising. Can the criticisms Berger makes of the traditional nude in oil painting still be levelled against the nude in advertising? Look at a range of different magazines to substantiate your answer. You will also need to look at the section *The relationship between oil painting and publicity images* in the summary of Berger's book.

2. Clark and Berger have very different notions of the nude. For Clark, to be naked is simply to be without clothes, while a nude is created by art, For Berger, 'To be naked is to be oneself. To be nude is to be seen naked by others and yet not recognized for oneself. A naked body has to be seen as an object in order to become a nude.' (p. 54). Interestingly, the truthfulness of photography precluded it from being an art form for Clark. In modern terms, it could not 'objectify' the body for him, yet for Berger its realism makes it the ideal medium to objectify the body. In common English usage, the terms 'nude' and 'naked' seem quite interchangeable. Look at the nude, both past and present, in a range of media, or just in photography. When looking at the modern nude, look at the work of the painters Lucien Freud and Jenny Saville, and the photographers John Coplans, Sally Mann and Lee Friedlander for example. Do you think the distinctions Clark and Berger make are sustainable or helpful?

3. Berger uses a pictorial essay to make the point that photography has taken over from traditional oil in objectifying the nude. Collect copies of a range of images and make a pictorial essay of your own either to endorse or refute this point.

Publicity

Envy, glamour and publicity

1. Berger explains how advertising (publicity) works on its audience in a very negative way. Select a series of advertisements and use them to illustrate an argument that either supports Berger or undermines his case. When answering this question you will also need to consider the section headed *Functions of publicity* in the summary.

The relationship between oil painting and publicity images

1. Berger lists a whole range of ways in which advertising uses aspects of oil painting. Find examples of as many aspects of these as you can, and where possible also show examples of the precedents in oil painting. Your response can be completely visual as in Chapters 2, 4 and 6 in *Ways of Seeing*. You can also look at Judith Williams' chapter 'The function of Art in Advertising' in her book *Consuming Passions*.

Functions of publicity

1. To what extent do you agree with Berger that advertising undermines democracy through encouraging people to assert their individuality by consuming rather than by being politically active? When answering, consider the notion that if you are swayed by an advertisement you are not actually asserting your individuality but are doing what the advertiser wants you to do. Weigh this up against the advertiser's claim that they are just informing you of choices you could make.

Publicity and the world

1. Berger comments on the incongruous juxtaposition of advertising images with hard hitting news photographs in magazines and seems not to have anticipated Oliviero Toscani's Benetton advertisements in which the hard hitting news photograph is the advertisement. Do the Benetton advertisements undermine Berger's claim that 'Publicity is essentially *eventless*...situated in a future continually deferred.' (p. 153), and that it replaces events with tangibility, and everything it shows is waiting to be acquired? Or can advertising appropriate any

image and undermine its meaning? You can use other examples to substantiate your answer.

2. Since writing *Ways of Seeing* there have been significant changes in the magazine world. The Sunday newspaper magazine supplements, and the example Berger uses is one, have changed from being news orientated, to being lifestyle orientated. Don McCullin, the photographer whose work appears in Berger's example, was sacked by the *Sunday Times* for criticising this change in emphasis. This change strengthens publicity's way of seeing as there is now less likelihood of a clash of ways of seeing the world in such a magazine. If your country has newspapers with magazine supplements, evaluate them in terms of these potential clashes and the value of the magazines as purveyors (suppliers) of news.

2 John Szarkowski, *The Photographer's Eye* and Stephen Shore, *The Nature of Photographs*

Both Szarkowski and Shore attempt to give what they feel are the defining characteristics of photographs. Szarkowski's book is based on the exhibition of the same title that he curated in 1966. Shore's book was published in 1998 and can be seen as being in the same tradition as Szarkowski's book. There is a sense in which whatever else a photograph is, it is first of all what they say it is, although some would argue that this approach is too limiting.

Both of these books are very well illustrated, and should be referred to in order to fully appreciate their authors' arguments. Note that the illustrations used in this book to illustrate the Szarkowski and Shore summaries are, for the most part, different from those used by the authors, and as such are interpretations of their points. Unfortunately, *The Photographer's Eye* is no longer in print.

THE PHOTOGRAPHER'S EYE

Szarkowski says his book is about '...what photographs look like, and why they look that way' (p. 6). Unlike paintings that are '*made*', based on traditional skills and theories, photographs were selected, i.e. '*taken*'. For early photographers, this raised a new issue of creativity as to how a mechanical process could make meaningful images that revealed a point of view. Since photography did not have the old artistic traditions, Szarkowski states that the answer to the question was not to be found in the photographic work of those who tried to follow those old traditions.

New ways to make the meaning clear were to be found, firstly in the work of those who consciously broke from the tradition and secondly from the multitude

of new photographers from many different backgrounds who never had any allegiances to, or were ignorant of the traditions of painting. By 1853 these photographers were producing millions of photographs a year. The degree of skill and knowledge behind these images varied but all were a '...part of a massive assault on our traditional habits of seeing' (p. 6). Once photography became easier with the advent of the dry plate process in the late nineteenth century, the impact became greater, as this led to the development of the hand-held camera and the snapshot. The new mass of amateur photographers photographed things because they looked nice. They had no time for such concepts such as composition and form. A vast variety of things were photographed in many different ways. Whereas an artist could show a dozen perspectives of a hand, the photographer could produce an infinite number. Although most of these images seemed accidental, some were coherent and had significance. These images broadened the way in which people looked at the world and in turn influenced the way other photographs were taken. The way photography 'described' a thing was new, as was the range of its subject matter. Unlike painting it was cheap, quick and was not precious.
It recorded anything. 'By the end of the century, for the first time in history, even the poor man knew what his ancestors had looked like' (p. 7).

The photographer learnt from his own practical experience and from the multitude of other photographs being produced. Photographers of varying abilities with different aims took the photographs reproduced in Szarkowski's book. 'They have in fact little in common except for their success, and a shared vocabulary:
These pictures are unmistakably photographs. The vision they share belongs to no school or aesthetic theory, but to photography itself' (p. 7). If this is the case then a history of photography can be made that refers to how photographers have become aware of, and have developed the particular characteristics of this unique medium. Szarkowski describes five characteristics that he argues are interdependent aspects of photography that he hopes '...may contribute to the formulation of a vocabulary and a critical perspective more fully responsive to the unique phenomena of photography' (p. 8). The characteristics are 'The Thing Itself', 'The Detail', 'The Frame', 'Time' and 'Vantage Point'.

The thing itself

Photography deals with the actual; the photographer had to accept and 'treasure' this or else is defeated by photography. The intelligent photographer realized that the world was itself an incomparably inventive artist and he was able to '...recognize...anticipate...clarify...' and make permanent aspects of the world.

Despite being factual and convincing the photographs were also different from reality. Reality was filtered, reduced in size, rendered in monochrome, clarified and/or exaggerated. The photographer had to both see the reality and the photograph he had not yet taken and make his choices in terms of this unseen photograph.

This was an artistic rather than a scientific problem, yet people believed the camera could not lie. It was easier for the photographer to agree with this view or at least pretend to. As a result, it was credible to claim that the camera saw the truth and the eyes an illusion. In support of this, he quotes from Hawthorne's *The House of the Seven Gables*. Holgrave, a fictional daguerreotypist in the story, says that no matter how hard he tried the camera always revealed the true character of his subject, in this case the very negative characteristics of the sitter when everyone else saw him as a good and pleasant person.

Szarkowski concludes by quoting William M. Evans, 'The nineteenth century began by believing that what was reasonable was true and would end up by believing that what it saw a photograph of was true' (p. 8).

The detail

Out of the studio the photographer could not 'pose' the truth. Rather, he found it fragmented in nature and from these fragmented facts he had to force the truth. These facts, 'suggestive clues,' could not be assembled into a narrative, a story, but by isolating and documenting fragments he gave them meaning and significance, which was more than description. Szarkowski describes the often trivial subjects of photography as having a 'compelling clarity' that suggested they were not trivial but had, prior to photography, unseen meaning. While photographs could not tell stories '... they could be read as symbols' (p. 9).

He finds it curious that the decline of narrative painting has been attributed largely to photography as he feels photography has failed as narrative. Of Robinson's and Rejlander's complex, posed montages he says that even the Victorians recognised them as 'pretentious failures' (p. 9). He dismisses early picture magazine story telling sequences as superficially coherent and lacking 'photographic discovery'. Even major documentary projects like that of Mathew Brady is dependent on text to explain the events photographed. Szarkowski feels that Robert Capa's quote 'If your pictures aren't good you're not close enough' express 'both the narrative poverty and the symbolic power of photography' (p. 9).

The frame

The photographer's subject is never self-contained because it is selected not conceived. The edges of the photograph surrounded what he saw as most important, but in reality the subject extended beyond the frame. By isolating the subject or subjects from their surroundings new relationships are formed. 'The central act of photography, the act of choosing and eliminating, forces a concentration on the picture edge–the line that separates in from out–and on the shapes that are created by it' (p. 9).

For practical reasons, early photographers could not enlarge their photographs, they contact printed the whole of their glass plate. If after taking the photograph they wanted to crop out part of the photograph they would have to reduce the size of their final print. Given the enormous practical problems in taking photographs, photographers made sure they filled the frame of the photograph. This usually resulted in parts of things intruding on the edge of the photograph. Although not part of the subject, these things, in a good photograph, added to the balance and correctness of the photograph. For the photographer, the world provided an infinite number of croppings. In the late nineteenth century, leading painters started to explore this aspect of photography (although some would argue that they were exploring an aspect of oriental art).

Time

Photographs are not instantaneous; they are either longer or shorter time exposures. The distinct piece of time they show is always the present, the period in which they are made, which is unlike other pictures. 'Photography alludes to the past . . . through its surviving relics, [and] the future through prophecy visible in the present' (p. 10).

Early photographs were taken with slow lenses and films showing a piece of time several seconds long. As a result, photographs accidentally but quite commonly showed blurred movement, ghostly people and other 'failures'. Szarkowski suspects that art historians compare the time-lapse painting of Balla and Duchamp to the photographs of Edgerton and Mili (who deliberately made time-lapse photographs later in the twentieth century), rather than compare Balla and Duchamp's work with the earlier photographs because the earlier photographs were just accidents.

With faster emulsions, lenses and shutters, photography increasingly explored moving objects. The inability of the eye to see parts of fast moving objects is illustrated by the depiction, by various cultures, over thousands of years of running horses. It took Muybridge's photographs of a galloping horse in 1878 to break the inaccurate convention of showing both front and back legs extended. While freezing time, the photographer '...discovered that there was a pleasure and a beauty in this fragmenting of time that had little to do with what was happening. It had rather to do with seeing the...patterning of lines and shapes...previously concealed...' (p. 10). Cartier-Bresson called his approach 'The decisive moment', a phrase Szarkowski feels has been misunderstood. Cartier-Bresson is not referring to a dramatic climax but a visual climax, a picture not a story.

Vantage point

While photography's clarity is recognised, there seems little awareness of its obscurity. Photography '...has shown us pictures that give the sense of the scene, while withholding its narrative meaning'. It uses unusual angles of view, the bird's, the worm's, views from the back of the stage, it distorts by foreshortening or not foreshortening, or using patterns of light, or by the ambiguity of things. Szarkowski quotes Ivins as pointing out how in the nineteenth century the public initially were very aware of photographic distortion, but how they soon began to see photographically. 'Just as nature had once imitated art, so now it began to imitate the picture made by the camera' (p. 11).

Photography continues to challenge our concepts of reality. Szarkowski quotes Alloway who comments on the influence of photography on the paintings of Francis Bacon, 'The evasive nature of his imagery, which is shocking but obscure...is arrived at by using photography's huge repertory of visual images...Bacon used...photography to subvert the clarity of pose of figures in traditional painting' (p. 11).

Photography has had a great influence on painters and writers, yet it is easy to forget its influence on photographers. Not only the influence of great photographers but the influence of the whole mass of photography on those photographers who have used photography as an art form. It '...has been teacher, library, and laboratory...' (p. 11). Much of these photographers' sense of reality and craft and structure '...are anonymous and untraceable gifts from photography itself' (p. 11).

The history of photography is not linear but centrifugal. 'Like an organism photography was born whole. It is in our progressive discovery of it that its history lies' (p. 11).

Szarkowski summarises each of these aspects of photography and follows each summary with a selection of images:

- 'The Thing Itself'. More than other types of images, photographs give a tangible sense of reality. In essence they have been used as a clearer more permanent version 'of the plain fact'. We see the photograph as true because the lens is impartial and we ignore the photographer's role. 'The photographer's vision convinces us to the degree that the photographer hides his hand' (p. 12) (see Figs 1, 2 and 3).

- 'The Detail'. Out of the studio the photographer, unlike the painter, could not bring together things that had been separated in time and space to tell a story. From reality he photographed what was relevant but too ordinary to paint, '... the significant detail. His work, incapable of narrative, turned toward symbol' (p. 42) (see Figs 4 and 5).

- 'The Frame'. 'To quote out of context is the essence of the photographer's craft' (p. 70). He has to decide what to include and what not to. The frame 'isolates unexpected juxtapositions', creates relationships between 'facts' that have been framed, cuts through familiar forms revealing unusual fragments and '... creates the shapes that surround objects' (p. 70). The frame '... is to the photograph as the cushion is to the billiard table' (p. 70) (see Figs 6 and 7).

- 'Time'. Photographs only describe the present. Exposures were so long in early photography they sometimes accidentally described a space–time dimension as the subject moved during exposure. Photographers went on to study isolated segments of time, from galloping horses to milk drops. Cartier-Bresson's 'decisive moment' was subtler. It was not decisive because of some particular event '... but because in that moment the flux of changing forms and patterns was sensed to have achieved balance and clarity and order – because the image became, for an instant, a *picture*' (p. 100) (see Fig. 12).

- 'Vantage Point'. To get a view, clear or otherwise of the subject, the photographer often had to reject the usual vantage point and shoot from above, below, the back, close up, changing orders of importance or obscuring the subject etc. This revealed a richer and more complex world. These images revealed both the clarity and obscurity of things '... and that these mysterious

and evasive images could also...seem ordered and meaningful' (p. 126)
(see Fig. 12).

THE NATURE OF PHOTOGRAPHS

In the foreword to Shore's book James L. Enyeart says that the texts of
P.H. Emerson, John Berger, Roland Barthes and John Szarkowski are the
precursors to Shore's book.

Since the 1960s artists such as Robert Rauschenberg, Sigmar Polke, John Baldesari
and Cindy Sherman have used '...photography for qualities other than its
inherent aesthetics...' Shore, however, is not concerned with such artists who use
photography for other ideas but with those '...who remain deeply impassioned by
the creative apprehension of the photograph itself' (p. xiv). Shore begins by
explaining what a photograph is both as an object and a work of art. By dealing
with the photograph as an aesthetic object, not tool of trade, he provides a visual
standard which can be applied to other forms of photography.

Enyeart points out that Berger, in *Ways of Seeing*, like Shore, sought to have
harmony between '...seeing as an instrument of vision and seeing as a revelation
of the vision of artists' (p. xiv). Berger expected his strictly visual essays and his
written essays to have the same level of communication. However, Berger and
Shore come to different conclusions. Berger doubts our ability '...to see anything
outside our learned assumptions about art (beauty, truth, civilization)' (p. xv), and
sees the medium as being allied to our materialist culture. While Shore argues
'...that it is possible for visual language to inform and reform our learned
assumptions...a photograph functions by providing a visual grammar...' (p. xv)
that explains its meaning.

Roland Barthes also sees photography as having its own linguistic powers.
However, like Berger he moves towards philosophy away from process, Berger
being concerned with 'learned assumptions' about reality and Barthes, the moving
but inadvertent aspects of reality he called 'punctum'. Enyeart feels that unlike their
work, Shore's is not judgemental.

Enyeart states that Shore's approach is closest to Szarkowski's in that both divide
photography into separate sections for critical analysis to the extent that they even
have two sections, time and frame, that are the same. They differ in that Shore
concentrates on the photograph and Szarkowski on the photographer. Shore's
book is divided into four areas, two deal with the physical construction of

photographs and two with how we understand what we see. Enyeart feels it is important that Shore is an artist of international standing who has influenced, amongst others, Hilla and Bernd Becher. He sees the book as '...a primary tool for critical analysis...' of photographs (p. xvii).

In the prologue to his book, Shore asks of a Robert Frank photograph how different from the actual scene it was and how '...much of this image is a product of lenses, shutters, and emulsions?' Shore says he wants to understand how '...all photographs made with a camera and printed directly from a negative...' function. 'All photographic prints have qualities in common. These qualities determine how the world in front of the camera is transformed into a photograph; they also form the visual grammar that elucidates the photograph's meaning' (p. 3). Photographs can be viewed on three levels: a physical object; an image (which is an illusionary window onto the world revealing its content, for example a landscape); in this level is the third level which has visual signals that allow us to mentally interpret what is shown by the image. Shore does not want to look at the content of photographs but wants '...to describe the physical and formal attributes of a photographic print that form the tools a photographer uses to define and interpret that content' (p. 3).

The physical level

In most cases, a photographic print is a paper, or plastic or metal base coated, with a light sensitive emulsion of metallic salts or metallic salts coupled with dyes. It is flat (but not a true plane), has edges and does not move. With films and papers, the type of emulsion, developer and light source used will control both how many shades of grey there are and how the tones are compressed or separated. Shore reproduces a print by Richard Benson as an example of one displaying a large tonal range. On the physical level, the flatness determines the plane, the edges the 'boundedness', and the base the texture of the print. On the chemical level, the type of emulsion determines the tonal range and hue of monochrome prints and gives more descriptive information with colour prints.

A photograph is an independent object in the world; it can be stored and displayed in a range ways, bought or sold. The context the viewer sees the photograph in will affect '...the meanings a viewer draws form it' (p. 10).

The depictive level

The physical characteristics of the image are determined by '...physical, chemical, and optical factors' (p. 17) resulting in formal constraints on the way in which a

photograph depicts the world. When the world is photographed it is changed in four ways, in terms of flatness, frame, time and focus. 'They define the picture's depictive content and structure. They form the basis of a photograph's visual grammar' (p. 17). Photographers can express their perceptions and meanings by using them.

Flatness

Although the world is three-dimensional and a photograph is two-dimensional, a photograph can convey the illusion of space. Our perception of three dimensions is helped by our binocular vision. A photograph is the result of monocular vision and as a result it creates relationships between subjects in the foreground and subjects in the background that did not exist before. By changing the camera's vantage point the relationships change. These relationships are the result of photographic vision (see Fig. 13). Out of the studio the photographer is faced with a continuously changing set of relationships as he moves around. 'In bringing order to this situation, a photographer solves a picture more than composes one' (p. 23) (see Fig. 14).

Frame

Unlike the world a photograph has edges, by including something within the edges the photographer can change the photograph's meaning (see Fig. 15). The frame encloses the things that the photographer is interested in, it relates to them and makes the viewer look at them. Monocular vision creates relationships between shapes and lines. The edges of the photograph create visual relationships between these monocular relationships and the frame and also creates relationships of content. Shore gives the example of a Helen Levit photograph, *New York, ca. 1945*, in which a group of five people, only two of whom relate to each other, are brought into a 'jazzy cohesion' by the frame (see Fig. 16). A passive frame is simply one where the image ends. The photograph starts within the frame and works outwards, implying a world extending beyond the frame (see Fig. 17). With an active frame the structure of the photograph starts with the frame and extends inward. We know the world extends beyond the frame but the photograph is a self-contained world (see Fig. 8).

Time

Photographs, unlike the world, are static. They show a new, photographic meaning. In reality, a person saying 'cheese' may appear to be smiling, or if

saying 'crackers' may appear to sneer. Garry Winogrand's photograph *Texas State Fair, Dallas, 1964* shows a cattle handler leaning away from a bull as it sweeps its head around and licks the rim of his hat. The scene only existed for a fraction of a second from one viewpoint before disorder returned (see Figs 11 and 19).

The length of the exposure, in relation to the static film and print, affect photographic time. Szarkowski calls this 'a discrete parcel of time'. Frozen time is a very short exposure like one ten-thousandth of a second and produces a 'new moment' (see colour Figure C3). Extrusive time is longer allowing accumulated movement to register as a blur, e.g. two seconds (see Fig. 18). Still time could have very long exposures, say six minutes, but the subject is still, as is time (see Fig. 24).

Focus

The focus creates an order of importance in the depictive space by creating one plane of focus in the depictive space. This separates the subject of the photograph from its content. P.H. Emerson's photograph *During the Reed Harvest* has a little depth of focus, i.e. a shallow depth of field, which separates the reed harvesters in the foreground from the one in the background and the background itself (see Fig. 20).

Shore uses Robert Adams's photograph *Outdoor Theater Cheyenne Mountain* to show how although a photograph itself is only on one plane, when we look at its depictive space our eyes seem to us to change focus. Further, the way the eyes seem to focus can be opposite from reality, things that were further away in reality can seem to require closer focus when looking at the image (when looking at the clouds in the photograph for example) (see Fig. 21). He uses a Jan Groover photograph to illustrate how a view camera can turn the plane of focus from parallel to the film plane to perpendicular to it.

The only way to eliminate the order of importance caused by focus is to photograph a flat subject parallel to the film plane as in Brassaï's graffiti photographs (see cover photograph). In other cases, increasing the depth of field will minimise the effect of focus but there is always only one plane in focus and sharpness lessens both in front of and behind it.

The mental level

In real life we construct mental images from the light that enters our brain. People who have their eyesight restored after having been blind from birth initially only

see light. When we look at a photograph, the sensation we have of refocusing our eyes is on a mental level, not an optical one.

Although the mental and depictive pictures may coincide, they are not identical as, at the mental level, we rework the depictive level and construct a mental image of the photograph. In the depictive level, the vantage point, frame, time and focus are the formal decisions that influence the mental level. 'Focus is the bridge between the mental and depictive levels: focus of the lens, focus of the eye, focus of attention, focus of the mind' (p. 56).

Shore uses several photographs to show how what is on the depictive level may not transfer to the mental level, for example deep depictive space may not result in the eye seeming to change focus (see Fig. 22) while shallow depictive space may do so. The complex use of structure, lines, diagonals etc. that would suggest deep mental space may actually not do so (see Fig. 23), while a simple structure may (see Figs 24 and 26). Walker Evans' photograph *Gas Station, Reedsville, West Virginia, 1936* illustrates how when the photographer pays particular attention to parts of a photograph other parts appear to be collaged in (i.e. the sky), when in fact they are not (see Figs 40 and 25).

The photographer decides, either consciously, intuitively or automatically to arrange a photograph in terms of vantage point, frame, focus and time. If this is done effectively, it will have an effect on the viewer.

Mental modelling

Photographers base their photographs on mental models they have in their minds. These models can be very rigid, for example a photographer who only recognises sunsets as worthy of photographing. The other extreme would be an evolving model. In general, the model is unconscious but the photographer can control it, and the mental level, by making it conscious.

By way of illustrating the notion of a changing mental model, Shore suggests that the reader becomes aware of the space between the page and the reader, in doing so the reader's mental model changes. The reader can become aware of other things such as sounds, and while their mental model changes they still '... continue to read and to contemplate the nature of photographs' (p. 72).

Shore says of himself that when he makes photographs his perceptions are fed into his mental model that is then altered to accommodate them and this in turn alters his photographic decisions, all of which finally alter his perceptions. It is an ongoing self-modifying process.

'The print provides the physical framework for the visual parameters of the photographic image. The formal decisions, which themselves are a product of the nature of that image, are the tools the mental model uses to impress itself on the picture' (p. 78). Each level is the foundation for the next, which reflects back broadening the meaning of the earlier. 'The photographic image turns a piece of paper into a seductive illusion or a moment of truth and beauty' (p. 78).

ASSIGNMENTS/DISCUSSION POINTS

1. Unlike paintings that are '*made*', based on traditional skills and theories, photographs are selected i.e. '*taken*'. One way a photographer can 'make' a photograph is to arrange or set up a still life and photograph it. Take two photographs, one a set up still life in the studio and the other a found or 'taken' one which you have not arranged or created. Evaluate your results in terms of their success and if to any extent one approach felt more appropriate than the other.

2. Szarkowski points out that paintings are made and photographs taken. For early photographers this raised a new issue of creativity as to how a mechanical process could make meaningful images that revealed a point of view? Szarkowski argues that because photography did not have the old artistic traditions, the answer was not to be found in the work of those who tried to follow those old traditions. Some photographers however, notably Oscar Rejlander and Henry Peach Robinson did try to follow these traditions by making single photographs from different negatives. David Hockney also makes single images from different photographs. Compare a Hockney photograph to one by either of the Victorian photographers. In your response explain what you think the photographs show about the artists' attitude to photography and art in general, and why they have chosen photography as their medium for these images.

3. For Szarkowski, photography's accessibility, cheapness and ease of use allowed a vast number of people to record images. As many of these people had no allegiance to, or were ignorant of paintings traditions, a new way of seeing developed as a vast variety of things were photographed in many different ways. Could it be argued that Hockney's work combines this 'democratic' characteristic of photography with a more conventional notion of art?

4. Make a single image from several negatives or photographs using either the Victorian photographers' approach or Hockney's or both. Be aware that the

Victorian approach using traditional photography will be extremely time consuming, the use of digital photography will make it somewhat quicker.

5. Under the section 'The Thing Itself', Szarkowski says that despite being factual and convincing the photographs are also different from reality, and yet people believed the camera could not lie. It was easier for the photographer to agree with this view or at least pretend to. As a result it was credible to claim that the camera saw the truth and the eyes an illusion. Szarkowski quotes William M. Evans, 'The nineteenth century began by believing that what was reasonable was true and would end up by believing that what it saw a photograph of was true'. The social reformist photographer Lewis Hine wrote 'The average person believes implicitly that the photograph cannot falsify ... while photographs may not lie, liars may photograph'. In what sense do we believe the camera never lies? Is the problem with using quotes like Evans' one and sayings like 'the camera never lies' that they are not meant to be taken literally? Evaluate these two quotes and the saying. Include in your evaluation to what extent our understanding of them has changed by the advent of digital photography.

6. Under the heading 'The Detail' Szarkowski describes the often trivial subjects of photography as having a 'compelling clarity' that suggested they were not trivial but had, prior to photography, unseen meaning. Take a series of photographs exploring this notion. (See the cover photograph for example.)

7. Szarkowski is dismissive of photography's attempts at narrative, be they Victorian montages, mid-twentieth century picture magazines or major documentary projects. However, in the book accompanying another exhibition that he curated, *Mirrors and Windows* (looking at the evolvement of the art of photography in America since 1960), he includes a narrative series of photographs by Duane Michals, *Chance Meeting*, 1969. This would suggest that he has changed his mind and that photography is capable of narrative. Look at examples of the type of work given above and evaluate the work in terms of its narrative success or otherwise. Produce a series of images using any of the approaches Michals uses.

8. There are two people on a street, one standing and the other moving. They are completely unrelated, they just happen, at that instant, to be next to each other. By taking a photograph of them in the same frame a relationship is created. Produce two or more images exploring this notion.

9. Early photographers could not enlarge their photographs; they contact printed the whole of their glass plate. This usually resulted in parts of things intruding

on the edge of the photograph. Szarkowski argues that although not part of the subject, these things, in a good photograph, added to the balance and correctness of the photograph. Produce at least two photographs exploring this notion.

10. Explore the notion of time in photography by producing a series of photographs. If you limit yourself to just one aspect of time then you should give a written explanation of other approaches. Aperture #158 *Photography and Time* would be a good reference.

11. Some photographers are particularly noted for their exploitation of vantage point, for example Alexander Rodchenko. Look at his work or that of other photographers that exploit vantage point and produce one or more photographs in the same vein.

12. Szarkowski gives as an example Francis Bacon as an artist whose work was influenced by photography. A contemporary artist whose work has been influenced by photography is Gerhard Richter. Look at the work of both artists and produce either a written evaluation of the way they have exploited photography or produce a practical response to their uses of photography.

13. The five characteristics of photography for Szarkowski are 'The Thing Itself', 'The Detail', 'The Frame', 'Time' and 'Vantage Point'. Take a series of at least five photographs that you feel emphasise each of these characteristics. Your research should include looking at the photographs in *The Photographer's Eye*.

14. In the section 'Flatness' Shore points out that the camera creates relationships between things that are photographed that did not exist before. Find a scene and photograph it from different viewpoints to create different relationships between the subjects.

15. Shore points out that there are two types of frames, 'active' and 'passive'. Take two or more photographs illustrating them.

16. 'Frozen', 'extrusive', and 'still time' are the three ways in which photography reveals time. Take a series of photographs that illustrate these three concepts of time.

17. The focus creates an order of importance in the depictive space by creating one plane of focus in the depictive space. This separates the subject of the photograph from its content. Produce a series of photographs that explore the notion of focus.

18. The photographs used to illustrate this summary of Shore's book are different from the ones Shore used. Look at Shore's book and evaluate the appropriateness of the images that have been used in this summary. Select your own set of images by other photographers to illustrate Shore's points and then take a set of your own to do the same.

3 Susan Sontag, *On Photography*

IN PLATO'S CAVE

Photographs themselves have become so widespread, and their subject matter so all encompassing that it has changed both what we think is worth seeing and, in terms of ethics, what we think we have a right to see. For Sontag, collecting photographs is like collecting the world in a cheap, portable and permanent form (unlike moving images that go out). She describes the camera as '...the ideal arm of consciousness in its acquisitive mood' (p. 4). Yet despite being modern, photographs are mysterious.

Photographs are not interpretations like writing and handmade images. Photographs seem to be pieces of reality that one can own. They impart knowledge about the world that gives power to the viewer, but having power over something is the first step towards being alienated from it. Photographs change the scale of reality and in turn have their context, i.e. presentation, use, ownership, condition, changed. Books are the most influential way of presenting, preserving and arranging photographs. And unlike a painting, a photograph is a flat smooth object that loses few of its characteristics (including that of being collectable) when published in a book. The book can control the order in which photographs are looked at, but cannot control the length of time they are viewed.

Neither amateurish inadequacies nor artistic distortions undermine the notion that behind every photograph there was something there in the first place. This closeness to reality distinguishes photography from other forms of representation. Sontag sees painting, speech and writing as being a 'narrowly selective *interpretation*' and photography as a 'narrowly selective *transparency*' (p. 6). It is this presumed truthfulness that makes photography authoritative and seductive, yet despite capturing reality photographs are also interpretations. She cites as an example the photographers of the Farm Security Administration (FSA) project who would take numerous photographs of the same person until they had captured exactly the right expression to convey how the photographer interpreted poverty (see Figs 27 to 32). Even photographs that seem innocent are not neutral statements. It is because photography is passive and is everywhere,

30

and it is aggressive in the sense that it sees everything as a potential photograph. This gives it an 'imperial' scope (unlike painting). Its early promise to democratise all experiences by giving them equal value by turning them into images has sped up technological advances.

Early photography was essentially an artistic activity. Photography's mass production resulted in the development of the amateur photographer with his or her social uses of the camera. Photographers practicing photography as an art reacted to this by becoming even more self-conscious.

Photography has become a mass art form and so most people do not practice it as an art. It is a social rite, in weddings for example. It is a 'defense against anxiety', providing a substitute for the extended family, allowing people to think they have a particular past that is in fact not real; and it is a 'tool of power'. Sontag argues that tourists feel insecure and use photography to take possession of their new spaces (just as they photograph to take possession of their past). The photographs become proof both of the visit and the pleasure; however they can negate the experience by getting between the tourist and the experience, as the tourist now searches for photographs rather than experiences (see *Memories Are Made Of This*, Fig. 42). Sontag sees societies particularly prone to this use of photography as those driven by the work ethic (photography becomes a substitute for work) and those that have had a traumatic break with their past (German, Japanese and North Americans).

Sontag quotes an advertisement showing a group of people, apart from one they are all passive but moved by what they see. The unmoved one holds a camera and is self-possessed. The only words on the advertisement are Prague, Woodstock, Vietnam, Sapporo, Londonderry and LEICA. These place names were all associated with radically different events. Sontag feels this illustrates her case that photography equalizes everything and makes people voyeurs (the photographer depicted being uninvolved). This is significant because Sontag feels that photography has become one of the main ways of experiencing things.

She states that photography feels it has the right to either invade or ignore anything, and partly because the images outlast us, photography determines our sense of events. For her 'Photography is essentially an act of non-intervention' (p. 11). Yet it is not passive, it encourages what is going on (however bad), to continue for at least as long as it takes for the photograph to be taken, so implicating the photographer in the subject's suffering.

Sontag quotes Arbus as saying that she liked photography because it was 'naughty'. Sontag feels however that seeing the camera as a phallus is a fantasy, '...using

a camera is not a good way at getting at someone sexually. Between the photographer and the subject, there has to be distance. The camera doesn't rape or even possess, though it may presume, intrude, trespass, distort, exploit, and, at the farthest reach of metaphor, assassinate . . . all activities that . . . can be conducted . . . with some detachment' (p. 13).

Cameras do not kill, yet they are marketed as predatory weapons, and for Sontag there is something predatory about photography. It violates people by seeing them as they cannot see themselves and turns them into objects that can be 'symbolically possessed'. Cameras have to some extent replaced guns on safaris reflecting the weakening of nature to the point where people no longer need protection from it. 'When we are afraid we shoot. But when we are nostalgic, we take photographs' (p. 15).

For Sontag photography is an 'elegiac art' [an elegy being a poem, usually about the dead]. By freezing a moment photographs show the subject's mortality and the inevitability of change. And photography's rise coincided with the large-scale destruction of all sorts of natural, man-made and social entities. She cites Atget and Brassaï as two photographers who photographed aspects of Paris that have now vanished. Photography is magical as it makes us aware of the subject's absence and at the same time gives it a 'pseudo-presence'.

As desire is superficial, photographs catering for it have to be general and based on archetypes, so they are in a sense abstract. Photographs making a moral point cannot be general; they have to be based on specific historical situations. They also have to have a moral context to have an effect. Sontag cites the examples of Mathew Brady's horrific American Civil War photographs, which had little impact on people's attitudes; and of the outrage in the North caused by photographs of starving Northern prisoners of war. Photographs reinforce and help develop new moral positions but they cannot by themselves create them. Sontag gives 'Nick' Ut's photograph of the screaming napalm bombed Vietnamese child as an example both of a photograph causing moral outrage; and of how the still image can have more impact than televised images. She feels this greater impact is due to the fact that the still image is easier to remember as moving images cancel each other out, and because moving images cannot be constantly re-viewed. She notes that there were no horrific Korean War photographs because people had no ideological interest in seeing them.

Sontag wants to make two points about events [she does not define what she means by an 'event', but given the context within which she uses 'event' it is probably reasonable to assume she means events involving people]. Firstly, she states that there can be no evidence of any kind for one until the event has been

'named and characterized' (p. 19). For her, photographs cannot identify events. Photography follows the naming of the event. Her second point is that a moral reaction to the photographs will depend on the viewer's moral/political standpoint. Without this standpoint, horrifying photographs will probably be seen either as unreal or emotionally demoralising.

The moral impact of disturbing images lessens as people are continually exposed to them and become used to them. To shock, photographs have to be novel and so they become increasingly horrific. Sontag argues that Don McCullin's images of starving Biafrans in the early 1970s (see Fig. 9) had less impact for some people than Werner Bischof's images of starving Indians taken twenty years earlier (see Fig. 10), which had become banal. Initially photography makes things more real, but constant exposure ends up making them less real. She concludes, 'In these last decades, "concerned" photography has done at least as much to deaden conscience as to arouse it' (p. 21). Apart from photographs that have become 'ethical reference points' (p. 21), for example those of Nazi concentration camps, photographs do not hold their moral value with age. They, like all photographs, get viewed with the general sadness, pathos with which we view the past, and are looked at in terms of art.

Sontag gives her personal response when in 1945 aged twelve; she saw photographs of Bergen-Belsen and Dachau. She asks what good was served by seeing them. They were of an event she knew little of and could do nothing to change. 'Some limit had been reached ... I felt irrevocably grieved, wounded, but a part of my feelings started to tighten; something went dead; something is still crying' (p. 20).

Sontag sees photography as being part of a reductionist or realist approach to society, in which knowledge is reduced to techniques and information and used by bureaucrats and society as a means of gathering information and exerting control. While acknowledging the importance of this approach to a range of occupations such as meteorologists and archaeologists, she goes on to say '... in the situations in which most people use photographs, their value as information is of the same order as fiction' (p. 22). Sontag links the rise of the perceived importance of photography as information with the rise of popular newspapers and the notion of the 'right to' news. Photography was seen as a way of conveying the news to the less educated. Yet she feels that in a strict sense '... one never understands anything from a photograph' (p. 23). Photographs fail for five reasons.

- Firstly, a photograph is both a piece of time and of space. By including or excluding things its arbitrary boarders both create and break relationships.

This temporal and spatial dislocation results in social reality being presented as small discontinuous particles.

- Secondly, a photograph only shows us the surface, so it has many meanings and encourages us to deduce or intuit what the reality was like.

- Thirdly, photography can only give us knowledge of the world if we accept the world as we see it 'But this is the opposite of understanding, which starts from *not* accepting the world as it looks' (p. 23). Photographs have a use in giving us mental picture of things, but they always hide more than they reveal. She quotes Brecht as pointing out that a photograph of the Krupp works show very little of that organisation. The 'amorous function' is based on looks but understanding is based on functions, which takes place in time and so can only be explained in time. 'Only that which narrates can make us understand' (p. 23).

- Fourthly, while photographs can arouse conscience this is only a semblance of ethical or political knowledge because it is always sentimental (whether it be cynical or humanist).

- Fifthly, by duplicating the world in such a comprehensive way it has made the world seem more available than it really is.

Sontag concludes this essay by saying that people in industrialised societies have become 'image-junkies' needing reality and experience confirmed by photographs. 'Ultimately, having an experience becomes identical with taking a photograph of it . . .' (p. 24).

AMERICA, SEEN THROUGH PHOTOGRAPHS, DARKLY

Sontag points out that Walt Whitman, in *Leaves of Grass* (1855), argued that in terms of value, the beautiful and ugly, the important and trivial were equal, and that everything displayed a beauty. He also felt that art would be demystified by reality. This did not as much happen as photography set out to demystify the world. Early photographers, like most amateur photographers, sought to take beautiful photographs of beautiful things. From the early 1900s, however, photographers increasingly photographed the ordinary, so endorsing Whitman's claim (she gives as an example Steichen's photograph of a milk bottle on a fire escape). Sontag points out three key aspects of Whitman's work relevant to photography, its giving equal value to everything (democratising things), its humanism and its concept of the artist as an individualistic hero. For Sontag, the

last great photographer to affirm Whitman's humanism was Walker Evans (see Figs 3, 15, 26 40 and 41). She feels he levelled up his subject matter in his desire to make photographs that were 'literate, authoritative, transcendent', qualities she feels nobody would attribute to photographs today. Evans however had moved away from the heroism of Whitman and Stieglitz. She regards this heroism as a contradiction in that it gives everything equal value, yet aggrandises the artist.

Whitman wanted Americans to identify with one another; something Sontag feels is alien to them now. The last great expression of Whitman's universality was the *Family of Man* exhibition in 1955. Steichen arranged the exhibition of hundreds of photographs, by hundreds of photographers from scores of countries showing humanity as one. When photography at the Museum of Modern Art next drew comparable crowds it was in 1972 to view Diane Arbus's work, over one hundred photographs by one photographer showing one thing; those outside society and with no attempt to encourage the viewer to identify with them. Sontag argues that both approaches are flawed. The humanism of the *Family of Man* exhibition creates a false sense of unity by ignoring genuine historical differences. Arbus's anti-humanism undermines politics as effectively by doing the opposite and showing a world of alienated people. The first consoles and distracts people of good will, the second troubles them, '... both render history and politics irrelevant' (p. 33).

Arbus's work is not unusual in showing victims, but in that she seems not to have a compassionate motive. It is frank and forces intimacy between the viewer and subject. Although some have claimed this a moral achievement, it is really an aggression towards the public. Arbus's work depends on a separation between the viewer's and the subject's world. Her subjects looked strange or flawed and if they did not she was able to insinuate these characteristics into them. Like Brassaï, Arbus does not spy on her subjects; they willingly posed for her revealing themselves to be unaware of their pain and ugliness. The viewer expects them to be unhappy yet few show signs of this. Only her 'normal' subjects show pain. By posing her subjects she did two things; the awkwardness of posing enhanced their strangeness; and it also shows they trusted her, that she had become their friend.

Arbus's suicide in 1971 resulted in guaranteeing '... that her work is sincere, not voyeuristic, that it is compassionate, not cold' (p. 39), and it suggests her work was dangerous to her. The notion of her work being dangerous is reinforced by Arbus's own description of it in military terms. Sontag is unhappy with this vision of Arbus the artist not surviving a trip to hell. She feels that writers may feel compelled, and have a right to express their own pain, but photographers

volunteer to look for other people's pain. This is done, not for compassionate reasons but to prove both the viewer's and photographer's hardness, to get them to feel less. It is a part of the movement in western art that raises the tolerance to terrible things, gradually establishing how arbitrary society's taboos are. Sontag sees this as diminishing, rather than liberating, as it lessens people's ability to react in real life.

For Arbus the camera removes '...moral boundaries and social inhibitions, freeing the photographer from any responsibility toward the people photographed' (p. 41). Sontag feels this is the point of photography, to visit people, not to interfere in their lives, to be a 'supertourist' (p. 42), colonising new experiences in a fight against boredom. Like fascination, boredom depends '...on being outside rather than inside a situation...' (p. 42). Arbus's photography was private, 'ahistorical'. She describes the awful world she photographs in childlike terms, like ' "terrific" ' and ' "fantastic" '. She photographs it for a number of reasons. Having had an overprotected childhood she wanted to undermine her innocence, privilege and safety with the camera. As a fashion photographer she is reactive against the lies of fashion photography, as a Jew she reacts against the Jewish over-developed moral sensitivity, she rebels against the world of success by promoting failure and fights boredom with her world of horror.

Arbus's and Warhol's work lie between '...boringness and freakishness...' (p. 44), but Warhol was narcissistic, sentimental and happy with success, she was more vulnerable, pessimistic and her work had no humour or mockery. She found Middle America as exotic as those on the fringes of society, but her reaction would not be possible today, as public imagery is not monopolised by safe images. Arbus claimed that as a photographer she was closest to Weegee. However although they both took disturbing urban images, she, unlike Weegee had no journalistic motives. Sontag places Arbus in the tradition of Surrealism with '...their taste for the grotesque, their professed innocence with respect to their subject...' (p. 46) and their claim that their subjects were found objects, *objets trouves*.

Sontag quotes Arbus 'I never choose a subject for what it meant to me when I think of it.' (p. 46). Sontag describes this as a 'Surrealist bluff', pointing out that presumably viewers are not meant to judge the subjects of the photographs when they in fact do. Unlike the photographers Hine, Brassaï, Evans and Frank all of whom at times took photographs of similar subjects to Arbus, she is unique in photographing only one thing. Arbus makes everybody; freaks, suburban couples and nudists look the same, all members of the idiot village America. This is not Whitman's democratic vision which shows '...identity between things that are different' (p. 47).

Whitman had a positive notion of America, as the Occident [the Western World], but right from the start the American photographers had their doubts. Sontag sees Stieglitz's work as '...almost quixotic...camera/lance against skyscraper/windmill...' (p. 47) and feels he ends up patronising reality. With the rise of big business and consumerism after World War One, the spiritual notion of America was lost and American photographers documented '...discontinuity, detritus, loneliness, greed, sterility' (p. 48). Stieglitz believed in the existence of a spiritual America as opposed to America being the grave of the Occident, however 'The implicit intent of Frank and Arbus...is to show America *is* the grave of the Occident' (p. 48).

Since American photography has lost it affirmative bias, its attempt at literacy, authority and transcendence, it has become Surrealist.

MELANCHOLY OBJECTS

Sontag sets out the Surrealists aims as '...blurring the lines between art and so-called life, between objects and events, between the intended and the unintentional, between pros and amateurs, between the noble and the tawdry, between craftsmanship and lucky blunders' (p. 51). Despite photography having a reputation as being the most realistic and simplistic of arts she feels it is the only one that is 'natively surreal' and is the art that managed engineer the '...Surrealist takeover of modern sensibility...' (p. 51).

Initially Sontag gives three reasons for Surrealism being at the heart of photography. Firstly, photography creates a '...duplicate world, of a reality in the second degree...' (p. 52). Secondly, the very notion of something that reproduces itself with so little effort and that can be enhanced by an accident is surreal. Thirdly, photographs do not seem strongly bound by the intentions of the photographer; they are created by '...a loose co-operation...between the photographer and the subject – mediated by...a machine...' (p. 53). The more naïve and less manipulated the image, the greater its impact. Because photography is so naturally surrealistic, those photographers most consciously influenced by surrealism, Man Ray, Lázsló Moholy-Nagy, Bragaglia, John Heartfield (see Fig. 34) and Alexander Rodchenko are to be found on the fringes of photographic history.

In giving a fourth reason she questions the Surrealists' claim that surrealism dealt with the psychological and universal, stating that culture and time bind it. 'What makes a photograph surreal is its irrefutable pathos as a message from time past,

and the concreteness of its intimations about social class.' (p. 54). For this reason, Sontag finds the earliest surreal photographs come from the 1850s when photographers first photographed street life. For her, these lost customs and times are more surreal than effects such as 'solarization'. She argues that Surrealism's claim to deal with universal issues is undermined because it is a 'bourgeois disaffection', a middle class rebellion. As such it dealt not with universal issues but middle class taboos, typically sex and poverty.

The counter culture of surrealism and middle-class 'adventurism' come together in the photographer as a hunter of the lower order of social reality, documenting the reality hidden from the middle classes. Sontag groups Paul Martin, Arnold Genthe, Atget, Brassaï and Weegee together, as a line of '*flaneur*', solitary street wanderers, voyeurs who discover the city rich in extremes, the real but unofficial life hidden by the middle-classes. Sontag sites Jacob Riis' *How the Other Half Live* (1890) (see Fig. 36) and Bruce Davidson's *East 100th Street* as typical examples of two things: firstly of the poor as a recurring subject; and secondly of humanist photography as social documentation used as an instrument of middle class attitude that is '...both zealous and merely tolerant, both curious and indifferent...(p. 56). This type of photography is justified as both revealing the truth and preserving the past. With few exceptions, Jacques-Henri Lartigue for example, who photographed his own family and class, '...the camera makes everyone a tourist in other people's reality, and eventually in ones own' (p. 57).

John Thompson in his *Street Life in London* (1877–1878) not only produced the first substantial body of work looking downwards, but also provided a model for the photographer moving from one area of photography to another, in Thompson's case, from China to London's streets and then to portraits of rich people in their homes. Sontag calls this a type of broader 'class tourism' and gives Steichen, Bill Brandt, Cartier-Bresson (see Fig. 12), and Richard Avedon as more modern examples, singling out Brandt as perhaps making the most dramatic changes. With the exception of the few photographers trapped by their private obsessions, like Lewis Carroll and Arbus, dealing with a range of realities '...is part of the very momentum...' of photography (p. 57).

Photography both imposes and bridges a social and temporal gap, and it is this, not the subject that makes photography surreal. Sontag illustrates this by referring to the work of two contemporaneous photographers of celebrities, Cecil Beaton and Ghitta Carell. Beaton made his portraits look surreal, while Carell simply pandered to Mussolini era celebrities' egos. Nowadays Beaton's work looks contrived, but Carell's not only looks surreal but also looks as eccentric as Avedon's.

Photographers who set up as scientists make an inventory of the world; the moralistic photographers '... concentrate on hard cases (p. 59). In 1911, August Sander started his major scientific project, to document in a neutral way the German people showing 'archetypes' in terms of trade class and profession (see Fig. 1). Comparing his *Circus People* (1930), Arbus's circus people and Lisette Model's 'demimonde' [questionable] characters, shows the subjects facing all three photographers, yet in Sander's photograph the gazes are not intimate nor do they reveal secrets, he only shows the typical. Like Eadweard Muybridge who broke movement down into discrete sections of time revealing how people actually moved, Sander breaks down society and enlightens the viewer. This neutral enlightenment could not be politically neutral; it offended the Nazis who destroyed the book, ending the project. The Nazis objected to '... his idea of the photographer as an impassive census-taker, the completeness of whose record would render all commentary, or even judgement, superfluous' (p. 60).

Unlike most documentary work, Sander includes all social types. Despite this he still, according to Sontag, suffers from an unconscious 'class condescension'. The rich tend to be photographed indoors, while labourers are often photographed outside, and this setting locates and speaks for them. Sontag quotes Sander ' "It is not my intention either to criticize or describe these people" ' (p. 61). By working with his subjects and photographing them, all in the same 'dispassionate' way, he negates himself, creating for Sontag a truly abstract body of work.

Sontag cannot imagine an American attempting a similar project. Evans's *American Photographs* (1938) and Robert Frank's *The Americans* (1959) are random and emphasise the poor. Roy Stryker's massive Farm Security Administration (FSA) project on the rural poor aimed to convince the middle-class that '... the poor were really poor, and that the poor were dignified' (p. 62) (see Figs 3 and 27 to 32). Sander gave the poor dignity without using propaganda, they had it because they were photographed in exactly the same way as everyone else. Adam Clark Vroman, who made 'uncondescending' and 'unsentimental' photographs of Indians between 1895 and 1904, is one of the few detached American photographers.

Sontag feels that because of European social stability, European photography tends to aim at neutrality. American photography is more partisan, and as a result it '... is both more hopeful and more predatory' (p. 63). Hine (see Fig. 35) and the FSA are examples of the hopeful side, stirring the conscience of America. However, even at its most moralistic, Sontag describes documentary photography as 'imperious in another sense ... the urge to appropriate an alien reality' (p. 63). This can be understood to mean that it forces a particular meaning on something

that is not the photographer's in the first place. Photographers do this to all subjects, be they scandalous or beautiful (or can be beautified by the camera). Ideally, in photography, even the scandalous should be made artistic.

Predatory photography is at the heart of the link between tourism and photography. The earliest manifestation of this came about when the railways opened up the American West in 1869 and tourists poured in to photograph their version of Indian life without regard to the Indians' privacy or culture. Photography became a routine part of changing things ranging from an Indian ceremony for the benefit of a tourist to scandalous conditions in a city to benefit the poor. Sontag sees a danger in a token reaction to photographs. For example, the Mulberry Bend slum Riis photographed was demolished but others were left intact.

For Sontag, 'Photography both loots and preserves, denounces and consecrates' (p. 64). Unlike Sander who was at home in his own country, Americans are overawed by theirs, it is too vast, they are 'foreigners' in their own land and use cameras to take possession of it. Europeans see society having stability like nature, so Sander could conceive of documenting the whole of society. Americans on the other hand are suspicious of nature, it is too immense and is something cannibalised by progress.

America is too vast for scientific cataloguing; the only way to classify it is to get a part to represent the whole ('synecdoche'). Sontag quotes from Jack Kerouac's introduction to Frank's '*The Americans* where he describes the vastness of Frank's task and how he photographed things not recorded before. The quote concludes, 'After seeing these pictures you end up finally not knowing any more whether a jukebox is sadder than a coffin' (p. 66). For Kerouac, the main tradition of American photography is one of loss. Sontag endorses this by referring to the work of Clarence John Laughlin and she quotes Berenice Abbott ' "The photographer is the contemporary being par excellence; through his eyes now becomes past." ' (p. 67). Having discovered Atget's work, she later published *Changing New York*, but unlike Atget who recorded the replacement of old Paris with the new, she recorded the self-destructive replacement of the new with the new. Americans do not have old possessions handed down the generations but they do have their photographs their 'portable museum'.

All photographic collections are Surrealist montages and Surreal abbreviated histories. These histories imply melancholy, surface detail and impertinence. Although all photographs are made there are so many that they seem unpremeditated found objects. However, photographs benefit both from being seen as pieces of the real and having the prestige of art.

One of the most powerful aspects of photography is that it is a record of our mortality. Photographs show us how we have aged, '…show people irrefutably *there* and at a specific age…' (p. 70). Roman Vishniac's photographs of the occupants of the Polish ghettos are moving because we know they are going to die. The filmmakers Robert Siodmak in *Menschen am Sonntag* (1929) and Chris Marker in *La Jetee* (1963) have used this characteristic of photography to great effect. In Siodmak's film, a group on a Sunday outing take it in turns to have their photographs taken, the movie camera records each mobile face and then freezes it in a still '…transmuting, in an instant, present into past, life into death' (p. 70).

Photographs are also invitations to sentimentality, blurring moral distinctions. Sontag cites the example of a book of photographs of various famous people as babies or children. Arranged alphabetically, it makes no moral distinctions when pairing people, Stalin and Gertrude Stein for example. Sontag feels this sort of Surrealist irony works best with either naïve or conventional portraits.

Photographs are only fragments, so as time passes their place in their original context gets weaker. For Sontag, a photograph can be seen as a kind of quotation, and increasingly books of photographs are being presented with matching quotations. For example, Bob Adelman's *Down Home* 1972. 'Illustrating the continuing predilection of documentary photography for losers…' (p. 72). The portraits are paired with quotes from the subjects, so the subjects adopt positions. Although it may seem a scaled down version of Sander's work, the quotes make it different. It is also different from Evans' *Let Us Now Praise Famous Men* where James Agee's text increases the viewers' empathy with the sharecroppers. Adelman claims to have no such intention, it is meant to be impartial. Michael Lesy's *Wisconsin Death Trip* (1973) links quotes from newspapers, asylum records and fiction to unrelated photographs taken between 1890 and 1910 by Charles Van Schaick to create a bleak but historically valueless document.

Written fiction like novels may explain more than photo-fictional books like Lesy's, but because photographs and quotes seem to be pieces of reality they carry more authority. Likewise, crude written records (court records, diaries etc.) are seen as more credible than fine writing. Sontag sees this as an American cultural problem where people are suspicious of good writing and cannot be bothered to read. She sees this 'self-disparaging', 'off-hand', 'undisciplined' approach spreading to photography itself in the 'anti-photograph' (p. 74).

People are searching for photographs everywhere, attics, historical societies and archives producing more and more photographic books. 'Photographs furnish instant history, instant sociology, instant participation' (p. 75). However, this way of

showing history is rather pain free. Surrealism, which promised an exciting and radical view of society, has slipped into 'easy irony' equalising all evidence. It makes a reactionary judgement turning history into a collection of oddities and a joke.

Sontag gives the writer and critic of photography Walter Benjamin as an extreme example of a collector of, amongst other things, quotations. Benjamin argued that reality justified the destructive nature of the collector's activities. As the pace of change accelerates, the past has become the most surreal subject, making it possible for Benjamin to see new beauty in what was vanishing. Photographers chose to record the disappearing world and were even employed to do so by those destroying it. By collecting, Benjamin felt collectors were trying to renew the old world. But as Sontag points out the old world cannot be renewed. This reveals the quixotic nature of photography.

Sontag uses the analogy with Benjamin because '...he was photography's most original and important critic...' (p. 76), and also because his ideal project, a literary criticism, was based on precisely the same principles as photography. It would consist entirely of quotations and so would have no empathy, and make the author invisible. This ties in with the history of photography where there is a reluctance to take sides, because in doing so would undermine the notion that all subjects are valid. Sontag sees Benjamin's literary project as allowing for the past to speak for itself, but as an approach to photography she sees it 'de-creating' the past, creating a parallel reality that is accessible, but emphasises its ineffectuality and gives it unlimited irony.

Traditionally, those arts concerned with history have tried to discriminate, giving emphasis to those things of importance. Photography recognises no order; traditional classification is there to be subverted and so the work is a lot more contrived than claimed.

Like the Surrealists, photography claims all subject matter is equal, yet it shows an overwhelming '...fondness for trash, eyesores, rejects, peeling surfaces old stuff, kitsch' (p. 78). Bleak factories and streets not only look beautiful through the camera, but by modern taste are more beautiful than churches and landscapes. Sontag points out that it was the Surrealists who first frequented the second hand shops and flea markets to claim others' cast-offs as beautiful.

Photography does two things; it shows that everything is perishable, and because the evidence it collects is arbitrary, it suggests reality is basically unclassifiable, '...an array of casual fragments' (p. 80). Surrealism and photography express a '...fundamental discontent with reality...' (p. 80). In the industrialised countries, this has manifest itself in a general attitude of alienation from reality. Despite this,

instead of longing for another world, modern society reproduces this one in the form of a photograph to make it real or surreal.

Just as taking a film still from a film contradicts the very nature of the film, taking a photograph of reality is in an inaccurate relationship to the real world, which is a process, not a single instant fixed in time.

The modernist revolt against traditional aesthetic norms has led to the promotion of standards of taste that are kitsch. This reflects the connoisseur's relation to the world and at the same time 'a promiscuous acceptance *of* the world' (p. 81). Some photographs are important works of art, but the vast numbers of photographs not only affirms kitsch but give the viewer a false sense of experience. Surrealists, who see themselves as cultural radicals or revolutionaries, often thought they could be Marxists; however, Surrealist aesthetics are too ironic for moralism. Marx argued that philosophers were wrong for trying to understand the world rather than trying to change it; photographers, as a result of Surrealism, do not even try to understand the world; they just collect it.

THE HEROISM OF VISION

'Nobody ever discovered ugliness through photographs. But many...have discovered beauty' (p. 85). Apart from documentation and at social rites, people take photographs because something is beautiful, not because it is ugly. It is common for people to want to photograph things they find beautiful. In fact photographs, rather than the world itself, have become the standard for what is beautiful, but the beauty can be used up; we have seen so many images of sunsets that they are now regarded by many to be corny.

The claims to truth made by photography make the notion of lying far more important to photography than it is to painting. A photograph that has been altered or given a false caption lies about reality. The history of photography can be seen as the struggle between the need to beautify and the need to tell the truth. The need to beautify came from the fine arts; truth telling from both value-free scientific truth telling and from journalism, which both exposed and educated. Photography was regarded not only as more truthful in terms of showing physical features, but also in terms of revealing character.

Painting takes time, so painters are very selective; photography is quick so anything seen can be photographed. By trying to see everything, photographers hoped to accommodate both beauty and truth. At first photography both amazed because of its truthfulness, and was scorned for its crude realism. It has, however,

had the effect of greatly increasing the importance of appearances (as the camera shows them). The reality that is photographed is carefully evaluated for its truthfulness to photographs. Sontag points out that in 1901, Zola claimed that you could not say you had seen something until you had photographed it. Photography has changed our idea of reality by establishing the way things should look.

Fox Talbot conceived of the idea of photography as an impersonal way for nature/reality to record itself accurately. However, it soon became apparent that different people took pictures of the same thing in different ways. Photographs became not only records of the subject but also of how the photographer saw it – an evaluation. However groups as radically different as the Surrealists and Bauhaus (Moholy-Nagy) continued to advocate it as impersonal.

By 1841, travel photography had started, but the photographers not only photographed the great sites but found beauty in ordinary things that others overlooked. A heroism of vision was established that allowed the individual to express their unique vision. Going to extremes to take a photograph, even of an ordinary subject was what the heroic photographer was perceived to do.

Between 1920 and 1935, close ups of subjects ranging from plants, bowls, machines and nudes, by photographers such as Paul Strand and Albert Renger-Patzsch (*The World is Beautiful*, 1928) and Moholy-Nagy (*The New Vision*, 1928) seemed to indicate a grand role for photography as a bridge between art and science.

Although both painters and photographers have influenced each other (for example, photography influenced impressionism) '...their procedures are fundamentally opposed. The painter constructs, the photographer discloses...the identification of the subject of a photograph always dominates our perception of it...' (p. 92). Sontag gives as an example Weston's *Cabbage Leaf* of 1931. The photograph has an impact on two levels, it has a pleasing form and unexpectedly it is a cabbage leaf; despite the fact that when first looked at it looks like gathered cloth. Sontag feels that if it were gathered cloth it would not be so beautiful as we are familiar with that beauty from fine art. 'Hence the formal qualities of style – the central issue in painting – are, at most, of secondary importance in photography, while what a photograph is *of* is always of primary importance' (p. 92). The underlying assumption for every photograph is that it is a piece of the world and we only know how to react to a photograph when we know what it is. Harold Edgerton's *Coronet* of 1936 has far more impact when we know it is a splash of milk.

Originally, seeing was regarded as one sense amongst others and sights were always placed in context and linked to notions of what was worth seeing. Photography

not only changed what was seeable but also nurtured the idea of seeing for its own sake. This motivates all modernist art movements.

Traditionally, photography is seen as having liberated painting from literal representations of reality, allowing it to move towards abstraction. Sontag points out however that Turner was born twenty-five years before Fox Talbot, strongly suggesting that painting would have started to move from literal representation anyway.

The traditional account also fails to point out that from the outset photographers, starting with Fox Talbot, conceived of isolating forms that painting had not recorded. Photographers also strove for abstract images. However, despite many photographers pursuing perception for perceptions sake, and claiming the relative unimportance of subject matter, their photographs cannot transcend the subject like a painting can. The modernist movement closest to photography (apart from Super and Photo-Realism) is poetry. Painting is still wary of the simply visual and has become increasingly conceptual while poetry has become more interested in the visual.

Most people taking photographs are only copying accepted notions of beauty; however there is a group, 'heroic modernists', like Edward Weston who challenge these notions showing others what they have missed. Weston claimed to be indifferent to the issue of whether photography was an art, but his claims for photography in the way he spoke and wrote in his *Day-books* have the romantic notions about being an 'Artist'. Weston saw himself and photography as being in the forefront of the challenge to conventions, and just as important saw photography as better equipped to do this than painting.

There seem strong similarities between Weston's beliefs and those of D.H. Lawrence, the '... affirmation of the sensual life, rage at bourgeois sexual hypocrisy, self-righteous defence of egotism in the service of one's spiritual vocation, manly appeals for a union with nature...' (p. 97). Lawrence, however, sought a 'wholeness of sensory perception' (p. 97), something a photographer can never do, as the visual must dominate. Weston asserts that photographic seeing creates a union with nature, however Sontag feels that it creates an estrangement.

Sontag calls photographic seeing a 'kind of dissociative seeing' (p. 97). The fact that there are differences between the way the eye and camera focus and judge perspective means that the camera can make one type of thing look like something else when photographed. At first, people commented on the differences between the eye and the camera, but once they started to see photographically the comments stopped. As a result, photography has been particularly successful in turning people into things and things into people, for example, Edward Weston's

nudes and peppers. Although both sets of subjects are photographed for their forms, they are done so differently. Sontag feels the nudes are de-sensualised by being bent over with the extremities cropped off; by having their skin made to look opaque, so emphasising the abstract nature of the body's form. On the other hand the peppers are photographed whole with polished skins suggesting a touchable erotic form.

The beauty revealed in scientific photography inspired many including the Bauhaus, yet it is no longer regarded as the way to show beauty in photography as it does not seem to show human decisions. The elegance of Weston's toilet bowls became important than the structure of a snowflake.

Weston saw beauty as being subversive, and this view seems to have been confirmed when some people were scandalised by his nudes. (Sontag feels that Weston, André Kertész, and Bill Brandt in fact made the nude respectable.) Modernists like Weston and Cartier-Bresson saw photography as a precise and intelligent new way of seeing, who through the beauty revealed by it could achieve some kind of 'psychic breakthrough' (p. 99). Later photographers, like Robert Frank, wanted images that were not piercing but democratic and did not claim they were setting new standards for seeing.

Although photography broke conventional ways of seeing, the new ways of seeing became the new conventions, and photographers felt these had to be broken. Modernist subjects, for example detailed close-up studies of leaves and shells have become clichéd. 'What once took a very intelligent eye to see, anyone can see now' (p. 100).

Sontag feels that photographers like Weston and Strand had notions of beauty that have come to be seen as 'banal', she feels this cannot be explained by familiarity alone but that there is a moral dimension. Sontag sees the modernists' notions of beauty revolving around the notion of order. For Weston, nature offered this order, Aaron Siskind created it and Cartier-Bresson revealed it despite all the chaos. Sontag feels that showing the world's perfection was both '...too sentimental, too ahistorical a notion of beauty to sustain photography' (p. 101). No matter what these photographers photograph, they do so with '...the same fastidious eye that discerns order everywhere' (p. 101).

This insistence on beautiful composition, seems to Sontag contrary to 'the truth of disorder' (p. 101) in the same way that the Bauhaus' faith in science and technology was misplaced. She states that there has been a shift in 'taste', away from Weston towards nineteenth century English and French primitive photographers and photographers like Atget. Weston criticised Atget's work on technical grounds

and for often missing the 'real' thing, yet current 'taste' has moved from Weston's perfect prints towards technical imperfection '...because it breaks the sedate equation of Nature and Beauty' (p. 102). Nature is no longer contemplated, but treated with nostalgia and indignation.

As society has become more disillusioned, it seems less sense can be made out of a notion of timeless beauty, photographers adopted a harsh approach and despite this, photographs still beautify because for Sontag '...the real has pathos. And that pathos is – beauty' (p. 102).

Weston's photographs are beautiful because of his skill and taste in composition and lighting. Jacob Riis's are beautiful because of the grimy subject matter, the appropriateness of the poor framing, the harsh contrasts produced by the flash; this is an amateurish and inadvertent beauty (see Fig. 36). These double standards are always a part of the evaluation of photographs. Like paintings, good photographs were thought to eliminate the non-essential and be well designed, as in Weston's work. Now however no conflict is seen between amateurish use of the camera and formal beauty. Having democratised notions of beauty, photography has also democratised formal standards.

In photography, the beautifying of the world is as legitimate as exposing it. Sontag cites the example of portrait photographers who usually take care to make beautiful people more beautiful than they really are, and yet at the same time there is a tradition of photographing less glamorous people in a more brutal way. Examples of this are Strand's *Blind Woman* and Avedon's portraits of his dying father. Sontag feels that '...the surrealist preferences which rule photographic taste' (p. 104) allow this 'cruelty' to produce another type of beauty, and although idealising remains the objective of portraiture, commercial and everyday photography in general, it is the crueller side of photography that is more highly regarded as art.

Even compassionate photojournalism has to meet two different criteria; our surrealist way of looking at photographs and our belief that photographs can give truthful information about important events. Sontag gives as an example W. Eugene Smith's photograph of a dying boy on his mother's lap (from the Minamata series documenting the mercury poisoning of a Japanese fishing village). Sontag feels our indignation is aroused by the suffering shown in these photographs but that they distance us '...because they are superb photographs of Agony conforming to surrealist standards of beauty' (p. 105).

Photographs are fragments, and because of this their context changes them. Each context '...suggests a different use for the photograph but none can secure their meaning...the meaning *is* the use...' (p. 106) (Sontag acknowledges

Wittgenstein for this definition). By sectioning out the truths, into relative truths the proliferation of photographs has eroded the idea of meaning. This is a problem for socially concerned photographers as they assume that their photographs reveal the truth, yet the contextual use of the photograph inevitably results in the meaning becoming less relevant. The most notable way this happens is through the absorption of photography '...by the discourse of art...' Some photographs, in fact, refer to art from the beginning, Sontag gives the example of the photograph of Che Guevara's body surrounded Bolivian troops, journalists and an a U.S. intelligence agent. For Sontag this photograph showed the 'bitter realities' (p. 107) of Latin America. However, John Berger has pointed out that it resembles Mantegna's *The Dead Christ* and Rembrandt's *The Anatomy Lesson of Professor Tulip*, and it is these similarities that contribute to its impact. Sontag goes on to say the more unforgettable the image the greater the chance of becoming both timeless and de-politicised.

Sontag refers to Walter Benjamin who in 1934 commented on the fact that photography had '...succeeded in turning abject poverty itself, by handling it in a modish, technically perfectly way, into an object of enjoyment' (p. 107). He felt that captions could save the meaning of a photograph (Sontag feels the best writing on photography has been by moralists of a Marxist inclination). Berger found the Guevara photograph '...too satisfying aesthetically, too suggestive iconographically' (p. 108). His essay is really a long caption that tries to emphasise the political and moral meaning of the photograph. Sontag gives the example of the film *A Letter to Jane* by Godard and Gorin, she quotes them, ' "This photograph, like any photograph ...is physically mute. It talks through the mouth of the text written beneath it." ' (p. 108). She adds, '...words do speak louder than pictures. Captions do tend to override the evidence of our eyes...' (p. 108) and consequently no caption can give a permanent meaning to a photograph.

For Sontag, a photograph can never do what moralists want it to do, and that is to speak. Its voice is the caption. 'But even an entirely accurate caption is only one interpretation...' (p. 109). It can easily be changed. So the moral claims the photograph makes can be weakened either; by the many meanings every photograph has; '...by the acquisitive mentality implicit...' (p. 109) in all picture taking and collecting; and by aesthetics. Even the most powerful photographs, the Che Guevara, the Minamata and the people in them are in the end beautiful.

This beauty outlasts the relevance of the photographs as, for example, in Hine's photographs of child labour (see Fig. 35). The inhabitants of the richer parts of the world tend to learn of the world's troubles through photography, and although

these images do cause distress, their aesthetic nature tends to neutralise the distress. By transforming history into a spectacle, it anaesthetises the morals and stimulates the senses.

The main effect of photography is to '... convert the world into a department store or museum – without walls in which every subject is depreciated into an article of consumption, promoted into an item for aesthetic appreciation' (p. 110). Some photographers restrict their work to their own obsessions, for others the most diverse subjects are brought together in a sense of false unity by the ideology of humanism. Sontag cites a critic's view on Strand's social documentary work that praises its '... heroic quality – humanity ...' (p. 111). For Sontag, this humanity is simply '... a quality things have when they are viewed as photographs'.

For her, the '... urge to take photographs is in principle an indiscriminate one ...' as everything can be made to look interesting when photographed. 'But this quality of being interesting, like that of manifesting humanity, is an empty one' (p. 111). Photography is reductive both with things and when documenting lives. 'By disclosing the thingness of human beings, the humanness of things, photography transforms reality into a tautology. When Cartier-Bresson goes to China, he shows that there are people in China and that they are Chinese.'

She disputes the humanist photographers' claim to encourage understanding, rather than explain what she feels photographs acknowledge. She quotes Robert Frank ' "... to produce an authentic contemporary document, the visual impact should be such as will nullify explanation." '; and Arbus ' "A photograph is a secret about a secret ... The more it tells you the less you know." ' (p. 111). Photography does not promote understanding, rather it stimulates an acquisitive relationship to the world that encourages aesthetic awareness at the expense of emotional involvement.

Photography's strength is that in freezing an event in time it allows the study of something that is usually instantly replaced. Yet, despite this having established new and more inclusive notions of beauty, these truths '... however significant or decisive, have a very narrow relation to the needs of understanding' (p. 112). Sontag states that humanist photography's ability to turn '... reality into something beautiful derives from its relative weakness as a means of conveying the truth' (p. 112). She feels humanism has replaced formalism and become the dominant ideology for photographers because it hides the confusion about truth and beauty involved in photography.

PHOTOGRAPHIC EVANGELS

Despite photography's general acceptance in all spheres of life, including high art, photographers are still defensive and need to extol the virtues of their discipline, yet they often contradict each other.

There is no agreement as to how our knowledge of a subject is increased through photography, or how much knowledge you need of a subject to be able to take a good photograph of it, even though everyone accepts that photography has greatly increased our knowledge of the visible. Photography is seen in two different ways '... as a precise act of knowing ... or as a[n] ... intuitive encounter' (p. 116). Sontag cites Nadar and Avedon as examples of these opposing approaches.

Minor White and Cartier-Bresson (see Fig. 12) are given as examples of photographers who see their photography as '... ascetic discipline, a mystic receptivity to the world ...' For these photographers, photography is more than just a literal representation, it is an intellectual paradox '... a form of knowing without knowing ...' (p. 116).

Sontag states that '... suspicion of the intellect ...' (p. 117) is very common in those arguing photography's case. Despite this photographers state that the pre-visualising required in photography is very demanding, and she quotes Ansel Adams in rejecting the multiple photographing of things in the hope that one of the photographs will be good. However, even if they are reluctant to admit it, she believes that photographers are almost superstitious in their belief in the lucky accident.

According to Sontag, current photographic thinking has increasing doubts about the degree of awareness photography involves. Like other arts, the anti-intellectual claims made by photographers have moved to a sceptical analysis of itself. What she regards as the most 'influential' younger photographers have reacted against both the pre-visualisation and the notion of truthfulness and now try to show how photography makes things look different.

She goes on to say that in the place of claims about knowledge, there are now claims about creativity, this despite '... the fact that many superb pictures are by photographers devoid of any serious or interesting intentions ...' (p. 118). She names Weston, Harry Callahan and Ansel Adams and quotes Paul Rosenfeld on Stieglitz, as all being part of a strong tradition in photography that claims it is the photographer's temperament more than the camera that makes a good photograph.

There is a difference between photography seen as self-expression and photography seen as the truthful recording, as self-denying. Sontag feels that most accounts of photography try to minimise the difference and that photography is generally understood to be truthful recording. However, there is also a similarity, they both assume photography shows us reality in a way not seen before.

This type of photography that reveals the world is generally known as realism and Sontag quotes Fox Talbot, Berenice Abbott and Cartier-Bresson in their defence of it. She states that '...most of the contradictory declarations of photographers converge on pious avowals of respect for things as they are' (p. 119). She expresses surprise that in a medium, usually considered merely realistic, photographers should have to do this. She feels these calls are another example of photographers having to make their process of appropriating the world seem mysterious.

Abbott does not convince Sontag of the superiority of her realist approach to photography. Sontag points out that photography, like other art forms, increasingly defines realism as not what is 'really' there, but what the artist 'really' sees. Despite photography's seemingly close relationship to reality it, like other arts, cannot take what is seen for granted.

Sontag states that photographers believe that reality is hidden and it is their role to reveal it, whether it is Stieglitz's 'moment of equilibrium' or Frank's 'disequilibrium' his 'in-between moments' (p. 121). She claims that for photographers, photographing even familiar things, is to show that reality is hidden and mysterious in some way. Because this can be done with any subject, she argues that photography illustrates a formalist understanding of art in which reality is made unfamiliar. Sontag interprets this as an 'aggressive relation to all subjects' an 'assault on reality' which is seen as deceptive and 'unreal' (p. 121). She quotes Avedon as saying that his photographs have a reality that the subjects do not have, and that he gets to know the subjects through the photographs. She feels there is not a contradiction saying a photograph must be realistic and at the same time creating an even wider gap between reality and the photograph. This is because photography presumes 'a prior alienation or deviation of reality' (p. 121).

Sontag states that photographers see photography as both capturing an objective world and as an expression of a 'solipsistic' individuality. She quotes Moholy-Nagy who feels the strength of a photographic portrait is its lack of subjectivity, and Lange who feels portraits of other people are self-portraits. These two ideals are not compatible.

For Moholy-Nagy, the ability of photography to enhance our powers of observation is crucial; writing in 1936, he listed eight ways of seeing created or

improved by photography: abstract, exact, rapid, slow, intensified, penetrative, simultaneous and distorted. This self-denial is also a characteristic of a quite different type of photography typified by the work of Frank, who quoted by Sontag, sees ' "simply, as through the eyes of the man in the street" ' (p. 122).

Sontag feels that an attraction of the photographer as an 'ideal viewer' is that it denies photography is an aggressive act. The notion of photography as being exploitative makes many photographers uneasy. Sontag points out that photographers cannot '... be characterized either as simply predatory or simply ... benevolent'. It is an example of the ambiguous nature of the relation between oneself and the world, and one side of the relation '... is always being rediscovered and championed' (p. 123).

As a result of the existence of these two contradictory ideals, the 'assault' on reality and the submission to it, photography has an uneasy relationship towards its '*means*', equipment and materials. Photography may be able to make claims for personal creativity on par with painting, but its originality depends on the power of the machine. The advances in technology have resulted in photographs of great formal beauty, for example in the work of Edgerton and Lennart Nilsson, yet there are photographers that react against these advances and take pride in using more primitive equipment, for example Weston, Brandt, Evans, Cartier-Bresson and Frank, the more primitive equipment allowing for the creative accident.

The advances in technology both stimulate an interest in '... a more artisanal, purer past ...' (p. 125) and introduced new processes that are similar to archaic ones, for example the Polaroid produces unique positive prints like the Daguerreotype. There are doubts about the value of realism that make photographers fluctuate between '... simplicity and irony, between ... control and cultivating the unexpected ...' (p. 126) between their 'knowingness' and the need to 'remystify'.

Only after photography was accepted as a fine art did photographers start worrying about the deeper kind of knowledge photography gives. Yet while many photographers identify their work as art (Stieglitz, White, Siskind, Callahan, Lange, Laughlin), others such as Strand and Moholy-Nagy regard the whole question as irrelevant. Photographers who established themselves after the 1940s, influenced by the modernist belief that '... the better the art, the more subversive it is of the traditional aims of art' (p. 127) tended to snub art, 'And modernist taste has welcomed this unpretentious activity that can be consumed, almost in spite of itself, as high art' (p. 127). Photographers claimed photography was an art for different reasons: Julia Margaret Cameron because like painting it beautifies, Henry Peach Robinson because it can lie, Alvin Langdon Coburn because of its

modern impersonal way of seeing and Weston because it allowed for a new means of individual creation.

The desire to be seen as art is still left in parts of photography; Sontag feels Cartier-Bresson's continued use of black-and-white and failure to embrace colour photography is part of a tradition in which colour is reserved for painting. Photographers regard black-and-white images as '... more tactful, more decorous ... less voyeuristic and less sentimental or crudely lifelike' (p. 128).

People defining photography as an art have always tried to stipulate certain principles, and photography has been characterised by clashes between photographers championing different approaches, the straight print versus the manipulated print, for example. All of these attempts are bound to fail because photography is a 'promiscuous' way of seeing. Sontag quotes John Szarkowski as saying ' "a skillful (sic) photographer can photograph anything well." ' (p. 129). Sontag feels it was in conflict with art, which once had a demanding tradition with a discriminating way of seeing and standards that made genuine achievement rare.

Sontag sees a convergence of aims between photography and contemporary movements in art in their subversion of Art. Abstract Expressionist painters attempted to undermine Art by using the canvas as a 'field of action' not as an object, others substituted '... encounter for fabrication, found objects or situations for made (or made-up) ones, decision for effort ...' (p. 130). Photography was the first medium to demonstrate art produced by chance. Despite photography's early entry into the field, photographers are 'less secure' than the Duchamp-influenced artist and need to point out that the moment of exposure is based on a substantial background. Sontag sees another reason for photography's success in the ease with which it is understood. She feels 'classical modernist' paintings (mid to late twentieth century) require a deep knowledge of art history and intellectual ability to understand. Like pop art, photography is easy, about subjects not art.

Photography as pop art is most successful as a modernist approach. Debunking high culture, excluding nothing as subject matter, courting vulgarity and kitsch, turning art into cultural documentation, its 'pseudo-radical patronising of art as reactionary, elitist, snobbish, insincere, artificial, out of truth with ... everyday life ...' (p. 131), while combining the avant-garde with commercialism. Despite this success many photographers are worried that this has gone too far and that people will forget that photography is 'noble and exalted' – an art.

Photographers stopped debating the issue of photography as an art at about the same time that the public and museums accepted it as an art. The museum's acceptance of it as an art was the end of a century old battle by modernists to get an

'open-ended definition' (p. 131) of art. Modernists championed photography because unlike painting there is no real distinction between the work produced by amateurs and professionals, or the sophisticated and the primitive in photography. Further they feel there is no difference in kind between any of the branches of photography or practitioners.

This assumption that all photography is part of one continuum allows for an 'indefinite expansion of taste', (p. 132) and became possible when museums presented photography '...as a collection of simultaneous intentions and styles which however different, are not perceived as in any way contradictory' (p. 132). This has been very successful with the public but is a cause for concern for many photographers as it places on the same level all photographs, from the most ambitious to snapshots, so trivialising photography.

For Sontag, in most photography the 'descriptive function' is of primary importance, so placing them in museums contradicts their very essence, as they are no longer primarily about their subjects but '...become studies in the possibilities of photography'. This makes photography seem problematic in a way only those few photographers whose work revolves around questioning the truthfulness of photography find it. The comprehensive nature of museum collections '...reinforce the arbitrariness, the subjectivity of all photographs...' (p. 133).

When looking at a painting we are very aware of the artist. This is not the case when looking at photographs, and in the case of ordinary and utilitarian photographs the photographer is almost irrelevant. Photojournalism is successful because the work of good photojournalists is so similar, they are powerful images because they copy the world and do not express '...an individual artist's consciousness' (p. 133). In the vast majority of photographs this consciousness '...interferes with the primary demand on the photograph: that it record, diagnose, inform' (p. 133).

The more varied the photographer's work the less it seems like the work of an individual. Much of the work done by the most talented photographers looks as though an equally talented contemporary could have done it. Only work that shows a 'formal conceit' like Duane Michals's narrative sequences or 'thematic obsessions' like Eakin's male nudes easily reveals the author. Work by artists in other art forms has an 'integrity' even when they change their style, for example the work of Picasso and Stravinsky. Sontag gives the example of Muybridge's varied work (motion, Central American photographs and Alaskan and Yosemite surveys). Each series is internally consistent, yet they do not relate to each other. In photography, the subject matter has a greater influence on the final image than does the photographer. Even a distinct photographic style (Avedon, Atget)

implies a similarity in subject matter. And it is this subject matter that determines the viewer's preferences when looking at photographs, not the formal characteristics of the photograph. 'The formalist approaches to photography cannot account for the power of *what* has been photographed...' (p. 135).

Although the subject is more important in photography than in the other representational arts, the many contexts in which photographs are looked at complicate the status of the subject and lessen its dominance. 'The conflict of interest between objectivity and subjectivity, between demonstration and supposition, is un-resolvable' (p. 135). Photographs have authority because they are photographs of something, but claim to be an art dependent on subjectivity. It is this internal conflict that makes photographic taste so defensive and changeable.

From Stieglitz to Weston a consensus was established on evaluating photographs '... impeccable lighting, skill of composition, clarity of subject, precision of focus, perfection of print quality (p. 136). Sontag regards this approach as now 'bankrupt' and feels a broader one has replaced it where the emphasis has shifted from the final print as an object, to the image as being a photographic way of seeing. She cites Weston's 'depreciating' comment about Atget not being a 'fine' technician as an indication of the weakness of his position. This new way of evaluating includes Weston's work but also includes work of poor technical quality. The proponents of this new way see it as freeing photography of the oppression imposed by beauty and technical perfection. 'It opens up the possibility of a global taste, in which no subject (or absence of subject), no technique (or absence of technique) disqualifies a photograph' (p. 136).

This photographic way of seeing is most obvious with 'offbeat or trivial' subjects. Banal subjects are chosen because we are disinterested in them, when photographed they reveal the camera's ability to see. Irving Penn's photographs of cigarette butts is an example of this approach; Szarkowski described such subject matter as being 'profoundly banal', which along with the 'nominal subject' are regarded as important modernist 'conceits' (p. 137) by Sontag. For her this lessens the importance of the subject but also distances it from a particular photographer. For photography to be an art she feels the photographer needs to be seen as '*auteur*', the author of the work in a strong sense, and for the photographer's work to be seen as a 'body of work'. Man Ray seems to meet these requirements, but Steichen with his portraits, abstractions, advertising, fashion and aerial reconnaissance photographs seems less likely to.

Because the work is looked at in terms of photographic seeing, it is not really relevant that it is seen as one photographer's body of work, it needs to seen in an anthology (in galleries or books), with other photographers' work so illustrating the

photographic way of seeing. These anthologies inform people about a way of seeing that make all subject matter equal. These criteria for photographic seeing seem formal and neutral but are '...powerfully judgmental about subjects and styles (p. 138). The reappraisal of ordinary nineteenth century photographs can be seen as a reaction against the soft focus look of work by people like Cameron and Stieglitz which was linked to artistic claims. Photographic seeing is not however committed to sharp focus; it can accommodate all manner of styles and subjects.

There is not much of a vocabulary for evaluating photographs, some terms borrowed from painting, 'composition' etc. and others that are very vague like 'subtle', 'interesting', 'complex' or even 'deceptively simple' (p. 139). The poor language is because the 'process of imagination' and taste in photography is very different from that in traditional painting. Aesthetic evaluation in painting depends on authenticity and craftsmanship, and the organic relationship to the rest of the artist's work and to schools of painting, these notions are weak in photography.

Both paintings and photographs do however change our 'visual language'. Walter Benjamin argued that an essential characteristic of art was that it has a 'quality of presence', which he felt photography lacked. Sontag however disagrees, pointing out that original vintage photographic prints in museums and galleries do have an authenticity and give 'visual pleasures' that reproductions and latter prints do not have and cannot give. The physical deterioration of paintings over time tends to work against paintings, however it helps photographs acquire an aura. Given time all photographs become interesting. Sontag feels there are no bad photographs only less interesting, relevant, or mysterious ones.

Museums are very important in forming photographic taste, but not by setting standards of evaluation. They offer new conditions for looking at photographs, and every time they exhibit work of a particular taste they show that there are no fixed rules of photographic evaluation, no canon. Photography's tradition is in a state of flux because it undergoes more frequent rediscoveries than all other arts. Photography illustrates T.S. Eliot's point that important new work changes the way we see past work, Arbus's work, for example, allowing us to appreciate more Hine's portrayal of '...the oblique dignity of victims'. Changes in contemporary taste also show that opposing styles complement each other and are of equal value.

In the second half of the twentieth century, many American photographers reacted against 'The technical perfection of Weston's photographs, the calculated beauties of White and Siskind, the poetic constructions of Frederick Sommer, the self-assured ironies of Cartier-Bresson...' and produced work that '...was more naïve...direct...hesitant, even awkward'. Yet despite this move towards '...informal photography and to photography as social document...' (p. 142), there is

a revival of interest in Weston's work. This is because the photographic way of seeing has a broad definition of naiveté and so Weston's work now looks naïve.

Even pictorialists such as Oscar Rejlander, Henry Peach Robinson, and Robert Demachy are experiencing a bit of a revival. Because everything is a subject for photography all tastes are catered for, unlike literature for example, where past work can be diminished by newer and one cannot like everything. There are no limits to the eclecticism in photography. The 1870s 'record' photographs of Dr Barnardo's street children are just as moving as Hill and Adamson's 1840s artistic portraits of Scottish notables. Weston's classic modernism is not diminished by Benno Friedman's pictorial blur.

While each viewer will prefer one photographer's work over another, the nature of photography is such that '... one is not really obliged to choose; and that preferences ... are ... merely reactive. Taste in photography ... is perhaps necessarily ... permissive, which means that in the end it must deny the difference between good and bad taste' (p. 143). For this reason, Sontag feels that all attempts to establish rules for evaluating photographs (a 'canon') seem simplistic or ignorant, and that photographic controversies seem somewhat fake. Museums, by levelling up all schools of photography, have made this clear. Schools have a real role in the development and understanding of painting, but no photographer is better understood as a member of a group for example, Stieglitz (Photo-Secession), Weston (f64), Renger-Patzsch (New Objectivity), Walker Evans (Farm Security Administration) (see Figs 3, 15, 26, 40 and 41), and Cartier-Bresson (Magnum) (see Fig. 12).

Photography seems to have arrived at a point from which it probably cannot turn back, with museums playing a leading role in shaping photographic taste. The museums are biased towards the 'profoundly banal', and diffuse the history of photography by promoting photography's entire history. This is a cause for concern for many photographers and critics who fear that photography is a 'senile art' (p. 144). Sontag is not surprised that this has happened at the time of photography's acceptance '... for the true extent of photography's triumph as art, and over art, has not really been understood' (p. 144).

Baudelaire's view of photography as a 'mortal enemy' of painting was widely held. There is a false but widely held belief, that a truce was established by which painting was liberated from representational work and explored abstraction, while photography concentrated on the representational. However, painting did not simply pursue abstraction but explored photographic ways of seeing, painting the fragment, humble life, motion and the effects of light, copying the realism of photography. Photography in its turn kept pace with all the anti-realist developments

in painting. [In a footnote (p. 145) Sontag takes issue with Valery who argues that a photograph can better describe than text. Valery uses the example of a passport photograph, and states that no matter how skilfully a writer describes, each reader will have a different vision. Sontag responds that the same is true of photographs.]

Sontag points out that photography always gets the better of painting. Painters such as Delacroix, Turner, Picasso and Bacon have used photographic aids, but photographers do not get help from painting. While painters may incorporate photographs in their work, as collages, for example, Sontag feels '... photography encapsulates art itself' (p. 146). While looking at paintings helps us appreciate photographs more, the reverse is not true. Photographs '... turn interesting details into autonomous compositions ... transform true colors into brilliant colors, provide new, irresistible satisfactions' (p. 147) (see colour Figures C1–C6). Photography has exceeded its original goal, it does not accurately report reality, it enhances it, becomes the reality, thereby often making reality an anti-climax.

Most works of art are now known through photographic reproductions, much art is modelled on photography, on taste determined by photography, and this transformation of fine arts includes even the idea of a work of art. This has weakened the idea of a work of art as a unique object made by an individual artist. Some art is created to be viewed as a photograph, Christo's packaging of the landscape for example. At times this work is so large it can only be viewed as a photograph, so there is not even the pretence of the photograph leading the viewer to an original experience.

Through the imagined truce between painting and photography, photography was eventually endorsed as a fine art, yet Sontag feels that the question of photography being a fine art is misleading. Although it can generate art, it is a medium like language with which a range of things can be done. Both can be used for scientific, bureaucratic, documentary and artistic purposes. However she feels it is not an art like painting or poetry. Photography conforms both to the traditional notion of individual works of fine art and the notion that states that art is obsolete. Its confirmation of the latter is however stronger.

Photography and painting are not two image-producing systems that can be reconciled by an appropriate 'division of territory' (p. 148). Photography has the unique ability to turn any subject into art and creates new aims for the arts. It is the forerunner for the direction taken by both modern high and commercial art, '... the transformation of arts into meta-arts or media' (p. 149). Traditional fine art is elitist; a single artist; a unique work of art; a hierarchy in terms of subject matter; a distinction between the genuine and fake or copy; and an assumption that

subjects and experiences have meaning. The media are more egalitarian; collaborative; multiple works; all subject matter equally valid; they have an ambivalent attitude towards meaning and originals; and their '...tone is ironic, or dead-pan, or parodistic' (p. 149). She feels this lies behind Marshall McLuhan's remark that the message is the medium. Sontag feels it is inevitable that more art will end up as photography. Pater's dictum that '...all art aspires to the condition of music...' needs to be rewritten to '...all art aspires to the condition of photography' (p. 149).

THE IMAGE-WORLD

Sontag starts by making two claims, that reality has always been interpreted through images, and that philosophers since Plato have tried to develop an image-free way of knowing the real. As humanistic and scientific understanding advanced and old religious and political beliefs retreated in the mid-nineteenth century, an image-free way of knowing seemed attainable. The opposite happened. The credibility given to reality understood in the form of images was instead given to reality understood to be images. She quotes Feuerbach, writing in 1843 as saying people prefer ' "... the image to the thing, the copy to the original...appearance to being..." ' (p. 153). The power of images came to the fore in the twentieth century when the production and consumption of images was perceived to be a major factor in determining whether or not a society was modern. In such societies images 'determine our demands on reality' (p. 153), are substitutes for experience, are essential in sustaining the economy, political stability and pursuing private happiness. These images are mainly photographic, their range and power depend on characteristics unique to the camera.

Photographic images are able to replace reality because unlike paintings they are more than just images; they are a trace, 'a material vestige' (p. 154) of the subject. Sontag speculates that most admirers of Shakespeare would rather have that a photograph was taken of him than a portrait painted by Holbein the Younger.

She points out that most contemporary concerns about images replacing the real world are based on Platonic arguments, which, she argues, are misleading as his arguments were based on the relationship between paintings and reality, and photographs have a different relationship. She also points out that the equating of image with reality is not new. E.H. Gombrich has observed that in primitive societies image and reality were simply two different manifestations of the same thing.

The separation of the image from reality was a result of increasingly secular societies, at the point of total separation of image and subject; the loss of the image's

magic, photography restored the link in secular terms. Our sense of photography being in some way magical does have a basis; '...a photograph is not only like its subject...It is part of, an extension of that subject; and a potent means of acquiring it ...' (p. 155).

Photography acquires in three ways. Firstly, a photograph is a 'surrogate possession' having some of the characteristics of the original thing. Secondly, photographs give consumers a relation to events that the consumer has both participated in and those events they have not; a distinction consumerism blurs. Thirdly, through photographs we acquire things as information, its effectiveness in giving knowledge without the need to experience things and this makes the second form of acquisition very effective.

The third form of acquisition is the most inclusive, once photographed, things are part of a system of information, from the most basic, family albums, to the most complex, '...weather forecasting, astronomy, microbiology, geology, police work...' etc. (p. 156). We never see vast amounts of this material. The definition of reality depends on its use 'an item for an exhibition, as a record for scrutiny, as a target for surveillance' (p. 156). All this provides the potential for control unimaginable with writing. The technological advances in photography ranging through astronomy, infrared, holography, cinema, video etc. '...has made photography an incomparable tool for deciphering behavior, predicting it, and interfering with it' (p. 157).

Photography is so powerful because it depends on an optical-chemical or electronic process rather than on an image-maker, this automatic, mechanical and literal process has created a new relationship between image and object. Whereas primitive people assumed images had the quality of real things we assume the opposite.

Sontag compares photography to Balzac's writing, where small details are magnified, incongruous things are juxtaposed, where a life can '...be summed up in a momentary appearance. And a change in appearance is a change in person' (p. 159). She feels 'Reality has started to be understood as a kind of writing, which has to be decoded...' (p. 160), noting that Niépce called photography heliography (sun-writing) and Talbot called the camera 'the pencil of nature'.

Sontag does not accept Feuerbach's notion of a fixed reality and changeable images. She feels '...the notions of image and reality are complimentary' (p. 160). When the notion of one changes so does the other. One reason our society prefers images to reality is that the '...notion of what is real has been progressively complicated and weakened...' (p. 160).

Few people in modern societies fear the camera in the way that some people in more primitive ones do, but there is a residual feeling of the magic, most people would be reluctant to tear up or throw away a photograph of a loved one. The 'true modern primitivism' (p. 161) does not regard the image as real but regards reality as being like images. People will often describe things 'it seemed like a movie' (p. 161). While people in non-industrialised countries may be apprehensive about having their photographs taken, people in industrial countries feel it is a conformation of their reality.

With the increasing complexity of reality, and the resultant depleted sense of reality, one of the most addictive ways of coping is picture taking. A way of bolstering reality is to travel, photographing new experiences. For those who are unable to travel, collecting as opposed to taking photographs becomes important and '...can be used to make a substitute world...' (p. 162). Sontag uses a series of examples, mainly drawn from fiction, to illustrate her point. Her examples also illustrate the point that the same photograph can have a very different significance for different people. In *The Magic Mountain*, the X-rays of his patients are diagnostic aids for Hofrat Behrens, while Hans Castrorp, lovesick for Clavdia Chauchat finds X-rays of her '...the most precious of trophies' (p. 163).

Photography also fills out reality. Sontag cites Proust's unusual view of reality, that one must be able to possess it. Reality is in the present, it cannot be possessed; images are of the past and can. Sontag states that Proust presupposes that '...reality is distant...' and she points out '...photography implies instant access to the real' (p. 164). Because Sontag feels reality is unreal and remote, all that this instant access does is to create distance by allowing the viewer '...to reexperience the unreality and remoteness of the real' (p. 164). For Proust, photography was not a satisfactory way of possessing the past, as it was too shallow, too visual. He felt all the senses had to be involved. Sontag feels he misunderstands what photographs are, '...not so much an instrument of memory as an invention of it or a replacement' (p. 165) (see *Memories Are Made Of This*, Fig. 42).

Photography makes images, not reality, immediately accessible. Before the advent of photography only some of the rich may have had an image of themselves as a child. The point of these portraits was to '...confirm an ideal of the sitter...' (p. 165), i.e. social standing and appearance. Nowadays people have numerous photographs of their family members at many stages of their lives. The photographs simply confirm that the person exists, so there cannot be too many, but it does not give access to reality.

In the 1850s, there was a strong fear that the uniqueness of the subject was being lessened by photography. She quotes from Meville's *Pierre* in which the hero

states that in the time of painting, having a portrait was a mark of distinction, with the proliferation of photographic portraits even a 'dunce' has one, so not having a portrait becomes the mark of distinction.

'But if photographs demean, paintings distort in the opposite way: they make grandiose' (p. 166). The main difference between photographic and painted portraits is that the latter usually sum up, photographs are more ongoing and imply that more will be taken, so do not sum up. Sontag quotes Lewis Hine ' "Ever the Human Document to keep the present and the future in touch with the past" ' (p. 166). However, she feels that not only does it record the past but is a new way of dealing with the present. By photographing something we are transforming it into a mental image, we establish 'instantly retroactive' relation to the present. 'Photographs give mock forms of possession: of the past, the present, even the future' (p. 167). Sontag illustrates this point by referring to Nabokov's *Invitation to a Beheading* (1938) where the prisoner Cincinnatus is shown an album of photographs of Emmie. It shows photographs of her in the past, present and manipulated images of her in the future, including one of her on her deathbed. Nabokov described the album as a 'parody of the work of time'. Sontag feels it also parodies the work of photography.

Photography, which has many narcissistic uses, also depersonalises our relation to the world. Sontag uses the analogy of a pair of binoculars looked through from either end. From one end, exotic things are brought up close, made clear and familiar, from the other intimate and familiar things are made strange and distant. The camera offers '... both participation and alienation in our own lives and those of others – allowing us to participate while confirming alienation' (p. 167). Our society tries to avoid suffering of any sort yet creates a great deal of curiosity about suffering, which is partly satisfied by photography. Sontag feels that being exempt from the suffering stimulates interest in the images of suffering and strengthens our feeling of being exempt. This is for two reasons: firstly the viewer is 'here' not 'there', secondly because in the real situation things are happening and those seeing it do not know what will still happen. In a photograph it has happened and is fixed for all time.

Sontag argues that exposure to photographs often weakens our feelings when we see the same thing in real life. Photographs are often more disturbing than the real thing. Sontag witnessed a major three-hour long surgical operation in China, she never felt queasy nor did she look away. A year later when watching a less gory operation depicted in Antonioni's documentary Chung Kuo, she was unnerved at times. We often find photographs more disturbing than reality for three reasons. Firstly in reality we are usually not passive, we have things to do. This is related to the second reason, in a photograph or film we have to look at what the photographer

want us to see, in real life we look at what we want for as long as we want. Thirdly the photograph or film condenses time so only the most interesting (or shocking) things are shown, and they are shown happening in more rapid succession than in reality.

The Chinese authorities were offended by Antonioni's film and their attacks on it, published in a number of articles in 1974, inadvertently revealed a view of photography very much opposed to modern photography's way of seeing. Sontag points out that for us photography is closely connected to a 'discontinuous' way of seeing (using cropping, selection etc.), showing a part as a way of showing or saying something about the whole. In China photography must show continuity. There are proper subjects (the positive) and proper ways of photographing and these are determined by a concept of '. . . the moral order of space that preclude the very idea of photographic seeing' (p. 170). Antonioni offended the Chinese authorities both by photographing the right subjects in the wrong way, and by photographing the wrong subjects (there is no right way to photograph the wrong subjects). Wrong subjects included archaic farming methods (and ignoring modern methods), dilapidated walls, children running out of a classroom (instead of studying inside it) etc. Examples of the wrong way of photographing included using dreary colours, placing people in dark shadows, using high or low angles, and by using close-ups of people instead of full shots etc.

Sontag points out that it is not only the official photographs and those that are taken from the position of an ideal viewer that have a posed formality. Family snapshots too are not candid; there is no sense of movement. People assemble and pose for their photographs; they prepare for, and consent to the photograph being taken. (Antonioni was criticised for not doing this.) They are aware of the photographer. In our (camera) culture the photographer is allowed to intrude and the subjects in general accept this and do not pose.

The Chinese do not see beauty in disorder, decay or odd angles. For us '. . . beauty is not inherent in anything; it is to be found, by another way of seeing – and a wider notion of meaning, which photography's many uses illustrate and powerfully reinforce' (p. 173). The more variations a thing has the more meanings it has. This is exploited photographically in the West. So Antonioni's images mean more than indigenous Chinese photographs do. For us photography can produce both clichés and new views. The Chinese do not want new angles or meanings, only 'correct' views – images that we would regard as clichés.

Unlike us the Chinese authorities see reality as straightforward, there is right and wrong, and photography should illustrate the right way. Their ideology sees reality as a historical process made up of recurring opposites with clear-cut moral meanings.

The past is judged as mostly bad. We, on the other hand, see history as complex with occasionally contradictory lessons to be drawn from it. We also have an interest in knowing as much as possible. The only use the Chinese have for history is didactic, to teach a 'narrow moralistic' worldview. The Western approach to photography therefore has no place in their society.

Likewise, our use of photography is locked into our worldview. For Sontag, our view of society is one based on the 'the denial of conflict' (p. 174), photography is part of this view because it does not show conflict but more diversity. The recording of the world as images encourages this mistaken 'one' worldview, and images can always be made compatible, even when their subjects are not.

One of the key aspects of modern society is photography's ability not only to reproduce reality but also to recycle it. '...things and events are put to new uses, assigned new meanings, which go beyond the distinctions between the beautiful and the ugly, the true and the false, the useful and the useless, good taste and bad' (p. 174). By doing this photography is one of the main means of producing 'the interesting', which Sontag defines as something '...that can be seen to be like, or analogous to, something else' (p. 175). There is an art to making things interesting, coupled with this are fashions of seeing. Images and ways of seeing are continuously recycled, clichés become 'meta-clichés', unique objects become clichés and clichés in turn become unique objects, images of images are mixed with images of the real. For the Chinese, there is no ambiguity '...all images reinforce...each other' (p. 175). We, however, make photography say anything at all.

The difference between photography as individual expression (art) and objective recording (documentation) seems fundamental. Yet Sontag sees both as '...extensions of what photography means: note-taking on...everything in the world, from every...angle. Nadar as early as 1855 realised that the scope of photography ranges from portraits to 'photo-interviews' to warfare.

Sontag argues that there are two attitudes behind the belief that everything is material for photography. Firstly, a perceptive photographer can find beauty or interest in everything, to the extent that even photographs taken solely for practical purposes can be co-opted into art, accordingly there is nothing that should not be seen. This aesthetic view of reality is facilitated by the 'machine-toy' nature of the camera that allows everybody to make objective value judgements about '...importance, interest, and beauty. ("That would make a good picture.")' (p. 176). Secondly, every object is seen as having or potentially having a use '...as a matter for estimates, decisions, and predictions'. Accordingly, there is nothing that should not be recorded. This instrumentalist view enables us to make rapid and accurate responses (benevolent or otherwise) to events.

In a society, which divorces the public from the private, individuals are going to have contradictory feelings about situations. Sontag feels that the aesthetic and the instrumental attitudes produce the same contradictions, for this reason 'picture taking', which is so useful in both the public and private, helps us to live with these contradictions. The camera serves power, the state, industry and science. It also enables people to express themselves visually in their private lives. In China, this space has been taken by political moralising leaving no room for individuality in aesthetic expression. As westerners become more '. . . detached from politics . . .' (p. 177), the camera is able to fill the space. Sontag reasons that because we equate behaviour with character, the potential for surveillance of the public by video is far more significant than increased personal use. In China, because they are more repressive, monitoring is not adequate, a change of heart is required and self-monitoring is essential. For this reason she speculates that there will be limited public surveillance.

China has the kind of dictatorship that has a central concept of 'the good' and so limits all types of expression, including images. Sontag sees the potential for another type of dictatorship in which the master idea is 'the interesting' sustained by the proliferation of a vast range of images. Only the radical eradication of history, as in China, can prevent this proliferation. When one considers '. . . in what contexts photographic images are seen, what dependencies they create, what antagonisms they pacify – that is, what institutions they buttress, whose needs they really serve' (p. 178), they clearly serve capitalism.

Capitalism '. . . requires a culture based on images'. Firstly, it has to produce entertainment on a vast scale both to stimulate buying and to obscure the injustices of class, race and sex. Secondly, it needs unlimited information to exploit resources, increase productivity, keep order etc. The camera's capacity both to make reality subjective and to objectify it is essential for an advanced industrial society. It provides an ideology in which social change is replaced with a change of images, and free political choice is replaced with choices about consumption of goods and images.

Sontag sees the need to photograph tied into lustful consumption; consumption uses things up and lust cannot be satisfied, but because the subject matter for photography is infinite this cycle of consumption continues contributing to a 'depleted sense of reality'.

The power of photography has blurred the distinction between reality and images. Plato was able to criticise images as '. . . transitory, minimally informative . . .' (p. 179). 'But the force of photographic images comes from their being material

realities in their own right, richly informative deposits left in the wake of whatever emitted them...' (p. 180). So powerful in fact that reality seems less real. Because the image world is unlimited the real world would be able to accommodate it only if there were an 'ecology' of images.

ASSIGNMENTS/DISCUSSION POINTS

In Plato's cave

1. Sontag refers to photographs ability to change the scale of reality and then the photographs themselves undergoing changes as their context is altered (p. 4). Take a photograph or series of photographs that explore these notions.

2. Despite capturing reality, Sontag argues that photographs are also interpretations. Take a series of photographs of the same subject matter but interpret the subject in at least two different ways.

3. In her essay Sontag states 'Photography is essentially an act of non-intervention (p. 11). Discuss the issues she raises in this paragraph and refer to the work and aims of one or more of the following photographers, Jacob Riis, Lewis Hine, Eugene Smith, Don McCullin, Susan Meiselas and Sebastião Salgado. (The Hine, McCullin, and Meiselas photographs reproduced in this book, Figs 35, 9 and 37 respectively, are relevant to this question.)

4. In the essay Sontag claims, 'In these last decades, "concerned" photography has done at least as much to deaden conscience as to arouse it' (p. 21). Look at the work of two contemporary photographers you would regard as 'concerned', for example Tom Stoddart and Marlene Bergamo. Explain why you regard your choice of photographers as 'concerned' and discuss their work in relation to Sontag's claim.

5. As a child Sontag saw photographs of Nazi concentration camps and these had an enormous impact on her '...I felt irrevocably grieved, wounded, but a part of my feelings started to tighten; something went dead; something is still crying' (p. 20). She asks what good was served by seeing them? Answer her.

6. Sontag gives five reasons for our inability to understand reality through photographs (p. 23) and in the essay *The Image World* (p. 169). When talking about films, she expands on them. Compare her explanation of why photographs differ from reality with those advanced by Szarkowski and Shore.

7. Sontag argues that '...one never understands anything from a photograph.' And that understanding '...starts from *not* accepting the world as it looks' (p. 23). Do you think a scientist will agree with her? Give reasons for your answer.

8. Is information gleaned from a photograph any less reliable than information gained from the other senses (hearing, touch etc.), and could a written account of a visual experience give a complete understanding of the experience without the experience being presented visually? See the summary of Bertrand Russell's *Appearance and Reality* in this book.

America, seen through photographs, darkly

1. Sontag links the claim that everything has equal value, as espoused by Walt Whitman's *Leaves of Grass*, to photography's acceptance of anything as worthy subject matter. Given that *Leaves of Grass* was published in 1855, only fifteen years after photography's invention this seems a logical link. However, over fifty years earlier William Blake, in *Auguries of Innocence*, uses the sentence 'To see the world in a grain of sand'. Given this, could it be argued that the arts in general (not only American) were moving towards a more inclusive notion of beauty anyway and that although Whitman and photography further encouraged it they were not primarily responsible for it? Take one or more photographs exploring the notion of beauty in the ordinary. (Curtis in *Mind's Eye, Mind's Truth* says of Dorothea Lange 'On the door of her darkroom, she displayed the following quotation from Francis Bacon:

The contemplation of things as they are
Without substitution or imposture
Without error or confusion
Is in itself a nobler thing
Than a whole harvest of invention' (p. 47).

The quotation is from Bacon's *Novum Organon* which was published in 1620.)

2. Sontag quotes Walker Evans as wanting his photographs to be 'literate, authoritative, transcendent' (p. 31), qualities she feels nobody would attribute to photography today. If these are qualities that can be attributed to the work of Evans (see Figs 3, 15, 26, 40 and 41) and say August Sander (see Fig. 1) can they be attributed to any contemporary photographers. Select one or more photographers who have worked within the last thirty years and make a case for their work having these qualities. (You may wish to look at the work of Bernd and

Hilla Becher, Lewis Baltz, Richard Misrach, Flor Gardino, Simon Norfolk and Fazal Sheikh for example).

3. Sontag points out that Arbus's photography depends on being 'outside' rather than 'inside' the situation. Compare Arbus's work with that of a photographer that is inside the situation, for example Nan Goldin. See the summary of Solomon-Godeau's *Inside/Out* in this book.

4. Sontag states that Arbus's photography depends on being 'outside' rather than 'inside' the situation. Take a series of photographs, one set of a situation in which you are an 'insider' and one in which you are an 'outsider'. Explain in detail what you felt were the advantages and disadvantages to you as a photographer in both situations. Evaluate both sets of work.

Melancholy objects

1. Sontag sets out the Surrealists aims as '... blurring the lines between art and so-called life, between objects and events, between the intended and the unintentional, between pros and amateurs, between the noble and the tawdry, between craftsmanship and lucky blunders' (p. 51). Take one or more of these concepts and produce a photograph or photographs exploring your chosen concept(s). Evaluate your work. You may wish to look at the work of photographers like Man Ray, Moholy-Nagy and Anton and Arturo Bragaglia as part of your research.

2. Sontag cites Jacques-Henry Lartigue as a photographer who confined himself to his own family and class. Compare his work to that of Richard Billingham (see colour Figure C5) or another contemporary photographer who does the same thing. Produce a set of photographs, of your family, in the manner of one of the photographers.

3. For Sontag a photograph has 'pathos' (p. 54), and the main tradition of American photography is one of loss. Take one or more photographs exploring these notions and evaluate your work relating it to one or more of the photographers Sontag names.

4. Sontag describes documentary photography as having a 'predilection' for losers. For the sake of argument accept this as being true, and justify this predilection. Evaluate the work of one or more such documentary photographers and produce one or more photographs in a similar vein. (See assignment 7, 'The Heroism of Vision'.)

5. Sontag argues that photography has managed a '...Surrealist takeover of modern sensibility...' (p. 51) and the way she describes surrealism seems equally applicable to post-modernism. Could it be argued that post-modernism is nothing more than a new name for an aging art movement. (See Chapter 8, Andy Grundberg *The Crisis of the Real.*)

The heroism of vision

1. Sontag argues 'Hence the formal qualities of style – the central issue in painting – are, at most of secondary importance in photography, while what a photograph is *of* is always of primary importance' (p. 92). Is Sontag understating the value of the formal qualities, and if not how would one judge the worth or effectiveness of different photographs of identical subjects. Look at the Five versions of the photographs Dorothea Lange took in the *Migrant Mother* series (see Figs 28 to 32). They are essentially *of* the same thing, it is formal qualities that differentiate them. Had she not taken the fifth photograph, would any of the others had the same impact? Take two or more photographs of the same subject using different approaches. Imagine you had to choose one of them for an exhibition or for publication and justify your choice. (There is a similar question/discussion point, number 13, after the Martha Rosler section in this book.)

2. Edward Weston asserts that photographic seeing creates a union with nature, however Sontag feels that it creates an estrangement. Ansel Adams was closely associated with Weston, can any sort of case be made that Weston and/or Adams was estranged from nature?

3. Sontag states that Robert Frank's work is less piercing and more democratic than either Weston's or Henri Cartier-Bresson's. Given that Frank's *The Americans* is generally regarded as a harsh look at America, that Weston's subject matter included toilet bowls and vegetables and Cartier-Bresson photographed a wide range of nationalities, social and ethnic groups, can these claims be sustained? (See Fig. 12). Is there a particular aspect of Frank's work that she could use to justify her claim?

4. Sontag views Weston's and Strand's notions of beauty 'banal' for a moral reason, because they see or create order, their beautiful compositions are contrary to '... the truth of disorder...' (p. 101). Discuss the following three issues. Firstly, can Sontag prove there is such a thing as 'the truth of disorder'? Secondly, if she cannot is it legitimate for her to criticise these photographers' work on the

grounds that she has a different world view from theirs? And thirdly, if their work were to have no composition and so no structure would its ability to communicate be enhanced or weakened?

5. Sontag states that Weston's photographs are beautiful because of his skill and taste in composition and lighting. Jacob Riis's (see Fig. 36) are beautiful because of the grimy subject matter, the appropriateness of the poor framing, the harsh contrasts produced by the flash, this being an amateurish and inadvertent beauty (p. 103). She goes on to say these double standards are always a part of the evaluation of photographs. Is she right to use the word 'beautiful'? Could she not have said they were highly regarded because they were 'revealing' or 'compelling' for example, and if so would she still be able accuse photographic evaluation of double standards?

6. Sontag gives the example of W. Eugene Smith's photograph from the book *Minamata*, of a dying boy on his mother's lap. Sontag feels our indignation is aroused by the suffering shown in these photographs but that they distance us '... because they are superb photographs of Agony conforming to surrealist standards of beauty' (p. 105). Do you agree with her? In dealing with this issue she also refers to a Lewis Hine interview 'Treating Labour Artistically' (p. 64) and quotes from Walter Benjamin (p. 107). More recently Ingrid Sischy criticised Sebastião Salgado's work in a similar vein in her essay *Good Intentions*, while A.D. Coleman praised it. If you wish you may broaden the scope of your essay to incorporate Salgado's work and critics' responses to it. Sischy's essay is reproduced in *Illuminations* edited by Liz Heron and Val Williams and Coleman's in his collection of essays *Critical Focus*.

7. Sontag states that documentary photography has a '... continuing predilection – for losers...'. Find examples about five 'concerned' documentary photographers (preferably from different countries), whose work cannot be said to be preoccupied with losers. Write briefly about their work and select one to write about in detail. Undertake a documentary project of your own that does not focus on losers. For example it could be argued that George Rodger's African photography and most of Cartier-Bresson's was not preoccupied with losers.

8. Sontag points out that photographs are fragments and because of this their context changes them. Each context '... suggests a different use for the photograph but none can secure their meaning – the meaning is the use...' (p. 106). She quotes Godard and Gorin ' "This photograph, like any photograph... is physically mute. It talks through the mouth of the text written beneath it" ' (p. 108). Find two or three typical examples of documentary photographs, and research

their backgrounds. Show them to a number of different people who have never seen the photographs before, without giving the viewers any information about the photographs. Ask the viewers to tell you what the photographs are about. Record their responses and see to what degree their responses coincide and reflect the original meaning of the photograph.

9. According to Sontag the inhabitants of the richer parts of the world tend to learn of the world's troubles through photography, and although these images do cause distress their aesthetic nature tends to neutralise the distress. Look at the photograph by Don McCullin (Fig. 9). It could be appreciated in terms of its formal or aesthetic merits. The wall in the background creates a diagonal band that narrows from right to left so drawing the viewer's eye to the children; the albino child is the only child who is tall enough to break the top line of the diagonal and so stands out; his skin colour being lighter than that of the other children again isolates him, as does his placement in the foreground; he leans against the wall so his feet are close to the viewer and this helps to draw the viewer's eye up his body to his head, which leans forward towards the viewer emphasising its relative size (relative to his emaciated body) forcing an intimacy with the viewer; this intimacy is further reinforced by the vantage point – McCullin must have bent or knelt down to force the viewer to look at the child at the child's eye level. Do you think these formal elements, part of the aesthetic nature of the image, neutralise or emphasise the distress caused by this image? In her book *100 Historic Photos* Marie-Monique Robin re-prints this photograph and writes of it 'This photo caused an international outcry and hastened the end of the war ... it stunned Bernard Kouchner, who founded Médecins Sans Frontières,' and quotes him as saying ' "This photo ... marked the start of a collaboration between press and medics, without which humanitarian efforts are doomed to fail" '. Arguably Tom Stoddart's work also falls into the tradition Sontag criticises. This is an excerpt from short news story in the *Amateur Photographer*, 6 February 1999, ' In August of last year photojournalist Tom Stoddart travelled to southern Sudan to cover the catastrophic famine which has claimed hundreds of thousands of lives there. When three of these photographs were published in *The Guardian* the response was immediate and massive: thousands of people phoned in to pledge donations. Within eight hours £40,000 had been received. By the end of the week that figure had risen to nearly £100,000. Tom's images are a perfect example of photography's power to move people in a way mere words often cannot.' Do these quotes help to refute Sontag's claim?

10. In this essay Sontag argues that photography does not promote understanding, rather it stimulates an acquisitive relationship to the world that encourages

aesthetic awareness at the expense of emotional involvement. In the essay *In Plato's Cave*, she says of her reaction to seeing photographs of German concentration camps, 'Some limit had been reached...I felt irrevocably grieved, wounded, but a part of my feelings started to tighten; something went dead; something is still crying'. Is Sontag contradicting herself, or can she reconcile these two apparently opposed attitudes?

Photographic evangels

1. In criticising photography Sontag points out that photographers contradict each other. Is this peculiar to photography or in common with other art forms? Look at the work of two photographers from similar periods who held different views on photography and produce two or more photographs. About half your work is to be influenced by one photographer and the remainder to be influenced by the other photographer. Evaluate your work in terms of their beliefs. For example, Henri Cartier-Bresson and William Klein, or (although their careers only overlap in a nominal sense) Henri Cartier-Bresson and Martin Parr (see Fig. 12 and colour Figure C4). *Photography in the Modern Era* edited by Christopher Phillips would be a useful source of debates in Europe from 1913 to 1940.

2. Sontag notes that for Moholy-Nagy the ability of photography to enhance our powers of observation is crucial, writing in 1936 he listed eight ways of seeing created or improved by photography. See question/discussion point 1 at the end of Chapter 7 of this book.

3. Sontag states that some photographers prefer to use more primitive equipment, so allowing for the happy accident (p. 124). Amongst the photographers she gives as examples are Bill Brandt and Edward Weston. Discuss the work of both photographers with particular reference to the notion of the happy accident in their work. Produce one or more photographs which rely on unpredictable (accidental) factors to have impact. For example, Bill Brandt's distorted nudes resulted from him wanting a lens that included both the floor and ceiling of a room, and only after using it did he realise the extent to which it distorted figures, while Weston neither used professional models nor posed them, he would just get them to move around and stop them when struck by a pose.

4. Sontag argues that photojournalism is successful because the work of good photojournalists is so similar, they are powerful images because they copy the world and do not express '...an individual artist's consciousness'. Attempt to find two photojournalists who photographed the same or similar events in ways that

expressed their individual consciousness. Explain how their work is different. If you cannot find an example, explain why your attempts failed. A possible example would be Henri Cartier-Bresson's photographs of George VI's coronation in 1938 which did not show the pomp and ceremony that other photographers concentrated on.

5. Sontag argues that the subject matter of photographs is of over-riding importance and as a result the only photographs that readily reveal their author are those that have a 'formal conceit or thematic obsessions' (p. 134). Mario Giacomelli and Bill Brandt are two photographers who produced substantial bodies of work in a range of genre. Look at their work, neither can be accused of a thematic obsession, but is their work distinctive because of formal conceits or because it has some form of artistic integrity?

6. For Sontag 'The formalist approaches to photography cannot account for the power of *what* has been photographed . . .' (p. 135). Szarkowski and Shore provide formalist approaches to photography, can they account for the power of what has been photographed, if not, do they, or should they attempt to?

7. For Sontag the new way of photographic evaluation '. . . opens up the possibility of a global taste, in which no subject (or absence of subject), no technique (or absence of technique) disqualifies a photograph' (p. 136). If neither subject nor technique determine the value of a photograph what criteria can be used to determine whether or not a photograph is good?

8. For Sontag, Irving Penn's photographs of 'profoundly banal' (Szarkowski's phrase) subject matter distances his work from him. Could it be argued that his demanding technical requirements link it closely to him? Produce one or more photographs of banal subject matter in a technically demanding way by, for example, using a large format camera and artificial lighting.

9. For Sontag there is not much of a vocabulary for evaluating photographs, some terms have been borrowed from painting, 'composition' etc. and others are very vague like 'subtle', 'interesting', 'complex' or even 'deceptively simple' (p. 139). The poor language is because the 'process of imagination' and taste in photography is very different from that in traditional painting. Aesthetic evaluation in painting depends on authenticity and craftsmanship, and the organic relationship to the rest of the artist's work and to schools of painting; these notions are weak in photography. Attempt to refute this argument.

10. Sontag seems to argue that photography is different from other art forms in that new work does not refute old and that anything is acceptable, denying in

the end '...the difference between good and bad taste' (p. 143). Is this true of photography, and if so, is it also now true of art?

The image-world

1. For Sontag photography acquires in three ways. Firstly, a photograph is a 'surrogate possession' having some of the characteristics of the original thing. Secondly, photographs give a consumer's relation to events that the consumer has both participated in and those events they have not; a distinction consumerism blurs. Thirdly, through photographs we acquire things as information, its effectiveness is in giving knowledge without the need to experience things and this makes the second form of acquisition so effective. Find a number of images that you feel illustrate these three ways of acquisition well and justify your choices. You may wish to refer to John Berger *Ways of Seeing* (Chapter 1) when answering this question.

2. Sontag states that 'Reality has started to be understood as a kind of writing, which has to be decoded...' noting that Niépce called photography heliography (sun-writing) and Talbot called the camera 'the pencil of nature' (p. 160). Was Talbot suggesting the use of the pencil as in writing or as in drawing? Substantiate your answer.

3. Sontag does not accept Feuerbach's notion of a fixed reality and changeable images. She feels '...the notions of image and reality are complimentary.' When the notion of one changes so does the other. One reason our society prefers images to reality is that the '...notion of what is real has been progressively complicated and weakened...' (p. 160). Could it not be argued that there are aspects of reality that cannot be changed by photography just as there are aspects of reality that are changed as a result of being photographed? Give examples to substantiate your argument.

4. In criticising Proust's understanding of photography she feels he misunderstands what photographs are, '...not so much an instrument of memory as an invention of it or a replacement'. Could they not be both or either?

5. Sontag points out that for the Chinese authorities there is a right way to photograph things. In the Soviet Union, Rodchenko in his debate with Kushner, for example, advocated what he considered to be a revolutionary approach to photography that would have fallen foul of the Chinese authorities. Investigate these two different approaches and try to explain why people committed to a similar political ideology would advocate such different approaches to

photography. Undertake a documentary project but photograph it using both approaches. Compare and critically evaluate your results. *Photography in the Modern Era* reprints a number of the debates between Rodchenko and others, see pp. 243–270.

6. The Chinese authorities approve only of things being photographed in a straightforward way. It could be argued that August Sander did this, yet his work met with the strong disapproval of another authoritarian regime. How do you think the Chinese authorities would have reacted to a Chinese photographer photographing Chinese society in the way Sander photographed German society? Produce a series of portraits in the spirit of Sander's work (see Fig. 1).

7. Sontag argues that capitalism '...requires a culture based on images' (p. 179). This endorses Berger's arguments in Chapter 7 of *Ways of Seeing*. Compare and evaluate their arguments.

8. For Sontag, the power of photography has blurred the distinction between reality and images. Plato was able to criticise images as '...transitory, minimally informative...' (p. 180), 'But the force of photographic images comes from the being material realities in their own right, richly informative deposits left in the wake of whatever emitted them...', so powerful in fact that reality seems less real. Discuss this point of view in relation to advertising. Produce one or more photographs that illustrate this point.

In 2003 Susan Sontag published *Regarding the Pain of Others* in which she returned to many of the issues she raised in *On Photography*. *Regarding the Pain of Others* is well worth reading and develops and refines some of the arguments in *On Photography*. In comparison with *On Photography* it is not as wide ranging and written in a more accessible style.

4 Roland Barthes, *Camera Lucida*

1. Specialty of the photograph

On seeing an 1852 photograph of Napoleon's youngest brother, Barthes was amazed to realise that he was '...looking at eyes that looked at the Emperor'. (p. 3). No one seemed to share his amazement and he became interested in photography in opposition to the Cinema, overcome by the desire to understand what was the 'essential feature' that separated photography from other images.

2. The photograph unclassifiable

Barthes feels that attempts to classify photographs in terms professional/amateur, subject matter or movements fail because they are external to the subject and can be applied to other, older types of images. However, the photograph mechanically makes infinite something that only occurred once and cannot be repeated. Further, the photograph cannot lead the viewer somewhere else, it always leads back to the subject. Unlike other images, the photograph always points to or shows something, it is '...a weightless transparent envelope' (p. 5), making it impossible to distinguish it from what it represents, its 'referent' (at least not immediately).
To see the photographic signifier requires a second level of contemplation because there is something tautological about photographs. The photograph as signifier is inextricably bound with its referent. Barthes sees photography as belonging to a class of 'laminated objects' that cannot be separated from each other without destroying both parts.

The fact that there cannot be a photograph without first there being some thing '...involves photography in the vast disorder of objects...' and the difficulty of explaining why a particular moment or object has been photographed. If photography is to be a sign it must have a mark, but it has no mark, it is always invisible, we do not see it.

The persistence of the referent (the subject), makes it difficult to understand photography. Those who have tried to do so try in very different ways, from close up by looking at technical aspects and from a distance by looking at the totality of photography from a historical or sociological aspect. Barthes realised neither group '…discussed precisely the photographs which interest me, which give me pleasure or emotion…I saw only the referent, the desired object, the beloved body …'. Dismissing sociological commentary, he wanted to be '…a primitive, without culture'.

3. Emotion as departure

Barthes realised that the dilemma he had with photography reflected the problem he had between balancing being expressive and being critical. At all costs he wanted to avoid any form of reductionism. He decided to study a few photographs he was sure existed for him, in the hopes of finding the fundamental and universal feature that underpinned photography.

4. *Operator*, *spectum* and *spectator*

A photograph is subject to three things, 'to do, to undergo, to look.' The photographer does and is the *operator*, those that look, the *spectator*, and the thing photographed is the *spectum*, a term used because it is related to the word 'spectacle', which is appropriate because in every photograph there is 'the return of the dead'. Barthes had no experience, even as an amateur as an *operator* and so does not try to speak of their emotions.

5. He who is photographed

Barthes does not deal with photographs taken of him without his knowledge. He wanted to be guided by his emotions and so dealt with the experience of posing for a photograph. He points out that as soon as he was aware of being photographed, he started to pose, actively transforming himself into an image, aware that the photograph would create or mortify his body. Although it was only metaphorically that he owed his existence to the photographer he experienced anguish as his image was made. He wished to have a noble expression as in classical paintings, but the skill required to produce 'a delicate moral texture' is found only in the greatest photographers and in general photography is not subtle. He gave a slight smile playing the game; he wanted the viewer to know he was posing and he knew he was posing; yet he not want this to alter the 'precious essence' of his individuality.

However, whatever his situation or age, the photographs of him were always heavy and motionless, unlike his real self which was light and dispersed.

Prior to photography, portraits generally showed a person's social status or wealth. Photography has changed the way we look at ourselves, but there is no history of looking. The '... Photograph is the advent as myself as other: a cunning dissociation of consciousness from identity' (p. 12).

In a culture in which one's being is based on ownership, photography creates problems by turning subjects into objects, Barthes asks, 'Is a landscape only a kind of loan made by the owner of the terrain?' (p. 13).

In portrait photography, there are four opposing and inter-related forces; '... the one I think I am, the one I want others to think I am, the one the photographer thinks I am, and the one he makes use of to exhibit his art' (p. 13). As a result, whenever Barthes was photographed he imitated himself and felt a 'sensation of inauthenticity'. For Barthes, the Photograph represents the moment when he is neither subject nor object but is changing from one to the other, and he experiences a micro-version of death, as he becomes a spectator. Nothing the photographer tries to do to keep the photograph alive helps. There are many readings of the same face and Barthes does not know how society will read the photograph. He became 'Total-Image ... Death in person; others ... turn me ... into an object ... classified in a file, ready for the subtlest of deceptions ...' (p. 14). Barthes gives as an example of a photograph of which he was very satisfied with as he felt he could see in it the distress of a recent bereavement. A little later, however, someone had used the photograph to illustrate a pamphlet, and through the printing he now looked sinister. He concludes, '(The "private life" is nothing but that zone of space ... where I am not an image, an object. It is my *political* right to be a subject which I must protect.)' (p. 15).

Barthes is looking for death in the photograph, for him death is the form, '*eidos*' of the photograph. For him the only thing that can break through the deathly nature of the photograph is the sound of the shutter.

6. The *spectator:* chaos of tastes

As the *spectator*, Barthes rediscovered the disorder of photography, all practices and subjects mixed up. Photographs are everywhere (ubiquitous) and entered his life uninvited. He found he had a mixed reaction even to those photographs 'culture' deemed good. He detested Atget's trees, Pierre Boucher's nudes and Germaine Krull's double exposures. He also realised that he did not like all the

work of any single photographer (the only Stieglitz photograph he liked was *The Horse-car Terminal. New York, 1893*). The artist's style, so useful in history, and aesthetics was of no use as Photography is an '*uncertain*' art.

Barthes felt he was dealing with an excessive subjectivity, inadequate in its stated likes and dislikes.

7. Photography as adventure

Barthes was certain that he was attracted to a number of photographs and decided to take this as a guide for his analysis. However, the type of attraction varied – fascination, interest, astonishment and admiration – and as such still could not explain why particular photographs had such a powerful effect on him. To designate this attraction he decided to use the terms '*advenience*' and '*adventure*'. A powerful picture would '*advene*'.

Barthes quotes Sartre who explains how he can be indifferent to many newspaper photographs, how '... they drift between the shores of perception, between sign and image, without ever approaching either' (p. 20). Despite this, Barthes still finds photographs that animate him and he animates them, so he names the attraction '*animation*'.

8. A casual phenomenology

[For a Phenomenologist a statement that asserts the existence of the material world has the same meaning as those that describe sensations.]

In his attempt to find the essence of Photography, Barthes had borrowed from phenomenology and its language, but he had done this in a prejudicial way ensuring that '... the anticipated essence of the photograph could not ... be separated from the 'pathos' of which, at first glance, it consists' (p. 21). He was being sentimental and was interested in photography not as a question, but a wound.

9. Duality

On looking through an illustrated magazine, Barthes paused at a photograph taken by Koen Wessing during the civil war in Nicaragua in 1979. He realised that its 'adventure' for him lay in the duality contained in the photograph. Two soldiers patrol a rubble-strewn street, while behind them two nuns cross the street. The nuns and soldiers are two 'discontinuous elements' that belong in different worlds.

This suggested a structural rule to him and he looked at other images by Wessing to see if duality attracted him to other photographs. Although he found the rebellion photographically banal, he did find this type of duality attracted him to some of the photographs. Of a photograph of the body of a child, covered in a sheet lying on a torn up street he '... noted certain interferences: the corpse's one bare foot, the sheet carried by the weeping mother (why this sheet?), a woman in the background, probably a friend, holding a handkerchief to her nose' (pp. 23, 24). Other photographs expressed '... the dignity and horror of rebellion ...', but for him they had no mark or sign, their homogeneity was cultural.

10. *Studium* and *punctum*

He felt he needed to name the two elements that attracted him to these photographs. The first referred to a body of knowledge relating to culture, notions of rebellion and Nicaragua, and signs of them, ruined streets, corpses, the sun etc. Of the thousands of photographs in this field, Barthes feels that to be interested in them his '... emotion requires the rational intermediary of an ethical and political culture' (p. 26). He decided to call this general effect '*studium*' which has a cultural connotation and means indirectly to 'study'.

The second element breaks or punctuates the *studium*. Barthes found he did not have to look for this element; rather it struck him like an arrow. The word he used to describe this is '*punctum*'. This Latin word designates a wound or prick, but also refers to punctuation and so is well suited for Barthes. He concluded, 'A photograph's *punctum* is that accident which pricks me (but also bruises me, is poignant to me)' (p. 27).

11. *Studium*

Barthes found that most photographs were 'inert' for him, and even those that were of interest mostly aroused only a '*polite* interest', they had no *punctum*. They belonged to the field of *studium*, an order of liking of being 'all right', but not loving.

In recognising the *studium*, the *spectator* understands and recognizes the photographer's intentions and is part of a cultural contract between creators and consumers, it allows the *spectator* to discover the *operator*'s (the photographer's) intentions. Barthes describes the photographer's intentions as myths aimed at '... reconciling the photograph with society ...' (p. 28). The *functions* of the photograph (and Barthes regards them as the photographer's alibis) are: '... to inform,

to represent, to surprise, to cause to signify, to provoke desire' (p. 28). The *spectator* invests them with their *studium* but not *punctum*.

12. To inform

Unlike text, which can change from description to reflection by changing one word, a photograph is always dependent on the thing it represents and it always shows details, which are the material of ethnographical knowledge. Barthes refers to William Klein's photograph *Mayday Moscow. 1959* and points out how it informs him as to how Russians dress. Photography gives these sort of small details much better than painting, and Barthes particularly liked this kind of knowledge.

13. To paint

Painting is an absolute reference for photography, which '... has been, and is still, tormented by the ghost of Painting...' (p. 30). Barthes gives as an example of this, the way Mapplethorpe represents an iris stalk; like an Oriental painter, and at this point of his investigation, Barthes has no clear visual distinction between painting and photography.

Barthes however feels that photography is related to art through Theatre. He points out that Daguerre, one of the founders of photography, ran a panorama theatre and that the camera obscura was responsible for perspective painting, photography and the diorama, all of which are arts of the stage. The most important link is perceived by Barthes to be their relationship to Death. Barthes lists the relationship between Death and the theatre across many cultures. He sees the same relationship in the Photograph and sees the drive for the 'lifelike' in photography as '... our mythic denial of an apprehension of death... Photography is a kind of primitive theatre... a figuration of the motionless and made-up face beneath which we see the dead' (p. 32).

14. To surprise

Barthes feels the key gesture of the *operator* is to surprise or shock (this is not the same as *punctum*). This is done in one of five ways. The first is the rarity of the referent, the subject, a man with two heads for example. The second is showing something that the eye normally cannot see, perhaps a gesture or someone jumping out of a window. The third, Barthes calls 'prowess' and gives as an example the fifty years Harold Edgerton spent photographing a drop of milk at a millionth

of a second. The fourth surprise are the 'contortions of technique' blurring, deceptive perspectives etc. The fifth is the 'lucky find', for example a Kertész photograph where he photographs a window and behind the windowpane, looking out onto the street, are two classical busts.

These surprises defy the laws of probability; they obey a principle of defiance. At the extreme the photographer defies the interesting, the surprise is in not knowing why the photograph was taken. Initially, to surprise, the notable was photographed, but this was reversed and soon anything that was photographed became notable.

15. To signify

As all photographs are dependent on uncertain circumstances (contingent), and so 'outside of meaning' they 'cannot signify (aim at generality) except by assuming a mask' (p. 34). If a face is turned into '...the product of society and of its history', then it is a mask. Barthes uses Richard Avedon's photograph, *William Casby, Born a Slave. 1963*, to illustrate his point. He says '...the essence of slavery is here laid bare: the mask is the meaning, insofar as it is absolutely pure (as it was in the ancient theatre). This is why the great portrait photographers are great mythologists: Nadar (the French bourgeoisie), Sander (the Germans of pre-Nazi Germany), Avedon (New York's 'upper crust')' (p. 34) (For Sander see Fig. 1).

Society mistrusts the mask because it is pure meaning and wants the '...meaning to be surrounded by a noise...which will make it less acute'. If its meaning (not its effect) is too impressive, this impact is lessened by '...consuming it aesthetically not politically'. Although the photograph of the mask is 'critical enough to disturb' (the Nazis censored Sander's work), it fails as a critique of society because science cannot be based on facial features (physiognomy). At a more basic level it fails because, although Sander's Notary is stiff and self-important, he would never read the signs in the photograph. Social observation becomes an intermediary in a 'delicate aesthetic'. Only those who are already able to criticise see the critique.

Apart from advertising, which must have a clear meaning to sell products '...the semiology of photography is therefore limited to the admirable performances of several portraitists' (p. 38). The rest of good photography '*speaks*' and vaguely encourages us to think. Even this is problematic and Barthes cites the example of the *Life* editors who in 1937 rejected Kertész's photographs because they ' "spoke too much" '. Photography is subversive not when it shocks but when it has a meaning different from its literal one and makes us reflect.

16. To waken desire

Barthes was deeply effected by Charles Clifford's photograph *The Alhambra (Grenada). 1854–1856*. It shows a sunny empty street, an old building with Arab decoration, a Mediterranean tree and a man sitting against a wall. It is there that he would like to live, but he cannot explain why it affects him so strongly and offers a range of possibilities, the warm climate, the Mediterranean myth, and anonymity amongst others. He feels a landscape photograph has to be habitable, and that is why tourist photographs do not satisfy him, they are just 'visitable'. His longing to inhabit is neither oneiric (a dream) nor practical (he does not want to buy a house), but is 'fantasmatic', a second sight that looks to some utopian future or takes him back to somewhere in himself. When he looks at these landscapes he is sure of having been there or of going there.

17. The unary photograph

The *studium*, if not affected by the *punctum*, generates most photographs and these Barthes calls the 'unary photograph'. Such a photograph '...emphatically transforms 'reality'...without making it vacillate...no duality, no indirection, no disturbance' (p. 41). These are banal photographs and are tightly composed.

Although news photographs can shock they are often unary, they can ' "shout" but not wound'. They are perceived at once, but Barthes does not recall them, he is interested in them as he is in the world but does not love them. Pornographic photographs (unlike erotic photographs) are also unary. They are naïve and are '...completely constituted by the presentation of only one thing: sex: no secondary, untimely object ever manages to half conceal, delay or distract...' (p. 41). A photographer whose work shifts from the pornographic to the erotic is Mapplethorpe who breaks the unary nature of his work by including a close up of the fabric of the underwear, and Barthes is interested in the texture of the material.

18. Co-presence of the *studium* and the *punctum*

The photographs usually have unary space and Barthes very rarely finds a detail that attracts him, but the detail, the *punctum*, raises the photograph to a higher level. There is no rule about the connection between the *studium* and the *punctum*, it is just co-presence. From the viewpoint of the *Operator* there is a causality that explains why the nuns were in the background of Wessing's photograph of the Nicaraguan soldiers; but from the *Spectator*'s viewpoint the detail is a chance occurrence with no creative logic behind the composition. The photograph has duality but no

analysis is required to perceive the *punctum* (although memory may sometimes be required).

19. *Punctum*: partial feature

Often the *punctum* is a partial object and in giving examples of them Barthes reveals himself. Using James Van der Zee's *Family Portrait. 1926* as an example, he says of it that it is a good photograph in that it '*speaks*' of '...respectability, family life...an effort of social advancement in order to assume the white man's attributes...' (p. 43). The image interests him but what 'pricks' him is the standing woman's belt worn low, and especially her '*strapped pumps*'. Barthes wonders why this dated fashion appeals to him and to what date it refers? Although this *punctum* arouses great sympathy in him, the *punctum* is not tied to morality or good taste. To illustrate this point he uses William Klein's photograph *Little Italy. New York. 1954*. Although it is a touching and amusing image, Barthes says '...but what I stubbornly see are one child's bad teeth'. Likewise of Kertész's 1926 portrait of Tzara, the *punctum* is Tzara's large hands with dirty nails.

The *punctum* has the power to expand, often as a metonymy [the use of an aspect of something to refer to the whole thing, e.g. the crown for the monarchy]. In Kertész's image *The Violinist's Tune. Abony, Hungary, 1921*, a blind violinist is led across a dirt road. Barthes' ' "thinking eye" ' adds to the photograph, sees the dirt road, its texture and makes him certain of being in Central Europe. He recognizes with his '...whole body, the straggling villages I passed through on my long-ago travels in Hungary and Rumania' (p. 45). This for him is the sole proof of its art. He sees the referent, the photograph transcends itself by annihilating '...itself as medium, to be no longer sign but the thing itself...' (p. 45).

Although the *punctum* is a detail it can fill the whole image. Duane Michals made a portrait of Andy Warhol in which Warhol hides his face with his hands; the *punctum* is not the gesture '...but the slightly repellent substance of those spatulate nails, at once soft and hard-edged' (p. 45).

20. Involuntary feature

Barthes states that if details do not 'prick' him, then it is probably because the photographer has put them in deliberately. For example, William Klein uses an unusual camera angle to give the character a 'monstrous' head in his image *Shinohiera, Fighter Painter (1961)* and as a result it says nothing to Barthes. The nuns behind the soldiers were *punctum* for Barthes but Bruce Gilden's

deliberate photographing of a nun with some drag queens only irritates him. Barthes concludes that the detail that interests him is probably not intentional and so is not a credit to the photographer's art; it only says he was there, and had to photograph it when photographing the subject: Kertész had to photograph the road to photograph the violinist.

21. Satori

Barthes describes the *punctum* as 'the virtuous gesture' a '*satori*, the passage of a void'. It is a mistake to think of the chemicals developing the photograph. The *punctum* cannot be developed '...but only repeated under the instances of...the insistent gaze...'. This makes some photographs similar to the Haiku. In both everything is given without '...the possibility of a rhetorical expansion'. They have '...an *intense immobility*: linked to a detail...' and neither can make us 'dream' (p. 49). Of Lewis Hine's photograph *Idiot Children in an Institution. New Jersey. (1924)*, he says he does not see the pathetic figures but instead the boy's Danton collar and the bandage on the girls' finger. '...I am a primitive, a child—or a maniac; I dismiss all knowledge, all culture, I refuse to inherit anything from another eye than my own' (p. 51).

22. After-the-fact and silence

The *studium* is coded but the *punctum* is not. To illustrate the point Barthes refers to Nadar's portrait of Savorgnan de Brazza seated between two black boys dressed as French sailors. One has his hand on de Brazza's thigh. The incongruity of this action would suggest a *punctum*, but is not because Barthes immediately codes the action as ' "aberrant" ' (the *punctum* is the other boys crossed arms). It is what he cannot name that disturbs and pricks Barthes and this is the *punctum*. An example of this is Mapplethorpe portrait of Robert Wilson and Phillip Glass. 'Wilson *holds* me, though I cannot say why, *i.e.*, say *where*; is it the eyes, the skin...The effect is certain but unlocatable, it does not find its sign...' (p. 51).

Sometimes the *punctum* is revealed once the photograph is out of view. In the case of the van der Zee photograph, it was only later that Barthes realised the real *punctum* was the gold necklace worn by the standing woman, it was identical to one owned by Barthes' aunt who had died an old maid. The *punctum* has latency. ' "The necessary condition for an image is sight," Janouch told Kafka; and Kafka smiled and replied: "We photograph things in order to drive them out of our minds. My stories are a way of shutting my eyes" ' (p. 53). To achieve absolute

subjectivity, it may at times be better look at a photograph with closed eyes and 'to allow the detail to rise of its own accord into affective consciousness.' (p. 55).

23. Blind field

Triggered or not the *punctum* is both in the photograph and what Barthes adds to it. In the Hine photograph he can add nothing to the profiles, the codes speak but he can add to the collar and the bandage. In a film he does not have the time for *pensiveness*, hence his interest in photography.

Film also has a 'blind field'; people can emerge from the screen and continue living. In a photograph people cannot emerge or leave. However, a *punctum* creates a blind field, the necklace gives the woman a life external to the portrait, and because Barthes wants to meet Robert Wilson he has a life outside the photograph. G.W. Wilson's *Portrait of Queen Elizabeth (1863)* also has a blind field created by its *punctum*. She sits on her horse with her vast skirt draping the animal. A Scotsman holds its bit in order to ensure it does not rear, and this is the *punctum*. If it did rear what would happen to her skirt, *'her magestry'* the *punctum* ' "brings out" the Victorian nature' p. 57.

Erotic photography has a blind field and this separates it from pornography. Pornography, unlike erotica, concentrates on the sexual organs and has no *punctum*, the erotic image may not even reveal the sexual organs; '...it takes the spectator outside the frame, and it is there that I animate this photograph and that it animates me...the image launched desire beyond what it permits us to see...toward "the rest" of the nakedness...the fantasy of a *praxis*...toward the absolute excellence of a being, body and soul together' (p. 59). Barthes says Mapplethorpe has found the right moment in his *Young Man with Arm Extended*. In it, despite the body being half out of the frame, the extended arm, 'radiant' smile, unconventional beauty and hand opened to just the right degree offer the 'divined' body benevolently. A pornographic body is not generous, rather than give itself it just shows itself.

24. Palinode

Barthes realised that he may have established how his desire worked, but could not say what the nature, the *'eidos'* of photography was. He was too subjective and would have to look deeper into himself to find the universal that would distinguish photography from other images. 'I would have to make my recantation,

my palinode' (p. 60). [A 'palinode' is a poem that retracts the thoughts and feelings of an earlier poem.]

PART TWO

25. 'One evening...'

Soon after his mother's death, Barthes was looking through some photographs of her. He had little expectation of finding one that adequately showed her features. He quotes Proust as saying of photographs that they recall less than just thinking of the person. Only one photograph, of her as a young woman on a beach at Les Landes, shows him her gait, health and glow; but it is too far away to show her face. He doubts that any of the photographs could '*speak*' to his friends.

26. History as separation

Barthes states that history for him is the time before his birth. It is this notion of history that separates him from many of the photographs. He feels a sense of 'stupification' on seeing his mother dressed differently. A photograph of his mother in 'chic' attire is the only time he has seen her '...caught in a History (of tastes, fashions, fabrics)...'. He is distracted by the fact that the clothes she was wearing were perishable, commenting, '...it makes a second grave for the loved being' (p. 64). However, he is able to figuratively 'find' his mother by finding photographs of her that include objects that he was familiar with, for example a powder box with a lovely sounding lid and a small chair he now had.

Her life, which preceded his, illustrates the tension and division of history. History is 'constituted' only if we look at it, and to do so we must be excluded from it. As living person he feels he is contrary to history and will destroy it for his own history. He believes it is impossible to be a witness to history. While he cannot remember his own beginning, a photograph his mother hugging him as a child can awaken in him '...the rumpled softness of her crepe de Chine and the perfume of her rice powder' (p. 65).

27. To recognise

For Barthes the essential question of a photograph is '...did I *recognize* her?' He can only say he does in fragments, and that he missed her *being* and so missed her altogether. While it was not she, neither was it anyone else, he did not recognize her 'essentially'. For him the images were '...partially true, and therefore totally false' (p. 66). This forced him into a painful search to identify her essence. He found it more

distressing if a photograph almost showed what his mother was like than if it did not. This notion of 'almost showing' he likened to dreaming of her (the only person he dreamt of) where there was always something missing from her. He concludes '...I do not dream *her*...'.

The photographs did, however, reveal an 'essential identity...each of these photographs manifested the very feeling she must have experienced each time she "let" herself be photographed: my mother "lent" herself to the photograph...'. She overcame the ordeal of being photographed by sitting in front of the lens '*with discretion*' without appearing theatrical or sulky, seeing a civic value in the photograph. 'She did not struggle with her image, as I do with mine: she did not *suppose* herself' (p. 67).

28. The Winter Garden Photograph

Looking back through the photographs of his mother, Barthes finally found the photograph that showed '...the truth of the face I had loved'. The old, faded photograph showed his mother, aged five, standing next to her older brother on a bridge in a Winter Garden (conservatory) 'united...by the discord of their parents' (p. 69). She stands back a bit awkwardly holding one finger with her other hand. 'The distinctness of her face, the naïve attitude of her hands, the place she had docilely taken without either showing or hiding herself, and finally her expression...all this constituted the figure of a sovereign *innocence* (...which is 'I do no harm')...' (p. 69). This concept of her kindness and gentleness '...so abstract in relation to an image, was nonetheless present in the face revealed in the photograph...(p. 69). Barthes quotes Godard ' "Not a just image, just an image" ' (p. 70), but Barthes feels that this is a just image.

For Barthes, this image is like Nadar's portrait of his own mother (or wife), and which Barthes rates as one of the loveliest in the world. Both are photographs that go beyond what it would be reasonable for the technical nature of photography to offer. The photographs of his mother that had not achieved this effect were in phenomenological terms 'ordinary' objects, analogical, giving her identity '...not her truth; but the Winter Garden Photograph was indeed essential, it achieved for me, utopically, *the impossible science of the unique being*' (p. 71).

29. The little girl

Significantly, Barthes discovered this photograph of his mother by going back in time, starting with the latest photograph of her, looking tired but noble,

surrounded by his friends and ending with an image of her as a child: like the Greeks entering Death backwards, so in front of them was their past. He finds the 'mother as child' but now loses her twice, in her old age and as a child.

During her final illness he nursed her, she had been strong but '. . . she had become my little girl, uniting for me with that essential child she was in her first photograph' (p. 72). Barthes had never had children, and if one sees Death as the victory of the race over the individual who in procreation has transcended himself, then this was a way for Barthes to resolve Death; through her illness he 'engendered' her. With her death he had no '. . . reason to attune myself to the progress of the . . . species . . . My particularity could never again universalize itself (. . . unless by writing . . .). From now on I could do no more than await my . . . death' (p. 72).

This was his reading of the Winter Garden Photograph.

30. Ariadne

For Barthes, the essence of Photography was in this photograph, it was the only photograph that 'assuredly existed' for him. If all photographs formed a labyrinth, at the centre he would find this photograph and wanted to know what drew him to it. He realised that he had to study Photography '. . . not from the viewpoint of pleasure, but . . . love and death'.

Barthes sees no point in reproducing the Winter Garden Photograph, as it would be an ordinary and indifferent image for the viewer. It cannot 'establish an objectivity'. It contains information about the period, the *stadium*, but for the viewer 'no wound'.

31. The family, the mother

From the beginning Barthes wanted to avoid the institutionalised notions of the Family and the Mother. He felt his family, consisting of a mother, a brother and nothing else, did not conform to the institutionalised notions. Further, he felt the models applied to families, either one of allegiances or one of repression, and were inappropriate to his family in which everyone loved one another. Catholicism established an 'Image Repertoire' of the Mother, and Barthes despite being raised as a Protestant, a 'religion-without-images', was culturally influenced by this. When he saw the Winter Garden Photograph it was part of this Image Repertoire, the 'Mother-as-Good' but he escaped this generality because in it was his radiant mother and to the Mother she '. . . added that grace of being an individual soul'.

His mother was not indispensable, he could live without her, but she was irreplaceable and his life would be 'absolutely and entirely' without quality (p. 75).

32. 'That-has-been'

Barthes started by noting, '...every photograph is somehow co-natural with its referent...'. Photography's referent is different from the referent in other representational systems, in that it is '...not the *optionally* real thing to which an image or sign refers but the *necessarily* real thing which has been placed before the lens without which there would be no photograph' (p. 76). Unlike other forms of representation and discourse '...in photography I can never deny the thing has been there'. The essence of photography, its '*noeme*', is then '...of reality and of the past' (p. 76). Photography is not Art or Communication it is Reference, and photography is founded on Reference.

He names photography's essence, its *noeme* ' "That-has-been" ' or the 'Intractable', and uses the Latin word *interfuit* to describe its characteristic of having been here and the Latin *intersum* of having been here but of having been separated. Although the *noeme* may be experienced with indifference it can never be repressed. Before we state something is true we verify it, however in the case of the Winter Garden Photograph the intensity of Barthes' experience confirmed the truth. 'I had identified truth and reality in a unique emotion, in which I henceforth placed the nature—the genius—of Photography, since no painted portrait, supposing it seemed "true" to me, could compel me to believe its referent had really existed' (p. 77).

33. The pose

Alternatively, the nature of photography can be explained as being founded on the pose. The length of the pose is irrelevant; the millionth of a second for Edgerton's drop of milk is adequate. The pose is neither the attitude of the subject nor a technique of the photographer (*operator*). It is a term of looking at a photograph and in looking Barthes is aware of the real thing being still as he looks at it. 'I project the present photograph's immobility upon the past shot, and it is this arrest which constitutes the pose' (p. 78). This explains the difference between Photography and cinema. In Photography something has *posed* in front of the camera and stays there forever, and in cinema something *passes* in front of the camera. Cinema denies the *pose*, so although derived from photography it is a different art.

The presence of the thing in photography is not metaphoric. A photograph of a corpse '...is alive, as *corpse*; it is the living image of a dead thing' (p. 79).

The photograph's immobility is the result of the confusion between the concepts of the Real and the Live. Because we have the 'delusion' that Reality is '...an absolutely superior, somehow eternal value...' and we know the object was real '...the photograph surreptitiously induces belief that it is alive' (p. 79). The reality is shifted to the past 'this-has-been', so it also suggests it is already dead. It would be more accurate to say that photography's *noeme* was that someone has actually seen the referent in person. At its beginning, photography was an art of the Person, concerned with the body's *'formality'*, its identity and social status. This is another difference between photography and cinema; the latter has two poses, the actor's 'this-has-been' and his role (painting cannot produce this experience). Barthes experiences melancholy when seeing films featuring now dead actors (as he does when listening to recordings of now dead singers).

Returning to Avedon's portrait *William Casby "born a slave"*, 'The *noeme* here is intense; for the man I see here *has been* a slave: he certifies that slavery has existed, not so far from us; and he certifies this not by historical testimony but by a new, somehow experiential order of proof...', a proof of the past that is not induced, but is like that of St. Thomas wanting to touch the resurrected Christ. As a child, Barthes cut out and kept a photograph (not a drawing), from a magazine, of a slave market showing the slave master and slaves. His horror and fascination '...came from this: that there was *certainty* that such a thing had existed; not a question of exactitude, but of reality; the historian was no longer the mediator...the fact was established *without method*' (p. 80).

34. The luminous ray, colour

For Barthes, it was not painters but chemists that invented photography; the *noeme* 'that-has-been' only became possible when it was discovered that silver halogens were sensitive to light, making it possible '...to recover and print directly the luminous rays emitted by a variously lighted object. The photograph is literally an emanation of the referent. From a real body, which was there, proceed radiations which ultimately touch me, who am here...as Sontag says, will touch me like the delayed rays of a star...light...is here a carnal medium...' (p. 81).

Barthes suggests that because he has such a strong reaction to the thought that in a photograph something from the past has actually touched the photograph's surface that he does not like colour. He feels that just as some daguerreotypists painted over their photographs, colour is something added later, a cosmetic. Barthes is not concerned about the photograph's 'life', but '...the certainty that the photographed body touches me with its own rays and not with superadded light' (p. 81).

35. Amazement

The photograph does not restore the past but confirms that what the viewer sees did exist. Barthes feels his astonishment in looking at photographs may be in part due to his religious background in that photography is to do with resurrection.

Of Kertész's 1915 photograph of some Polish soldiers resting in a field, Barthes says it gives him the fact that *'they were there...* at once past and real', something no realist painting can do. He gives the example of three photographs, an anonymous 1910 English wedding photograph, and photographs by Lartigue of the beach at Biarritz in 1931 and by Kertész of the Pont des Arts in 1932. On looking at the wedding photograph, he tries to work out who would still be alive: two little girls and a baby, all of who would now be elderly. Of the Lartigue and Kertész photographs, he cannot help but wonder if that is he among the people in the photographs. The dates of the photographs interest him not for stylistic reasons but because they allow him '...to compute life, death, the inexorable extinction of the generations' (p. 84). When looking at Kertész's 1931 photograph of the schoolboy Ernest, he wonders if he is still alive and reacts by saying '...but where? how? What a novel'. Barthes sees himself as the reference for every photograph and causes him to ask the metaphysical question '...why is it that I am alive *here and now*?'. The immediate presence photography offers to the world is not only political '("to participate by the image in contemporary events")' (p. 84), but also metaphysical.

36. Authentication

A photograph says for certain *what has been*, and may say what is no longer. This is an important distinction. On seeing a photograph we do not necessarily remember nostalgically, but for every photograph we know for certain: '...the photograph's essence is to ratify what it represents' (p. 85). Barthes illustrates his point by recounting when he received a photograph of himself from a photographer. Despite his best efforts, Barthes could not recall when or where the photograph had been taken. 'And yet, *because it was a photograph* I could not deny that I had been *there...* I went to the Photographer's show... to learn... what I no longer knew about myself' (p. 85).

Language cannot give him this certainty; it cannot authenticate itself whereas photography is 'authentication itself'. Photography is only laborious when it fakes and even then it can only lie about the meaning of the subject not its existence. Although there is nothing better to confirm reality, it is a contingent reality *'so much, no more'*.

From the first photograph onwards (Niépce's, *The Dinner Table*, circa 1823), man was confronted with a new being: 'neither image nor reality... a reality one can no longer touch.' Our resistance to believing in the past, in History was ended by the photograph; it, not cinema, divides the history of the world. Because photography is an anthropologically new object, Barthes feels it should be treated differently from other images. He criticises the fashion amongst sociological and semiological commentators on photography for seizing on 'semantic relativity', and denying reality: '*Thesis*, not *Physis*'. They argue that photographs are not analogous with the world, that what they represent is fabricated because through historical accident they are subject to Albertian perspective and because titling or captioning turns a photograph, a three-dimensional object, into a 'two-dimensional effigy'. Barthes regards this as a futile argument. Like other forms of representation, nothing can stop photography from being analogical, but its *noeme* is not analogy. Realists (Barthes was one when he asserted that photographs were images without codes; although obviously codes do influence our reading of photographs) do not see photographs as copies of reality but as emanation of *past reality*. Good analysis will not result from asking if a photograph is analogous or coded but by realising it has 'evidential force... its testimony bears not on the object but on time... the power of authentication exceeds the power of representation' (p. 89).

37. Stasis

Sartre and others have commented on the inadequacy of the images that reading a novel generates. Photography has a corresponding '*Totality-of-Image*'; both because it is an image and a special image – it is complete '*integral*... nothing can be added to it' (p. 89). Despite the cinema's raw material being photographic, it does not have this completeness. This is because, like reality the cinema is in a state of flux moving forward so its photographic referent shifts, it does not state the reality of its former existence. Film is 'normal' like the world, and life is sustained by the presumption that experience flows in a 'constitutive style' but photography '... is *without future* (this is its pathos, its melancholy)... the Photograph flows back from presentation to retention' (p. 90).

When looking at the Winter Garden Photograph Barthes is in a closed circle. He cannot *transform* his grief into mourning. His photograph is without culture and so culture cannot help ease his pain which he experiences '... entirely on the level of the image's finitude (this is why despite its codes I cannot *read* a photograph...' (p. 90). If dialectic thought can be described as that which deals with corruption and death, converting it into the power to work then the photograph is '... undialectical: it is

a denatured theater where death cannot "be contemplated", reflected and interiorized . . . it excludes all purification, all *catharsis* . . .' (p. 90).

In the photograph time's immobilisation is 'engorged', and despite being modern, the Photograph has a puzzling sense of arrest and the inactual. A photograph is not memory and in fact 'blocks memory'. Barthes recounts how a group of his friends were discussing childhood memories but because he had been looking at his photographs he had none. He quotes Rilke ' "Sweet as memory, the mimosas steep the bedroom" '. It is this 'steeping' that photography is incapable of, it gives nothing but the ' . . . *exorbitant thing . . . it fills the sight by force* . . . nothing can be refused or transformed . . .' (p. 91).

38. Flat death

Although all photographers deal with the live, Barthes sees them as agents of death. Along with studying photography in its social and economic context, Barthes would like it studied in its anthropological context, investigating photography's relationship to Death. In society, Death is now less intensely found in religion and he suggests that the photographic image ' . . . produces Death while trying to preserve life'.

Contemporaneous with the decline in rites, photography may be an 'asymbolic' non-religious type of quick Death. '*Life/Death*: the paradigm is reduced to a simple click, the one separating the initial pose from the final print' (p. 92).

Barthes describes photography as '*flat Death*', for him the horror of Death is its 'platitude'; that he has nothing to say about the death of his mother or her photograph, which he cannot transform. All he has is the 'thought' that at the end of the first death his own death is inscribed and that he can do no more than wait between the two. All that is there is the *irony* of speaking, of having nothing to say.

The photograph can only be transformed by turning it into refuse. Like paper it perishes, like a living organism it ' . . . is born on . . . the spouting silver grains . . .' it thrives briefly and then light and humidity age it, causing it to fade, after which it is thrown away. Memory is a substitute for life and earlier societies made the memory eternal through the Monument. Modern society has made the mortal photograph the witness to 'what has been', rejecting the monument. Both History and Photography were invented in the same century. History is an intellectual debate, a fabricated memory based on positive formulas ' . . . which abolishes mythic Time . . .', and while the Photograph is a certain testament it is not permanent. As a result we

are now unable '...to conceive *duration*, affectively or symbolically...' (p. 93).
The photographic age is one of turmoil, impatience and the denial of ripening.
The astonishment of 'that-has-been' has already gone and Barthes sees his book as
an archaic trace by one of its last witnesses.

When the photograph fades and is thrown away, 'life' goes with it; i.e. the
confirmation that the subject of the photograph was alive and had been before
the lens. Barthes also argues that love goes too. He can look at the photograph of
his parents together and he knows they loved each other. Once the photograph
is gone and he is dead, nothing will testify to this love, all that will remain is
'indifferent nature'.

39. Time as *punctum*

When he started this book Barthes separated the *studium* (the cultural context)
from the *punctum*. There is another *punctum*, it is not as a result of detail and '...is
Time, the lacerating emphasis of the *noeme* ("*that-has-been*"), its pure representation'
(p. 96).

In 1865, Alexander Gardner photographed Lewis Payne in a prison cell while he
waited to be hanged for attempting to assassinate Secretary of State W.H. Sewart
(see Fig. 2). Describing Payne and the photograph as 'handsome', Barthes says this
is the photograph's *stadium*, but the *punctum* is that '*He is dead and is going to die...*'
(p. 95). What '*pricks*' Barthes is the discovery of this 'anterior future', the
photograph both gives the 'absolute past' and tells of death in the future.

In 1850, August Salzmann photographed the road to Bethlehem, although it
showed little but stony ground and olive trees, the mix of three tenses dizzies Barthes;
his time, that of Jesus and that of Salzmann, '...all this under the instance of
'reality' – and no longer through the elaborations of the text...which itself is
never credible *down to the root*' (p. 97).

40. Private/public

As individuals, photographs challenge each of us because all photographs contain
a demanding sign of our own future death. Photographs are also (in general) looked
at in private. Just as some religious devotees in the late Middle Ages turned from
collective to private prayer, Barthes feels reading a photograph is in the end a
private affair. Although this seems obvious in the case of old photographs that are
contemporaneous with our youth or photographs that are associated with our lineage

(parents etc.), it is also true of ones where there is no obvious link, for example journalism. 'Each photograph is read as the private appearance of its referent ...' (p. 98). Photography and the aggressive placing of the private into the public coincide and Barthes wants to re-establish the division between the public and private for the following reasons; the private falls under the laws of property and so is one of our goods; it is the site where his image is free to abolish itself; and it is linked to '...an interiority which I believe is identified with my truth...' (p. 98). He divides the world of the photograph into two; Images which he describes as inessential noise and 'my photographs ... the burning, the wounded' (p. 98).

Unlike other art forms, in photography he feels it is the amateur who masters the profession rather than the professional as the amateur is closer to photography's *noeme*.

41. To scrutinise

If a photograph disturbs Barthes or he likes it, then he scrutinises it trying to learn more about the thing it represents. His first impulse on seeing the Winter Garden Photograph was to exclaim that he had found his mother (despite the image having faded). However, in order to understand it better as a *spectator*, he decomposed, like the *operators* Marey and Muybridge, by enlarging it in stages (with each successive shot enlarging smaller details) hoping to get to the 'very being' of his mother. This desire is justified because photography's *noeme* is *that-has-been*, but it is not satisfied. The enlarging only reveals grain; the only knowledge he has is that what he sees has been. Although the Photograph does not conceal '...it cannot say what it lets us see' (p. 100).

42. Resemblance

Barthes reacts strongly when he deems a photograph to have 'a likeness', but as resemblance conforms to an identity and '...identity is imprecise, even imaginary...I can...speak of "likeness" without ever having seen the model'. He cites a number of portraits (mostly by Nadar, one by Avedon) of people he has never seen and characteristics he is aware that these people have which make him think the portraits are a good likeness: Guizot – austerity; Dumas – swollen, self-important; Offenbach – witty music; Rossini – false; Marcelle Desbordes-Valmore – slightly stupid virtues; Kropotkin – anarchic idealism. They are 'likenesses' because they conform to his expectations. In opposition to these photographs, he asks about photographs of himself; someone he knows. 'All I look *like* is other

photographs of myself...', copies of real or mental copies. At best, Barthes endures
the image if he finds it in agreement with the image he wants to give of himself. Yet,
at times when shown a photograph of someone he has been told about, he cannot
believe the person looks like the photograph. 'Ultimately a photograph looks like
anyone except the person it represents' (p. 102). Resemblance refers to a purely legal
notion and leaves Barthes sceptical and unsatisfied – the only truthful photograph
of his mother did not look like her and was of a child he did not know.

43. Lineage

Photographs sometimes show what we do not see in a real face, they show the truth
of lineage revealing genetic features; as an example, Barthes gives a medallion
that looked as if it showed him with his mother, but it turned out to be his
grandmother with his uncle. In such a way it shows '...a certain persistence of the
species...The Photograph is like old age: even in its splendor, it disincarnates the
face, manifests its genetic essence' (p. 105). This linear identity is stronger and more
reassuring than legal status as thinking of our origins is reassuring; it is the future
that disturbs. However, although it reassures through permanence, it disappoints it
revealing the differences that issue from the same family.

44. *Camera Lucida*

Barthes concludes that the photograph is flat and cannot be penetrated. Associating
it with its precursor, the *camera obscura* (a dark passage), is a mistake. It is more
like the *Camera Lucida*, an early drawing aid that made use of a prism. To describe
photography from the eye's viewpoint Barthes quotes Blanchot '..."the essence of
the image is to be altogether outside, without intimacy, and yet more...mysterious
than the thought of the inner-most being; without signification, yet summoning up
the depth of any possible meaning..." ' (p. 106).

It is the power of the photograph as evidence that prevents it from being
penetrated. Barthes quotes Sartre as saying that the object yields itself fully in
the image.

45. The 'air'

A photograph of an object deals only with reality and authenticates its existence.
A photograph of a face '*authenticates* the existence of a certain being' and this is
more problematic, in particular in the case of a loved one, as Barthes wants to

discover the beings' essence 'beyond simple resemblance'. This is evident as it has been photographed, yet it is improbable, as it cannot be proved, this expression or look Barthes calls the *air*. The *air* cannot be analysed because analysis requires doubt and this would be to deviate from the nature of the photograph, which is by nature evidence. The air leads us from body to soul, be it good or bad in the person. Barthes started with photographs that gave him his mother's crude legal identity through to those in which he 'could read her "individual expression" ' and finally to the Winter Garden Photograph 'in which I discover her: a sudden awakening, outside of "likeness"... in which words fail, the rare, perhaps unique evidence...' (p. 109).

The air is an expression of truth, a supplement of identity that expresses the subject. In the truthful photograph of his mother, she is not separated from herself 'there remained a soul, ageless but not timeless', unlike the other photographs of her which were like masks. The air may be something moral '...contributing to the face the reflection of a life value...'. Barthes says of Avedon's portrait of the American Labor Party leader Philip Randolph that it has an air of goodness and certainly 'no impulse of power'. The air, the body's 'luminous shadow' prevents the body from being sterile and it is this air that a few photographers like Nadar and Avedon capture to show the subject's value not just their identity. The provincial photographer who took the Winter Garden Photograph was lucky to capture his mother's air making permanent what Barthes sees as the truth.

46. The look

The latest reportage photographs have no impact on Barthes despite the death and destruction they show. They lack a subject looking at him and photography is losing the power of the 'straight in the eye' look as the frontal pose becomes less fashionable. There is a paradox in the photographic look similar to that of someone looking at someone else without seeing at them, '...the photograph separates attention from perception, and yields up only the former, even if it is impossible without the latter... an action of thought without thought... And it is this scandalous movement which produces the rarest quality of an air. That is the paradox: how can one have an *intelligent air* without thinking about anything intelligent...?' To illustrate his point, Barthes gives as an example Kertész's photograph *The Puppy. Paris, 1928*. The boy '...looks into the lens with his sad, jealous, fearful eyes: what pitiable, lacerating pensiveness! In fact he is looking at nothing; he retains within himself his love and his fear: that is the Look' (p. 113).

If the Look lasts through time, it can be crazy as it is the effect of both truth and madness. Galton and Mohamed attempted to establish a link between peoples' facial

features and illnesses (physiognomy) producing, in 1881, a series of photographs to this end. The project failed, but nearly a century later these patients look at Barthes leaving him with the notion '...that whoever looks you straight in the eye is mad' (p. 113).

The photograph leads him to believe he has '...found what Calvino calls ' "the true total photograph" ', combining '...reality ("*that-has-been*") with truth ("there-she-is")' (p. 113), the evidential with the 'exclaimative'. The image is taken so far that the emotional affect guarantees the Being.

47. Madness, pity

For Barthes, the photograph (its '*noeme*') is banal and has no depth, it is simply 'that has been', however it is also extended evidence '...as if it caricatured not the figure of what it represents...but its very existence' (p. 115). Phenomenology describes the image as the object-as-nothing. In the photograph not only is the object absent, but with equal force, the fact that it has existed is also confirmed. Barthes sees this as madness. Until the advent of photography all images needed intermediaries to confirm the past of a thing, with a photograph '...certainty is immediate'. This makes it a bizarre medium, a shared hallucination '...a mad image, chafed by reality' (p. 115). When watching Casanova dancing with the young automaton in Fellini's *Casanova*, Barthes has a similar reaction to the one he has when touched by a photograph. '...each detail, which I was seeing so exactly, savoring it...down to its last evidence, overwhelmed me...' (p. 116). It was then that Barthes realised that there was a link between photography, madness and what he, at first, thought was love; thinking that he was in love with the automaton and with photographs of people from the Proustian world (Julia Bartet, the Duc de Guich). However, it was not love but pity. When he thought of all the photographs that 'pricked' him he '...passed beyond the unreality of the thing represented...taking into my arms what is dead, what is going to die, as Nietzsche did when...he threw himself in tears on the neck of a beaten horse: gone mad for Pity's sake' (p. 117).

48. The photograph tamed

Society wants to tame the photograph and does this in two ways. Firstly by turning it into an art, as art is not mad; hence '...the photographer's insistence on his rivalry with the artist,...' (p. 117), the language of painting and its sublime way of exhibiting. Photography can be an art but only if it has no madness and loses its *noeme* (and its effect on Barthes). Barthes sees the fictional cinema as participating

in this domestication of photography (it can only be mad by trickery not by nature). The second way of taming the photograph is to generalise it and make it banal. 'This is what is happening in our society where the photograph crushes all other images by its tyranny' (p. 118). We live in a world now where everything is turned into, produced, consumed and only exists as images. He gives as an example people (not actors) who allow themselves to be tied up and beaten in for pornographic photographs (Mapplethorpe derived some of his photographs from these sorts of images), pointing out that they conceive of their pleasure '... only if this pleasure joins the stereotyped ... image of the sado-masochist: pleasure passes through the image: here is the great mutation'. This reversal raises an ethical question because when the photograph is generalised '... it completely de-realizes the human world of conflicts and desires, under the cover of illustrating it' (p. 118). A characteristic of today's 'advanced' societies is that instead of consuming ideas as they did in the past they consume images so they are more liberal, less fanatical but more ' "false" '. This creates an impression of boredom '... as if the universalised image were producing a world that is without difference (indifferent)...' allowing for the occasional anarchic, marginal or individual cry '... let us abolish the images, let us save immediate Desire (desire without mediation)' (p. 119).

Tame photography has relative realism and is bound to aesthetic or empirical habits, as when looking at a magazine at the dentist's; when mad, the realism is absolute '... obliging the loving and terrified consciousness to return to the very letter of Time'. This reverses the course of the thing and is 'photographic *ecstasy*'. The choice is between the '... the civilized code of perfect illusions, or ... the wakening of intractable reality' (p. 119).

ASSIGNMENTS/DISCUSSION POINTS

5. He who is photographed

1. Barthes points out that as soon as he is aware of being photographed he transforms himself '... in advance into an image' (p. 10). Take a series of portraits of people. In the first instance, take the photographs without the subjects being aware that their photographs are being taken. Later, take photographs of the same people, but this time with their knowledge so that they 'pose' for their portraits. Evaluate the two sets of photographs, and in the evaluation include your subjects' opinions of the photographs. Did any of them echo Barthes' feelings?

2. Look at the work of a number of photographers who have different approaches to portraits, for example, Julia Margaret Cameron, August Sander,

Henri Cartier-Bresson, Bill Brandt, Weegee, Yousuf Karsh, Martin Chambi, Nicholas Nixon, Cindy Sherman, Bruce Gilden, Nan Golden and Annie Leibovitz. Select two (not necessarily from this list), who have very different approaches, and compare and evaluate their work. Produce a number of images using the approach of one or more of these photographers. Evaluate your work.

3. For Barthes, in portrait photography there are four opposing and inter-related forces; '...the one I think I am, the one I want others to think I am, the one the photographer thinks I am, and the one he makes use of to exhibit his art' (p. 13). Attempt to produce four photographs that illustrate Barthes' point. In your evaluation of your work you need to say why you have chosen particular images and if you think the project is even achievable.

6. The *spectator*: chaos of tastes

1. Barthes realised that he did not like all the work of any single photographer. The artist's style, so useful in history, and aesthetics was of no use as photography is an '*uncertain*' art. Sontag also has problems with the notion of photographic style when she says 'Many of the published photographs by photography's greatest names seem like work that could have been done by another gifted professional of their period. It requires a formal conceit...or thematic obsession...to make work easily recognizable'. (*On Photography*, pp. 133–135). Look at the work of the photographers they cite in these sections of their work and try to establish if Barthes and Sontag are making the same or at least a similar point.

13. To paint

1. Barthes lists the relationship between Death and the theatre across many cultures. He sees the same relationship in the Photograph and sees the drive for the 'lifelike' in photography as '...our mythic denial of an apprehension of death...Photography is a kind of primitive theatre...a figuration of the motionless and made-up face beneath which we see the dead' (p. 32). Sontag sees photography as an 'inventory' of mortality (p. 70), and the fascination they exercise, as a reminder of death (p. 71). They seem to have come to very similar conclusions in different ways. Do you agree with them? If they are right does their position undermine that of Berger, who sees advertising (publicity) photography as often referring to the past but always speaking of the future (p. 130),

'Its promise is . . . of happiness . . .' (p. 132) and Szarkowski who writes 'Photography alludes to the past . . . through its surviving relics, [and] the future through prophecy visible in the present' (p. 10). When answering this question you may wish to refer to both Section 37, *Stasis*, of Barthes' book where he writes that photography '. . . is *without future* (this is its pathos, its melancholy) . . . the Photograph flows back from presentation to retention'; and to Section 38 *Flat Death*.

14. To surprise

1. Barthes feels the key gesture of the *Operator* is to surprise or shock (this is not the same as *punctum*). This is done in one of five ways. Find at least two examples of each of the five ways in which the *Operator* (photographer) has used surprise and explain both why the photographs are effective and how they fit into Barthes' categories. Take a photograph or series of photographs that fit into at least one of these categories. Given the nature of some of the categories you are not likely to be able to do work in all unless you start a very major project.

2. Barthes states that these surprises defy the laws of probability; they obey a principle of defiance. At the extreme the photographer defies the interesting, the surprise is in not knowing why the photograph was taken. Initially, to surprise, the notable was photographed, but this was reversed and soon anything that was photographed became notable. Select a number of photographs that you feel illustrate Barthes' point and evaluate them. Then take a series of photographs exploring this notion.

15. To signify

1. A mask (either in the sense of something physical or an expression) usually hides a face, preventing us from seeing the 'real' person behind it. We see a mask as hiding the truth. Yet Barthes states that if a face is turned into '. . . the product of society and of its history', then it is a mask and '. . . the mask is the meaning, insofar as it is absolutely pure (as it was in the ancient theatre)'. He says of Richard Avedon's photograph, *William Casby, Born a Slave. 1963*, in which Casby's face assumes a mask that '. . . the essence of slavery is here laid bare . . .'. However, he adds that although the photograph of the mask is 'critical enough to disturb,' it fails as a critique of society because science cannot be based on facial features

(physiognomy). Given the above there are a number of issues that need to be explored.

(a) Can a photograph ever show the real person, and if it can, can you ever know it does so without knowing the person first? Find a photograph, of someone you know, that you feel reveals his or her personality. Speak to someone else who knows the photographed person and see if they agree with you.

(b) If a face is turned into '...the product of society and of its history', then it is a mask and '...the mask is the meaning, insofar as it is absolutely pure...'. As all photographs are dependent on uncertain circumstances (contingent), and so 'outside of meaning', they '...cannot signify (aim at generality) except by assuming a mask'. Do you think Barthes is suggesting a portrait is either a mask or a 'portrait' in the usual sense of the word, but is not both? If the mask is a product of society and of its history, to what extent is the person? Barthes names Nadar, Sander and Avedon as great portrait photographers. Look at their work, select two or three photographs by each photographer and say what you think each photograph tells you about the subject personally and about the society they lived in. Are the photographs ambiguous in any way, and are they useful?

(c) We constantly react (mostly correctly) to people in terms of their facial expressions, and the classical Greek masks *tragedy* and *comedy* seem unambiguous, yet Barthes points out that although the photograph of the mask is 'critical enough to disturb' it fails as a critique of society because science cannot be based on facial features (physiognomy). In the Victorian era, Francis Galton attempted just such a study making extensive use of photography, but ultimately the project was a failure because it could not stand up to scientific investigation. Look at the work of several photographers who could be seen to represent the extremes of *tragedy* and *comedy*, for example Diane Arbus, Roger Ballen, Henri Lartigue, Robert Doisneau and Elliot Erwitt, does their work suggest that at the extremes photography is more revealing?

(d) Relate the work of Cindy Sherman to Barthes' concept of the mask.

(e) Apart from advertising, which must have a clear meaning to sell products '...the semiology of photography is...limited to the admirable performances of several portraitists' (p. 38). The rest of good photography '*speaks*' and vaguely encourages us to think. Photography is subversive not when it shocks, but when it has a meaning different from its literal one and makes us reflect. Select several well-known photographs that you feel are subversive because their meaning is different from their literal one. Justify your choices. One

example could be Martin Parr's 1994 *'Kleine Scheidegg' Switzerland* from his *Small World* series.

(f) The *Life* editors in 1937 rejected Kertész's photographs because they ' "spoke too much" '. Look at Kertész's pre-1937 work and images used by *Life* around the same time and explain why *Life* rejected his work (prior to this, European picture magazines, which were at the cutting edge of this type of publication, made extensive use of his work).

17. The unary photograph

1. The *studium*, if not affected by the *punctum*, generates most photographs and these Barthes calls the 'unary photograph'. Such a photograph '...emphatically transforms "reality"...without making it vacillate...no duality, no indirection, no disturbance..."free of useless accessories"...' (p. 41). These are banal photographs and are tightly composed. Barthes' description of 'unary' photographs could be read to suggest 'straight' photographs. Look at the work of at least two straight photographers, for example Edward Weston's *Pepper, 1930* and Albert Renger-Patzsch's *Echeoeria, 1922*. Make a case for the photographs either being or not being 'unary'. Take two or more photographs of your own that could be categorised as 'straight' and justify this categorisation (Renger-Patzsch's work would normally be categorised as 'New Objectivity', a European 'straight' movement).

18. Co-presence of the *studium* and the *punctum*

1. From the *spectator's* viewpoint the *punctum* is a detail that is a chance occurrence with no creative logic behind the composition. The photograph has duality but no analysis is required to perceive the *punctum*, (although memory may sometimes be required). If it is *punctum* that makes a photograph 'good', and the *punctum* is arbitrary, dependent totally on the spectator, do you think that there is any objective sense in which a photograph can be good or bad?

19. *Punctum*: partial feature

In the section *To Inform*, Barthes refers to William Klein's photograph *Mayday Moscow. 1959* and points out how it informs him as to how Russians dress. Photography gives these sorts of small details much better than painting and Barthes particularly liked this kind of knowledge. In the section Punctum: partial

feature Barthes says of Klein's photograph *Little Italy. New York*. 1954, that although it is a touching and amusing image '...what I stubbornly see are one child's bad teeth'. Likewise of Kertész's 1926 portrait of Tzara, 'the *punctum* is Tzara's large hands with dirty nail. In his book *Close Ups*, on pages 8 and 9, Klein reacted to Barthes' interpretation of his photographs by saying:

'80–81. 1961. Moscow, May Day. In his book Camera Lucida, Roland Barthes talks about a few of my photographs, this among them. What did I see here? First of all, Russians in 1961, in ten square feet, representatives of five different national groups, so, a fragment of an empire with, in the bargain, Gorki's grandmother: Then, an illustration of a possible subject-photographer interplay: The grandmother; knowing she is photographed, strikes a pose, her pose. She is in the center with the camera aimed at her; but it's a wide-angle lens and six other characters have found an author without realizing it. Each demonstrates a possible attitude towards a lens: irony, wariness, distrust or violated dignity. On a formal level, looks cross, heads and bodies converge and form a touching variation on the group portrait.

What Barthes sees is the document: Russians in 1961, how they dress, what hats they wear, how they cut their hair. How you read a photo is up to you. And what I like about Barthes is that he sees what he wants and blithely justifies it. Here, the document. Elsewhere, in one of my New York photos, a boy's carious teeth. His own obsession, which makes him Barthes. What surprises me, though, is his lack of interest in a photographer's intention. For him, photographs are accidents or found objects.

94–95. 1955. New York. Barthes, again: WK... photographed some kids in Little Italy; in New York. I'm moved...but what obsesses me are the bad teeth of the little boy. Concerning what he calls the punctum or the point of a photograph, Barthes gives something of himself away.

Elsewhere, he speaks of the subject, the studium, and says: To admit the studium is to deal with the photographer's intentions...discover, in the photo, his myths...fraternise with them without really believing in them.

When taking a photo I can also be taken by this precious punctum, be obsessed by a detail and arrange for everything to be organized around it. It's also possible to take in. In some intuitive flash, the whole scene and the meaning I give it. I can see myself taking this picture more than thirty years ago. I had the nerve to stop this little family and say, Hold it. Flattered, they got into position. The mother took the boy's pistol and held it to his temple. He rolled his eyes towards her, put his hand in hers and laughed happily. His big sister bent down to be in the shot, his little sister

giggled. One picture. Two teenaged girls come towards us, 1955 fashion-plates, men's shirts over their jeans rolled up above their ankles, white socks, curlers and scarves. Another picture.

I was thinking: these kids who hang around with dirty shirts and a mother who thinks it's funny to stick a gun in their faces are kids I might have crossed the street to avoid when I was their age. I thought: do a chapter, Gun, in my book. I thought: that fake violence, that real tenderness, those bad teeth (yes, that too). I thought: these poor kids.

To what extent is Klein critical of Barthes' comments about his photographs. Their comments can be seen as a range of things, for example; interpretations, explanations, justifications, revelations etc. Evaluate their comments.

20. Involuntary feature and 21. satori

1. Barthes concludes that the detail that interests him is probably not intentional and so is not a credit to the photographer's art; it only says he was there, and had to photograph it when photographing the subject: Kertész had to photograph the road to photograph the violinist. Barthes may be correct in saying that the detail he is interested in is probably not deliberately included, but would this always be the case, and even if it were is it a real criticism of the photographer's ability? Could you argue that he would just as likely to be moved by some one's family photo album as an exhibition of, say, Don McCullin's photographs? In the case of Wessing's photograph do you think that it is likely that Wessing did not mean to include the nuns?

23. Blind field

1. The *punctum* creates a blind field; the necklace gives the woman a life external to the portrait. If the *punctum* creates the 'blind field' and what the *punctum* is, is subjective, is there any sense in which the photographer can control the interpretation of the photograph?

24. Palinode

1. Barthes states that he has been too subjective and must now recant. Although Barthes has not found the nature of photography, make a written and/or

visual response to the first part of the book that explores what you have found most interesting in it.

25. 'One evening...'

1. Barthes quotes Proust as saying of photographs that they recall less than just thinking of the person. Do you agree with Proust? Think of someone you know you have a photograph of (try not to think of the photograph). Note down what you recall about the person. Now look at the photograph and note what you recall. Compare the two sets of notes and see if you can draw any conclusions.

27. To recognise

1. When Barthes writes of images of his mother he says the images were '...partially true, and therefore totally false' (p. 66). In a poetic sense this may be true, but logically speaking if something is partially true then it can only be partially false. Could it be this sort of shift in reasoning that results in the Postmodernist scepticism about the truthfulness of the photographic image? See Chapter 8, Andy Grundberg, *The Crisis of the Real*.

2. The photographs did, however, reveal an 'essential identity...each of these photographs manifested the very feeling she must have experienced each time she "let" herself be photographed: my mother "lent" herself to the photograph...'. She overcame the ordeal of being photographed by sitting in front of the lens '*with discretion*' without appearing theatrical or sulky, seeing a civic value in the photograph. 'She did not struggle with her image, as I do with mine: she did not *suppose* herself' (p. 67). Barthes is suggesting here that some people are at ease with having their photograph taken, does this mean that these portraits are more truthful and that the photographer is less important than the subject when it comes to the taking of a good portrait? Take several portraits of different people who have different attitudes to having their photographs taken, evaluate these, making sure that in your evaluation you explain the sitter's attitude to having their portrait taken.

28. The Winter Garden Photograph

1. Despite reproducing a number of other photographs in this book Barthes does not reproduce this image. The image is the key to the whole book and he would

have had no copyright problems in printing the photograph. What are his reasons for not reproducing the photograph and are they valid?

2. Nadar's photograph of his mother (or wife) and the 'Winter Garden Photograph' are different from the other photographs of Barthes' mother which were 'ordinary' objects, analogical, giving her identity '...not her truth; but the Winter Garden Photograph was indeed essential, it achieved for me, ... *the impossible science of the unique being*' (p. 71). Here, Barthes gives two levels of truth, the first that the photograph identifies physically the subject, the second is a utopian '*impossible science*' that identifies the 'truth' of the subject which for him is not the same as the physical identity. Can he claim this truth of the 'Winter Garden Photograph' and can he claim it of Nadar's photograph?

3. Look at a series of I.D. photographs taken by or under the supervision of Nhem Ein. These photographs could not be more utilitarian in that they were taken solely to prove identity, do they go beyond this? Look at a typical Thomas Ruff portrait, intended to be concerned only with the surface. Does it go beyond this? After your initial response, if you know nothing about the background of these photographers and photographs, do some research on them. Has this changed the way you see the photographs? The Nhem Ein photographs were taken in Cambodia between 1975 and 1978 and the Thomas Ruff photographs were taken from 1981 onwards in Germany. [Between 1975 and 1978, 1400 prisoners were interned in Tuol Sleng prison in Cambodia, all had their photographs taken, full face and in profile, only seven prisoners survived.] See question 2 in section 'Time as punctum'

30. Ariadne

1. Barthes has chosen to study photography from the viewpoint of love and death, not pleasure. List as many other viewpoints you can think of, for example beauty, truthfulness understanding, persuasion etc. Look up photography in Roget's Thesaurus and for each 'type' of photography point out what viewpoint it is approached from (a list is reprinted in the back of Sontag's *On Photography* as are many interesting quotes). Are any of these viewpoints contradictory; is there some underlying factor that links them? Take at least two photographs of the same thing, or at least two photographs of each of several different things, from different viewpoints and analyse the differences between them explaining the reasons for the differences.

31. The family, the mother

1. In this section Barthes refers to the institutionalised notions of the Family and the Mother and models applied to families. Find and photocopy a series of photographs to illustrate this section, relating it, if you wish, to Berger. Your response may be purely visual or a combination of visual and written work. Try to look at as wide a range of photographers' work as possible, for example Julia Margaret Cameron, Lady Clementina Hawarden, Lewis Carroll, Henry Peach Robinson, Lewis Hine, Paul Strand, August Sander, Jacques-Henri Lartigue, Dorothea Lange, Bill Brandt, Ernest Cole, Emmet Gowin, Jo Spence, Diane Arbus, Elliot Erwitt, Raghubir Singh, Mary Ellen Mark, Sally Mann, Nan Goldin, Barbara Kruger, Dayanita Singh, Martin Parr, Tina Barney and Richard Billingham.

32. 'That-has-been'

1. Unlike other forms of representation and discourse '...in photography I can never deny the thing has been there.' The essence of photography, its *'noeme'*, is then '...of reality and of the past' (p. 76). Photography is not Art or Communication, it is Reference, and photography is founded on Reference. 'I had identified truth and reality in a unique emotion, in which I henceforth placed the nature – the genius – of Photography, since no painted portrait, supposing it seemed "true" to me, could compel me to believe its referent had really existed' (p. 77). Assuming you accept this position, it has been argued that the advent of digital photography undermines the holding of this or similar views. Consider various fields of photography, for example medical/scientific, documentary, press, advertising, family snapshots and art etc., where photographers use both types (analogue and digital) of photography. Look at various images in these fields, does knowing the images are silver based or digital affect the knowledge that '...its referent had really existed.' and if so to what degree? Assume the images you have looked at were also drawn or painted, would these images have the same relationship to reality? Attempt to make a photographic image using digital photography, that does not depend on the referent or any part of it having existed. Evaluate your image in terms of success in meeting the brief, and to what extent (if at all) you feel digital photography undermines Barthes' position.

33. The pose

1. Barthes has the same reaction to seeing a photograph of someone now dead as he does to seeing a film featuring a now dead actor or listening to the music of a dead musician. The impact of digital technology on the recording of music has been comparable to its impact on photography. For example, old analogue recordings are frequently 'digitally re-mastered' for re-release in order to make them truer to the original sound and most people accept the fidelity of digital recordings. Why should digitisation be so controversial for photographers and not for musicians?

35. Amazement

1. For Barthes, photographs by their very nature are metaphysical. Certain photographers seem to deliberately raise metaphysical issues in their photography, for example Francesca Woodman, Helen Chadwick, Joel-Peter Witkin, Duane Michals and, less obviously, Edward Weston. Evaluate the way these photographers raise these issues and consider the notion that the necessarily metaphysical nature of the photograph has a greater and more direct impact than photographers' more conscious efforts.

36. Authentication

1. Barthes argues that language cannot authenticate itself whereas photography is 'authentication itself'. Photography is only laborious when it fakes and even then it can only lie about the meaning of the subject not its existence. Although there is nothing better to confirm reality it is a contingent reality *'so much, no more'*. How important is this distinction between the meaning of something's existence and its actual existence in documentary and press photography?

2. Realists do not see photographs as copies of reality but emanation of *past reality*. Good analysis will not result from asking if a photograph is analogous or coded but by realising it has 'evidential force . . . its testimony bears not on the object but on time . . . the power of authentication exceeds the power of representation' (p. 89). Do you think this is true? They could be as important as each other or representation could be more important. Look at a range of genre, e.g. scientific, advertising, documentary, portraiture etc. in answering this question.

38. Flat death

1. Although all photographers deal with the live, Barthes sees them as agents of death, and he suggests that the photographic image '...produces Death while trying to preserve life'. Look at a range of photographic images covering several different genres (including family snapshots). Do you agree with Barthes? Does his argument apply more forcefully to particular types of photographs and how does the age of the image affect his point, if at all? Take one or more photographs exploring this notion.

39. Time as *punctum*

1. In this section, Barthes comments on how photographs manage to combine different tenses and it is this that is the *punctum* of the image. He concludes by saying '...all this under the instance of 'reality' – and no longer through the elaborations of the text...which itself is never credible *down to the root*' (p. 97). Is this another way of saying that 'a picture is worth a thousand words', and/or that ultimately the photograph is more believable than the text even though it is dependent on the text for its *stadium*?

2. In 1865, Alexander Gardner photographed Lewis Payne in a prison cell while he waited to be hanged, the *punctum* is that '*He is dead and is going to die...*' (p. 95). What '*pricks*' Barthes is the discovery of this 'anterior future', the photograph both gives the 'absolute past' and tells of death in the future (see Fig. 2). There are many photographs that reveal this 'anterior future', for example Dietrich Mummendey's photograph of Patrice Lumumba, Christian Simonpiertri's massacre in Dhaka, Nhem Ein's of the victims of Pol Pot and Frank Fournier's little girl from Armero (all in Marie-Monique Robin's 100 Historic Photographs of the 20th Century, ISBN 3822865125). In what way is this notion of *punctum* different from Barthes' earlier one (see sections 'studium and punctum', 'co-presence of the studium and punctum, and punctum: partial feature), and is it more useful in evaluating and understanding photographs?

41. To scrutinise

1. Although the Photograph does not conceal '...it cannot say what it lets us see' (p. 100). What do you think Barthes means by this?

42. Resemblance

1. 'Ultimately a photograph looks like anyone except the person it represents' (p. 102). Resemblance refers to a purely legal notion and leaves Barthes sceptical and unsatisfied – the only truthful photograph of his mother did not look like her as he knew her and was of a child he did not know. In this section, Barthes states that some portraits resemble people because he has certain expectations, but on the other hand no photograph of him resembles him (in other than a legal way). Given the complexity of peoples' personalities, the fact that they often present themselves very differently to different people and in different circumstances, is it realistic to expect a single photograph to reveal a person's character? Find a number of photographs of famous people and explain how these photographs do or do not reveal their key characteristics. Try to select a range of people from 'good' to 'bad'. For example, Mahatma Gandhi and Nelson Mandela would almost universally be regarded as 'good' people; Mussolini, Joseph Stalin and Pol Pot as 'bad' as would General Pinochet; others such as Henry Kissinger and Margaret Thatcher would generate controversy wherever you put them; and some like Robert Mugabe are viewed very differently now as opposed to twenty years ago.

5 Martha Rosler, *In, Around and Afterthoughts (On Documentary Photography)*

This is a summary of the first part of Rosler's essay as it appears in *The Contest of Meaning*, edited by Richard Bolton.

Rosler asks why documentary photographers still want to photograph the Bowery (a skid row in New York), when it is no longer possible to justify photographing it either in terms of helping or exposing the occupants.

She states that documentary photography represents a liberal social conscience. In the USA, it was at its most important in the 'ideological climate' of state liberalism and reform movements in first half of the twentieth century. However, it had muckraking associations, and predated the 'myth of journalistic objectivity' (p. 306), which partly 'strangled' it. It can be argued that the Bowery photographs were a part of an '... aggressive insistence on the tangible reality of ...' poverty and a reality forced into consideration just by being photographed (p. 306).

Rosler quotes Jacob Riis in *The Making of an American* in which he describes his extreme distress at the plight of the tenement occupants and the failure of his writing on their conditions to make any impression on people. In the quote, he reveals his joy in finding out that a way had been found to photograph in low light conditions (flash), which would enable him to photograph tenement dwellers (see Fig. 36).

At the time much of the journalism dealing with the socially disadvantaged was sensationalist, unlike the work of Riis, Lewis Hine and others who were propagandising social work and righting wrongs (see Fig. 35). However, these reformers did not understand that these wrongs were essential to the social system that tolerated them. In calling for their righting the photographers both expressed sympathy for the poor and appealed to the self-interest of the privileged. They were making a strong case for charity rather than self help. This notion of charity is an argument for the preservation of class as it encourages the giving of a little in order to pacify potentially dangerous lower classes.

This link between moral arguments, rather than revolutionary politics, has been characteristic of documentary photography even in the work of the US's Film and Photo League during the depression era. Documentary photography has power because the images are more disturbing, and have the potential to generate arguments more radical than commonly considered. By using them to campaign for reform rather than radical or revolutionary change allows them to be institutionalised by the government so limiting their effect.

In the Bowery the subjects are the docile victims of the photographer, unless the photographer shows up before they have been drinking in which case they are likely to be hostile, having no interest in being photographed. This is particularly the case now that '...the meaning of all such work, past and present has changed...' (p. 307). The New Deal's fight against poverty has been given up and social concern has been replaced by political views that suggest the poor are poor because they deserve to be poor. The exposé, compassion and dedication to reform has given way to '...exoticism, tourism, voyeurism...trophy hunting-and careerism' (p. 307).

Although liberalism has been defeated, documentary, as a ritualistic cultural expression of liberalism survives. Occasionally found in newspapers, it becomes more common and expensive as it moves from glossy magazines to books, galleries and museums. Like scratching an itch, it relieves the conscience of its viewers and reassures them about their financial and social position. It both flatters and warns the viewer. By turning their fears into an image allows them to cope with their fears and walk away from them. It conveys old information about powerless people to a more powerful group and asks the more powerful group to help the typically 'pathetic, helpless, dispirited' victims (p. 307). But Rosler asks '...which political battles have been fought and won by someone for someone else?' (p. 307).

Liberal documentary tends to equate poverty and oppression with natural disasters so avoiding causal links and the assigning of the blame to oppressors, unless the oppressors are enemies of the United States.

By selecting the right subject, Diane Arbus allows the viewer to stare and to do so without feeling empathy. As 'pugnacious self-interest' asserted itself in the 1980s '...one displays one's toughness in enduring a visual assault without a flinch...' (p. 307), as the victims are turned into freaks and the '...boringly sociological becomes exciting mythological/psychological (p. 307).

Once images have ceased to be news they testify to how brave, manipulative or clever the photographer was in overcoming danger and/or social restrictions '...Or who, like the astronauts, entertained us by showing us the places we never

hope to go' (p. 308). Photography of war, slums, subculture, foreign poor, deviance and the past from the current stars of documentary photography '... W. Eugene Smith, David Douglas Duncan, Larry Burrows, Diane Arbus, Larry Clark, Danny Lyon, Bruce Davidson, Dorothea Lange, Russell Lee, Walker Evans, Robert Capa, Don McCullin, Susan Meiselas...' (p. 308) (see Figs 7, Smith; 27 to 32, Lange; 3, 13, 26, 40 and 41, Evans; 9, McCullin and 39, Meiselas).

In the early 1970s, Eugene Smith and his wife Aileen Mioko Smith produced a photographic and written expose of the devastating effects of mercury pollution on the Japanese town of Minamata. The victims, in a sometimes-violent campaign, eventually gained redress from the chemical firm Chisso. After this success, the American magazine *Camera 35* published text and photographs on Minamata submitted by the Smiths. For commercial reasons, the editor ignored Smith's proposed cover photograph and lay out and instead ran a portrait of Eugene Smith proclaiming him 'Our Man of the Year'. Not only does the magazine convert the Smiths into Smith but it also stifles their call for 'strong-minded activism' in appreciation. In a footnote Rosler adds: 'I am not arguing for Smith's art-history-quoting, bravura photographic style. Nevertheless, and in spite of the ideological uses to which Smith's (and in this case the Smiths') work has been put in the photo world, the Smiths' work at Minamata evidently was important in rallying support for the struggle throughout Japan' (p. 336).

Rosler cites the case of the mud men of New Guinea as an example of cultural degradation. She gives examples, of a travel editor calling for donations for a cultural centre for them on the grounds that it will enhance the value of the tourists' holiday. Of the use of images of mud men in a whiskey advertisement and of Irving Penn's '...effete mimicry of anthropological documentary...' in his portraits of mud men in his *Worlds in a Small Room*.

She points out that Edward S. Curtis in his attempts at photographically preserving the North American Indians' culture used his collection of clothes etc. on his sitters in often inauthentic or inappropriate ways. In describing these photographs as 'historical romances', Rosler states their truthfulness may be no more than that of travel photographs of groups such as Tahitians by North American tourists. Such photographs not only denied the contemporary native people as '*experiencing people*' (p. 310), but allowed the white Americans to shift their guilt in relation to these people '...onto the "Indians" for having sunk so low and having *betrayed their own heritage*' (p. 310).

Curtis' photographs however were an improvement on earlier photographs that showed native people in only negative ways. Yet, Rosler finds the 'sentimental pictorialism' of Curtis 'repulsively contorted' like the caricatures of Julia

Margaret Cameron, and prefers Adam Clark Vorman's more 'anthropological work (p. 310). Curtis and his fellow photographers were not guilty of wilfully participating in 'the dispossession of the American native peoples...', whose descendants have praised them for considering their forebears worthy of photographing and providing a visual record of them. Fortunately, unlike the urban immigrant poor, the poverty of the Indians was not shown, allowing for the sentimental myth of the Indian to develop as opposed to the negative view of the immigrant.

'Or consider a photo book on the teeming masses of India – how different is looking through it from going to an Indian restaurant or wearing an Indian shirt or a sari? We consume the world through images, through shopping, through eating...' (p. 311).

Rosler quotes from the December 1979 issue of *American Photographer* to illustrate a number of points. One article in the magazine is on a Visa campaign that used, amongst other photographers' work, a staged photograph by Elliot Erwitt. It shows a man, from the rear, riding a bicycle down a tree-lined avenue. On the bicycle behind the man, on the carrier, is a young boy looking over his shoulder at the photographer and behind him two baguettes strapped across the carrier. Rosler points out that Erwitt had produced a similar image for the French office of tourism about twenty years earlier, and a few years after the Visa photograph, Allée Dumanoir produced a similar image for the New York Times travel section. Common to all three images are tourism and the fact that the photographs look like documentary images. Erla Zwingle, in *American Photographer*, comments on how the image reveals Erwitt's 'gift' for documentary photography. In a footnote, Rosler highlights a quote from the advertising agency on the fact that the original French photograph, although set up, had to be turned into a 'documentary photograph', had to have 'believability', had to 'look authentic'. Rosler concludes, 'The question of documentary in the wholly fabricated universe of advertising is a question that can have no answer' (p. 338).

In the same issue of *American Photographer* was a feature on a photograph by David Burnett *Detained Prisoners, September 1973*, taken shortly after the 'brutal putsch' in Chile in 1973. Burnett took the photograph on a government tour of a notorious stadium where people were detained and shot. Rosler quotes from the article. [We]'...noticed a fresh batch of prisoners.' Burnett says, 'The Chileans had heard many stories about people being shot or disappearing [in war does one learn of death from hearing stories?] and they were terribly frightened. The haunting gaze of one man in particular, whose figure was framed by two armed soldiers,...caught my eye. The picture has always stayed with me' (Rosler's insertion

in the square brackets.) She points out that the article goes on to list the range of cameras that Burnett uses. And that his coverage of the coup won the Overseas Press Club's Robert Capa Award for 'exceptional courage and enterprise'.

Rosler asks 'What happened to the man (actually, men) in the photo? The question is inappropriate when the subject is photographs. And photographers. The subject of the article is the photographer' (p. 315).

In the late 1970s, a Cherokee, Mrs Thompson, attracted media attention on the basis that she was the migrant mother in the famous 1936 photograph by Dorothea Lange (see Fig. 32). Associated Press quoted her 'That's my picture hanging all over the world, and I can't get a penny out of it.' Although proud to be the subject she asked, 'What good's it doing me?' Lange took the photograph when working for the Farm Security Administration's photographic section headed by Roy Stryker. He described the photograph as *the* picture of Farm security '... So many times I've asked myself what is she thinking? She has all of the suffering of mankind in her but all of the perseverance too ... She is immortal' (p. 315). Another news story on her pointed out that she lived on an allowance from Social Security. Rosler says of her 'She is of interest solely because she is an incongruity, a photograph that has aged; of interest solely because she is a postscript to an acknowledged work of art.' She goes on to say of Burnett's photograph '... we will not discover what happened to the people in it, not even forty-two years later' (p. 315).

Rosler refutes claims that it is unrealistic for Mrs Thompson to benefit from the photograph because it has gone beyond being merely a photograph of her. Rosler points out that in her field notes Lange quotes Thompson as saying, 'She thought that my pictures might help her, and so she helped me'. Although conditions at the migrant camp were improved as a result of the photograph's publication, Mrs Thompson did not benefit directly. As a result, Rosler feels Mrs Thompson is justified in feeling aggrieved.

For Rosler, Mrs Thompson's case illustrates how documentary photographs have '... two moments: (1) the "immediate," instrumental one ... arguing for or against a social practice and its ideological–theoretical supports, and (2) the conventional "aesthetic-historical" moment ... in which the viewer's argumentiveness cedes to the ... pleasure afforded by the aesthetic "rightness" ... of the image' (p. 317). The second moment is historical only in the sense of time past, but refuses a specific historical meaning. Rosler regards this as dangerous as it does not accept '... a dialectical relation between political and formal meaning ...' (p. 317). Further, the loss of topicality and almost all specific references enhance the aesthetic aspect. For Rosler, aesthetics is ideological as all responses are based on social concepts.

This second moment is also problematic because it has the notion of 'aesthetic rightness' changes and it ignores this fact. There are no fundamental truths that determine whether or not a '...particular form is seen as adequately revealing its meaning...' (p. 317). As a result of these changes photographic history includes Jacob Riis along with the far more classical Lewis Hine (see Figs 36 and 35), and Weegee with Danny Lyon. Those like Lange who '...identify a powerfully conveyed meaning with a primary sensuousness are pushing against the gigantic ideological weight of classical beauty, which presses on us the understanding that in the search for transcendental form, the world is merely the stepping off point into aesthetic eternality' (p. 317).

Taking art out of its cultural context makes it hard to deal with this issue without diminishing photographers like Lange and their work. Rosler understands the photographer's identification with '*the work itself*' and 'its supposed autonomy' (p. 317). For her, however, this autonomy only signifies the work belongs to the photographer's body of work and to the realm of photographs. Being over-protective of the photographer's role has the danger of drawing us towards exploitation.

In a similar vein to the Thompson story, in 1980, the Sunday *New York Times Magazine*, ran an article criticising the key American documentary project *Let Us Now Praise Famous Men* (photographed by Walker Evans and written by James Agee in 1936). The *Times* ran current photographs alongside Evan's originals. Rosler comments on the irony of a newspaper targeted at the wealthy classes calling '...for the protection of the sensibilities of those marginalized sharecroppers...of forty years ago...' (p. 317) by re-photographing them in a new documentary which now reveals their real names and 'life stories'. For Rosler, this creates a new level of victimisation, where having once been the subject of someone's camera the victim then becomes the victim of a second photographer who exposes their current state of poverty. All we learn from this new documentary is that these poor people felt shamed by the exposure of their poverty in the first place and that although they see their situation has improved the *Times* readers can feel reassured that they are still far better off than the poor.

Rosler argues that the believability of documentary photography has come under attack from two politically opposed camps. The attack from left states that documentary is a social institution that serves one class (the wealthy). It legitimises and enforces the wealthy classes' dominance over the poorer classes while pretending to be fair and universal. It is able to do this because there is a generally accepted cultural belief that photography and mainstream journalism are transparent and objective and this allows the media '...to claim ownership of all

truth' (p. 319). Rosler feels this belief needs to be attacked. The attack on the truthfulness of documentary has also suited the right wing, which sees social inequalities and elites as natural. The elite is able to appreciate the beauty and truth found in a section of photography and attaches most importance to the author of the image, isolating the images in galleries, museums and the art market. In doing so, it separates the elite's understanding of the images from the common understanding. As a result debates about photography have shifted to the right and revolve around formal aesthetic considerations ignoring the content and political or ideological dimension of the images.

As an example of the right wing approach, Rosler gives the example of John Szarkowski, curator of Photography at New York's Museum of Modern Art (MOMA). Szarkowski encouraged the work of Garry Winogrand, '...who aggressively rejects any responsibility (*culpability*) for his images and denies any relation between them and shared or public human meaning'. Rosler feels that Lee Friedlander can be compared with Walker Evans and Winogrand with Robert Frank. She regards Frank's work as revealing left wing anarchism and Winogrand's, a right wing one. Frank's images of American life in the 1950s suggest that any observant person travelling through America would see its 'social-political meaning' (p. 339). For Winogrand, an image can reveal any narrative depending on the viewpoint of the viewer and the only meaning to be found is within the frame of the image.

Rosler quotes from Szarkowski's introduction (written in 1967) to his New Documents exhibition featuring the work of Winogrand, Arbus and Friedlander. In it he states that a new generation of photographers had redirected documentary photography away from trying to make the world a better place. The new generation of photographers had more personal aims and were more prepared to accept the world's imperfections. Despite the real world's 'terrors', they found value in the commonplace.

Rosler points out that this introduction was written during the 'terrors' of the Vietnam War. She feels Szarkowski makes a weak case for abandoning social causes in favour of a 'connoisseurship of the tawdry' (p. 321). She asks 'How do we define the...extent of the "world" from looking at...these images, and how can we be said to "know it"...At what elevated vantage point must we stand to regard society as having "frailties" and "imperfections"? High enough to see the circus before our eyes, a commodity to be "experienced" the way a...vodka ad entices us to "experience the nineteenth century"...' (p. 321). He makes a 'global claim' for their work which points out its actual limits. Compared with 'nightmarish' Vietnam photographs, the three photographers' images might seem to show

'sympathy' for the 'real world'. Rosler feels it is not photographers involved in social causes that are the forebears of Szarkowski's photographers '...but bohemian photographers like Brassaï and the early Kertész and Cartier-Bresson' (p. 321).

ASSIGNMENTS/DISCUSSION POINTS

1. Rosler asks the rhetorical question '...which political battles have been fought and won by someone for someone else?' (p. 307). Is she guilty of over-simplifying political relationships between the oppressed, the oppressors, the supporters and beneficiaries of either group, or those who are neutral? Could it not be argued that documentary photographs inform all parties and by giving information change the relationship between them and also change the balance of power by shifting support to the oppressed in their political struggles? Investigate how human rights groups (e.g. Amnesty International, Human Rights Watch), environmental groups (e.g. World Wildlife Fund, Greenpeace) and groups such as Médecins Sans Frontières use documentary photographs. Increasingly, pressure groups are involved in what are seen as animal rights issues, these can be included in the investigation.

2. Rosler states that liberal documentary tends to equate poverty and oppression with natural disasters, so avoiding causal links and the assigning of the blame to oppressors, unless the oppressors are enemies of the United States. Is this claim justified? Eugene Smith's *Minamata*, Don McCullin's coverage of Biafra (and his book *Homecoming*) and Philip Jones Griffiths's *Vietnam Inc.* could be regarded as classic examples of 'liberal documentary'. By no stretch of the imagination could the 'oppressors' in their work be regarded as enemies of the United States. Consider the examples given above and those given by Rosler and either defend or dispute her claim. You may use the work of other photographers to support your case but bear in mind her essay was first published in 1981. Post-1981 work can give an indication of later trends, but not to support or undermine her argument at the time it was published.

3. 'Or consider a photo book on the teeming masses of India – how different is looking through it from going to an Indian restaurant or wearing an Indian shirt or a sari? We consume the world through images, through shopping, through eating ...' (p. 311). Answer the question in this quote. If you wish to base your response around India, a good reference would be *India a Celebration of Independence*, Aperture 1997, and Chapter 9 of this book, Raghubir Singh's *River of Colour*.

4. Does the Elliot Erwitt photograph of the cyclist show anything exceptional, apart from the fact that advertising uses documentary images because documentary images have an air of believability? Look through current publications and collect one or more advertising photographs showing the use of apparently documentary images and images that are clearly not documentary. Evaluate their impact and explain why you think the particular types of images have been used.

5. In recent years, Benetton has used documentary photographs in its advertising. How do these advertisements differ from the Erwitt 'documentary' advertisements?

6. In a footnote, Rosler writes, 'I am not arguing for Smith's art-history-quoting, bravura photographic style. Nevertheless, and in spite of the ideological uses to which Smith's (and in this case the Smiths') work has been put in the photo world, the Smiths' work at Minamata evidently was important in rallying support for the struggle throughout Japan' (p. 336). Both Sontag and Rosler have problems with Smith's images, yet, other critics like A.D. Coleman (*Critical Focus*, 1999) do not. Look at a range of Smith's work and respond to these various points of view. More recently, Sebastião Salgado's work has been criticised in a similar vein to Smith's, you may wish to make links to his work. (See *The Heroism of Vision*, question 6, in the Sontag section of this book for the reference details).

7. Tom Hunter is a contemporary photographer who is explicitly 'art-history-quoting' and deals with social issues in his photography (see colour Figure C1). How is his work different from Smith's and Salgado's and would Sontag's, Rosler's and Sischy's criticisms apply to his work? Use the references given in question 6.

8. Of Burnett's photograph, Rosler asks 'What happened to the man (actually, men) in the photo? The question is inappropriate when the subject is photographs. And photographers. The subject of the article is the photographer' (p. 315). Could it be argued that the photographer is only of interest because he takes good photographs and that this photograph is good mainly because we do wonder what happened to the man or men? Why is this a disturbing image?

9. Is Rosler guilty of de-contextualising the Burnett article by ignoring the fact that the photographs were not taken to appear in a photographic magazine but as news/documentary photographs? She seems to suggest that listing Burnett's cameras is rather trivial information, is she right, and if so why does the magazine give it?

10. Like thousands of other civilians summarily detained by General Pinochet's soldiers, the men in the photograph may have been murdered and 'disappeared'. Do you think the men and their families would have wanted this photograph taken, and do you think today's dictators would normally allow photographers access to potential victims?

11. When writing about Mrs Thompson, Rosler says 'She is of interest solely because she is an incongruity, a photograph that has aged; of interest solely because she is a postscript to an acknowledged work of art' (see Fig. 32). She goes on to say of Burnett's photograph '...we will not discover what happened to the people in it, not even forty-two years later' (p. 315). Is there an ambiguity in Rosler's attitude to the two images? She seems to view our current knowledge of Mrs Thompson negatively and at the same time suggest our lack of current knowledge of the Chilean men is also negative: Is Rosler right to say Mrs Thompson is of interest *solely* because of her relationship to a *work of art* and is this an accurate description of the photograph and the interest in her?

12. Rosler states that the notion of 'aesthetic rightness' changes, that there are no fundamental truths that determine whether or not a '...particular form is seen as adequately revealing its meaning...' (p. 317). As a result of these changes, photographic history includes Jacob Riis along with the far 'more classical' compositions of Lewis Hine (see Figs 36 and 35). Are Riis and Hine put beside each other in photographic history for aesthetic reasons? Investigate the following notions: Although crudely used the harsh flash lighting used by Riis suited the conditions he was trying to expose, and as a result it was aesthetically effective (look at Roger Ballen's use of flash in his documentation of South Africa's poor whites): Riis's work is aesthetically inferior to that of Hine's and it is only because of Riis's pioneering role that he is put besides Hine's: A technically more skilled photographer and/or Riis with more sophisticated equipment would have produced aesthetically stronger images that would have had more impact in terms of Riis's goals.

13. Look at the following six photographs, Figs 27 to 32, in terms of Rosler's claim that the notion of 'aesthetic rightness' changes, that there are no fundamental truths that determine whether or not a '...particular form is seen as adequately revealing its meaning...' (p. 317). These are all photographs taken by Dorothea Lange in 1936, in California, during the depression for the Farm Security Administration (FSA). The purpose of these photographs was to reveal the terrible situation of farmers during the depression and in doing so persuade the American people of the need to support programmes developed to help the farmers. All the photographs have the same subject matter, a

struggling mother with her child or children, five of the photographs are of the same family, yet only one of the photographs has become an iconic image recognised world wide. The photographs were taken about 70 years ago, since then society has undergone enormous changes. Do you think that if the final photograph had not been taken any of the others would have had a similar impact? If the same photographs were taken today would the sixth photograph still be regarded as the most powerful image? How do your responses to these two questions relate to the Rosler quote at the beginning of this question/ discussion point? James Curtis' *Mind's Eye, Mind's Truth* has a very detailed analysis of these and other FSA photographs.

14. Take two sets of documentary photographs with at least two photographs in each set. In the first, use a camera mounted flash fired directly at the subject, do not attempt to bounce, soften, use pre-flash or manipulate the flash in any way. In the second set of photographs, the flash must be manipulated to give the most 'natural' light possible. You may use colour or monochrome. If you use both, your final selections must have colour and monochrome in each set. Evaluate your work with particular attention to the effect the two different ways of using the flash had on the images and their meaning. Look at the work of Jacob Riis (Fig. 36), Bruce Gilden (Fig. 39) and Roger Ballen as part of your research.

15. Both Berger and Rosler are concerned about the aesthetics of images. In *Ways of Seeing*, Berger does not seem to find fault with the notion that beautiful images can convey powerful messages but rather that they are misinterpreted, mystified. Rosler seems to be arguing that it is not critics mystifying images that is a problem, but that the very notion of fundamental 'aesthetic rightness' is flawed, and notions of classical beauty lead one away from the real world into an 'aesthetic eternality'. Evaluate their arguments and consider how a photograph is to convey a message if it does not conform to notions of aesthetic strength. Or, if 'aesthetic rightness' is a flaw in documentary photography, is it in art? Does Goya's work *The Third of May, in Madrid: the Shooting on Principe Pio Mountain* and *The Disasters of War* fail to convey a moral message because of their aesthetic strengths. Or, can Goya be seen as a precursor of the concerned photographer?

16. Rosler sees the 'bohemian' photographers like Brassaï and the early Kertész and Cartier-Bresson, as opposed to photographers involved in social causes, as being the forebears of Winogrand, Arbus and Friedlander. To what extent do you agree with her? Look at one photographer from each group, or at all six photographers to justify your response.

17. Sebastião Salgado, Bruce Gilden and Roger Ballen are three contemporary documentary photographers, how does their work relate to that of Winogrand, Arbus and Friedlander. Attempt to take at least one photograph in the style of each of Salgado, Gilden and Ballen.

18. In a later essay *Image simulations, computer manipulations: some considerations*, Rosler has a footnote referring to *In, Around and Afterthoughts (On Documentary Photography)* in which she states 'Although an essay of mine on the institutionalization of documentary photography...has been taken to support the idea that "documentary is dead," I believe, on the contrary, that documentary is alive – if those who do it exercise responsibility in their decisions relating to the production, dissemination, and marketing of their images. Not that voluntarism is the answer, but I don't think we are will-less creatures, either'. Discuss the notion that 'documentary is dead' is a reasonable interpretation of the essay (as summarised) and that Rosler has actually changed her mind. (This summary only covers the first half of the essay.)

6 Abigail Solomon-Godeau, Inside/Out

This is a summary of the essay as it appeared in *Public Information Desire, Disaster, Document* (SFMOMA 1994).

Solomon-Godeau sees Sontag's *On Photography* as critical of photography's colonisation of the world and points out that Sontag found that there were certain approaches to photography, in particular, that objectified people. These approaches prevented the viewer having empathy with the subject and Arbus's work was typical of this. Arbus photographed deviants (social, physical and those that looked deviant) in a way that prevented compassionate involvement. As a result, Sontag sees her as a morbid voyeur.

Sontag feels that for Arbus the camera removes '... moral boundaries and social inhibitions, freeing the photographer from any responsibility toward the people photographed' (Sontag, p. 41). She feels this is the point of photography, to visit people, not to interfere in their lives, to be a 'supertourist' (Sontag, p. 42), colonizing new experiences in a fight against boredom. Like fascination, boredom depends '... on being outside rather than inside a situation...' (Sontag, p. 42).

Solomon-Godeau argues that Sontag's criticism of the 'touristic' and irregular attitude behind Arbus's work depends in part '...on the binary couple inside/outside' (p. 49). This duality [Solomon-Godeau uses the word 'binarism', which stems from de Saussure's theory of language-semiology] is a part of much photographic criticism dealing with ethics and politics. In Sontag's example of Arbus's work, the insider position is seen as being the 'good' one and the alienated outsider position the 'bad'.

Solomon-Godeau sees Sontag as a humanist dealing with the ethics of photography (empathy etc.). She sees Martha Rosler, the left leaning author of the essay *In, Around and Afterthoughts (On Documentary Photography)*, as dealing with the politics of photography (power and powerlessness etc). Rosler calls outsider photography 'victim photography' and sees one alternative to it as

self-representation, which would give power to the 'victims'. However, from both Sontag's and Rosler's perspectives, the documentary photographer, the tourist etc. commits an act of violence against, and takes something from the subject, while only seeing a partial and probably distorted view of the subject.

Solomon-Godeau points out that this duality is far more complex than it seems. We see truth as being on the inside, yet define objectivity as being on the outside. From Walter Benjamin to Sontag a recurring view held by critics is that by its very nature photography is unable to do anything but show superficial appearances. If this is true, then how does one tell the difference between the insider's photograph and the outsider's? If the difference can be seen, how is it shown? Do insiders perceive or present things differently? Do they objectify people less?

The work exhibited in the exhibition *Public Information: Desire, Disaster, Document* provided an opportunity to see both the paradoxes and ambiguities involved in the inside/outside duality. On the one hand, Ed Ruscha's *Every Building on the Sunset Strip* (1966) and Dan Graham's *Homes for America*, (1965–1970) are the works of absolute outsiders, concerned only with the exterior of the subject, which is banal. Their approach is impersonal suggesting no particular photographer. (After abstract expressionism, these characteristics of vernacular photography were to influence many artists, such as Warhol and Richter.)

On the other hand, the 'confessional' work of Larry Clark and Nan Goldin is produced by people with a deep personal involvement in the subject matter. Solomon-Godeau sees this work's subjectivity as descendent from art photography. Although the work of Clark, Goldin and Arbus raise some of the same issues, in that they all deal with the fringes of society, Arbus is clearly an outsider in relation to her subjects. Whatever the original intention of their work, Solomon-Godeau sees it now existing '...in a nether zone between art and spectacle...' Unlike Arbus, Goldin's work is that of an insider. Solomon-Godeau quotes Goldin from her *Ballad of Sexual Dependency*, in which Goldin points out that the people in her photographs regard her camera as a part of her, and that it is as much a part of her every day life as eating. Further, the camera does not distance her from her subjects but creates clarity and 'emotional connection', she is not a voyeur as the people are her 'family' and it is her history.

In both *Ballad of Sexual Dependency* and *The Other Side* Goldin shows us her world. In the former, she is at times the subject itself and, although in the latter she is not, she makes clear in her introduction her deep personal involvement with the subjects. For these reasons, Solomon-Godeau regards both works perfect examples of the insider position, what she calls the 'confessional' mode.

Images of what would normally be private scenes, for example dressing, and the closeness of the camera to the subject, result in the viewer assuming an intimate relationship between the photographer and the subject. Yet, *The Other Side* deals with transvestites and the very nature of transvestism revolves around appearance. In the first group of photographs, Goldin's insider position results in images that show the subject as the subject would like to be seen, however these photographs resemble fashion photographs of the time and show no structural difference from such photographs. The style of photographs change later in the book from monochrome to colour and they become more informal, still 'Insiderness... can be seen to be about access and proximity, but whether one can argue a nonvoyeuristic relationship in consequence of the photographer's position is another matter entirely' (p. 55).

There is a risk that irrespective of the photographer's intentions the subject becomes an object and spectacle. Solomon-Godeau asks 'Does a photographic representation, however sympathetic, of drag queens and transsexuals constitute an effective intervention against the political and ethical problem of homophobia?' (p. 55). Part of the impact of these photographs is due to the success of subjects' ability to mimic the opposite sex, to switch genders. This is done in two ways, firstly so effectively as to undermine the division between the genders, and secondly, in a disturbing way in which the subject shows signs of both genders. In the first case, photography re-enforces the illusion, and so is close to the realm of studio photography and in the second case the truth is revealed and photography enters the realm of the expose. In both cases the photographs are about the exterior, the appearance and do not reveal an interior truth about the subject.

The notion of voyeurism is particularly interesting in Goldin's work both because of the original meaning the word (to get sexual pleasure from looking) and because the people being looked at are defined by their sexuality. Despite Goldin's intimacy with her subjects and her desire for the viewer to see with her eyes, the camera cannot penetrate what '...is simply, stupidly *there*' (p. 55).

Some of Larry Clark's photographic projects can also be seen as an insider's view. In a stereotypical gender division, Clark provides a macho delinquent explanation of his work as opposed to Goldin's warm caring explanation of hers. In Clark's first book *Tulsa*, the fact that he is an insider is fairly obvious, as he is one of the subjects, the notion of him as an insider in his second book *Teenage Lust* is less obvious. In both books the subject matter, amongst it seductive male youths and erections, suggest a strong identification with male adolescence. Solomon-Godeau quotes him ' "in 1972 and 1973 the kid brothers in the neighborhood took me with them in their teenage lust scene. it took me back" ' (p. 57). In *Teenage Lust* he is no

longer a teenager and they take him along, raising the question as to what extent he is an insider. If the nature of his identification, '. . . erotic, sociological or personal . . .' is not immediately obvious to the viewer how are we to understand the difference between outsider and insider work? Like *National Geographic* photographers, Clark gives the illusion that the world speaks for itself. Despite the presence of Clark and his camera being unacknowledged in many of the photographs they are part of the action. It is questionable whether this privileged vantage point (which Solomon-Godeau points out is literally voyeuristic), reveals the privileged knowledge that the insider is meant to have.

In trying to deal with the ambiguities raised by Goldin and Clark's work Solomon-Godeau suggests two alternative explanations. Firstly that all work dealing with sexuality '. . . intersects with the sexuality of the viewer' and as sexuality is located on the inside, there being no neutral or objective notion of it, this places work of a sexual nature on the inside. Secondly that photography can only show the outside and cannot make visible the subjective and internal truth of the subject.

In dealing with photographs of others, the ethical and political issues raised by Sontag and Rosler, voyeurism, objectification, tourism and imperialism need to be addressed. Rosler herself tries to do this in her own work. An example of this is her *The Bowery in two inadequate descriptive systems*; instead of showing the wino in a doorway, she shows the doorways only and juxtaposes this with various words used to describe winos. By not making a striking image of the wino, which Solomon-Godeau feels would be 'mindlessly consumed', Rosler has moved this problem from the visual to the debate about, or politics of, representation. Solomon-Godeau cites Jeff Wall as another photographer confronting on a political level the inside/outside problem.

Solomon-Godeau feels, however, that the validity of the duality needs to be questioned. She feels that what is actually the issue is how we know reality. Whether photography can represent the truth and reality depends on whether truth and reality can be represented. Further, while acknowledging that photography is still accepted as evidence in some areas, i.e. ID, the police, judiciary and racetrack, she feels that the 'truth status' of photography has not done well in the post-modern age. If, as some philosophers claim, reality is always known through representational systems, the question is then on what grounds can it be said that photography is inadequate in representing the real?

The debate about photographic representation of the real therefore takes several forms and the inside/outside debate is only relevant to certain practices. If it is possible that the photographic practice based on 'insiderness' shows the visual

cannot reveal the inside, then it is also possible that outsider photography reveals a truth of its own.

Solomon-Godeau cites Robert Frank's *The Americans* (1958) as an example of an outsider approach revealing a truth. She points out that since Romanticism there has been a tradition of seeing the artist as an alienated, at times rebellious, outsider in his own culture. This alienation, being on the outside is perceived to guarantee the artists, integrity and perception. When photographing the American Frank's nationality (Swiss) and language placed him on the outside and he '...produced what many consider to be one of the definitive, evocative, and, indeed, authentic portraits of fifties America. For me, Frank's America is as much a fiction as the America purveyed by *Life* magazine...Still, to say that *The Americans* is not *the* truth of America in the fifties is not to say that it doesn't possess a truth...' (p. 60). A truth very different from the image of America presented officially and through advertising.

Solomon-Godeau gives Chantal Akerman's film *D'Est* as a more recent example of the outsider approach. Like Ed Ruscha's photographic books, she considers this work to be an example of an absolute outsider approach. 'The camera observes, mutely; there is no text, no narration, no explanation, no commentary.' There is only the ambient sound and a '...seemingly nonselective and passive outsider's look, scanning faces, bodies, postures, gestures' (p. 60).

Logically, this work cannot be separated from cinematic tourism, yet the viewer does not have '...the sensation of intrusion and expropriation, the imperialism of representation' (p. 60). For Solomon-Godeau, the work of Akerman, Frank, Rushka and Dan Graham suggest a truth about appearance that escapes the inside/outside duality that '...runs counter to a cultural bias that maintains a truth behind appearance' (p. 61). She quotes Walter Benjamin ' "it is a different nature that speaks to the camera than speaks to the eye" ' (p. 61).

ASSIGNMENTS/DISCUSSION POINTS

Solomon-Godeau's last paragraph

This paragraph has been reduced by about half in the summary. The original contains only four sentences, yet within these several major issues are referred to and, arguably, none have been resolved in the essay *Inside/Out*. In order to emphasise the importance of reading the original work, and to show to some extent how complex photographic criticism can get, the paragraph is printed in full here and then broken down and analysed.

> *This cinematic looking cannot logically be distinguished from the more negative concept of cinematic tourism, and yet, for all that, one does not particularly have the sensation of intrusion and expropriation, the imperialism of representation. What Akerman's film suggests, as do the photographs of Robert Frank, the soul-chilling suburban-scapes of Dan Graham, the neutral inventories of Ed Ruscha, is a way to think about a truth of appearance that without prodding reveals itself to the camera and totally escapes the binary of inside/out. This runs counter to a cultural bias that maintains a truth* behind *appearance, a truth always veiled that reflects the philosophical divide between seeing and being. But as Walter Benjamin observed, "it is a different nature that speaks to the camera than speaks to the eye." It may well be that the nature that speaks to our eyes can be plotted neither on the side of inside nor outside but in some liminal and as yet unplotted space between perception and cognition, projection and identification.*

The first **four** assignments deal with issues, this paragraph raises. Read through them and make a written response to one or more of them.

1. If criticism is going to help to understand issues, it has to be logical. Without a logical argument, the reader will be neither follow the argument or be swayed by it. Solomon-Godeau presents a logical argument, the reader may disagree with some of her points and conclusions, but it is clearly a well-structured, informed and researched case. Yet, here she seems to be suggesting the reader abandons logic. Can she do this? Does she have to accept that either the notion of cinematic tourism is flawed, because it cannot account for Akerman's work, or it is not and so Akerman's work intrudes, expropriates and is imperialistic?

2. What is 'a truth of appearance'? How does it reveal itself? And how does it do this without 'prodding'? How does this escape the 'binary of inside/out'? In all the examples given, there is always a photographer, someone who selects the angle of view, the subject, the medium etc., and the appearance of the subject will change accordingly (but not necessarily the meaning). Has Solomon-Godeau satisfactorily dealt with these issues?

3. Is there 'a cultural bias that maintains a truth *behind* appearance'? And is the philosophical divide no more than the simple recognition that there is more to everything than what it looks like?

4. It is hard to know what the final sentence of this paragraph means; 'liminal' as a word is not in the Complete Oxford Dictionary of English (like a few other words Solomon-Godeau uses, and she is not the only writer on photography to do this). It may mean, 'on the threshold of conscious', assuming she has made

her own word by taking off the 'sub' from 'subliminal' and ending up with a word close to the Latin *limen* (meaning threshold). Irrespective of the meaning of 'liminal' Solomon-Godeau may be shifting the location of 'inside/outside'. In the context of her essay, it refers to the photographer being on the inside (personally involved with) or outside the subject photographed. In the context of this sentence it now seems to be some sort of (unknown – 'unplotted') relationship between the viewers' mental reaction to the visual and the act of seeing. This is an extremely complex proposition: could it be interpreted as a measure, not to preserve the inside/outside distinction, but to preserve the negative connotations (tourism, intrusion and colonialism) attributed to much photography?

5. Solomon-Godeau feels that Rosler, in her work *The Bowery in two inadequate descriptive systems*, has moved this problem (inside/outside) from the visual to the debate about, or politics of representation, and so avoids mindless consumption. In her work Rosler shows a typical doorway in which a 'wino' would shelter, but does not show the 'wino'. Alongside the photograph Rosler displays a number of words used to describe 'winos'. If, for Rosler, both photographs and words are inadequate descriptive systems, why should two inadequate systems be any more effective than one, and why should the work be any less mindlessly consumed? Consider the following ideas in responding to the question;

 • a single descriptive system is seldom adequate;

 • effective description depends on the quality and appropriate range of systems for a specific audience;

 • Jacob Riis (see Fig. 36), a journalist, and Sebastião Salgado, an economist, worked a century apart, both took up photography because they felt photography would be more effective in encouraging social change than the written word;

 • do you think Rosler will be more effective by moving from the visual to a debate about, or politics of, representation?

6. A.D. Coleman in *Critical Focus* quotes Jim Hughes on W. Eugene Smith ' "Where the accepted approach in photojournalism . . . had been for the photographer to put himself in the reader's place, Gene had found a way to put himself in his subjects' place" ' (p. 61). This quote introduces the reader to another facet of the inside/out debate and suggests that an outsider can see and

work from an insider's perspective. Do you agree and how does this quote relate to Solomon-Godeau's argument?

7. Solomon-Godeau states that the 'truth status' of photography has not done well in the post-modern age. She lists some areas in which photography is still accepted as evidence i.e. ID, the police, judiciary and racetrack, but does not list science, technology and medicine. Is she understating photography's current evidential value, its 'truth status'? In answering this question, consider the following issues raised by the war in Iraq;

- the notion that it was only because there were photographs of the abuse of Iraqi prisoners by US military personnel that any action was taken to deal with the abuse;

- why the US published photographs of Saddam Hussein's sons after they had been killed in battle;

- and why the US government tried to ban the photographing of the coffins of US war dead.

Remember that this is not a question about the rights and wrongs of the war in Iraq, it is about the contemporary 'truth status' of photography so you can use other examples to support your arguments. You should read the summary of Andy Grundberg's essay *The Crisis of the Real* before answering this question.

See questions/discussion points 3 and 4 in the section *America, Seen Through Photographs, Darkly* after the Sontag Summary.

7 Clive Scott, *The Spoken Image: Photography and Language*

CHAPTER ONE: THE NATURE OF PHOTOGRAPHY

Scott starts by using an excerpt from Bioy Casare's novel *The Adventures of a Photographer in La Plata* (1989) to illustrate two different positions in the debate over how much self-expression photography allows the photographer. One position argues that the photograph occurs at exposure, while in contact with the real world and it depends on the photographer's ability to see and anticipate. The photographer does not impose himself on the world but capitalizes on chance. The second argues that exposure is a link between before taking the photograph and afterwards (Scott warns that this distinction is not absolute, for example Ansel Adams used the darkroom to intensify reality and digital photography is undermining the link between the real and photography). The second also argues that the shutter speed is so fast it separates photography from other media, and because of this, speed photography also uses chance. This links photography to Surrealism in that it has chance as a key element in its aesthetic. Scott cites Walter Benjamin, Susan Sontag and Rosalind Krauss in support of this link. He quotes the photographer Edouard Boubat ' "I am surprised by the photos I find. *I* don't make the landscape. It's already there. I'm more surprised because I don't do anything. All you have to do is open you eyes and release the shutter from time to time" ' (p. 18).

In the first approach to photography, the photographer anticipates chance and on the second reacts to it, although photographers need both skills and Scott quotes Guy Le Querrec ' "I would always like to be available: available to be surprised by what I didn't expect and sharp enough to recognize what I expected. Two different kinds of surprise [. . .]. The important thing is to succeed in taking those photos which confirm my feeling about life" ' (p. 18). He also quotes Lartigue as seeking ' "to capture the passing wonderment" ' just as surrealists see magic in the everyday.

There are two different types of photographic seeing; ' ... (1) the eye of the photographer is an SLR camera, the brain the film, so that his camera merely registers what he has already seen ... for example Le Querrec, Cartier-Bresson or Lartigue ... (2) the camera is a different kind of seeing, and the photographer has to learn what its eye will reveal ...' (p. 19). He quotes Walter Benjamin ' "It is a different nature which speaks to the camera than speaks to the eye ..." ' (p. 19).

The camera sees a parallel but overlaid reality; it is the eye of modern technology that we must adopt to be literate. Scott lists the new types of vision attributed to photography by Moholy-Nagy: ' " ... abstract seeing (photogram), exact seeing (reportage), rapid seeing (snapshots), slow seeing (prolonged time exposures), intensified seeing (micro-photography, filter-photography), penetrative seeing (radiography), simultaneous seeing (transparent superimposition) and distorted seeing (optical jokes)" ' (p. 19).

Scott initially gives three things that interfere with photographic seeing, firstly intrusive function, secondly the identification or otherwise of the photographer by the subject and thirdly language.

Intrusive function occurs when photography replaces seeing and he quotes Sontag's example of tourists photographing something and moving on. In doing so they colonise the thing, but these photographs do not relate to the present but to the future when they will be viewed, but paradoxically they still authenticate experience. (See *Memories Are Made Of This*, Fig. 42.)

If the photographer is identifiable, then it is possible for the subject to prevent the photograph being taken, but if the photographer is unidentified there are issues of deceit and voyeurism, and this is particularly problematic in ' ... the highly moral universe of documentary photography ...' (p. 20). Ideally, the photographer wants to be identified and to be totally accepted by the subjects. Scott is sceptical that this can be achieved. Some photographers believe that the interaction between a subject aware of their photograph being taken and the photographer adds value to the image.

The third interfering factor is language. In order to return to the ' ... freshness of vision associated with the pre-conceptual, pre-interpretive, then language must be forcibly stripped away' (p. 20). Scott quotes Paul Theroux's Maude Pratt (*Picture Palace*, 1978) pointing out that words would simply distract from a particular set of photographs, she ends by saying, ' "No one got fat reading about food – he just got hungry" ' (p. 21). Although this seems a strong point, Scott quotes Victor Burgin as warning against the assumption that seeing is somehow separate from the rest of consciousness (which includes the verbal). Scott goes on to point out

that Maude has moved from the photograph as a record to an image in its own right. Despite speaking of language as irrelevant, she still accepts it could stimulate an appetite for the image.

If a photograph is seen as an image in its own right, the self-expression of the photographer plays a role. It is exercised through processes such as framing, shutter speed, film and paper choice etc. as a result the ability of the photographer to express himself is related to his mastery of the processes. This in turn can lead to the linking of self-expression with experimental photography. Scott quotes from *Photographic Tricks Simplified* (1974); in it the authors say there is nothing wrong with realistic photography, but just as painters broke away from realism in the late nineteenth century, so also photographers increasingly want to experiment. The processes (filters, grain, photogram and above etc.) are the photographer's vocabulary that he puts together to create his own language, an idiolect [a form of language particular to that person]. Like any art, photography is not bound to reality and is a resource that can be used in many ways to create a style. This line of thought assumes there is neutral photography; this however, is logically impossible since neutral photography is a choice in itself. It also implies that as documentary photography is not very experimental, it is not so expressive, Scott disagrees concluding, '...the expressivity of a photograph is much more likely to be found in appropriateness of means than in virtuosity' (p. 22).

Paradoxically, the authors of *Photographic Tricks Simplified* link photographic experimentalism with avant-garde painting. It is the modern technology that frees photography from painting, yet this same technology allows photography to be 'painterly'. This suggests that documentary photographers, photojournalists and snap shooters are removed from the spirit of photography. Many of photography's conventions came from art, the camera developed from the drawing aid, the *camera obscura*, many early photographers had been artists and photography took over many of the roles of art (miniature portraiture and realistic records etc.) and used many of the visual 'codes' (rectangular frame, Renaissance perspective etc.) Yet, writers like Benjamin argue against photography trying to claim itself a fine art.

The confusion over the relationship between photography and painting is echoed in the confusion over whether a photograph is coded or not. He quotes Frank Webster as arguing against seeing the photograph as passively referential. Webster argues that it is important to see the photograph as a selected and then an interpreted part of the world. The photographer selects and interprets a scene and so encodes it, and the viewer decodes it by interpreting or reading it. In *Ways of Seeing*, Berger made a similar point, stating, ' "That every image embodies a way of

seeing [...] photographs are not [...] a mechanical record. Every time we look at a photograph, we are aware [...] of the photographer selecting that sight from [...] other possible sights" ' (p. 23).

Ten years later in *Another Way of Telling*, Scott feels that Berger shifts his position a bit moving photography towards the uncoded. Here Berger argues that a photograph can only quote from appearances because it does not have its own language (unlike drawing which can translate). Berger is aligning himself to Barthes' position in *The Photographic Message* (1961). Here Barthes argues that the photograph is full of the subject's codes but has no codes of its own as a medium. Despite this Scott feels that Barthes' later work suggests otherwise. In *Camera Lucida: Reflections on Photography*, Barthes asserts that he is a realist and while a photograph may not have a code '[...] certain codes do inflect our reading of It [...]'. The photograph is not a copy of reality but '[...] an emanation of *past reality*: a *magic*, not an art'. The importance of a photograph is its '[...] evidential force, and that its testimony bears not on the object but on time [...] the power of authentication exceeds the power of representation' (p. 24).

Although Barthes is a semiologist, he wants to accommodate the very strong notion that the power of photographs to 'speak' depends on their direct contact with the subject and so do not need to be coded as part of the common cultural information (Barthes' '*studium*'). Whatever conventions there are in reading a photograph, there still remains directness that cannot be suppressed most notably Barthes' '*punctum*' which is prelinguistic.

Punctum is a refinement of 'trauma' which he explained in *The Photographic Message*. It is the suspension of language and the blocking of meaning when confronted by absolutely traumatic images. These rare images are ' "...wholly dependent on the certainty that the scene "really" happened: *the photographer had to be there*..." ' (p. 24). Scott states that the photographs do not have to be of things like death but can be of any direct reality that is shocking enough to leave the viewer 'speechless'. In Barthes' essay *The Third Meaning: Research Notes on Some Eisentein Stills* (1970), he introduces the notion of 'the obtuse meaning', a signifier without a signified; again, Barthes is trying to establish '...something which resists assimilation by language and which cannot be said to have an objective existence...' (p. 25).

'*Punctum*, trauma, obtuse meaning, all these kinds of experience of the visual relate to our first version of photographic expression, to a direct physical connection, which may ...trigger an involuntary memory... (p. 25). They are reactions specific to the individual viewer; Barthes' *Camera Lucida* revolves around one photograph

of his mother yet he does not reproduce it because no one else will see what he sees in it. He sees the *punctum*, they would only see the *studium*.

Scott sees the confusion about the nature of photography (painterly/non-painterly, coded/uncoded) as stemming from the assigning '... of photography to the semiotic category reserved for painting, the iconic...' (p. 26), and he quotes Katie Wales (*A Dictionary of Stylistics*, London 1989) as someone who does this, speaking of photographs, some map symbols and road signs having various degrees of iconicity depending on how accurate their representation is. For Scott and others, speaking of relative accuracy misses the point that whatever the photograph's codes and conventions are, it is produced directly by reality itself. [In the linguist Ferdinand de Saussure's theory of language, a unit of language, a sign, is composed of two things; the signified, which is a mental component or concept and the signifier, which is a sound-image or written word. For de Saussure there was no natural connection between the two, so different languages will use different words for the same thing.] Scott sees the problem with Wales's explanation stemming from the notion of there being no natural connection between the signified and the signifier. If the signifier is a photograph and not a word then it has been made directly by the subject (referent) and direct connection is established.

Scott points out that Frank Webster in his *The New Photographer* (1980) quotes from Larkin's poem *Lines on a Young Ladies Photograph Album*, from *The Less Deceived*, 1955, which both distinguishes photography from art and asserts the empirical truth of photography, but still Webster concludes ' "Photography is, to adopt the terminology of semiology, an 'iconic' mode of signification" ' (p. 26). Jefferson Hunter in *Image and Word: The Interaction of Twentieth-Century Photographs and Texts* (Cambridge, MA, 1987) also refers to the Larkin poem pointing out that it uses ' "...rhetorical flourishes...to mount a defense against naked feeling and supply a foil for or a contrast to picture taking" ' Scott feels we are left with '...a sense of photography's ability to disempower language...We shall surely have to examine the proposition that because it is framed, past, locked out of continuity, impervious now to any "blind field" (the extension of space and time beyond the photographic frame), the photograph endows its subject with a peculiar sovereignty...the subject enters into possession of the photo...the interested viewer can himself be subjugated...' (pp. 26–27), in Larkin's words ' "From every side you strike at my control" ' (p. 27), Larkin like Barthes comments on the ' "very pastness" ', the ' "that-has-been" ' of photographs, and like Barthes is struck by what seems incidental detail. Barthes also makes it clear that the photograph belongs to the indexical not the iconic as the 'photographic referent' (subject) is not an *optionally*

real thing the image refers to, but the *necessarily* real thing that was in front of the camera for there to be a photograph.

The philosopher C.S. Peirce developed a theory of signs in order to understand language. In his system of semiotics, the index is a sign that has a direct link (causal, sequential or spatial) with its subject, e.g. smoke and fire. However, an icon is a reconstruction that resembles or imitates the subject. This distinction between photography's sign being the index and painting's the icon is fundamental and suggests that the 'happy snapper' is closer to the real function of photography than the few art photographers whose work is hung in galleries. Seeing a photograph as in index brings it closer to the first version of photography, the taking as opposed to the second version, the production of the image.

The notion of authenticity re-enforces the argument for the indexical character of photography. In the relationship between (a) the subject, (b) the camera and (c) the photographer, '... the guarantee of authenticity lies between (a) and (b)' (p. 28). In the relationship between (a) the subject, (b) the painting and (c) the painter, authenticity is between (b) and (c). In photography faking lies between (a) and (b), in painting a fake lies between (b) and (c), whereas in a photographic print an exact copy between (b) a negative and (c) would not be a fake but would be authentic.

Scott uses a quote by Baudelaire from 1859 to illustrate a second difference between photography and painting; its inability to represent history. Baudelaire criticizes photographers for trying to set up and photograph scenes from history. Scott gives, as an example, Rejlander's *Two Ways of Life*; while it may work allegorically it is totally unconvincing as a documentary image. He points out that Rejlander's follower Henry Peach Robinson rejected historical photography. Scott concludes 'Photography, because of the presentness of its referent, can only be history, it cannot represent it ... it can represent the anachronistic, but it cannot be anachronistic' (p. 29).

A third difference is the instantaneous nature of the shutter release. Once the shutter has been released, there is very little the 'pre-digital' photographer can do alter the image '... and even then the photograph is an unavoidable given' (p. 29). The instant rules out the ongoing, and is responsible for the photographer's relationship to chance or encourages them to develop the skills that capitalize on chance. Because it is instantaneous, the indexical photograph is likely to be spontaneous and so reveals the photographers' subjectivity. The snapshot only has value because it is '... embedded in a specific instant of history ...', specific because the photographer had the irresistible need to photograph it; '... the *sign* of the photographer's inner need to express his subject'. This instantaneousness is also

responsible for what Benjamin calls the 'optical unconscious'. One justification for photography is that it makes things that we do not normally see visible, from an expression on face to the mechanics of movement and it is instantaneity that '... is the key to this visible but unseen (unseeable) world' (p. 29).

Through convenience and habit, our vision generalises and summarises, but the camera forces us to look, without discrimination, at everything. This is true despite the fact that some early paper-printed forms of photography failed to capture all the details (Delacroix commented favourably 'rests' for the eye in his 'Journal', 1 September 1859) and P.H. Emerson (1856–1936) made them a key component in his theories on photography as an art. Even modern commentators '... pay much attention to the process of selection and abstraction' (p. 30). Scott argues that the fourth feature unique to the camera (but not the photographer) is 'unselective seeing', detail included for neither aesthetic, expressive nor didactic reasons and it is this detail that leads to *punctum* and shows how frank the photograph's contact with reality was.

The fifth difference between photography and painting is photography's 'inbuilt amateurism', exemplified by the 1880s Kodak slogan 'You Press the Button. We Do the Rest', which promoted its box camera. Scott feels it would be going too far to suggest that the painter acquires skills and the photographer does not, but photography's peculiar relationship with chance means that an amateur can photograph in a more meaningful way than he can paint. Scott quotes Barthes who states that unlike other arts in photography it is not the professional who is closest to photography's *noeme* (meaning), but the amateur.

Scott returns to the notion of authenticity citing Phillipe Dubois. Authenticity in art is determined by originality, stylistic idiom, authorship and signature. In photography, it is determined by 'attestation (bearing witness to the existence of what is photographed)... designation (photographs point things out without affirming anything about them); singularity (the photographs referent is unique and happens only once – it can be reproduced but not repeated)' (p. 31). Because of these characteristics, Dubois asserts that in the first instance the photograph's meaning is pragmatic rather than semantic, '... its primary sense is its reference...' (p. 31). As further support for the notion that photography is more indexical than iconic, that its function is to say something happened rather to say what it means, Scott gives the example of family and holiday snapshots; those who took them would argue that their photographs are not substitutes for memory, but aids to remembering.

Scott sees the exclusively visual relationship as a kind of modern illness and the photograph has significance as 'taking'. 'Voyeurism is looking through the camera,

through a frame, through a window, isolating and fetishizing, breaking down responsibilities connected with the *continuity* of experience and one's *own visibility*; the camera, one comes to believe, conceals the photographer' (p. 31). In the nineteenth century, Baudelaire criticized the popularity of the pornographic stereoscope, and Scott sees the stereoscope as the perfect example of photography's voyeurism '... a piece of equipment which allows the viewer to isolate and insulate himself, to seem to manipulate the visible' (p. 32); he quotes from Tournier's *Erl-King* as further support for the notion that photography brings '... about the possession of what is photographed ...' (p. 32) and that whereas the painter works openly the photographer is insular.

Despite the evidence, Scott feels that simply to classify painting as iconic and photography as indexical is inadequate. Dubois sees photography being classified as indexical as indicative of a change of critical emphasis that moved from regarding photography as a mirror of the real, then to seeing it as transformation of the real, and finally to a trace of the real. For Scott, an account of photography is needed that accommodates both of the versions of photography he outlined at the beginning of the chapter. This account would see photography both as indexical and iconic in the following ways:

1. from the beginning, the photograph has a large 'dose' of the iconic, the photographer maximizes decisions about lenses, films, filters, proximity etc. before exposure, so minimizing chance. This results in the photograph reflecting a set of judgments made in front of reality before the exposure;

2. every photograph becomes an image and moves from the indexical to the iconic, but also remains indexical. This entails the change of status of the photograph between the negative and the print (irrespective of the changes made during printing; paper, chemicals etc.) and later (mounting and circulation etc.). The assumption is that the negative is the real photograph and the print is a version, a 'meta-photo'. Scott quotes from Tournier's *The Erl-King*, ' "A photographic image, which is indisputably an emanation of reality, is at the same time consubstantial with my fantasies and on a level with my imaginary universe." ' (p. 33);

3. photography as history, the older a photograph is the less able we are to say under what circumstances the photograph was taken, and so it fills a representative role. All that remains of their indexicality is *punctum*, but at the same time their *studium* (educative and cultural value etc.) increases. All photographs become, with time, documentary.

Scott lists the changes a photograph undergoes '... by being turned from a snapshot into an image, by becoming a signifier, now with a signified as well as a referent...' (p. 34).

(a) It gains cultural independence and can be a sign by itself.

(b) It is now subject to language. At the indexical stage, language can give information about the photograph's taking, but not about its meaning. At the indexical stage descriptive language is tautologous: 'This is a cow by a windmill'. However identification may needed: 'This is my mother, and that is my uncle'. As the photograph is now an image that is in circulation, questions of what and why must be answered. 'Language is now called upon not only to identify, but to explain, justify, give shape to the viewer's attention, indicate the level at which it is to be apprehended (indexical, iconic, symbolic)' (p. 35). At this level it is not tautologous and so no longer indexical. Its cultural independence means, however, that as a part of a cultural system, it is bound by that system's codes.

(c) The photograph not only denotes but has connotations, has both a signified and a referent, is coded and uncoded.

(d) Self-expression is not simply contact but now becomes style. Authenticity moves towards the photographer. However, many argue that photographic style is not really achievable. Scott quotes Sontag who points out that although a series of photographs on a particular subject by a photographer may have an identifiable style, when the photographer moves to a different subject, it is hard to recognise the photographer's style. She gives as an example Atget's photographs of trees as opposed to those of shop windows. In support of this notion, Scott quotes Michael Freeman who says of Lord Snowdon that he is a '... notable photographer not... constricted by a particular style' (p. 36). The photographic image has 'pretensions' to style because of its painterly techniques, but only language that can give a photograph intention and he quotes Benjamin ' "... Will not captions become the essential component of pictures?" ' (p. 36). Scott points out that photographers' work has ended up in galleries and museums based on the language of painting, indicating how hard it is to find a language appropriate to photography.

(e) The image moves from the instantaneous to the moment (even if the photograph is of an instant). Scott describes the instantaneous experience of time and perception as 'digital' and the moment as 'analogue'. The digital experience is '... the smallest division of psychological or perceptual time...'; it is so limited that it excludes us from an ongoing event. In the analogue experience, moments

are experienced in relation to each other giving them metonymic and metaphorical qualities, allowing the moment to be expanded both in time and space, and giving a greater subjective presence. Scott relates these to Benjamin's notions of the *Erlebnis* (where the ' "shock factor" ' of certain impressions are so great that the consciousness assigns the experience ' "…to a precise point in time in consciousness at the cost of the integrity of its contents." ') (p. 37), and *Erfahrung* (where the experience is admitted and 'digested over time'. The moving of the photograph from the indexical to the iconic frees it from the instant, the *Erlebnis*, to a generalised and more fruitful *Erfahrung*). Scott uses the following table to summarise:

Indexical	*Iconic*
Past reality	Present use
Non-painterly	Painterly
Uncoded	Coded
Erlebnis	*Erfahrung*
Instant	Moment
Punctum (trauma, obtuse meaning)	*Studium*
Prelinguistic	Linguistic

(f) 'The viewer's awareness of or need for, the 'blind field' is much reduced and may even be eradicated' (p. 34).

(g) The notion of authenticity becomes more difficult because of (d) and the functions it performs.

(h) Photographs change from being '… substitute realities to which we respond.' To '… the way we represent things … to ourselves …' (p. 34), i.e. images. To illustrate this point, Scott cites the Vietnam War. Thinking of it photographically, certain images have been 'sifted out by time' and represent 'our corporate sense of the war…' (p. 38). Irrespective of other photographs the individual thinks of, they think of the following: Nguyen Kong Ut's napalmed girl (1972), Tim Page's and/or Phillip Jones Griffiths's weeping boy with his dead sister in the back of a truck (1968), Ron Haeberle's group of My Lai villagers prior to being shot (1968), Don McCullin's dead North Vietnamese soldier lying next to a photograph of his wife or girlfriend, and Eddie Adams's Saigon Chief of Police summarily executing a Vietcong prisoner. Scott is concerned that the photographer may try to '…anticipate this process and, where reportage is concerned, engage in one of two "impure" forms of picture-taking: either the photographer is already thinking of the photograph as an image made rather than taken, so that aesthetic awareness ousts social/moral responsibilities;

or the photographer already chooses events, scenes, which he considers representative: again the indexical immediacy of reactive contact is sacrificed to a view with an ulterior motive, a view which wishes to shape or predict our perception of history...This latter observation should not, however, be allowed to disqualify photographers from pursuing their own agendas...' (p. 38).

(i) As a snapshot, a photograph has features no other art has, on becoming an image it starts to share features with painting on the iconic level; however its differences, technical and generic, are crucially important. On the technical level both are framed, but photography's frame comes from the viewing system, not the canvas, it does not guarantee 'compositional values' (p. 39), and as it is placed *'on* reality' the viewer is aware of a ' "blind field" '. Both use monochrome and colour as different 'languages', which they use in different ways. In painting, monochrome is '...often associated with the fantasies and memories of the psyche (as in the work of Max Klinger and Odilon Redon), allowing for the graphic exploitation of blank space, while colour promotes the sense of natural harmony and extroversion, with filled space' (p. 39). Monochrome in photography is linked to truth, stylisation, a tonal language peculiar to photography and self-expressivity, while colour is associated with pleasure, vulgarity, distraction, emotion and accessibility. Portraiture involves posing in both photography and painting, but in photography the subject suffers a unique 'psychological apprehension' waiting for the instant the photograph is taken. Related to this is the smile, it is a convention, it has no emotional implications and is designed to ease apprehension. In a painting it has emotional meaning. On the generic level, although photography shares painting's genre, it increases the number of subdivisions within each genre. Scott gives as an example the nude in photography, which includes the following subdivisions; pornographic (Braquehais); documentary (Bellocq); psychological (Brandt); distorted (Kertész); portrait (Lindberg); fashion (Newton); biomorphic (Lategan) and the art nude.

Peirce has three semiotic categories: the indexical, the iconic and the symbolic. As pointed out earlier, the indexical has a direct link to the subject, like smoke to fire, the icon resembles the subject and the symbol is only linked by convention, like a word. The symbol is essentially the same as de Saussure's signified in that their relationship to the subject is arbitrary and they need to be interpreted [de Saussure's signs are *dyads* in that they only have two components, the signified and the signifier, Peirce's are *triadic* having three components]. 'The symbolic code is the code of language, and the more the visual becomes involved in the language system ... the more deeply it will be carried into the semantic (not "What is it?" but "What does it mean?" and towards the abstract' (p. 40).

To illustrate the above, Scott uses a photograph by John Parsons of Jane Morris taken in 1865 and used by the pre-Raphaelite artist Rossetti to make a symbolic chalk drawing *Pandora* in 1869. On the level of index the photograph shows Morris leaning against a marquee pole in 1869. Her hands, in particular the protective thumb, and the crumpling of her dresses folds are the 'traumatic' features. On the iconic level her '...hunched shoulders, clasped hands and down-tilted head suggest sorrow, apprehension, secrecy' (p. 40). It is also at this level that compositional features become a factor establishing the photograph as an image: the diagonal lines that bear down on her head, the marquee's poles which contrast with her curved posture, her looking away from the shadow. The analysis is beginning to deal with the symbolic. 'Why are her hands clasped in this way? What is the connection between her hands and her expression and posture? Why is she turned to the light and to free space, the exit?' (p. 41). Rossetti's drawing connects and resolves these questions. Morris's real and symbolic meaning, which the photograph cannot express, but that language, because it can translate, interpret and abstract, can express, is that Morris gives form to Pandora (Zeus's revenge on Prometheus). 'But the photograph gives us a new view of that myth...not the image of flattery and guile, but an unwilling instrument, herself a victim of the evils she brings and which she tries to conceal and restrain...The symbol delivers the index-become-icon further into the hands of language, which draws the innocence of vision into the deviousness of association' (p. 42).

Scott takes the three categories of sign; index, icon and symbol and lists which genres of photography tend to belong to which category. Under index, he places photojournalism, documentary, portrait, photogram, pornography and the family snap; under icon, fashion, nude, photo-story and landscape; under symbol, allegory, photomontage and advertising. All the index genres can move towards being icons and all the symbol genres can move towards being iconic. The iconic genre's fashion and photo-story can move to either of the other signs while nude and landscape can only move to being indexical.

The classification is a bit crude, but does reveal certain trends. Many iconic genre '...unavoidably hark back to the indexical; the nude, for example, is to be seen as pornography transcended or sublimated. Even in the symbolic stratum, the indexical continues to exert its pull; much advertising photography, for example, is perceived as a fiction...an invitation to fantasy. And yet...the photograph does have a referent to be found in the shops' (p. 42). In order to link with the indexical, these adverts often include an insert of some description of a 'straight' photograph of the product, perfume adverts being typical of this approach. All uses of photography in this context rely on the authenticity of the indexical. 'Even the persuasive force of a photomontage, which as a photographic construct cannot in any sense be related

to an initial "taking", depends to some extent on photography's innate power to attest, bear witness and reveal' (p. 43).

Scott looks at Willy Ronis's photograph *La Peniche aux enfants, sur la Seine* to illustrate '... how our relationship with it shifts from the indexical through the iconic to the symbolic' (p. 43). The photograph shows a view looking down on four barges being towed around a bend on the river Seine. The first barge, which dominates the image, is empty, apart from two children running and playing deep within it and some washing hanging on a line. In the distance is a bridge and the river bank on which people are standing looking at the barges. The boat pulling the barges is already beneath them, but they cannot see the children. The photograph gives a visual jolt as we see a water-borne street or backyard and a sense of the instantaneous through the running child and the churning water. Through the high camera angle, the viewer sees the river and the quays, unlike the children whose restricted view explains their playful self-engrossment. This leads to a second jolt, our sense of both the physical and psychological distance between the spectators on the quay and the children. Because of the high camera angle, we are in the picture space and oversee the image giving us a degree of 'parentality' over the children. The lone item of washing at the bottom of the image is another possible source of *punctum*.

ASSIGNMENTS/DISCUSSION POINTS

1. Scott lists the new types of vision Moholy-Nagy attributes to photography: '... abstract seeing (photogram), exact seeing (reportage), rapid seeing (snapshots), slow seeing (prolonged time exposures), intensified seeing (micro-photography, filter-photography), penetrative seeing (radiography), simultaneous seeing (trans-parent superimposition) and distorted seeing (optical jokes)' (p. 19). Take a series of photographs exploring these types of vision (as you are unlikely to have the equipment for penetrative seeing, ignore it or try infrared photography which can penetrate 3 mm into the skin). You may find the assignment more of a challenge if you restrict yourself to one subject matter across all the types of vision. In a written evaluation of your work explain how the results are different from human vision and how other photographers in different fields of photography have used these approaches.

2. Ideally, the photographer wants to be identified and to be totally accepted by the subjects. However, if the photographer is identifiable then it is possible for the subject to prevent the photograph being taken and if the photographer is unidentified there are issues of deceit and voyeurism, and this is particularly

problematic in '...the highly moral universe of documentary photography...' (p. 20). Scott is sceptical that this identifiable acceptability can be achieved. Two contemporary photographers who, it could be argued, have achieved this are Nan Goldin and Richard Billingham. Look at their work and describe its characteristics. Compare their work with W. Eugene Smith's *Minamata; A Warning to the World* (1975). Do any or all of these photographers achieve Scott's ideal, and if so how have they managed it? If you wish you may refer to Solomon-Godeau's essay *Inside/Out*.

3. Scott explains that the 'index' is a sign that has a causal relationship between the sign and object or signifier and signified. This relationship is '...causal, sequential or spatial...Just as the finger actually, physically, points to its object, so smoke is an index of fire, a weathercock of wind direction, slurred speech of drunkenness' (p. 27). Produce a set of photographs (themselves indexes) that explore the notion of the index and icon.

4. Scott suggests, '...those hordes of happy snappers represent photography's real function much better than the few art photographers whose work ends up in galleries' (p. 28). Explore this notion in relation to Henri Cartier-Bresson's work (as an example of a candid photographer) and Cindy Sherman's pre-1980 work (as an example of something set up for the gallery).

5. Scott makes a case for reportage being indexical in the first instance pointing out that time sifts out those images that express our corporate sense of events and that the photographer should not '...anticipate this process and, where reportage is concerned, engage in one of two "impure" forms of picture-taking: either the photographer is already thinking of the photograph as an image made rather than taken, so that aesthetic awareness ousts social/moral responsibilities; or the photographer already chooses events, scenes, which he considers representative: again the indexical immediacy of reactive contact is sacrificed to a view with an ulterior motive, a view which wishes to shape or predict our perception of history...This latter observation should not, however, be allowed to disqualify photographers from pursuing their own agendas...' (p. 38). Do you think it is possible for the photographer to avoid these 'impure' practices or even try to? Photograph an event without any preconceived ideas as to what you should photograph. Print a set of images from the shoot. Evaluate your work not only from an aesthetic point of view but also in terms of how 'truthfully' they represent the event.

6. Scott points out the differences between photography and painting in the way monochrome and colour are used; both use monochrome and colour as

'languages' which they use in different ways. In painting monochrome is '... often associated with the fantasies and memories of the psyche (as in the work of Max Klinger and Odilon Redon), allowing for the graphic exploitation of blank space, while colour promotes the sense of natural harmony and extroversion, with filled space' (p. 39). Scott continues by saying that monochrome in photography is linked to truth, stylisation, a tonal language peculiar to photography and self-expressivity while colour is associated with pleasure, vulgarity, distraction, emotion and accessibility. Find examples of both photographs and paintings that support Scott's claim, justifying your selection. Take a series of photographs that either confirm or contradict Scott's claim. Raghubir Singh deals extensively with this issue in *River of Colour*.

7. Scott argues that the smile is different in photographed and painted portraits; in a photographic portrait the smile is a convention, has no emotional implications and is designed to ease apprehension. In a painting it has emotional meaning. Select a number of photographs that illustrate Scott's point and give an evaluation of them. Then try to find several photographic portraits that do not conform to Scott's stereotype and evaluate these. See if you can determine any factors that would result in the portraits being in one group or the other. Take one or more photographs to illustrate each group. You may wish to refer to the section *He Who Is Photographed* in Roland Barthes' *Camera Lucida* as part of your research for this assignment.

8. Scott argues that on the generic level, although photography shares painting's genre, it increases the number of subdivisions within each genre. Scott gives as an example the nude in photography, which includes the following subdivisions; pornographic (Braquehais); documentary (Bellocq); psychological (Brandt); distorted (Kertész); portrait (Lindberg); fashion (Newton); biomorphic (Lategan) and the art nude. He also gives examples in portraiture; the serial portrait (Rodchenko); close-up (Cameron); vortographic (Coburn); solarized (Man Ray); mechanical and literal (Futurist photography) and family snapshots. Can a case be made that painting has similar sub-divisions, or do you agree with Scott? Your response does not have to be based on the two genres given, it could, for example, be based on landscape or still life. Take a series of photographs within of a genre of your choice, but which show distinct subdivisions within that genre.

9. Scott takes the three categories of sign, index, icon and symbol, and lists which genres of photography tend to belong to which category. Under index he places photojournalism, documentary, portrait, photogram, pornography and the family snap; under icon; fashion, nude, photo-story and landscape; under symbol, allegory, photomontage and advertising. All the index genres can move

towards being icons and all the symbol genres can move towards being iconic. The iconic genres fashion and photo-story can move to either of the other signs while nude and landscape can only move to being indexical. Find a series of photographs that clearly illustrate Scott's classification and photocopy or scan them. Your selection should include examples of photographs that clearly belong to a single sign and examples of photographs that move over to another sign. See if you can find any photographs that seem to conflict with Scott's classification. Justify your selection. Take a photograph to illustrate one genre in each of the categories. If pornography is inappropriate to your level of study, exclude it.

8 Andy Grundberg, *The Crisis of the Real*

Grundberg notes that the notion of post-modernism is confusing and poses a number of questions. What is post-modernist art? How does it relate to photography as it has been conventionally seen, by the photo-historian Beaumont Newhall for example? Why is it so unsettling?

Numerous definitions of post-modernism have been suggested and all probably contain a degree of truth. Grundberg asks, 'Is it a method, like the practice of using images that already exist? Is it an attitude, like irony? Is it an ideology, like Marxism?' (p. 1). Or a plot by a group of artists, dealers, and critics to undermine the art establishment and enrich themselves? He goes on to say that he wants to show that it is more than simply a demonstration of some intellectuals' theories and is 'a reflection of our times'.

The first problem in trying to define post-modernism is that it means different things in different artistic media. As a term it was first used in architecture and was used to describe architecture produced as a reaction to the stark glass and concrete structures of modern architecture. The new style was very eclectic, taking and using a wide range of old and new styles. Grundberg quotes the architectural critic Charles Jencks ' "It is evidently an architecture of inclusion which takes the multiplicity of demands seriously: ornament, colour, representational sculpture, urban morphology – and more purely architectural demands such as structure, space and light" ' (p. 2).

Post-modernism in dance is very different from that of architecture. Modern dance is heroic and expressionistic, post-modern dance reacts against this and is more vernacular [ordinary], it '...eliminated narrative, reduced decoration, and purged illusion...', it in fact became like modern architecture. In music and literature, the same thing has happened and each art form has produced its distinct post-modernism.

The roots of post-modernism in photography can be traced back to the 1970s
when painting and sculpture branched off into a multitude of different directions.
Many felt that modernism had run its course, that minimalism was uninteresting
and that conceptualism lacked visual strength '...its goal being to avoid producing
still more art "objects"...'. One consequence of this pluralism was that artists
began using photography and photography was drawn into the broader art world.
However, some of the new practices were clearly incompatible with what was seen
as modernism's reductionism and its underlying principles. For some, the critic
David Crimp for example, post-modernism is not simply what comes after
modernism, but is '...an attack on modernism, an undercutting of its basic
assumptions about the role of art in culture and about the role of the artist in
relation to his or her art'. The philosopher Jacques Derrida coined the term
'deconstruction' to describe this sort of undercutting. It is based on a philosophical
theory of perception linked to structuralism.

Structuralism is an early twentieth century theory of language developed by
Ferdinand de Saussure and is closely related to semiotics, a theory of signs developed
at about the same time by Charles S. Peirce. These theories hold that things, texts
and images etc. do not have meanings in themselves; they need to be decoded to
understand their deeper structure.

In simple terms, everything is divided into two, the 'signifier' and the 'signified'.
Grundberg gives the example of the Morse code '...the dots are the signifiers, and
the letters of the alphabet the signified...' (p. 4). However, the signifier is an
arbitrary result of social practice. As a result '...structuralism in practice ignores
the "meaning," or the signified part of the sign, and concentrates on the relations
of the signifiers...In a sense the obvious meaning is irrelevant...' (p. 4).

Grundberg quotes from Terry Eagleton's book *Literary Theory: An Introduction*.
In which Eagleton points out firstly; that structuralism is indifferent to the quality of
the work; secondly, that it is contrary to common sense in that it '...does not take
the text at face value, but "displaces" it into a quite different kind of object' (p. 4),
and thirdly if the contents of the text are replaceable, the structure could be said to
be the content.

For Grundberg, structuralism is like sociology, a pseudo-science that tries to find
a rational and scientific basis for the actions of people. He, and Eagleton, also find
structuralism part of another historical process, that of replacing the obvious with
the obscure. They feel this started with Copernicus who said the earth revolved around
the sun when everyone could see the sun revolved around the earth. Marx who
argued that social processes occurred independently of individuals who followed this.
Freud then claimed that meanings of words and actions could not be understood

by the conscious mind. Structuralism, like these theories sees a gap between reality and our experience of it. Derrida takes post-structuralism further. Our perceptions do not tell us about the world, they simply tell us about themselves. Grundberg quotes Eagleton's summary of Derrida:

"Nothing is ever fully present in signs: it is an illusion for me to believe that I can ever be fully present to you in what I say and write, because to use signs at all entails that my meaning is always somehow dispersed, divided and never quite at one with itself. Not only meaning, indeed, but me: since language is something I am made out of, rather than merely a convenient tool I use, the whole idea that I am a stable unified entity must also be a fiction... It is not that I can have a pure, unblemished meaning, intention or experience which then gets distorted and refracted by the flawed medium of language; because language is the very air I breath, I can never have a pure, unblemished meaning or experience at all" (p. 5).

For Grundberg, the impossibility of having 'pure, unblemished meaning or experience at all' is the basis of post-modern art, as well as most contemporary photography and this is the crisis that photography and art face.

Given this theoretical basis of post-modernism, how is it recognised in art? At first, in the 1970s, its pluralist phase, it looked like anything except modernism, in fact it was so diverse it could even look modernist. This led to the rejection of pluralism, because although it pointed to the absence of a dominant style, it did not indicate the presence of anything.

Post-modernist critics rooted in structuralism mostly saw post-modernism as in opposition to either the modern tradition and/or to the dominant 'myths' of Western culture that they felt led to the creation of the modern tradition. They argued that post-modernism '... must debunk or "deconstruct" the "myths" of the autonomous individual ("the myth of the author") and of the individual subject ("myth of originality")' (p. 5). The critics, however, disagree on how this is to be done.

One approach is to mix media, so attacking the modernist concern for being true to the medium. One of the results of this has been to raise the status of photography within the arts. Another approach, advocated by Rosalind Krauss for example, argues that the media does not matter as long as the work is determined by 'a set of cultural terms' (p. 6).

One of the styles associated with post-modernism is pastiche. It is used neither to honour past work nor to parody it; Frederic Jameson describes it as ' "[...] blank parody, parody that has lost its sense of humor..." ' (p. 6). Grundberg says of it

that it '...can also be understood as a peculiar form of mimicry in which a simultaneous process of masking and unmasking occurs' (p. 6).

As an example of this process, Grundberg cites Walter Robinson's painting *Revenge* (1982). It looks like an image from a romance magazine showing a stereotypical, negligee-clad femme fatale painted in an illustrative way. By wearing this tacky mask, it neither mocks nor praises this type of image, but rather shows how this stereotypical view is inadequate and inconsistent.

Grundberg's second example is a portrait by Thomas Lawson, *Battered to Death* (1981). The almost photo-realist painting is based on a newspaper photograph. The 'blandly quizzical child's face' is totally at odds with the tile, and this is the point of the painting, it wears a mask of banality which is broken by the new meaning given by the title, as it would have been when originally published in the newspaper. It '...speaks to the separation between style and meaning, image text, object and intention...In...donning a mask it unmasks...it deconstructs' (p. 7).

Although these paintings are self-conscious, it is not a self-consciousness of the artist but one that promotes the awareness of our culture being camera-based, and this is an essential feature of post-modernist photography. Cindy Sherman's *Untitled Film Stills* are a good example of post-modern photography. Although she photographs herself, she masks herself by photographing herself as a stereotypical woman as depicted in films of the 1950s. Thus, she questions the notion of personal identity, 'woman-as-depicted object' and cultural stereotypes. 'Hers are perfectly post-structuralist portraits, for they admit to the ultimate unknowableness of the "I". They challenge the essential assumption of a discrete, identifiable, recognizable author' (p. 8).

Eileen Cowan also uses herself in her photographs and does another type of unmasking. At times she appears in the photographs with her identical twin sister. The viewer sees them as the same person so unmasking the conventions of interpersonal behaviour, making the viewer uncomfortably aware of the difference between how we see ourselves and how others see us.

Like Sherman and Cowin, Laurie Simmons creates surrogates and deals with the notion of masking and unmasking. She, however, uses dollhouse figures and environments to unmask the suburban social conventions of the 1960s and the conventions of their representation.

Richard Prince is a photographer who makes us aware of the process of unmasking. His art, that of 'rephotography' consists of photographing photographs from magazines and cropping them as he wishes. In doing so he aims to unmask the syntax or structure of the language of advertising photography, his work also

implies that the image world is exhausted as he sees no need to go out and take new photographs of the world. Grundberg quotes two passages from Prince's book '*Why I Go to the Movies Alone*'. The characters simply called 'he' and 'they' find it difficult to relate to people '. . . who passed themselves off as an example or a version of life put together from reasonable matter . . .'. And how they felt that '. . . painting was something they associated with a way to put things together that seemed to them pretty much taken care of'. They were, however, impressed with photographs of Jackson Pollock and liked hang them next to famous people from a range different spheres of life '. . . and what measurements or speculations that used to separate their value could now be done away with . . .' (p. 10).

Prince's use of other people's photographs is a characteristic of post-modernism and is called appropriation. Sherrie Levine uses appropriation in a far more controversial way. She simply photographs a reproduction of a famous image and claims it as her own. This is neither conceived as an affront to the creators of the originals or as test of the freedom of expression. It is a blunt statement about the limited nature of the visual world. Like Prince she feels it is dishonest to claim that there is still new material waiting to be photographed by photographers claiming to be original. In fact there are too many such photographs already. Added to this is the fact that any photographer going out to photograph goes out with culture bound preconceptions of what can be found. The resulting photographs just confirm these preconceptions.

For all post-modern artists, how images relate to other images and the context of images determines their meaning. Louise Lawler exploits this belief in her work by photographing groups of photographs arranged by her or by others, or by making installations of groups of pictures, so encouraging the viewer to explore their relationships.

James Welling appropriates by inference. His photographs of crumpled aluminium foil or of flakes of dough look like archetype modernist abstract photographs from the Equivalent school, which try to show some aspect of emotion. Welling's photographs '. . . offer the viewer the promise of insight but at the same time reveal nothing but the inconsequence of the materials with which they are made' (p. 11).

These post-modern artists do not necessarily see themselves as photographers nor do they have an affinity with the tradition of art photography. They use photography for a number of reasons. It is clearly reproducible; it is the common way of reproducing images of any medium; and of all the mediums, it is the one that least clearly indicates its author, and so is particularly suited to the post-structuralists who question the very notion of authorship. These artists have been shaped theoretically by post Second World War American art theory and

practically by conceptual art. They are also strongly influenced by all aspects of the mass media.

However photography's interest in '...pastiche, appropriation, questions of mass-media representation...' etc. pre-date the advent of post-modernism, for example Robert Heinecken's re-photographing of magazine images in *Are You Real?* from 1966. To understand the relationship between these early examples and post-modern photography generated by the art world, Grundberg feels he needs to define photography's modernism to see its '...inherent strain of post-modernism' (p. 13).

Modernists felt that photography's realism and truthfulness separated it from the other visual arts making it unique, they also argued that each art form should exploit its own strengths, they therefore had a strong notion of the 'photographic'. There were two strands that formed this modernism in America: Alfred Stieglitz's purism and Laszlo Moholy-Nagy's formal European experimentalism. These two strands 'developed and coalesced' during the twentieth century to form photography's claim to be a modern art, and in the 1970s, just as it was being recognised as such, things changed. As formalism collapsed in art a wide range of artists, from Ed Ruscha to David Hockney, who were not part of this modernist photographic movement started using photography and were gaining widespread recognition for what they were doing. Suddenly 'photographic-ness' was no longer an issue and the way was open for post-modernism.

Grundberg, however, sees the start of a post-modernist attitude in the American modernist photography of Walker Evans. Grundberg praises Evans '...as a documentarian...as a "straight" photographer of considerable formal intelligence and resourcefulness...' (p. 14), as an outstanding modern photographer. In the 1930s he made extensive use of signs, billboards, posters etc. and other photographs in his work (see Figs 40 and 41). It has been argued that these images are there to make the viewer aware the photograph is a '...two-dimensional, cropped-from-a-larger-context...' image (p. 14). They are also signs in both a literal sense and in the post-modernist sense that they show how far-reaching culturally loaded images are. '...Evans shows us that even in the dirt-poor South, images of Hollywood glamour and consumer pleasures – images designed to create desire – were omnipresent' (p. 14).

Grundberg sees Evans as using photography as a semiotic medium in the way he uses and orders the images in *American Photographs*, he tries to create a text with the photographs. By looking, or reading the book page after page this body of signs symbolically describes, in a political way, '...American experience as no other photographs had done before' (p. 15).

Robert Frank in his book *The Americans* conceived of '... imagery as a text – as a sign system capable of signification' (p. 15). He used the car and the road as metaphors of American culture, showing this culture as pessimistically as do post-modernists.

This pessimism and belief that the photograph can be a social sign continues with their successors. Some consider Lee Friedlander's work as a formalist, yet it mostly consists of a critique on the way we see. 'In his picture *Mount Rushmore*, we find an amazingly compact commentary on the role of images in the late twentieth century. Natural site has become accultrated sight. Man has carved the mountain in his own image. The tourists look at it through the intervention of lenses, like the photographer himself. The scene appears only as a reflection, mirroring or doubling the condition of photographic appearances, and it is framed, cropped by the windows, just like a photograph' (p. 15).

Grundberg feels that despite the photograph being taken in 1969, before people connected photography to post-modernism, it '... functions critically in a post-modernist sense' (p. 15). It does this by showing how '... our image of reality is made up of images' (p. 15).

Another photographer, also considered modernist, John Pfahl, also makes the post-modernist point that it is not possible to have a pure experience of nature that has not distorted by what we have seen before. For example, his *Moonrise over Pie Pan* (1977) from his series *Altered Landscapes* makes reference to Ansel Adams's *Moonrise over Hernandez*.

In photography, like other art forms there is a great deal of evidence that post-modernism thinking was present in these art forms' modernist phases. Grundberg feels this refutes the critic Douglas Crimp's assertion that post-modernism is a clean break with modernism and those institutions associated with it. Grundberg goes on to quote the French philosopher Jean-Francois Lyotard from his book *The Postmodern Condition: A Report on Knowledge* who concludes that post-modernism is not the end of modernism, but the on going birth of new types of modernism.

Post-modernism sees problems in the relationship between art and culture, yet it itself is problematic. It claims to be in opposition to the art market, yet thrives in the market place. It claims it is not possible to critically analyse culture from a neutral outside position, yet attempts to critique from the inside. It regards the avant-garde as a modernist myth, yet operates as an avant-garde. Its strong links to linguistic theory results in it placing a greater value on intellectual rather than visual analysis, yet many artists are attracted to it. It has caused very intense reactions suggesting that it not simply arts latest fashion.

Many people are both hostile and defensive about post-modernism, Grundberg suggests this may be because it has been presented as such a clean break with the traditions of art these people value. He feels, however, that this presentation is artificial and that we need to accept its evolution from modernism but retain its criticality.

Grundberg suggests that instead of defining post-modernism in terms of style and intention, it should be defined in terms of how the world is conceived.

Grundberg sums up. 'Postmodernist art accepts the world as an endless hall of mirrors, a place where images constitute what we *are*, as in Cindy Sherman's world, and where images constitute all of what we *know*, as in Richard Prince's universe. There is no...authenticity of experience,...sanctity of the individual artist's vision,...genius, or originality...things have been used up,...we are all prisoners of what we see' (p. 17). And photography with its almost indiscriminate production of images is to a large extent responsible for these disconcerting theories.

ASSIGNMENTS/DISCUSSION POINTS

1. Many post-modernists saw post-modernism in opposition to either the modern tradition and/or to the dominant 'myths' of Western culture that they felt led to the creation of the modern tradition. They argued that post-modernism rejects or 'deconstructs' the 'myths' of the author and of originality. One approach to do this is to mix media, so attacking the modernist concern for being true to the medium. Create an image that uses mixed media to undermine these 'myths' or any 'myths' you feel pertain to your culture or society.

2. Sherrie Levine uses appropriation in a very controversial way. She simply photographs a reproduction of a famous image and claims it as her own. As her images can reveal no more than a reproduction you can see in a book, is there any point in seeing a Levine photograph? If not, is there any point in her taking the photograph in the first place? One photographer whose work she has appropriated is Edward Weston. He exploited the technical capabilities of photography to the fullest to give maximum impact to his images. No reproduction can match the tonal range and detail of one of his original prints let alone a reproduction of a reproduction. Given this, has Levine actually appropriated Weston's work? You have been offered either a Weston vintage print or a Levine appropriation of the same image. The condition of the offer is that you can gain no financial advantage through your choice; you just get to keep the image until your death. Whose work would you choose and why?

Examine Levine's appropriation in terms of the issues raised above and any others you wish to consider.

3. Are John Heartfield (see Fig. 34), Bertolt Brecht (see Fig. 33) and Barbara Kruger part of the same tradition, and if so is the inclusion of Kruger in post-modern photography accurate? Is Rosler's *The Bowery in two inadequate descriptive systems* part of this tradition or is it concerned with issues that make it distinct and post-modern? (See Solomon-Godeau's *Playing in the Fields of the Image* in *Photography at the Dock*.)

4. Is any interpretation of photography that excludes other approaches, be it pictorialism, modernism, post-modernism etc. conservative and reactionary in that it tries to set out for all individuals what they should or should not be doing? If so, how does one determine that an image, or body of work is good?

5. It seems possible to find precedents for almost all photographic work, no matter how radical or contemporary critics and/or photographers/artists claim the work is. For example, Heartfield appropriated work and incorporated text in his images and Walker Evans was photographing signs and the use of images from mass media long before post-modernism was even a concept. In 1874, the art establishment rejected impressionism, but in turn found itself rejected as the art world embraced changes. Since then western art has gone through numerous major changes. Just as the art establishment in the 1870s was rigidly stuck in a formulaic way of doing and seeing things, could it be argued that contemporary art/photography is being stifled by having to meet the formula of always being new?

6. Despite the advent of post-modernism, there are still aspects of life that will be photographed in order to be better understood. For example, to reveal the greatest detail of a subject (scientific or otherwise) it will be photographed. The same could be said for the understanding of objects in relationship to time, for example a deciduous tree over the seasons. Does photography have a unique relationship to these and other concepts and as a result a special relationship to 'truth' that make it particularly appropriate for scientists and others as a means of understanding?

7. A post-modernist is knocked off his bicycle and is rushed to hospital. He is in some pain and a bit disorientated and has no say in the hospital's decision to X-ray his head and arm. On regaining his senses he is told that the X-ray shows that his arm is broken. Does he believe them?

8. One line of argument in post-modernism is that there is no point in trying to photograph anything new as everything has already been photographed, and that in any case the photographer would only photograph what society conditions them to photograph. Shore says of himself that when he makes photographs, his perceptions are fed into his mental model that is then altered to accommodate them and this in turn alters his photographic decisions, which alters his perceptions. It is an ongoing, self-modifying process. Make a case for one of these opposing views. As part of your research, look at Richard Misrach's book *Golden Gate* and discuss to what extent it does or does not undermine the post-modernist position.

9. Post-modernist photographers and critics suggest that there is no point to having a modernist approach to photography that it has no value nowadays. In music there are many genres, for example blues, jazz, traditional folk, contemporary folk, rock etc. Nobody would suggest that any of these music forms are inferior to any other and artists within each genre regularly perform their own interpretations of earlier work or produce new work in the style of their chosen genre. If this diversity of approaches is acceptable to musicians, their critics and audience, is there something peculiar to photography that makes such diversity unacceptable, or is this not a valid comparison?

Grundberg gives a fairly positive account of post-modernism, however as a philosophical position it is very controversial. For a well argued and very sceptical view of post-modernism read 'Post-modernism Disrobed' in Richard Dawkins' book *A Devil's Chaplain*.

9 Raghubir Singh, *River of Colour*

INTRODUCTION TO *RIVER OF COLOUR*

Raghubir Singh is regarded as one of the key Indian photographers of the twentieth century, this essay was written a year before his untimely death in 1999 and is the introduction to a retrospective of his work. As a photographer of international standing who knew many of the leading Western photographers of his time, he was well placed to comment on the differences between Indian photography and Western photography.

Singh starts by quoting from Sri Aurobindo's *The Foundations of Indian Culture* 'There is that universal beauty which is seen by the inner eye [...]... but different races or individual consciousnesses form different standards of aesthetic harmony' (p. 9). He goes on to point out that colour has always been a force in India and is '...of the continuum of life itself' (p. 9). This is to such an extent that Western term 'colourist' does not exist in Indian artistic vocabulary. He states that Indians know colour through intuition and Westerners do so through the mind.

Had Indians invented photography the theoretical and artistic problems seen by Western photographers concerning colour would never have arisen. While acknowledging there is a new generation of western photographers using colour, Singh cites Henri Cartier-Bresson, Walker Evans and André Kertész as influential photographers who '...preferred the distancing quality in black and white images to the emotional plunge resident in colour pictures' (p. 9). Indian artists did not see in black and white before colonialism and photography. Their tradition of drawing was unlike the Western one and was filled with colour. He gives as examples Moghul and Rajput art and says of the great seventeenth century drawing *Inyat Khan Dying* that it '...does not have the dark mood or the light and shade of European masterpieces'. The scarcity of such Indian drawings suggests their secondary nature.

Singh states that the Judeo-Christian world has always seen colour through a series of theories and only with Chagall did Judaism have a sense of colour. He quotes

Kenneth Clark from his book *Civilisation*, who, when writing about Turner, says that because colour has an immediate effect independent ' "[...] of those ordered memories which are the basis of morality" ', it was regarded as immoral. Singh cites John Gage's *Colour and Culture* as devoting '...a whole section to the moral theory of colour from Aristotle to Kandinsky'. He also quotes Charles A. Riley II from *Color Codes* as saying that colour is a source of anxiety and an unknown force and that artists such as Brice Marden, Frank Stella and Jasper Johns were uneasy about using it.

In contrast '...Indians have always intuitively seen and controlled colour' (p. 9). In the nine *Rasas*, which guide classical Indian aesthetics, colour is an integral part of freeing '...the human imagination...from earthly bondage and [is] attached to a flight of fantasy, interlocking the magical, the marvellous and the mystical' (p. 10). This aesthetic permeates all Indian culture. To make the 'psychological-cum-pictorial' differences clear, Singh compares a seventeenth-century painting from the *Padshahnama* showing the gruesome murder of Khan Jahan Lodi set against flowers and 'a paradise-like green' with David's *The Death of Marat*.

Singh sees 'angst, alienation and guilt' as significant aspects of Western twentieth-century vision where people are alone in the universe without God, and this is best expressed in monochrome. This is alien to India's buoyant life and philosophy in which the cycle of rebirth is fundamental and colour is a 'deep inner source'. 'The fundamental condition of the West is one of guilt, linked to death...', which is bound to black. India's epic literature has only brief vision of hell 'the river of blood of the *Mahabharata*', otherwise the Indian view of life is full of optimism, sparkle, illusion, pictorialism and with a spirit of community. 'This is the essence, the *Rasa*, of India's pictorial spirit – an essence which the artist cannot ignore'. Nor can the artist ignore the idea of *darshan* (sacred light) '...a way of seeing that encompasses the sensuality of touch...human contact and intimacy'. *Darshan* does not encompass black and it is taboo for over 850 million Indians. Only India's Islamic and tribal worlds consider it not to be so.

Despite Indians admiring Western black and white arts, Indian photographers '...cannot produce the angst and alienation...of...photographers such as Brassaï, Bill Brandt, Robert Frank and Diane Arbus. Psychological empathy with black is alien to India'. The low-life characters of Stendhal and Dostoevsky could inspire Brassaï's *Paris de Nuit* and *The Secret Paris*, but not an Indian photographer.

The most successful use of black and white in India is when a full tonal range is used to transpose all colours as in Henri Cartier-Bresson's photographs and as a psychological metaphor for colours in Satyajit Ray's films. With few exceptions even Ray's saddest films have a sense of optimism. Death is not depicted with the

'...dark vision related to the abjections of life...' found in Western work. Singh quotes Ray in explaining the difference ' "Violence in our country somehow gathers a debasing quality...In the West, experience of violence can have [...an] ennobling quality. [...] There is also the overburdening Christian sense of guilt. [...] I can't imagine any Indian raising evil to the level of a work of art, as say, Bunuel does" ' (p. 10).

Singh points out how in his home in Jaipur colour was an integral part of the culture, for example in song and in relating clothing and food to the seasons. Even when celebrating the Diwali festival on the darkest night of the year, dark colours, rather than black were worn and these '...sparkled with tiny tinsels...' (p. 11). White is the colour of mourning and the colour of life as it is receptive to all colours and before the influence of the British academic style, it was an important aspect of Indian painting. White's use can be traced back to the eighth-century AD where it was used on the exterior surfaces of the Kailas temples at Ellora and Kanchipuram to evoke the snows of the Hindus' and Buddhists' sacred mountain.

The Europeans used the steamship, train, telegraph and camera as instruments of colonialism. The camera destroyed Indian miniature painting. The vibrant Kotah style was one of the last, dying out at the end of the nineteenth century. In visual arts, only the folk tradition survived. However in Bengal some Indian photographers began imposing an Indian aesthetic on the photograph by richly hand colouring them in a way unlike that of other cultures, so re-introducing miniature painting and being a precursor to contemporary Indian colour photography.

The British colonists created a class of English-speaking Indians to help them rule and introduced a new visual language '...the art school style of South Kensington...Under these new conditions the Indian photographer became a craftsman-artist who looked at life through an imported instrument, with a new kind of sight, but did not have the confidence to create his own kind of language' (p. 11). This was unlike the situation in Japan where its culture could relate to reportage through woodcuts and to modernist inventions in perspective and fragmentation through Zen and haiku minimalism. All the Indian photographer could borrow from his own culture was hand colouring and flat perspective from miniature painting, and even these had no future because there was no place for a personal language under colonialism.

British landscape photographers like Samuel Bourne came to India with the heritage of the painters Poussin, Lorraine and Ruisdael; architectural photographers like John Murray and Linnaeus Tripe exploited India's strong

sunlight through the West's tradition of light and shade developed in drawing and engraving. This grand period of British photography ended with the arrival of the hand-held camera. Just as paint in tubes enabled the Impressionist painters to leave the studio, the photographer left the constraints of the tripod for rapidity related to drawing. Again there was no cultural precedent for the Indian photographer. Compounding the problem was the need for individuality, which runs counter to Hindu culture as Ananda Coomaraswamy explained in *The Dance of Siva*.

Colonialism both ended many artistic traditions and introduced new concepts; an assertive *I* replaced the passive *we*; the Indian artist ceased to be anonymous; a landscape tradition; light and shade; chiaroscuro; the street as a subject; bold frontal, as opposed to elliptical portraits; a 'democratic' audience for art through galleries and museums.

After Indian independence, patronage moved to nationalists whose power Satyajit Ray resisted. Some nationalists still condemn borrowing from the West, as though photography were uniquely Indian. Singh quotes from Rabindranath Tagore's essay *The Meaning of Art* ' "The sign of greatness in great geniuses is their enormous capacity for borrowing... only mediocrities are ashamed and afraid of borrowing for they do not know how to pay back the debt in their own coin... our artists were never tiresomely reminded of the obvious fact that they were Indians... they had the freedom to be naturally Indian in spite of all the borrowings that they indulged in" '.

Singh points out that he has borrowed from the West and from 'independent-minded Bengal', the first place to attempt to fuse '... modern arts with the centrifugal force of India that has forever sustained the land'. Referring to this force, Tagore wrote in Satyajit Ray's diary that despite travelling widely he had not found the ' "... time to take a few steps from my home, to look at a single dewdrop, on a single blade of grass" ' (p. 12). Unlike the British colonial photographers, Singh writes that he has photographed the dewdrop that mirrors the geography, ecology, morals, art and culture of India. At the same time he immersed himself in the history of photography, which is 'wholly Western'. However, because he has always photographed his country he has been '... carried by the flow of the inner river of India's life and culture' (p. 13).

Singh says that he built up his chromatic eye by borrowing a lot from Cartier-Bresson and other '... masters of the miniature camera. And yet, by intuition, I distanced myself from the angst, the alienation, and the guilt of recent nihilistic photography in the West' (p. 13). Cartier-Bresson's photographs of India's independence were different from those by earlier photographers because his photographs had what

Satyajit Ray calls ' "palpable humanism" ', so he was the first artist–photographer to photograph Indians as individuals.

For Singh, Cartier-Bresson's first visit to India, was similar to Delacroix's visit to Morocco and was the most successful. Both artists were escaping Parisian bourgeois society. Delacroix found Morocco full of ' "readymade pictures" – a phrase that evokes the pictorialism of India'. Singh relates some of Cartier-Bresson's Indian photographs directly to particular Delacroix Moroccan paintings. Cartier-Bresson's image of men exercising at Kurukshetra has the same sense of movement as Delacroix's *The Aissaouas*. After the 1930s, Cartier-Bresson '...worked with a deep knowledge of Masaccio and other masters...', his praying devotees at Tiruvannamalai '...parallels Masaccio's murals in the Brancacci Chaplel in the Santa Maria del Carmine in Florence' (p. 13). Matisse and other Western artists were indebted to Delacroix for his visual link between East and West, and Asian photographers are indebted to Cartier-Bresson for connecting European pictorialism and Asia's pictorial life. Singh classifies Cartier-Bresson's work as 'modernist-pictorial' and although encouraged by Cartier-Bresson, Indian photographers had to find their own way using a Western instrument but adapting its tradition to Indian aesthetics. The West no longer values beauty, spirituality and humanism, yet these are key aspects of India's heritage.

Singh was first inspired by Cartier-Bresson while at high school when he found, at home, a copy of Cartier-Bresson's book, *Beautiful Jaipur* (1949). The Magnum photojournalist, Marilyn Silverstone introduced Singh to Cartier-Bresson in 1966, and Singh was impressed by '...his quick fire intuition attached to a clarity of eye and a surety of stance' (p. 13). Rather than describe him as a photojournalist, Singh describes him as 'an original'. Singh went to live in Paris a decade later, and despite knowing Cartier-Bresson did not like colour photography, took copies of his first two books to give to him. Cartier-Bresson gave them a cursory glance and pushed them towards his wife, the photographer Martine Franck. This reaction and a fear of failure made Singh redo the books.

Despite borrowing things from the West such as the camera, concepts such as Marxism, and street photography (from Kertész to Winogrand), Singh sees standards as being based on vision alone and this is determined by one's own culture. For this reason, it is futile for the Indian photographer to attempt to bond '...to the Eurocentric Western cannon of photography, in which the contemporary concepts of morality and guilt push aside the idea of beauty. Beauty, nature, humanism and spirituality are the four cornerstones of the continuous culture of India' (p. 14). Cartier-Bresson expressed these values by 'intuitively' distancing himself from the

Western cannon. The Indian photographer is immersed in these four cornerstones and is culturally distinct. By adapting the modernist canon to beauty, nature, humanism and spirituality, the Indian photographer needs to avoid the sentimentality modernism sees in these values. Indians have the same instinctive reaction to these values as they have to colour. These concepts are important in the epics, the *Ramayana* and the *Mahabharata*, which have no contemporary Western equivalent, '...what makes India different is its great and ancient bond with religion' (p. 14). Singh quotes Rabindranath Tagore ' "the real India is larger than Hindu-India, its real art is greater than Hindu art" '. He attributes the failure of modernism in India to its non-selective attempt at absorbing Western modernism's philosophical foundations. Selection is needed because '...in true art the entities of language, life and philosophy are inseparable...That is why only geniuses like Satyajit Ray could successfully...take what they want from the modern, yet at the same time "Indianize" their...output' (p. 14).

Singh refers to two champions of modernism; he quotes Ezra Pound ' "Make It New!" ' and points out that T.S. Eliot's poem *The Love Song of J. Alfred Prufock* anticipates alienated territory exploited by modernist street photographers like Robert Frank. 'Prufock compares the evening sky to a patient upon a surgery table...[and] goes on to sing of half-deserted streets, one-night cheap hotels, sawdust restaurants and the butt-ends of his days'. Photographic modernism became a force with Stieglitz, Strand and Weston, and when the Surrealists endorsed Atget's 'intuitive modernism'. After this, modernist photography moved in different directions, one led to Walker Evans, Bill Brandt and Robert Frank.

Another photographer in the tradition of Eliot and Evans is Lee Friedlander 'the master modernist'. Twice he travelled in India with Singh, but Singh writes that the beauty of India meant little to him. When confronted with the mesmerising sight of a dust storm, instead of soaking it up he, as a 'self-conscious modernist', wondered what Atget would have done. Friedlander's favourite place in India is Calcutta...with its intense and sometimes wounded life...Lee told me in the tradition of Baudelaire's ragpicker and Breton's secondhand stores: "I like to collect junk, through my photographs" '. Singh's subject '...is never beauty as seen in abjection, but the lyric poetry inherent in the life of India: the high range of colouratura of everyday India. Those delicious...high and low notes...do not exist in the Western world' (p. 15).

Modernism's offshoot, post-modernism, with amongst other things, its distain of religion sits in opposition to India's values that are based on spirituality. The Indian photographer will borrow more from modernism than post-modernism, in particular adapting the notions of democracy and '...the colouratura of the

human setting' (p. 15). The tradition of Duchamp's urinal, George Bataille, Gilbert and George, Ingmar Bergman, Don DeLillo and others with their concerns with excreta, bodily functions, dirt and rubbish is not considered worthy of 'aesthetic meditation' in India. The Indian mind looks inward, inspired by the Hindu and Jain mandalas, while the Western mind follows Leonardo da Vinci's *Study of Human Proportion in the Manner of Vitruvius* analysing bodily functions.

Indians understand the philosophic roots of Western art but '. . . the pulse of India's richly textured and vibrantly coloured life beats to the rhythm of a dynamically different drum' (p. 15). For Singh, a Nataraja, the bronze sculptures showing Siva's cosmic dance, '. . . rises over religion and becomes a universal entity through high art'. (p. 15). The Nataraja's timelessness transfixed Rodin. It takes time to craft this timelessness and unlike the West, this sense of craft still exists in Asia. Indians should respect Rodin's maxim ' "what you do with time, time respects" '.

Singh feels that India can add other dimensions to photographic modernism's Eurocentricity and he gives the examples of Ray, Ghatak, Mizoguchi and Ozu in film. They never aimed to enter Hollywood, yet had a significant impact on the medium. Likewise R.K. Narayan and V.S. Naipaul had a similar impact on literature. Singh list artists from many cultures who are having this type of impact; the Iranian humanist filmmaker Abbas Kiarostami; the Chilean installation artist Alfredo Jarr with his political eye; the Chinese calligrapher Gu Wenda; from Pakistan Shazia Sikander reworking Indian miniature painting; the Indian sculptor Ravindra Reddy; the portrait photographer Seydo Keita from Mali; and the Cambodian photographer Nhem Ein. Western modernism will be broadened through multiculturalism and globalisation. Victor H. Mair in his book, *Painting and Performance*, points out that even before Alexander the Great's invasion of India, Indian-painted storytelling scrolls had reached Europe and Japan inspiring the narrative visual arts in those places. In Singh's native Rajasthan, he can still hear the bards sing their sad songs before their colourful scrolls, songs that have no 'hint of a dark vision'.

Key to Singh's development as a photographer was Calcutta, the home of Satyajit Ray and writer R.P. Gupta. These Bengalis made him understand that the modern arts are connected to the human condition, and it was Bengal where the novel took root leading to the humanism of Indian cinema and photography. Singh has been based in Hong Kong, Paris, London and New York, but his photography has remained Indian. He says of his work that within '. . . the tension of the frame lines, there is the buoyant spirit of Kotah painting . . . the archers oneness with the subject

to which Ananda Coomaraswamy has suggested an Indian outlook, in quoting...from the *Bhagvata Purana*: "I have learned concentration from the maker of arrows."...I have looked at the densely Indian characters of R.K. Narayan...at the acute analysis of today's India in the prose of V.S. Naipaul, and of yesterday's India in the prose of Nirad C. Chaudhuri...at the pictorialism and bazaar energy of Salman Rushdie's fiction...the Thames-side pictorialism pitched by Anish Kapoor...the sky and sunsplashed pictorialism raised by Charles Correa, the Indian architect. And I put within my frame lines a sense of Jawaharlal Nehru's *The Discovery of India*' (p. 17).

ASSIGNMENTS/DISCUSSION POINTS

1. Many leading Western photographers have photographed India, for example Henri Cartier-Bresson, Margaret Bourke-White, Werner Bischof, Don McCullin and Mary Ellen Mark. Look at their work and compare it with Singh's.

2. Don McCullin first photographed India as a photojournalist. He has since retuned to photograph it on a more personal level and published this later work in his book India. Compare this work with his earlier work and consider whether you would think Singh would regard the work from either period as giving a real sense of what India is like.

3. Singh writes that colour is key to understanding Indian culture. If you feel the same is true of your culture take a series of photographs to illustrate this or, if within your community there is an ethnic group for which you feel colour plays an important role, take a series of photographs to illustrate an aspect of their lives.

4. Photograph the same theme twice, once in colour and once in monochrome (if you have access to two cameras you can photograph in both mediums simultaneously). Try to produce about the same number of final images in each medium. Evaluate your results.

5. Photograph something you think naturally lends itself to monochrome but photograph it in colour (or vice versa). Evaluate your results and consider whether photographing in the 'wrong' medium revealed things you may have otherwise have overlooked.

6. Martin Parr and Richard Billingham are contemporary Westerners who use colour photography to document aspects of their culture. Evaluate the work of

one or both photographers in terms of Singh's essay. See the colour section for examples of the work of all three photographers.

7. Singh makes a strong case for 'Indian' photography, however national cultures may be harder to define than he suggests. For example, he feels Indian photography should be in colour or at least suggest the full range of colours if monochrome is used. However he points out that the Muslims and tribal Indians do not have the same attitude to black that the Hindus do. Sebastião Salgado is Brazilian and has photographed extensively in his own country and around the world, however he seems to be treated as a Western photographer rather than non-Western one. This could be due to a number of factors, his social class, his education, the ease with which he fits into Western society, his ability to play the Western system to achieve his goals or the fact that he looks European and his home language is Portuguese. In the Americas, Australia and New Zealand colonialisation assimilated or to a large extent destroyed the indigenous cultures; however, in South America in particular, significant communities of the original indigenous people survive. The descendents of the colonialists can now claim to be 'indigenous' yet the two, or possibly more 'indigenous' cultures will be different. Tibet is part of China, yet has a culture very distinct from China's and, with the Chinese pressures on Tibetan culture, Tibet's culture may be easier found in exile communities in India. A country like China will not only have regional cultural differences but overlaying these will be a traditional pre-revolutionary culture, a post-revolutionary communist culture and now a type of capitalist culture. In Southern Africa, there is a significant indigenous minority white population who are culturally quite distinct from the various black cultures. If, for political reasons a person is forced to leave their homeland and take the citizenship of another country can they still be regarded as nationals of their original homeland? Look at your own country and try to define its national characteristics. Are there minority or ethnic groups that would be outside these characteristics and, if so, can these then really be regarded as national characteristics? Take two sets of photographs, one showing stereotyped national characteristics and the second a broader non-stereotypical view. Or photograph, with their approval, a minority ethnic group (as part of your research look at Josef Koudelka's *Gypsies* or *Exiles*).

8. Martin Chambi and Sebastião Salgado are both South American photographers. Chambi, a Peruvian of Native American descent and Salgado, a Brazilian of settler decent. Both have photographed their native countries. To what extent do you think their work represents their respective cultures?

9. Ernest Cole (deceased), Peter Magubane, David Goldblatt and
 Obie Oberholzer are prominent South African photographers from
 different ethnic backgrounds. Look at their work, to what extent do you
 think it is particularly South African and does their work reveal a different
 cultural/ethnic background?

10 Bertrand Russell, *Appearance and Reality*

THE PROBLEMS OF PHILOSOPHY

Bertrand Russell was one of twentieth century's leading philosophers, and according to him the problem of 'appearance and reality' is a longstanding philosophical problem [predating the invention of photography]. This is a summary of the first chapter of Russell's book *The Problems of Philosophy*.

Appearance and reality

Russell starts by asking the philosophical question '... is there any knowledge ... so certain that no reasonable man could doubt it?' In seeking certainty, we can start with '... our present experiences, and in some sense ... knowledge is to be derived from them' (p. 2). Russell points out that his immediate experiences suggest that he is sitting in a chair at a desk of a certain shape that if he turns his head he can see, out of the window, the sun which he believes is ninety-three million miles away and due to the earth's rotation rises daily and will do this indefinitely. He also believes that if any normal person were to come into the room they would see the same. This seems so evident that there is no need to state it. However, all of this may be reasonably doubted.

Russell says of the table 'To the eye it is oblong, brown, and shiny, to the touch it is smooth, cool and hard; when I tap it, it gives out a wooden sound.' It is a description anybody else seeing, feeling or hearing the table will agree with. If we try to be precise problems arise. We believe the table is 'really' the same colour all over, however the parts reflecting light look brighter than other parts and may even look white. When we move, this distribution of colours changes. As no two people can see from exactly the same point of view at the same time, no two (or more) people can see the same distribution of colours at the same time. The painter unlearns the commonsense habit of seeing things as they 'really' are and learns to see them as they appear. This distinction between what things are and seem to be is problematic in philosophy.

Returning to the table, Russell points out that there is no '*the* colour' of the table or even part of it, the point of view changes the colour and there is no reason to favour any one of them. Even from a single point of view, the colour will change for example depending on the light source or colour blindness, and in the dark it has no colour although touch and sound are unaffected. In ordinary circumstances '*the* colour' refers to what '…a normal spectator from an ordinary point of view under usual conditions of light' sees (p. 2). 'But the colours which appear under other conditions have just as good a right to be considered real' (pp. 2, 3). Therefore we cannot say the table has a particular colour.

Texture poses similar problems. We can see the grain but the table looks smooth, however through a microscope there are hills and troughs. We might say what the microscope shows is more real, but a more powerful microscope will show something different and why should we trust the microscope if we do not trust the naked eye?

The shape fares no better. We all judge the 'real' shape of things but when trying to draw them we realise that things look different from every point of view. Our table never looks rectangular, although we construct the 'real' table from what we see '…here again the senses seem not to give us the truth about the table itself, but only the appearance of the table.' (p. 3).

The sense of touch also has difficulties. The sensation of hardness will depend on how hard we press and which part of the body we press with. Touch therefore '…cannot be supposed to reveal *directly* any definite property of the table, but at most to be *signs* of some property which perhaps *causes* all the sensations…' (p. 3). The same applies to sound. So '… the real table…is not the same as what we immediately experience…' (p. 3), we infer it. This raises two difficult questions: '(1) Is there a real table at all?, (2) If so, what sort of object can it be?'

Russell defines the terms he wants to use. 'Sense-data' are things known in sensation, i.e. colours, sounds, hardness, smells etc. 'Sensation' is the experience of being aware of sense-data. If we know anything about the table it is through the sense-data, but '…we cannot say the table *is* the sense-data…', or that sense-data are directly the table's properties. We do not know if there is actually a table, and if there is, what the relation of the sense-data is to it. Russell calls the real table, if it exists, a 'physical object' and the collection of all physical objects 'matter'. He restates the questions '(1) Is there any such thing as matter?, (2) If so, what is its nature?'.

Russell points out that it was Bishop Berkeley (1685–1753) who first showed that it was not absurd to doubt the existence of matter, '…and that if there are things that exist independently of us they cannot be the immediate objects of our sensations' (p. 4).

Matter, for Berkeley, is something opposed to 'mind'. He does not deny that something exists independently of us, but asserts it is mental, not matter. The thing exists when we are not looking at it because it is an idea in the mind of God. Philosophers who, when explaining matter, describe it as a collection of ideas, are called 'idealists'.

Idealists answer 'yes' to question (1) – there is a real table and in reply to (2), say its nature is mental. Most philosophers agree that even though our sense-data depend on us there is a real table and its nature is argued to be anything from an idea in the mind of God to 'a vast collection of electric charges in violent motion' (p. 6).

In the next two chapters Russell argues for the existence of matter and its nature.'

ASSIGNMENTS/DISCUSSION POINTS

One of Russell's last sentences in this chapter is, 'Thus our familiar table, which has roused but the slightest thoughts in us hitherto, has become a problem full of surprising possibilities' (p. 6).

1. Using this summary as a starting point, explore the nature of a table, giving a visual response to Russell's argument. Try not to make this simply a technical exercise, your images should be aesthetically strong. You can use camera movements, shift lenses, darkroom manipulation or digital manipulation to show 'real' shapes etc. if you wish.

2. Does Russell's essay suggest that debates about the 'truth value' of photography are misplaced, and the real debate revolves around the believability of our senses?

11 Italo Calvino, *The Adventures of a Photographer*

When spring comes, the city's inhabitants, by the hundreds of thousands, go out on Sundays with leather cases over their shoulders. And they photograph one another. They come back as happy as hunters with bulging game bags; they spend days waiting, with sweet anxiety, to see the developed pictures (anxiety to which some add the subtle pleasure of alchemistic manipulations in the darkroom, forbidding any intrusion by members of the family, relishing the acid smell that is harsh to the nostrils). It is only when they have the photos before their eyes that they seem to take tangible possession of the day they spent, only then that the mountain stream, the movement of the child with his pail, the glint of the sun on the wife's legs take on the irrevocability of what has been and can no longer be doubted. Everything else can drown in the unreliable shadow of memory.

Seeing a good deal of his friends and colleagues, Antonino Paraggi, a non-photographer, sensed a growing isolation. Every week he discovered that the conversations of those who praise the sensitivity of a filter or discourse on the number of DINs were swelled by the voice of yet another to whom he had confided until yesterday, convinced that they were shared, his sarcastic remarks about an activity that to him seemed so unexciting, so lacking in surprises.

Professionally, Antonino Paraggi occupied an executive position in the distribution department of a production firm, but his real passion was commenting to his friends on current events large and small, unraveling the thread of general causes from the tangle of details; in short, by mental attitude he was a philosopher, and he devoted all his thoroughness to grasping the significance of even the events most remote from his own experience. Now he felt that something in the essence of photographic man was eluding him, the secret appeal that made new adepts continue to join the ranks of the amateurs of the lens, some boasting of the progress of their technical and artistic skill, others, on the contrary, giving all the credit to the efficiency of the camera they had purchased, which was capable (according to them) of producing masterpieces even when operated by inept hands (as they declared their own to be, because wherever pride aimed at magnifying the virtues of mechanical devices,

subjective talent accepted a proportionate humiliation). Antonino Paraggi understood that neither the one nor the other motive of satisfaction was decisive: the secret lay elsewhere.

It must be said that his examination of photography to discover the causes of a private dissatisfaction – as of someone who feels excluded from something – was to a certain extent a trick Antonino played on himself, to avoid having to consider another, more evident, process that was separating him from his friends. What was happening was this: his acquaintances, of his age, were all getting married, one after another, and starting families, while Antonino remained a bachelor. Yet, between the two phenomena there was undoubtedly a connection, inasmuch as the passion for the lens often develops in a natural, virtually physiological way as a secondary effect of fatherhood. One of the first instincts of parents, after they have brought a child into the world, is to photograph it. Given the speed of growth, it becomes necessary to photograph the child often, because nothing is more fleeting and unmemorable than a six-month-old infant, soon deleted and replaced by one of eight months, and then one of a year; and all the perfection that, to the eyes of parents, a child of three may have reached cannot prevent its being destroyed by that of the four-year-old. The photograph album remains the only place where all these fleeting perfections are saved and juxtaposed, each aspiring to an incomparable absoluteness of its own. In the passion of new parents for framing their offspring in the sights to reduce them to the immobility of black-and-white or a full-colour slide, the non-photographer and non-procreator Antonino saw chiefly a phase in the race towards madness lurking in that black instrument. But his reflections on the iconography-family-madness nexus were summary and reticent: otherwise he would have realised that the person actually running the greatest risk was himself, the bachelor.

In the circle of Antonino's friends, it was customary to spend the weekend out of town, in a group, following a tradition that for many of them dated back to their student days and that had been extended to include their girl friends, then their wives and their children, as well as wet nurses and governesses, and in some cases in-laws and new acquaintances of both sexes. But since the continuity of their habits, their getting together, had never lapsed, Antonino could pretend that nothing had changed with the passage of the years and that they were still the band of young men and women of the old days, rather than a conglomerate of families in which he remained the only surviving bachelor.

More and more often, on these excursions to the sea or the mountains, when it came time for the family group or the multi-family picture, an outsider was asked to lend a hand, a passer-by perhaps, willing to press the button of the camera already focused and aimed in the desired direction. In these cases, Antonino couldn't refuse

his services: he would take the camera from the hands of a father or a mother, who would then run to assume his or her place in the second row, sticking his head forward between two other heads, or crouching among the little ones; and Antonino, concentrating all his strength in the finger destined for this use, would press.
The first times, an awkward stiffening of his arm would make the lens veer to capture the masts of ships or the spires of steeples, or to decapitate grandparents, uncles, and aunts. He was accused of doing this on purpose, reproached for making a joke in poor taste. It wasn't true: his intention was to lend the use of his finger as docile instrument of the collective wish, but also to exploit his temporary position of privilege to admonish both photographers and their subjects as to the significance of their actions. As soon as the pad of his finger reached the desired condition of detachment from the rest of his person and personality, he was free to communicate his theories in well-reasoned discourse, framing at the same time well-composed little groups. (A few accidental successes had sufficed to give him nonchalance and assurance with viewfinders and light meters.)

'... Because once you've begun', he would preach, 'there is no reason why you should stop. The line between the reality that is photographed because it seems beautiful to us and the reality that seems beautiful because it has been photographed is very narrow. If you take a picture of Pierluca because he's building a sand castle, there is no reason not to take his picture while he's crying because the castle has collapsed, and then while the nurse consoles him by helping him find a sea shell in the sand. The minute you start saying something, 'Ah, how beautiful! We must photograph it!' you are already close to the view of the person who thinks that everything that is not photographed is lost, as if it had never existed, and that therefore, in order really to live, you must photograph as much as you can, and to photograph as much as you can you must either live in the most photographable way possible, or else consider photographable every moment of your life.
The first course leads to stupidity; the second to madness'.

'You're the one who's mad and stupid', his friends would say to him, 'and a pain in the ass, into the bargain'.

'For the person who wants to capture everything that passes before his eyes', Antonino would explain, even if nobody was listening to him any more, 'the only coherent way to act is to snap at least one picture a minute, from the instant he opens his eyes in the morning to when he goes to sleep. This is the only way that the rolls of exposed film will represent a faithful diary of our days, with nothing left out. If I were to start taking pictures, I'd see this thing through, even if it meant losing my mind. But the rest of you still insist on making a choice. What sort of choice? A choice in the idyllic sense, apologetic, consolatory, at peace with nature, the

fatherland, the family. Your choice isn't only photographic; it is a choice of life, which leads you to exclude dramatic conflicts, the knots of contradiction, the great tensions of will, passion, aversion. So you think you are saving yourselves from madness, but you are falling into mediocrity, into hebetude'.

A girl named Bice, someone's ex-sister-in-law, and another named Lydia, someone else's ex-secretary, asked him to please to take a snapshot of them while they were playing ball among the waves. He consented, but since in the meanwhile he had worked out a theory in opposition to snapshots, he dutifully expressed it to the two friends:

'What drives you two girls to cut from the mobile continuum of your day these temporal slices, the thickness of a second? Tossing the ball back and forth, you are living in the present, but the moment the scansion of the frames is insinuated between your acts it is no longer the pleasure of the game that motivates you but, rather, that of seeing yourselves again in the future, of rediscovering yourselves in twenty years' time, on a piece of yellowed cardboard (yellowed emotionally, even if modern printing procedures will preserve it unchanged). The taste for the spontaneous, natural, lifelike snapshot kills spontaneity, drives away the present. Photographed reality immediately takes on a nostalgic character, of joy fled on the wings of time, a commemorative quality, even if the picture was taken the day before yesterday. And the life that you live in order to photograph it is already, at the outset, a commemoration of itself. To believe that the snapshot is more *true* than the posed portrait is a prejudice . . .'.

So saying, Antonino darted around the two girls in the water, to focus on the movements of their game and cut out of the picture the dazzling glints of the sun on the water. In a scuffle for the ball, Bice, flinging herself on the other girl, who was submerged, was snapped with her behind in close-up, flying over the waves. Antonino, so as not to lose this angle, had flung himself back in the water while holding up the camera, nearly drowning.

'They all came out well, and this one's stupendous', they commented a few days later, snatching the proofs from each other. They had arranged to meet at the photography shop. 'You're good; you must take some more of us'.

Antonino had reached the conclusion that it was necessary to return to posed subjects, in attitudes denoting their social position and their character, as in the nineteenth century. His antiphotographic polemic could be fought only from within the black box, setting one kind of photography against another.

'I'd like to have one of those old box cameras', he said to his girl friends, 'the kind you put on a tripod. Do you think it's still possible to find one?'

'Hmm, maybe at some junk shop . . .'.

'Let's go see'.

The girls found it amusing to hunt for this curious object; together they ransacked flea markets, interrogated old street photographers, followed them to their lairs. In those cemeteries of objects no longer serviceable lay wooden columns, screens, backdrops with faded landscapes; everything that suggested an old photographer's studio, Antonino bought. In the end he managed to get hold of a box camera, with a bulb to squeeze. It seemed in perfect working order. Antonino also bought an assortment of plates. With the girls helping him, he set up the studio in a room of his apartment, all fitted out with old-fashioned equipment, except for two modern spotlights.

Now he was content. 'This is where to start', he explained to the girls. 'In the way our grandparents assumed a pose, in the convention that decided how groups were to be arranged, there was a social meaning, a custom, a taste, a culture. An official photograph, or one of a marriage or a family or a school group, conveyed how serious and important each role or institution was, but also how far they were all false or forced, authoritarian, hierarchical. This is the point: to make explicit the relationship with the world that each of us bears within himself, and which today we tend to hide, to make unconscious, believing that in this way it disappears, whereas . . .'

'Who do you want to have pose for you?'

'You two come tomorrow, and I'll begin by taking some pictures of you in the way I mean'.

'Say, what's in the back of your mind?' Lydia asked, suddenly suspicious. Only now, as the studio was all set up, did she see that everything about it had a sinister, threatening air. 'If you think we're going to come and be your models, you're dreaming!'

Bice giggled with her, but the next day she came back to Antonino's apartment, alone.

She was wearing a white linen dress with colored embroidery on the edges of the sleeves and pockets. Her hair was parted and gathered over her temples. She laughed, a bit slyly, bending her head to one side. As he let her in, Antonino studied her manner – a bit coy, a bit ironic – to discover what were the traits that defined her true character.

He made her sit in a big armchair, and stuck his head under the black cloth that came with his camera. It was one of those boxes whose rear wall was of glass,

where the image is reflected as if already on the plate, ghostly, a bit milky, deprived of every link with space and time. To Antonino it was as if he had never seen Bice before. She had a docility in her somewhat heavy way of lowering her eyelids, of stretching her neck forward, that promised something hidden, as her smile seemed to hide behind the very act of smiling.

'There. Like that. No, head a bit farther; raise your eyes. No, lower them'. Antonino was pursuing, within that box, something of Bice that all at once seemed most precious to him, absolute.

'Now you're casting a shadow; move into the light. No, it was better before'.

There were many possible photographs of Bice and many Bices impossible to photograph, but what he was seeking was the unique photograph that would contain both the former and the latter.

'I can't get you', his voice emerged, stifled and complaining from beneath the black hood, 'I can't get you any more; I can't manage to get you'.

He freed himself from the cloth and straightened up again. He was going about it all wrong. That expression, that accent, that secret he seemed on the very point of capturing in her face, was something that drew him into the quicksands of moods, humours, psychology: he, too, was one of those who pursue life as it flees, a hunter of the unattainable, like the takers of snapshots.

He had to follow the opposite path: aim at a portrait completely on the surface, evident, unequivocal, that did not elude conventional appearance, the stereotype, the mask. The mask, being first of all a social, historical product, contains more truth than any image claiming to be 'true'; it bears a quantity of meanings that will gradually be revealed. Wasn't this precisely Antonino's intention in setting up this fair booth of a studio?

He observed Bice. He should start with the exterior elements of her appearance. In Bice's way of dressing and fixing herself up – he thought – you could recognise the somewhat nostalgic, somewhat ironic intention, widespread in the mode of those years, to hark back to the fashions of thirty years earlier. The photograph should underline this intention: why hadn't he thought of that?

Antonino went to find a tennis racket; Bice should stand up in a three-quarter turn, the racket under her arm, her face in the pose of a sentimental postcard. To Antonino, from under the black drape, Bice's image – in its slimness and suitability to the pose, and in the unsuitable and almost incongruous aspects that the pose accentuated – seemed very interesting. He made her change position several times, studying the geometry of legs and arms in relation to the racket and

to some element in the background. (In the ideal postcard in his mind there would have been the net of the tennis court, but you couldn't demand too much, and Antonino made do with a Ping-Pong table.)

But he still didn't feel on safe ground: wasn't he perhaps trying to photograph memories – or, rather, vague echoes of recollection surfacing in the memory? Wasn't his refusal to live the present as a future memory, as the Sunday photographers did, leading him to attempt an equally unreal operation, namely to give a body to recollection, to substitute it for the present before his very eyes?

'Move! Don't stand there like a stick! Raise the racket, damn it! Pretend you're playing tennis!' All of a sudden he was furious. He had realised that only by exaggerating the poses could he achieve an objective alienness; only by feigning a movement arrested halfway could he give the impression of the unmoving, the nonliving.

Bice obediently followed his orders even when they became vague and contradictory, with a passivity that was also a way of declaring herself out of the game, and yet somehow insinuating, in this game that was not hers, the unpredictable moves of a mysterious match of her own. What Antonino now was expecting of Bice, telling her to put her legs and arms this way and that way, was not so much the simple performance of a plan as her response to the violence he was doing her with his demands, an unforeseeable aggressive reply to this violence that he was being driven more and more to wreak on her.

It was like a dream, Antonino thought, contemplating, from the darkness in which he was buried, that improbable tennis player filtered into the glass rectangle: like a dream when a presence coming from the depth of memory advances, is recognised, and then suddenly is transformed into something unexpected, something that even before the transformation is already frightening because there's no telling what it might be transformed into.

Did he want to photograph dreams? This suspicion struck him dumb, hidden in that ostrich refuge of his with the bulb in his hand, like an idiot; and meanwhile Bice, left to herself, continued a kind of grotesque dance, freezing in exaggerated tennis poses, backhand, drive, raising the racket high or lowering it to the ground as if the gaze coming from that glass eye were the ball she continued to slam back.

'Stop, what's this nonsense? This isn't what I had in mind'. Antonino covered the camera with the cloth and began pacing up and down the room.

It was all the fault of that dress, with its tennis, prewar connotations.... It had to be admitted that if she wore a street dress the kind of photograph he described

couldn't be taken. A certain solemnity was needed, a certain pomp, like the official photos of queens. Only in evening dress would Bice become a photographic subject, with the decollete that marks a distinct line between the white of the skin and the darkness of the fabric, accentuated by the glitter of jewels, a boundary between an essence of woman, almost atemporal and almost impersonal in her nakedness, and the other abstraction, social this time, the dress, symbol of an equally impersonal role, like the drapery of an allegorical statue.

He approached Bice, began to unbutton the dress at the neck and over the bosom, and slip it down over her shoulders. He had thought of certain nineteenth-century photographs of women in which from the white of the cardboard emerge the face, the neck, the line of the bared shoulders, while all the rest disappears into the whiteness.

This was the portrait outside of time and space that he now wanted; he wasn't quite sure how it was achieved, but he was determined to succeed. He set the spotlight on Bice, moved the camera closer, fiddled around the cloth adjusting the aperture of the lens. He looked into it. Bice was naked.

She had made the dress slip down to her feet; she wasn't wearing anything underneath it; she had taken a step forward-no, a step backward, which was as if her whole body were advancing in the picture; she stood erect, tall before the camera, calm, looking straight ahead, as if she were alone.

Antonino felt the sight of her enter his eyes and occupy the whole visual field, removing it from the flux of casual and fragmentary images, concentrating time and space in a finite form. And as if this visual surprise and the impression of the plate were two reflexes connected among themselves, he immediately pressed the bulb, loaded the camera again, snapped, put in another plate, snapped, and went on changing plates and snapping, mumbling, stifled by the cloth, 'There, that's right now, yes, again, I'm getting you fine now, another'.

He had run out of plates. He emerged from the cloth. He was pleased. Bice was before him, naked, as if waiting.

'Now you can dress', he said, euphoric, but already in a hurry. 'Let's go out'.

She looked at him, bewildered.

'I've got you now', he said.

Bice burst into tears.

Antonino realised that he had fallen in love with her that same day. They started living together, and he bought the most modern cameras, telescopic lens, the most

advanced equipment; he installed a darkroom. He even had a set-up for photographing her when she was asleep at night. Bice would wake at the flash, annoyed; Antonino went on taking snapshots of her disentangling herself from sleep, of her becoming furious with him, of her trying in vain to find sleep again by plunging her face into the pillow, of her making up with him, of her recognising as acts of love these photographic rapes.

In Antonino's darkroom, strung with films and proofs, Bice peered from every frame, as thousands of bees peer out from the honeycomb of a hive, but always the same bee: Bice in every attitude, at every angle, in every guise, Bice posed or caught unaware, an identity fragmented into a powder of images.

'But what's this obsession with Bice? Can't you photograph anything else?' was the question he heard constantly from his friends, and also from her.

'It isn't just a matter of Bice', he answered. 'It's a question of method. Whatever person you decide to photograph, or whatever thing, you must go on photographing it always, exclusively, at every hour of the day and night. Photography has a meaning only if it exhausts all possible images'.

But he didn't say what meant most to him: to catch Bice in the street when she didn't know he was watching her, to keep her in the range of hidden lenses, to photograph her not only without letting himself be seen but without seeing her, to surprise her as she was in the absence of his gaze, of any gaze. Not that he wanted to discover any particular thing; he wasn't a jealous man in the usual sense of the word. It was an invisible Bice that he wanted to possess, a Bice absolutely alone, a Bice whose presence presupposed the absence of him and everyone else.

Whether or not it could be defined as jealousy, it was, in any case, a passion difficult to put up with. And soon Bice left him.

Antonino sank into deep depression. He began to keep a diary – a photographic diary, of course. With the camera slung around his neck, shut up in the house, slumped in an armchair, he compulsively snapped pictures as be stared into the void. He was photographing the absence of Bice.

He collected the photographs in an album: you could see ashtrays brimming with cigarette butts, an unmade bed, a damp stain on the wall. He got the idea of composing a catalogue of everything in the world that resists photography, that is systematically omitted from the visual field not only by cameras but also by human beings. On every subject he spent days, using up whole rolls at intervals of hours, so as to follow the changes of light and shadow. One day he became

obsessed with a completely empty corner of the room, containing a radiator pipe and nothing else: he was tempted to go on photographing that spot and only that till the end of his days.

The apartment was completely neglected; old newspapers, letters lay crumpled on the floor, and he photographed them. The photographs in the papers were photographed as well, and an indirect bond was established between his lens and that of distant news photographers. To produce those black spots, the lenses of other cameras had been aimed at police assaults, charred automobiles, running athletes, ministers, defendants.

Antonino now felt a special pleasure in portraying domestic objects framed by a mosaic of telephotos, violent patches of ink on white sheets. From his immobility he was surprised to find he envied the life of the news photographer, who moves following the movements of crowds, bloodshed, tears, feasts, crime, the conventions of fashion, the falsity of official ceremonies; the news photographer, who documents the extremes of society, the richest and the poorest, the exceptional moments that are nevertheless produced at every moment and in every place.

Does this mean that only the exceptional condition has a meaning? Antonino asked himself. Is the news photographer the true antagonist of the Sunday photographer? Are their worlds mutually exclusive? Or does the one give meaning to the other?

Reflecting like this, he began to tear up the photographs with Bice or without Bice that had accumulated during the months of his passion, ripping to pieces the strips of proofs hung on the walls, snipping up the celluloid of the negatives, jabbing the slides, and piling the remains of this methodical destruction on newspapers spread out on the floor.

Perhaps true, total photography, he thought, is a pile of fragments of private images, against the creased background of massacres and coronations.

He folded the corners of the newspapers into a huge bundle to be thrown into the trash, but first he wanted to photograph it. He arranged the edges so that you could clearly see two halves of photographs from different newspapers that in the bundle happened, by chance, to fit together. In fact he reopened the package a little so that a bit of shiny pasteboard would stick out, the fragment of a torn enlargement. He turned on a spotlight; he wanted it to be possible to recognise in his photograph the half-crumpled and torn images, and at the same time to feel their unreality as casual, inky shadows, and also at the same time their concreteness as objects charged with meaning, the strength with which they clung to the attention that tried to drive them away.

To get all this into one photograph he had to acquire an extraordinary technical skill, but only then would Antonino quit taking pictures. Having exhausted every possibility, at the moment when he was coming full circle Antonino realised that photographing photographs was the only course that he had left – or, rather, the true course he had obscurely been seeking all this time.

ASSIGNMENTS/DISCUSSION POINTS

1. 'It is only when they have the photos before their eyes that they seem to take tangible possession of the day spent...[events] take on the irrevocability of what has been and can no longer be doubted. Everything else can drown in the unreliable shadow of memory'. Both Barthes (Chapter 48 *The Photograph Tamed*, p. 118) and Sontag (*In Plato's Cave*, pp. 8–10) deal with this issue. To what extent do the three writers' views overlap and are there any significant differences? (See *Memories Are Made Of This*, Fig. 42.)

2. Select two events you were involved in and that you photographed, they could be holidays, parties etc. Without looking at your photographs note down the most memorable experiences. Now look at the photographs and see to what extent they change your view of the events. Do the photographs enhance your memories, distort them, would you have enjoyed some of the experiences more if you hadn't felt you had to take photographs of them and do some of the photographs create a false impression, and if so why? On balance, do you think the photographs contribute to the understanding and remembering of the events?

3. Calvino makes a very strong case for parents photographing their children. Does anything Barthes or Sontag write undermine this position (see question 1. for the relevant sections from Barthes and Sontag)?

4. Paraggi states 'The line between the reality that is photographed because it seems beautiful to us and the reality that seems beautiful because it has been photographed is very narrow'. Evaluate this statement. In your evaluation discuss the notions that: (a) things that were not really beautiful are seen as beautiful because they were photographed and (b) that through photographing something we are able to recognise the previously unseen beauty. You may wish to refer to the first part of Sontag's chapter *America, Seen Through Photographs, Darkly*.

5. Paraggi goes on to say 'If you take a picture of Pierluca because he's building a sand castle, there is no reason not to take his picture while he's crying because the castle has collapsed, and then while the nurse consoles him by helping him

find a sea shell in the sand'. Take a series of photographs following Paraggi's advice. Try to avoid sentimentality, for example look at Sally Mann's photograph *Jessie Bites*, 1985, from her book *Immediate Family*.

6. 'The minute you start saying something, " 'Ah, how beautiful! We must photograph it!' " you are already close to the view of the person who thinks that everything that is not photographed is lost...'. Is something that is not photographed lost? Think of some event in your own life or lifetime that you would like to have had photographed, and explain why you would like to have had it photographed. Are there also events that you are glad were not photographed? Give your reasons for not wanting them photographed.

7. 'But the rest of you still insist on making a choice. What sort of choice? A choice in the idyllic sense, apologetic, consolatory, at peace with nature, the fatherland, the family. Your choice isn't only photographic; it is a choice of life, which leads you to exclude dramatic conflicts, the knots of contradiction, the great tensions of will, passion, aversion. So you think you are saving yourselves from madness, but you are falling into mediocrity, into hebetude'. Do you agree with Parraggi? Evaluate your own 'photo album' and the work of Jacques Henri Lartigue, Nan Goldin, Sally Mann and Richard Billingham (see colour Figure C5) in terms of this quote.

8. ' "To believe that the snapshot is more *true* than the posed portrait is a prejudice..." '. Evaluate Parraggi's argument that leads to this conclusion. Look at the work of a range of photographers, for example, August Sander (see Fig. 1), Yousuf Karsh, Henri Cartier-Bresson (see Fig. 12), Annie Leibovitz, Richard Billingham (colour Figure C5) and Tom Hunter (colour Figure C1), and refer to both Barthes and Sontag.

9. 'Antonino had reached the conclusion that it was necessary to return to posed subjects, in attitudes denoting their social position and their character, as in the nineteenth century. His anti-photographic polemic could be fought only from within the black box, setting one kind of photography against another'. Look at the work of nineteenth century portrait photographers, for example Nadar, and attempt to take a series of photographs using Antonino's 'new' approach. Evaluate your work in terms of Antonino's aims.

10. Antonino, Bice and Lydia go to flea markets etc. to find old equipment. Do the same; find an old camera, making sure you can still get film for it and take a series of photographs using the camera. To what extent is what you photograph determined by the camera? Evaluate your work and take a second

series of photographs you think is appropriate for the camera. Evaluate the second set of photographs.

11. 'There were many possible photographs of Bice and many Bices impossible to photograph, but what he was seeking was the unique photograph that would contain both the former and the latter'. The first part of this sentence is logically consistent, however the second part seems impossible to achieve. Would Barthes's notion of *punctum* make it achievable?

12. 'He freed himself from the cloth and straightened up again. He was going about it all wrong. That expression, that accent, that secret he seemed on the very point of capturing in her face, was something that drew him into the quicksands of moods, humors, psychology: he, too, was one of those who pursue life as it flees, a hunter of the unattainable, like the takers of snapshots He had to follow the opposite path: aim at a portrait completely on the surface, evident, unequivocal, that did not elude conventional appearance, the stereotype, the mask. The mask, being first of all a social, historical product, contains more truth than any image claiming to be "true"; it bears a quantity of meanings that will gradually be revealed. Wasn't this precisely Antonino's intention in setting up this fair booth of a studio?' These two paragraphs suggest two very different ways of photographing. Evaluate the work of two photographers, one, who it could be argued takes the one approach, and the second, the other approach. For example Henri Cartier-Bresson for the first and August Sander for the second. What are the strengths and weaknesses of each approach? Produce at least one photograph in the manner of each photographer.

13. Barthes cites Calvino at the start of Chapter 15 and at the end of Chapter 46. Read these two chapters and relate them to what Antonino is trying to achieve.

14. 'Bice obediently followed his orders even when they became vague and contradictory, with a passivity that was also a way of declaring herself out of the game, and yet somehow insinuating, in this game that was not hers, the unpredictable moves of a mysterious match of her own. What Antonino now was expecting of Bice, telling her to put her legs and arms this way and that way, was not so much the simple performance of a plan as her response to the violence he was doing her with his demands, an unforeseeable aggressive reply to this violence that he was being driven more and more to wreak on her'. By asking someone to pose for you, you are interpreting him or her, and arguably forcing your will on them. Find some examples of portraits you would regard as 'non-violent' and justify your choices. Consider the notion that the only non-violent portrait is a self-portrait? Evaluate a number of self-portraits

by well-known photographers. Do they in any way look different from other portraits, if not in what way are they different? Take a self-portrait and evaluate it. Refer to the work of Francesca Woodman, Nan Goldin and Martin Parr who have all taken self-portraits and Deborah Irmas' book *The Camera I* (ISBN 810931974) which is a collection of self-portraits by well-known photographers.

15. After photographing Bice nude Antonino says 'I've got you now'. What does he mean? That he possesses her? That he has revealed the true her photographically? And if so what has he shown? Is a portrait of a naked person more revealing of who they are? Look at a number of portraits of people who have been photographed naked, for example John Lennon by Annie Leibovitz, Lee Miller by Man Ray, Edith Gowin by Emmett Gowin, Sally Mann's portraits of her children and Georgia O'Keefe by Alfred Stieglitz. Find portraits of these people clothed and compare your reaction to the clothed and unclothed portraits.

16. 'It isn't just a matter of Bice', he answered. 'It's a question of method. Whatever person you decide to photograph, or whatever thing, you must go on photographing it always, exclusively, at every hour of the day and night. Photography has a meaning only if it exhausts all possible images'. When Garry Winogrand died in his mid-fifties he had 2500 exposed but undeveloped spools of film and 6500 developed spools that had not been contact printed (as well as having had several major exhibitions and having published four books). Look at the work of Winogrand, evaluate it in terms of what Winogrand and Antonino were trying to achieve and consider if there is any point to such compulsive photography. For a short period, compulsively photograph something and evaluate your results.

17. 'But he didn't say what meant most to him: to catch Bice in the street when she didn't know he was watching her, to keep her in the range of hidden lenses, to photograph her not only without letting himself be seen but without seeing her, to surprise her as she was in the absence of his gaze, of any gaze. Not that he wanted to discover any particular thing; he wasn't a jealous man in the usual sense of the word. It was an invisible Bice that he wanted to possess, a Bice absolutely alone, a Bice whose presence presupposed the absence of him and everyone else'. Is there a sense in which an absolutely private person is the real person and that this is the person who should be photographed? Phillip de Lorca's recent work entails setting up cameras and lighting in streets to photograph people unaware. Evaluate de Lorca's work both on his and on Antonino's terms and in terms of the ethics of doing this; for example is there any difference between Cartier-Bresson's

approach (where he is present with the camera but the subject is unaware of the photograph being taken) and de Lorca's (where the camera is triggered remotely)?

18. Both Antonino and Sherry Levine (who is a real, not fictional) photograph other peoples' photographs. Is what they are trying to do significantly different, and if so how? Would there be any point in seeing photographs produced by either photographer?

19. Antonino Paraggi seems to be an archetypal post-modernist. Calvino published the story in 1955 long before there were any post-modernists in any art form. This would suggest that his thinking was far ahead of post-modernist practitioners or theoreticians, however should this story be read as an endorsement of a post-modernist position or a criticism of one? See Chapter 8, Andy Grundberg *The Crisis of the Real.*

20. *The Adventures of a Photographer* is a short story, not an academic essay on photography, yet is it in any way inferior to an essay in raising and answering questions on photography? Justify your answer.

21. Write a short story on photography that raises one or more of the issues you have been looking at in this book. If you wish you may illustrate the story with photographs.

12 Poems by Felix Morisseau-Leroy and George Szirtes

Critics, academics, curators and photographers are not the only people with an interest in photography, and the poems that follow show an equally valid way of reacting to issues raised by photography.

Felix Morisseau-Leroy

KODAK

<div align="center">

Tourist, don't take my picture
Don't take my picture, tourist
I'm too ugly
Too dirty
Too meager and too thin
Don't take my picture, white
Mr. Eastman wouldn't approve
I'm too ugly, too thin
And your Kodak will break
I'm too dirty and too black
Your Kodak will burst
Don't take my portrait, tourist
Let me be, white
Don't photograph my donkey
Donkeys here carry too much
Donkeys here are too little
Donkeys here don't eat
Tourist, don't shoot my house
My house is a house of hay
Don't take a picture of my poor house
My house is a house of clay

</div>

Go shoot the National Palace
Shoot Bicentennial Avenue
But don't take a picture of my garden
I have no plow or car or tractor
Don't take a picture of my tree
Tourist, I'm barefoot
And my clothes are all torn
Isn't this what you see?
Tourist, look at my hair
Your Kodak's not used to its color.
Tourist, don't take my picture
You won't understand my pose
You won't understand a thing
My affairs aren't yours, tourist
Gimme five cents
And be on your way

(Translated by Jeffrey Knapp)

ASSIGNMENTS/DISCUSSION POINTS

This poem by Haitian poet F. Morisseau-Leroy was published in *Haiti Feeding the Spirit* (Aperture, 1992) and was presented alongside six studio portraits of children taken between 1959 and 1969 by Abraham Photo, Port-au-Prince. The portraits do not attempt to reveal poverty and show the children neatly dressed in a range of outfits. Marilyn Houlberg says of the photographs and the poem *Kodak* that they highlight the relationship between Haitians 'caught' by the tourist's camera '... and the way Haitians respond to photographic studio camera. The studio photographs ... are remarkable for the clear cultural negotiations that are apparent in the photographs themselves. The subject, the camera, and the studio photographer are engaged in [a] ... socially and artistically agreed upon photographic process. The subjects are in control. They are paying for the photographic sessions, which they themselves have initiated. In contrast to the "tourist" photography that Morisseau-Leroy deplores, it is the Haitian clients who will determine how and in what context their images will be both made and displayed' (p. 59).

1. The difference between the tourists' photographs and the indigenous studio photographs are significant. Look at the poem and the images reproduced in

Haiti Feeding the Spirit and/or the work of Malian photographer Seydou Keita (who in recent times has gained international recognition for his studio photography) and evaluate the photographs in terms of what truths they reveal about their subjects. Can a case be made for the poem also being aimed at documentary photographers? Can the differences between what the different types of images show be resolved, and to what extent are the parties involved; the tourist (and possibly the documentary photographer); the studio photographer; and the subjects justified in what they do?

BLIND FIELD

George Szirtes

FOR DIANE ARBUS

Paragons

Those with two heads know something you don't

Diane Arbus

Distrust everything – especially the happy face,
the successful face, the face with something solid
stacked behind the eyes. Locate instead the scapegrace,
the lost and the squalid,

those who have nothing to say with the eyes but the eyes
are open and are inward or are lost down a well
where you look down the shaft to find them and their faces rise
like your own in the circle

of water, with lips large as dinner-plates: the man with a tail,
the man who smoked cigars with his eyes, the Siamese twins
in Hubert's or Huber's where there is neither male nor female
but paradigms and paragons

that tickle your guilt and your pity. You say: I don't want
to make you cry, but when the button's there you press it.
And it's true that those with two heads know something you don't,
only you guess it.

The Baths on Monroe Street

You're carrying some slight magic which does something
to them. It fixes them in a way

Diane Arbus

At the baths of Monroe Street two women are crying.
The walls are patched and blistered like Eliot's Jew.
Decades of steam. The carpet is wet through
with feet or with tears and the matrons are dying
of cancer or disappointment, their hair crimped in sheets,
their broad bosoms swaying over stomachs arranged in pleats.

In a sudden fury Alice begins. She launches a volley
of clicks at the mist and the leery disappearing
smiles of a hundred Cheshire Cats who may be hard of hearing
but know an assault when they see one. Like a reveille
the cry goes up to wake the dead, and the dead rise
out of the walls and the water with terrible answering cries.

Ah love let us be true to one another! they wail in the steam
of the baths, remembering their Matthew Arnold. The towels snap
as they descend on the savage intruder, the teeth also snap
and the air's full of flesh. They can see the gleam
of the lens, which is Alice in action, and they close in
as all nightmares do, on those who are rigid or frozen.

They take the instrument from her (and who after
all can blame them? Because theirs is a life not to be opened
like a tin of sardines, because they feel they own what has happened
and goes on happening to them as they totter and fall
on the slippery carpet) and by the time their energies fail
the camera is drowned in a cleaner's convenient pail.

Bichonnade

that we may wonder all over again what is veritable
and inevitable and possible and what it is to become
whoever we may be

Diane Arbus

The Mystic Barber teleports himself to Mars. Another carries
a noose and a rose wherever he goes. A third collects string
for twenty years. A fourth is a disinherited king, the Emperor of Byzantium.
 A fifth ferries
the soul of the dead across the Acheron. There's a certain abandon
in asking, Can I come home with you?

like a girl who is well brought up, as she was, in a fashion,
who seems to trust everyone and is just a little crazy,
just enough to be charming, who walks between fantasy
and betrayal and makes of this a kind of profession.
It takes courage to destroy the ledge you stand on,
to sit on the branch you saw through.

or to fly down the stairs like Lartigue's Bichonnade
while the balustrade marches sturdily upward, and laughter
bubbles through the mouth like air through water,
and the light whistles by, unstoppable, hard
and joyful, though there is nothing to land on
but the flying itself, the flying perfect and new.

This collection of poems draws its title from Barthes' *Camera Lucida* and is
prefaced with Barthes' definition of a 'blind field' (see p. 57, *Camera Lucida*).
Although Szirtes also dedicates six poems to André Kertész in this collection,
the Arbus ones have been used because her work has been fairly extensively dealt
within this book.

ASSIGNMENTS/DISCUSSION POINTS

To do the assignments you will need to refer to a Diane Arbus monograph,
and for the second assignment a Lartigue monograph as well. Refer both to the
images and text in the monographs

1. *Paragons, The Baths on Monroe Street and Bichonnade*: A photograph can be
 looked at from three different perspectives: the subject's; the photographer's;
 and the viewer's. This is an issue (amongst others) that these poems respond to.
 In what way do these poems illuminate these differences and at times blur them?

Explain which issues each poem raises. Taken together, how effective are the poems in raising your critical awareness of Arbus' work and do they encourage you to respond differently from the approaches provided by Sontag, Rosler and Solomon-Godeau?

2. *Bichonnade*: Why would using a title of a Lartigue photograph seem an unlikely choice for a poem dedicated to Diane Arbus? Why has Szirtes done this and is it effective?

13 Robert Adams', John Baldessari's and Peter Godwin's Analysis of Particular Photographs

In this chapter there are three un-summarised responses to three different photographs by three different people. They can all be regarded as examples of photographic criticism. The writers react strongly to the images, but substantiate their opinions with information from the photographs. Robert Adams is a photographer, John Baldessari, an artist and Peter Godwin, a writer. They have all achieved international recognition in their own fields.

JOHN BALDESSARI (SEE FIG. 38)

I buy a lot of pictures nobody wants, odd movie publicity stills that used to be ten cents a piece, and are now up to twenty-five cents each. I started looking at these kinds of pictures *not* because they were from movies, but because early on, I was looking for photographs to incorporate into my own work that didn't involve my own sensibility.

I went to places that sold movie stills every few weeks, and I would spend hours and hours looking through disorganized cardboard boxes of photographs until my eyes started to go out. I liked the randomness of going through these pictures. I pulled photos intuitively, things I thought I could use in making my own pieces. I have to use pictures that are banal, so banal that they are not very interesting by themselves, but have some charge that begins to work when I shove one of them up against another. They're pictures that have some hold on me.

There are some pictures I've bought but have *never* been able to use. Like *this* one, which is so charged in subject matter that all I can do is just show it to people. In all my searching, I've *never* found anything like this picture. There's something very troubling and sad about it. It speaks about sexuality in some way as death and dirt. There's also something very judgmental about it, something bipolar, This picture seems like it's about strange and overlapping sensibilities.

Why would anybody make a picture like this? I cannot figure it out. It's so enigmatic. There are really weird overtones in it: beauty, birth and death, pain, decay. It's very open. You can read so much into it. What's out the window? Could be clouds. You can look at this picture from now until doomsday, and still have no idea about what is going on. I know why I like all of the other pictures I have. There's no another one that eludes me, like this one does. I've had this picture around for a *long* time. And although I've always loved it, it's just too good to use in my own work.

When I used to categorize the pictures I bought, this one got placed in the folder called 'art', because it's so perfectly composed. In some way, it seems to comment on art. It's got the quality of being both here *and* there. The backs of movie stills usually have captions printed on them, and this one does, too. It says, 'Assembly Line of Beauty-3. Emerging from the "Bubble Bath," Dolores Casey will halt behind the flimsy screen for a rubdown, after which she dons a negligee, also the creation of one of the famed Parisian designers'. It was number three of a sequence, but I can't imagine what the other pictures might have been like. The caption implies that she's going to come out of this bubble bath, go behind this screen, go to get a massage – no a 'rubdown'.

It's mysterious. There's something on the left, behind what I guess is a curtain, which looks like a figure out of a Masaccio painting. A figure going to hell. It's wearing a towel. Maybe it's being transformed. And *this* figure on the right, covered in suds, is very sensual. The idea of soap or suds, cleansing like fire. The picture has a lot of religious overtones to it, I suppose. But then when you look at *this* part in the center, suddenly the picture moves off into another area. Once I was going to use this photo to make a reference to Barnett Newman's paintings or to Jackson Pollock's *Blue Poles*. But it was just *too* good.

This picture became important to me because it's a reminder of what happens when art becomes too beautiful. I admire it, but on the other hand, it provokes me, and maybe I'm resentful about that. I would like to make something so perfect, but on *my* terms. I mean this is *brilliant*. Look at the divisions. The negative space is very important, as important as anything else. Compositionally, why would anybody put what looks like artificial fingers in front of the rope on those poles? That idea wouldn't come to you in a million years. It drives me *mad* trying to figure that out. That hand, it's gorgeous. How the fingers repeat the poles. How the poles are bound. Those decisions have to figure into the story the photographer was trying to tell. It was a brilliant move. This picture is almost Cocteau-like, dreamy, and the longer I look at it, the weirder it gets.

In fact, this picture has a lot to do with an artist's dream of becoming artless. What is great about this picture is that it is *stupid*. Artists all want to be stupid, in a *good* way, and artless. It gets to the root of a fundamental question for artists. When does something flip? At what point does something become art? When is something *not art*? It happens on a sliding scale, and I'm always interested in finding the point when a picture all of the sudden goes over the edge, in one way or another. All it would take to make this picture *not* art is just a slight shift in its arrangement. As it is, this picture smacks of art, because it's so composed and such a *beautiful* image. This picture does just what an artist does. Takes a piece of dirt and keeps doing something with it, until it's still a piece of dirt *and* it's art. But how do you keep its 'dirtness'? It's a pretty hard line to walk. Its either *dirt*, or its *art*. Just where do you stop? When do you push it too far? At what point do you kill it? It takes a lifetime to learn how to do that. You never want to make something *so* totally beautiful that it doesn't leave any room for a person to enter it. *That* would be boring.

Usually, when you say something can be art, it's because you've found a precedent for it in art that already exists, You say to yourself, 'It looks like *that*'. The things that are resistant, you might say, 'Why not? Why *couldn't* it be art? What can I do to push it over the edge?'. But this picture starts and ends at the absolute ground zero level of what art is. It is enough to make me catatonic.

It would kill me if this picture looked anything like the art I make. I don't want to give people something comfortable to look at. I want to upset people. *This* is too beautiful, too comfortable. I *always* distrust beauty. I'm very jittery about it. There is no way that this is *not* a beautiful picture. No way.

ROBERT ADAMS ON A PHOTOGRAPH BY SUSAN MEISELAS (SEE FIG. 37)

Susan Meiselas's picture of the shadows of bus passengers being searched by the Salvadoran military (plate XXV) makes me afraid both for the passengers and for her. I don't think she wanted us to fear for her – I saw her once in a public interview and she was absolutely self-effacing – but in order to show the passengers' danger she shared it. Only by standing with them and partly turning her back on the soldiers, by accepting that risk, could she make us feel what was happening. She records it so well that we can almost hear sounds – the chambering of ammunition . . . the crying of a baby.

Even though I know that Meiselas survived the incident, I also know from the bravery it took to make the picture that she would probably do it again, and that

things might end differently. It was unpredictable when one of Somoza's soldiers killed television correspondent Bill Stewart as he knelt in the street in Managua, Nicaragua.

The setting of Meiselas's picture, which suggests a mass grave, seems to be a cut by the side of the road, a ditch. We have looked at many such places. I remember watching on the news in the 1960s a report about a patrol that captured a man along a road during an African civil war. As the soldiers interrogated their prisoner he realized that they were going to kill him; he implored their mercy. weeping, stumbling into a ditch, pleading, until an officer put an end to him with a machine gun. 'If you have no imagination', Celine wrote, 'death is nothing. If you do it is too much'. Watching this person die, for whom it had been too much, was one of a number of filmed murders that helped awaken my imagination.

I hate my country's part in most third-world politics, but to keep that abhorrence alive – it is almost the only virtue I have in the matter – I seem to have to be shown the problem again and again. I depend on others' courage. I am saved in a different way from the people on the bus, who may literally owe their lives to Meiselas's presence, but I owe her my caring.

There are many contexts in which it is embarrassing to say one is a photographer, but with the example of Meiselas's witness it is too easy.

The word 'artist' is, on the other hand, not at all tempting to use about oneself in the presence of her photograph. Her goal seems not to have been art, with its eventual calm. but reporting that would move us. What pictures have artists made that deserve as wide an audience as does hers? There are some, but an economically perfumed aestheticism that has dominated the visual arts in the United States since World War II has resulted mostly in pictures that are, when set against the facts in Meiselas's photograph, irrelevant.

The shadows in the picture are long. Is it morning or late afternoon?

This excerpt was taken from Robert Adams' book Why People Photograph.

PETER GODWIN ON ROB COOPER'S PHOTOGRAPH OF ROBERT MUGABE (SEE COLOUR FIGURE C6)

The Emperor's New Clothes

On the face of it there's nothing that is remarkable about this photograph of Zimbabwe's president Robert Mugabe. It seems like another stock shot of him at a political rally. The iconography of power is all here. The bulky armchair chair is

appropriately throne like, the gold ring and watch peep from beneath the sleeve, indicating that he is a 'big man' in the African tradition, a man with resources who can help those who curry his favour. And behind him are arrayed the usual tableaux of enforcers: the senior cop, garnished with braid and medals, and the security agent, complete with aviator shades, goatee and moustache, and double breasted jacket – all the better for concealing the shoulder holster beneath its bulkier cut. And underneath them all, of course, that old cliche of power, the red carpet.

But to my mind, this image is laced with the visual clues to the elderly president's desperate political calculus.

It is taken in 2000 when, after twenty years of a consolidating his one party state – that party being the ZANU PF on the banner behind him – his formerly quiescent people have suddenly risen to challenge him by voting against a constitutional amendment that would extend his presidential term limits.

Mugabe is furious and in this election campaign he is fighting back by dusting off his old credentials as a guerrilla leader and reheating the congealed remnants of an ancient anti-colonial struggle that most of his young population can barely recall.

So he has changed out of the Saville Row suits and silk polka dot ties of the proto-capitalist, foreign investment friendly leader and donned once more the garb of the guerrilla: the olive combat gear that he used to wear in the early 1970s, in order to emphasise his man-of-action persona, with its chilling reminder of the 'power flows from a barrel of gun' dictum that seems to remain indelibly in his political DNA. (Fidel Castro is the main practitioner of this ageing guerrilla act.) The uniform is part of a greater problem, the near universal inability of former guerrilla groups to transform themselves into truly democratic political parties; their inability to distinguish disagreement from treason. Their assumption that the concept of the 'loyal opposition' is an oxymoron.

But his get-up also reveals something else about Mugabe – that he was never actually a soldier in the bush war. The signs are all here: the light blue socks and slip-on, leather soled loafers, the coltish knock-kneed stance, the geeky multiple pens of the school teacher he once was, carefully arrayed in his top pocket, the outsized, almost feminizing spectacles – which themselves provide a mask for his impassive face. All of these help to betray a man who was always more at home behind a desk than in the field.

The president has a lot on his mind. He is busy putting in place a campaign of torture, intimidation, media clampdowns, gerrymandering and vote rigging.

And the slogan partial concealed behind him, actually reads (in Shona, the vernacular) Our Land is Our Power (chk). This was the cornerstone of his furious reaction to the sudden appearance of a credible political challenge: to dismiss the new opposition (Movement for Democratic Change) as lackeys to former white rulers, and to confiscate those farms still owned by whites and redistribute them to political allies. Over the next few years this deliberately anarchic transfer destroys commercial agriculture and with it most of the country's economy. Zimbabwe now has the fastest shrinking GDP in the world, and the highest inflation rate. Since this photograph was taken, almost half of its adults have fled the country.

What we are seeing here is an old man in his moment of Sampsonian spasm, pulling down the pillars of the temple around him, ruining an entire country in order to cling to power. This is a man who once thought his legacy might rival Nelson Mandela's. Zimbabwe had the highest literacy rate in Africa, and a flourishing economy, with the continent's second highest standard of living. But Mugabe is sacrificing all of it to stay on this chair into his dotage. His expression, disdainful, aloof, sees barely to mask his cold rage at his querulous populace and his determination to whip them back into line – whatever the cost.

It is a powerful portrait of political hubris.

ASSIGNMENTS/DISCUSSION POINTS

1. All three writers respond to the photographs from different perspectives. Put rather simply it could be argued Baldessari is concerned with the image itself, Adams, the photographer and Godwin, the subject. To what extent is this true, and to what extent does the depth of their understanding of the photographs depend information that is not shown in the photographs?

2. Find a photograph that you have a strong reaction to and write an analysis of it.

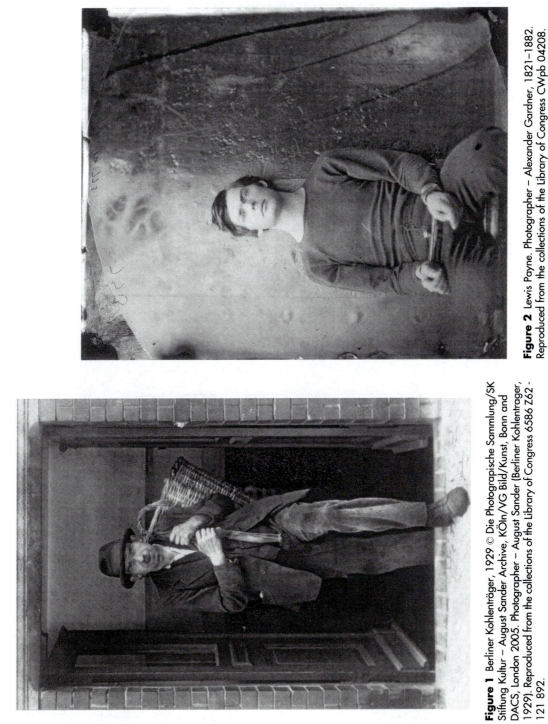

Figure 1 Berliner Kohlenträger, 1929 © Die Photograpische Sammlung/SK Stiftung Kultur – August Sander Archive, KÖln/VG Bild/Kunst, Bonn and DACS, London 2005. Photographer – August Sander (Berliner Kohlentrager, 1929). Reproduced from the collections of the Library of Congress 6586 Z62 - 121 892.

Figure 2 Lewis Payne. Photographer – Alexander Gardner, 1821–1882. Reproduced from the collections of the Library of Congress CWpb 04208.

Figure 3 Part of the bedroom of Floyd Burrough's cabin. Hale County, Alabama, 1935 or 1936. Photographer – Walker Evans, 1903–1975. Reproduced from the collections of the Library of Congress 6582 USF 342 - TOI - 8134A.

Figure 4 The valley of the shadow of death. Photographer – Roger Fenton, 1819–1869. Forms part of the Roger Fenton Crimean War photograph collection. Reproduced from the collections of the Library of Congress 6588 LC - USZC4 9217.

Figure 5 Hands' Italian priest holds hand of starving child–Famine–Karamoja–Uganda © Mike Wells. 1980.

Figure 6 Between Wallasey and Birkenhead, 1979 © Tom Wood.

Figures

Figure 7 1951 SPAIN. Estremadura. Town of Deleitosa, 1951. Members of the Guardia Civil, the rural police force in charge of patrolling the Spanish countryside © W. Eugene Smith/Magnum Photos.

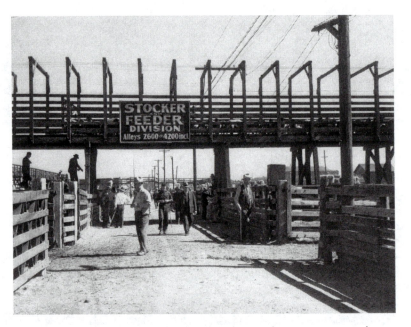

Figure 8 Highway from Denver to Idaho Springs, Colorado, 1941. Photographer – Marion Post Wolcott, 1910–. Reproduced from the collections of the Library of Congress 6587 LC-USF34-05 9394-D.

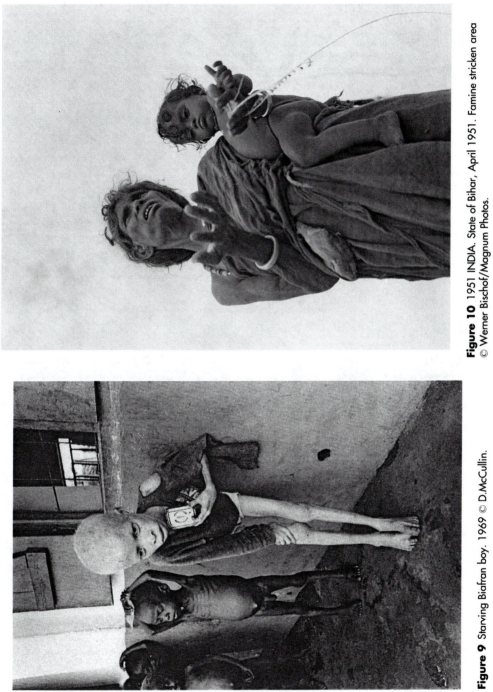

Figure 10 1951 INDIA. State of Bihar, April 1951. Famine stricken area © Werner Bischof/Magnum Photos.

Figure 9 Starving Biafran boy. 1969 © D.McCullin.

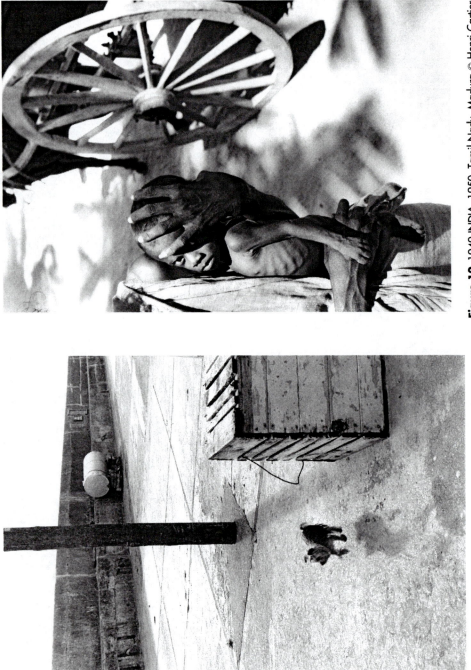

Figure 12 1949 INDIA. 1950. Tamil Nadu, Madura © Henri Cartier-Bresson/Magnum Photos.

Figure 11 1968 IRELAND, 1968. Ballycotton © Elliott Erwitt/Magnum Photos.

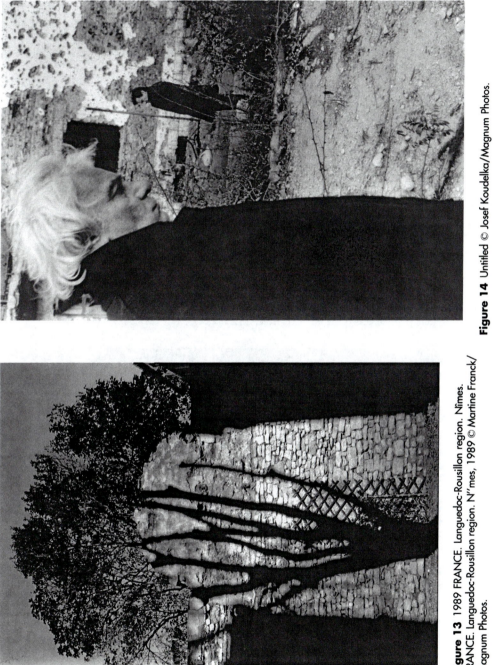

Figure 13 1989 FRANCE. Languedoc-Rousillon region. Nîmes. FRANCE. Languedoc-Rousillon region. N″mes, 1989 © Martine Franck/Magnum Photos.

Figure 14 Untitled © Josef Koudelka/Magnum Photos.

Figures

Figure 15 Mississippi River steamboat. Vicksburg, Mississippi. 1936. Photographer – Walker Evans, 1903–1975. Reproduced from the collections of the Library of Congress 6582 USF 342 - TOI - 8079 - A.

Figure 16 1966 ITALY. Campania region. Town of Naples,1966. Beggar © Bruno Barbey/Magnum Photos.

206

Figure 17 Kyla c 1994 © Ashley la Grange.

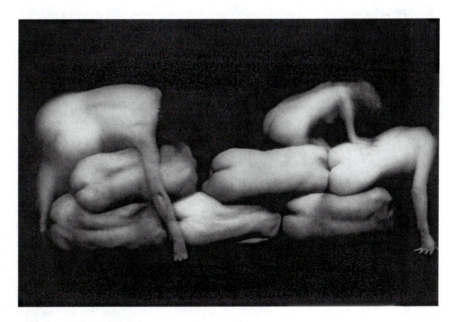

Figure 18 Untitled c 1985 © Ashley la Grange.

Figure 19 Untitled © Tsvangirayi Mukwazhi. Courtesy of Tsvangirayi, Mukwazhi. Courtesy Manchester Art Gallery.

Figure 20 Ricking the reed. Photographer – Peter Henry Emerson 1856–1936. Illus. in *Life and lanscape on the Norfolk Broads* by P.H. Emerson and T.F. Goodall. London: Sampson Low, Marston, Searle, and Rivington, 1886. Reproduced from the collections of the Library of Congress 6586 262 - 98828.

Figure 21 1978 UNITED KINGDOM. Town of Newcastle on Tyne © Martine Franck/Magnum Photos.

Figure 22 1966 USA. Florida. Fort Lauderdale. Man excercising on a beach, not far from the port where nuclear submarines are stationed © René Burri/Magnum Photos.

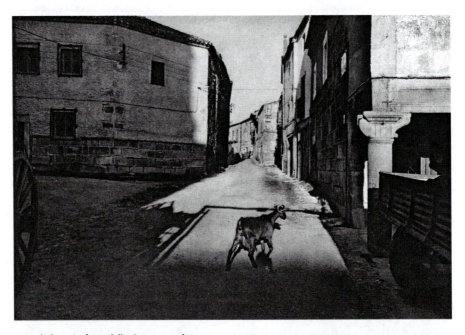

Figure 23 Untitled © Josef Koudelka/Magnum Photos.

Figure 24 1999 Miscellaneous. A stone from the Valley of the Kings in Egypt, a gift from René Burri to Le Corbusier © René Burri/Magnum Photos.

Figure 25 1980 USA. Arizona. A typical desert garden in a suburb of Phoenix, Arizona. Cactus, gravel and little model animals © David Hurn/Magnum Photos.

Figure 26 Detail of tabby wall. Ruins of supposed Spanish mission, St Marys, Georgia, 1936. Photographer – Walker Evans, 1903–1975. Reproduced from the collections of the Library of Congress 6582 USF 342 - TOI - 8006 - A.

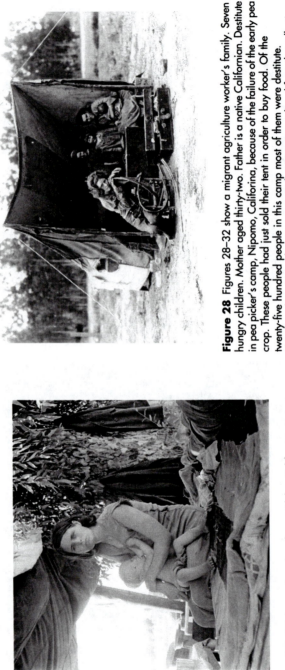

Figure 28 Figures 28–32 show a migrant agriculture worker's family. Seven hungry children. Mother aged thirty-two. Father is a native Californian. Destitute in pea picker's camp, Nipomo, California, because of the failure of the early pea crop. These people had just sold their tent in order to buy food. Of the twenty-five hundred people in this camp most of them were destitute. Photographer – Dorothea Lange, March 1936. Reproduced from the collections of the Library of Congress 6586 262 - 583 55.

Figure 27 Oklahoma drought refugees Blithe, California. August 1936. Photographer – Dorothea Lange, August 1936.

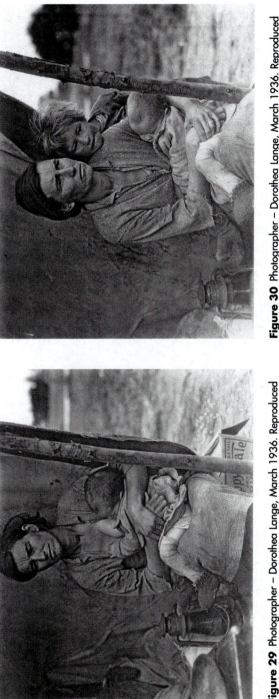

Figure 30 Photographer – Dorothea Lange, March 1936. Reproduced from the collections of the Library of Congress 6582 - USF 342 - TOI - 9093 - C.

Figure 29 Photographer – Dorothea Lange, March 1936. Reproduced from the collections of the Library of Congress 6582 USF 342 - TOI - 9097 - C.

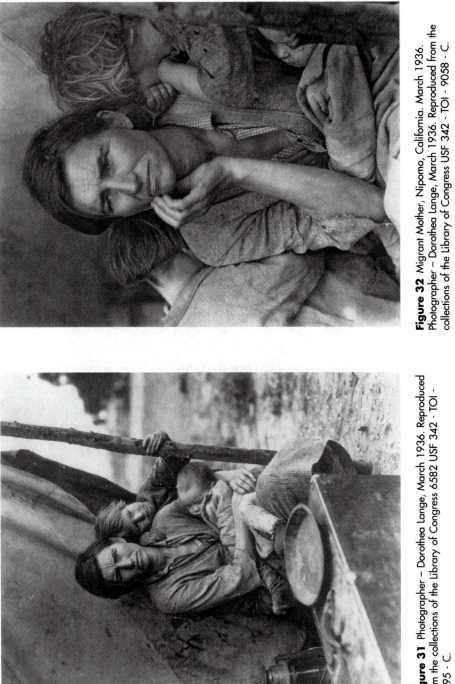

Figure 32 Migrant Mother, Nipomo, California. March 1936. Photographer – Dorothea Lange, March 1936. Reproduced from the collections of the Library of Congress USF 342 - TOI - 9058 - C.

Figure 31 Photographer – Dorothea Lange, March 1936. Reproduced from the collections of the Library of Congress 6582 USF 342 - TOI - 9095 - C.

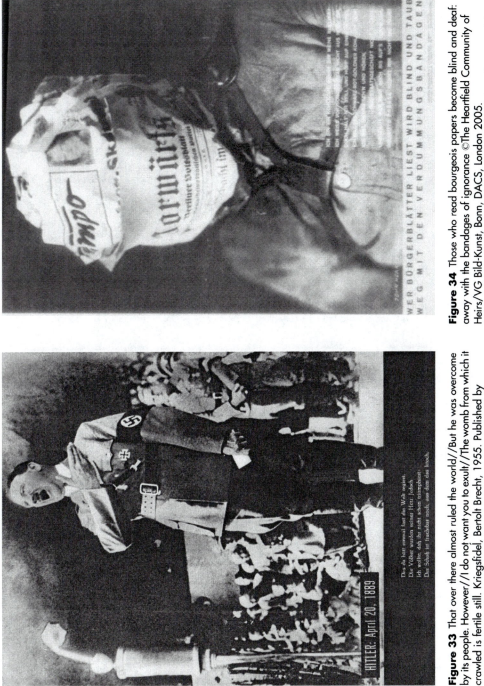

Figure 33 That over there almost ruled the world//But he was overcome by its people. However://I do not want you to exult//The womb from which it crawled is fertile still. Kriegsfidel, Bertolt Brecht, 1955. Published by Eulenspiegel-Verl, former East Berlin. Translation by Marianne Zappen-Thomson.

Figure 34 Those who read bourgeois papers become blind and deaf: away with the bandages of ignorance ©The Heartfield Community of Heirs/VG Bild-Kunst, Bonn, DACS, London 2005. Photographer – John Heartfield. Reproduced from the collections of the Library of Congress Yan la 36655.

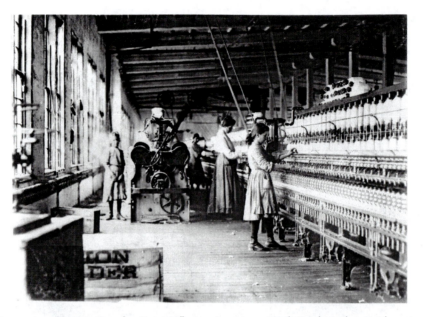

Figure 35 Two young spinners in Catawba Cotton Mills. Location: Neton, North Carolina. Photographer – Lewis Wickes Hine, 1874–1940. Reproduced from the collections of the Library of Congress 6586 242 - 65666.

Figure 36 Peddlar [i.e., Peddler] who slept in a cellar, New York City. 1890. Photographer Jacob A Riis, 1849–1914. Reproduced from the collections of the Library of Congress 6586 Z62 - 12492.

Figure 37 El Salvador. 1980. Soldiers search bus passengers along the Northern Highway © Susan Meiselas/Magnum Photos.

Figure 38 Talking Pictures © John Baldessari. Courtesy of John Baldessari.

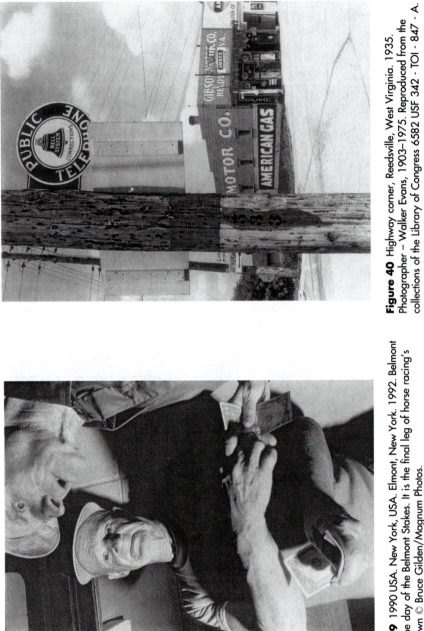

Figure 40 Highway corner, Reedsville, West Virginia. 1935. Photographer – Walker Evans, 1903–1975. Reproduced from the collections of the Library of Congress 6582 USF 342 - TOI - 847 - A.

Figure 39 1990 USA. New York, USA. Elmont, New York. 1992. Belmont Park on the day of the Belmont Stakes. It is the final leg of horse racing's Triple Crown © Bruce Gilden/Magnum Photos.

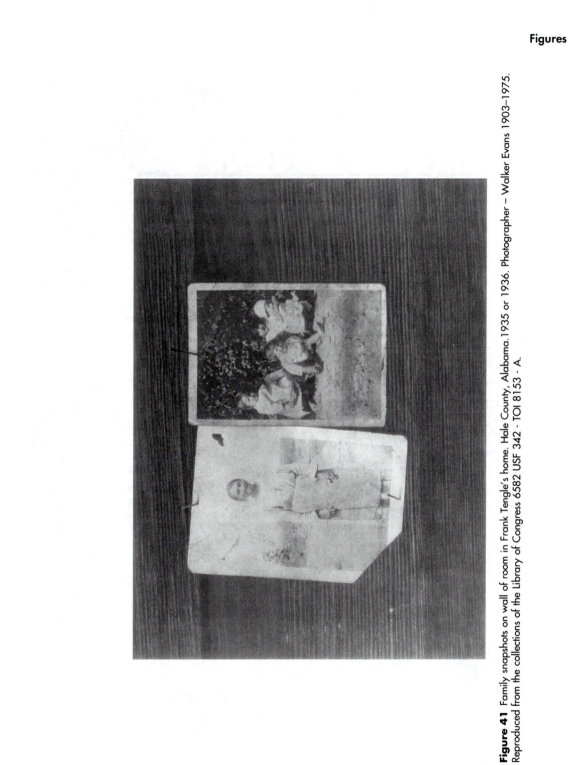

Figure 41 Family snapshots on wall of room in Frank Tengle's home. Hale County, Alabama. 1935 or 1936. Photographer – Walker Evans 1903–1975. Reproduced from the collections of the Library of Congress 6582 USF 342 - TOI 8153 - A.

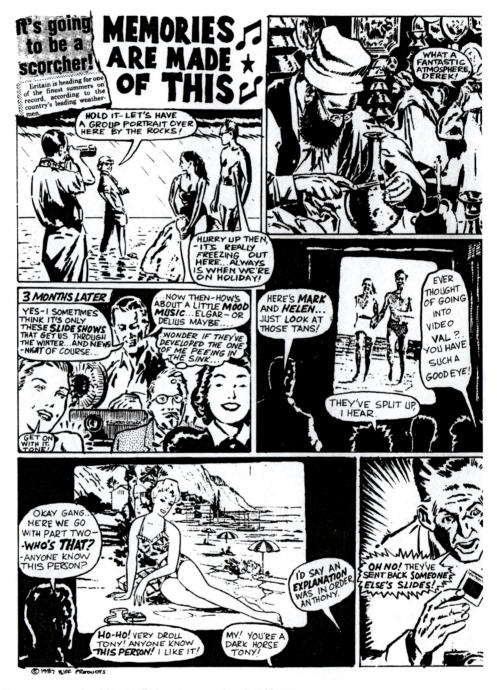

Figure 42 Memories are made of this © Biff.Chris Garratt and Mick Kidd. TBC.

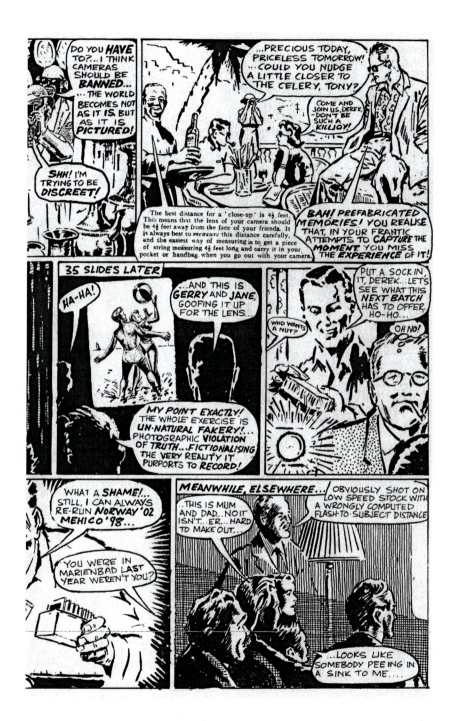

Bibliography

Aperture (1992) *Haiti Feeding the Spirit*, New York: Aperture. 0-89381-512-8

Aperture (1994) *Metamorphoses: Photography in the Electronic Age*, New York: Aperture. 0-89381-602-7

Aperture 138 (1995) *On Location With: Henri Cartier-Bresson, Graciela Iturbide, Barbara Kruger, Sally Mann, Andres Serrano, Clarissa Sligh*, New York: Aperture. 0-89381-609-4

Aperture 146 (1997) *On Location With: Lynn Davis, Mary Ellen Mark, Duane Michals, Richard Misrach, Raghu Rai, Lise Sarfati, Doug and Mike Starn*, New York: Aperture. 0-89381-660-4

Aperture 158 (2000) *Photography and Time*, New York: Aperture. 0-89381-898-4

Amelunsxen, H.V., Iglhaut S., Rotzer F., (1996) *Photography after Photography: Memory and Representation in the Digital Age*, Munich: G+B Arts. 90-5701-101-8

Adams, R. (1994) *Why People Photograph*, New York: Aperture. 0-89381-603-5

Adams, R. (1996) *Beauty in Photography*, New York: Aperture. 0-89381-368-0

Akeret, R.U. (1973) *How to Interpret the Hidden Psychological Meaning of Personal Photographs*, New York: Peter H. Wyden, Inc.

Appignanesi, R. and Garratt, C. (1999) *Introducing Postmodernism*, Cambridge: Icon Books. 1-84046-056-3

Baldwin, G. (1991) *Looking at Photographs: A Guide to Technical Terms*, California: The John Paul Getty Museum. 0-7141-1720-X

Barrett, T. (2000) *Criticizing Photographs: An Introduction to Understanding Images*, California: Mayfield Publishing Company.

Barthes, R. (1984) *Camera Lucida*, London: Fontana. 0-00-654061-9

Benjamin, W. Editor H. Arenet. *Illuminations*, Glasgow: Fontana Press. 0-00-686248-9

Berger, J. (1972) *Ways of Seeing*, London: Penguin Books. 0-14-013515-4

Berger, J. (1980) *About Looking*, New York: Vintage Books. 0-679-73655-7

Berger, J. and Mohr, J. (1982) *Another Way of Telling*, London: Writers and Readers. 0-906495-68-7

Bolton, R. (1989) *The Contest of Meaning: Critical Histories of Photography*, Massachusetts: Massachusetts Institute of Technology. 0-262-52169-5

Brecht, B. (1955) *Kriegsfibel*, East Berlin: Eulenspiegel-Verl.

Bruce, C. (1994) *After Art: rethinking 150 years of photography: essays/by Andy Grundberg, Chris Bruce*, Washington: Henry Art Gallery, University of Washington. 0-295-97415-X

Caponigro, E. (1994) *Far from Main Street: Three Photographers in Depression-Era New Mexico: Russell Lee, John Collier, Jnr., and Jack Delano*, Santa Fe: Museum of New Mexico Press. 0-89013-259-3

Clark, K. (19..) *The Nude*

Cobley, P. and Jansz, L. (1999) *Introducing Semiotics*, Cambridge: Icon Books. 1-84046-073-3

Coleman, A.D. (1999) *Critical Focus*, Tucson AZ: Nazraeli Press. 3-923922-26-4

Curtis, J. (1989) *Mind's Eye, Mind's Truth: FSA Photography Reconsidered*, Philadelphia: Temple University Press. 0-87722-823-X

Dawkins, R. (2003) *A Devil's Chaplain Selected Essays by Richard Dawkins*. Weidenfield and Nicolson. 0297829734

Edwards, E. (1992) *Anthropology & Photography 1860–1920*, London: Yale University Press. 0-300-05944-2

Ensdorf, M. (1991) *Digital Dialogues: Photography in the Age of Cyberspace*, Birmingham: Ten8. ISSN 01-42-9663

Grundberg, A. (1990) *Crisis of the Real*, New York: Aperture Foundation Inc. 89381-401-6

Heron, L. and Williams, V. (1996) *Illuminations: Women Writing on Photography from the 1850s to the Present*, London: I.B. Tauris. 1-86064-070-2

Hill, P. (2004) *Approaching Photography* Lewis: The Photographers Institute Press. 861083238

Hill, P. and Cooper, T. (2005) *Dialogue with Photography*, Manchester: Dewi Lewis Publishing. 1899235612

Hirsch, M. (1999) *The Familial Gaze*, Hanover: University Press of New England. 0-87451-895-4

Hirsch, R. (2000) *Seizing the Light: A History of Photography*, McGraw-Hill. 0-697-14361-9

Hunter, T. (2003) *Tom Hunter* Hatje Cantz. Ostfildern-Ruit. 3-7757-1277-1

Janus, E. *Veronica's Revenge: Contemporary Perspectives on Photography*, Scalo. 3-931141-78-0

Jeffrey, I. (1998) *Timeframes: The Story of Photography*, New York: Amphoto Art. 0-8174-6015-2

Johnson, B. (1989) *Photography Speaks*, Norfolk, Virginia: Aperture/The Chrysler Museum. 0-89381-355-9

Johnson, B. (1995) *Photography Speaks II*, Norfolk, Virginia: Aperture/The Chrysler Museum. 0-89381-652-3

Kenyon, D. (1992) *Inside Amateur Photography*, London: Batsford. 0-7134-6774-6

Kirk, K. (1994) *Public Information: Desire, Disaster, Document*, New York: Distributed Art Publishers. 1-881616-45-2

Kozloff, M. (1994) *Lone Visions: Crowded Frames*, Albuquerque: University of New Mexico Press. 0-8263-1494-5

Langford, M. (1997) *The Story of Photography*, Oxford: Focal Press. 0-240-51483-1

Lester, P.M. (2000) *Visual Communication: Images with Messages*, Belmont: Wadsworth/Thompson Learning. 0-534-56142-X

Morris, B. (1986) *Images: illusion and reality*, Canberra: Australian Academy of Science. 0-85847-131-0

Neff, T.A.R. (1998) *Photography's Multiple Roles: Art, Document, Market, Science*, New York: The Museum of Contemporary Photography. 0-9658887-2-X

Neumaier, D. (1995) *Reframings: New American Feminist Photographies*, Philadelphia: Temple University Press. 1-56639-331-0

Orvell, M. (2003) *American Photography*, Oxford: Oxford University Press. 0-19-284271-4

Owen, U. *Index on Censorship: Underexposed*, Volume 28, No 6, (1999) London. 0-904-286-762

Phillips, C. (1989) *Photography in the Modern Era: European Documents and Critical Writings, 1913–1940*, New York: Metropolitan Museum of Modern Art/Aperture. 0-89381-407-5

Rabb, J.M. (1995) *Literature & Photography: Interactions 1840–1990: A Critical Anthology*, Albequerque: University of New Mexico Press. 0-8263-1663-8

Rabb, J.M. (1998) *The Short Story & Photography 1880s–1980s*, Albequerque: University of New Mexico Press. 0-8263-1871-1

Ritchin, F. (1999) *In Our Own Image: The Coming Revolution in Photography*, New York: Aperture. 0-89381-856-9

Robin, M. (1999) *100 Historic Photos of the 20th Century*, Koln: Evergreen. 3-8228-6512-5

Scott, C. (1999) *The Spoken Image: Photography and Language*, London: Reaktion Books. 1-86189-032-X

Singh, R. (1998) *River of Colour: The India of Raghubir Singh*, London: Phaidon Press. 0-7148-3996-5

Shore, S. (1998) *The Nature of Photographs*, Baltimore: The John Hopkins University Press. 0-8018-5720-1

Solomon-Godeau, A. (1991) *Photography at the Dock: Essays on Photographic History, Institutions, and Practices*, Minneapolis: University of Minnesota Press. 0-8166-1913-1

Sontag, S. (1979) *On Photography*, London: Penguin Books. 0-14-005397-2

Sontag, S. (2003) *Regarding the Pain of Others*, London: Penguin Books: Hamish Hamilton. 0-241-14207-5

Squires, C. (1991) *The Critical Image: Essays on Contemporary Photography*, London: Lawrence & Wishart. 0-85315-737-5

Szarkowski, J. (1966) *The Photographer's Eye*, London: Secker & Warburg. 436-44149-7

Szarkowski, J. (1978) *Mirrors and Windows: American Photography since 1960*, New York: The Museum of Modern Art. 0-87070-476-1

Szirtes, G. (1994) *Blind Field*, Oxford: Oxford University Press. Oxford. 0-19-282387-6

Tagg, J. (1988) *The Burden of Representation: Essays on Photographies and Histories*, London: Macmillan Education Ltd. 0-333-41824-7

Thody, P. and Course, A. (1997) *Barthes: For Beginners*, Cambridge: Icon Books. 1-874166-52-8

Trachtenburg, A. (1980) *Classic Essays on Photography*, New Haven, Conn: Leete's Islands Books. 0-918172-08-X

Turner, P. and Badger, G. (1988) *Photo Texts*, London: Travelling Light. 0-906333-22-9

Warburton, N. (2003) *The Art Question*, Routledge. 0-415-17490-2

Wells, L. (1999) *Photography: A Critical Introduction*, London: Routledge. 0-415-19058-4

Wells, L. (2003) *The Photography Reader*, London: Routledge. 0-415-24661-X

Williamson, J. (1986) *Consuming Passions*, Marion Boyars. London 0-7145-2828-5

Wolfe, T. (1976) *The Painted Word*, New York: Bantam Books. 0-553-38065-6

Wright, T. (1999) *The Photography Handbook*, London: Routledge. 0-415-11594-9

Yorath, D. (2000) *Photography: A Crash Course*, East Sussex: The Ivy Press Limited. 0-8230-0986-6

Zakia, R.D. (2002) *Perception & Imaging*, Focal Press. 0-240-80466-X

Appendixes

A. PRINT QUALITY

The context within which an image appears is of major concern to critics of photography, however this original context is often not available to students and as a result they rely to a significant extent on reproductions of the original images to make judgements. These reproductions vary significantly in quality, scale and accuracy.

As a rule reproductions are inferior in quality and this is particularly important to remember when looking at the work of photographers who exploit photography for its ability to render detail and a full tonal range, for example Edward Weston's work. Ideally, before making any judgements (and that includes agreeing with a critic), the photographer's original work should be viewed at a gallery, museum or archive. If this is not possible, an understanding of reproduction processes will help make more informed judgements.

The crudest, and most widely used form of photomechanical reproduction is the half tone. Look at any monochrome (black and white) photograph in a newspaper to see one. By looking through a loupe (magnifying glass) the regular dot pattern that makes up the image is very apparent. These are the lowest quality reproductions. By using smaller dots the quality can be improved and most books use this process. By overlaying two sets of dots, (a duotone), the quality is enhanced further and many better quality photographic books use duotones. Tritones (three sets of dots) and quadratones (four sets of dots) refine the process further, but only expensive books use these processes. If colour printing is used for monochrome images, the resulting quality is better than that of a half tone (see Michael Langford's *Advanced Photography* for a comparative example of this).

Arguably, the best quality reproductions are photogravures. These have random dots of variable size and so can more closely match the grain of the print (Szarkowski's *The Photographer's Eye* uses photogravures). Generally, books using photogravures are very expensive. As a rule the more sophisticated the

printing process the better the reproduction, however even photogravures can be done badly.

On occasion reproductions can be better than the original use of the image. For example Weegee's work was intended for newspapers so modern reproductions, unless facsimiles (which are designed to copy the original), will be sharper, more detailed and have greater contrast than the images his original audience would have seen. This change in quality may or may not suit the uses the photographs are put to now (which are probably different from the original use) and that is a critical decision the viewer has to make, and one the photographer has to consider when their work is reproduced after its original use.

The scale of the work is also important. Advertisements and some of Barbara Kruger's work are examples of work designed for billboards, and (on a slightly reduced scale) photographers like André Gursky produce mural sized work, so no book can really match the visual impact of the original image. Less obvious is either a slight reduction in size when an image is reproduced, or a slight increase in size. Typically, Weston's 10×8 inch contact prints will be reduced in size while André Kertész's early work will be enlarged.

Other considerations are monochrome papers can be warm, neutral or cold (brownish, pure black or bluish) but most books will reproduce all images as a neutral black; some images are cropped when reproduced; the paper surface and thickness will be different. Photojournalistic or reportage images are often found in a series when originally used but individual images can be taken out of sequence or used in isolation when reproduced – they may not even have been used originally! For example Larry Burrows' classic image from the Vietnam War, of a staggering, wounded black US soldier apparently reaching out to his wounded and prone white comrade was not used by *Life* at the time.

This does not mean that without the original informed judgements cannot be made, they can, but the viewer needs to take into account the changes the reproduction might make.

Assignment

Find a photograph that is reproduced in many different publications, Weston's *Pepper* for example and compare the reproductions to see to what extent your appreciation of the image is changed by the quality of the reproductions. Try to find examples of all the photomechanical processes listed above. In order to see examples of all the different photomechanical processes you are likely to have to look a range of

photographers' work. Most books note the process used (photogravures are also known as heliogravures or gravures).

A small, but very useful book, which explains a large range of photographic processes, historic and contemporary, is Gordon Baldwin's *Looking at Photographs: A Guide to Technical Terms*.

B. SCHEMES FOR CRITICISING PHOTOGRAPHS

In an attempt to make it easier to criticise photographs, a number of writers have suggested a range of questions that can be asked of a photograph through which the photograph can be evaluated. **Do not try to ask every question of every photograph, some of the questions will not be appropriate and do not think that these are the only questions you can ask.**

Barbara London with John Upton *Photography*

This is a textbook on photography that covers the technical, historical, aesthetic and critical aspects of photography. In the section *Looking at – and Talking About – Photographs* the authors give their guidelines for evaluating photographs.

Upton and London start by pointing out that all photographs, even snapshots are made to convey certain messages, and although you may never know exactly the photographer's intention, they suggest there are up to eight questions you can ask to understand a photograph.

1. What type of photograph is it? For example it could be an advertising photograph. A caption can help in understanding the image, but in order not to restrict your response they feel this should only be read after looking at the photograph.

2. What do you think was the photographer's intention? In an advertisement it could simply be to give visual details of the product, or it could, for example, suggest that you will be a desirable person if you use the product.

3. What is emphasised? For example, a shallow depth of field will draw attention to the subject focused on and away from those things not focused on.

4. How effective are the technical considerations. For example, are you distracted from an important aspect because there is too much detail in the photograph?

5. How important are graphic elements? Do tone, line and perspective play a major part in looking at the image?

6. Does the photograph reveal things other than the main subject? For example, a fashion photograph can also reveal the status of woman in a culture.

7. Does the photograph have an emotional or physical impact?

8. Relate the photograph to others made by the photographer or to other photographs made in the same period or of the same genre. Look for at it in its, social, historical, or, if relevant, artistic context.

London and Upton also list terms for visual elements that the photographer may have exploited and the student can use in justifying their interpretation of the image. They also include examples of photographs illustrating these elements.

Light: front lit, side lit, back lit, direct light, directional-diffused light, diffused light, silhouette and glowing light

Tone and contrast: high key, low key, full scale, high and low contrast

Texture: emphasised and minimised

Focus and depth of field: sharp overall focus, soft focus, selective focus, shallow and great depth of field

Frame: how the shapes in the photograph meet the edges

Viewpoint: eye-level, overhead, low and unusual viewpoint

Space and perspective: shallow or deep space, positive space or figure, negative space or ground, compressed space (telephoto effect), and expanded perspective (wide-angle distortion)

Line: curved, straight, broken, horizontal, vertical and diagonal line

Balance: are the elements within the frame balanced or do they lean towards one side

London and Upton's list is not comprehensive and there are other visual elements they could have included, for example the graininess of the image, the depiction of movement (blurred, or frozen either as a result of shutter speed or the use of flash), double or multiple exposure, composite images (seamless or photomontage) and whether it is colour (full or spot) or monochrome.

When evaluating a photograph, remember that these visual elements are a means
to an end. It is easy, for example, to point out that the photographer has used side
lighting, but you need to say why and how this helps convey meaning and what
the meaning is.

Assignment

Most photographers will use a wide range of visual elements, but there are
photographers whose work is characterised by the use of particular techniques or
visual elements, for example, high contrast; Bill Brandt, Mario Giacomelli,
Ralph Gibson, Eikoh Hosoe; grainy images; Mario Giacomelli, Sarah Moon,
Sheila Metzner, wide-angle distortion; Bill Brandt; unusual view point;
Alexander Rodchenko; composite images; John Heartfield, Jerry Uelsmann,
David Hockney, Barbara Kruger; low key; Bill Brandt, Don McCullin; full scale
tonal use; Edward Weston, Imogen Cunningham, Ansel Adams; double or multiple
exposure; Duane Michals, Imogen Cunningham; movement; Harold Edgerton,
Philippe Halsman, Ernst Haas. Select one of these visual elements/techniques and
explain why at least one photographer has used it referring to at least three
different images. If you write about more than one photographer, use at least
one image from each photographer. Produce a series of images that explore at least
two of these techniques or visual elements.

Terence Wright *The Photography Handbook*

This is a wide ranging text book that covers technical, historical and theoretical
aspects of photography.

Wright quotes Charles Suchar ' "all photographs can *equally* be considered as
documentary photographs if they can be seen as providing answers to questions
that we have about them; that is, if they fulfil the *interrogatory principle*" ' (p. 114).
Wright suggests that if the 'interrogatory principle' is used the following questions
can be asked:

> ...what information has been selected by the photographer and what do we
> find interesting in the photograph?

How does this photograph compare with others taken by other photographers
at the same time?

What is its value as a particular type of image?

What did the photographer intend?

How has the image been used?

What do we know about the photograph's subject?

How does the photograph relate to other historical evidence?

How does the image relate to '... visual representation in general...'
and in particular to '... theoretical perspectives of photography...'

When asking questions of photographs **you** have taken:

What information do you find in the photograph?

What is the range of meanings and interpretations a viewer might get from the
photograph?

Can you judge how the image relates to others of the same kind?

How does the photograph relate to the history and theory of photography,
the arts and culture?

Assignment

Look at two photographs, one a well-known image by an established
photographer and one by yourself and evaluate them in terms of the questions
outlined by Wright.

Dr Robert U. Akeret, *Photoanalysis*

In his book the psychologist, Dr Akeret explains how to interpret the 'hidden'
psychological meanings of both personal and public photographs of people.
One of the most interesting aspects of his interpretation is that, in many cases,
the photographs reveal significant information despite being largely de-contextualised.
Dr Akeret gives a series of questions one can ask of an image in order understand
the information it reveals about the people in the photograph.

'What's your immediate impression? Who and what do you see?

What is happening...?

Is the background...of any significance, either real or symbolic?

What feelings does it evoke in you?

What do you notice about physical intimacy or distance?

Are people touching physically? How are they touching?

How do the people...feel about their bodies? Are they using their bodies to show them off? To hide behind? To be seductive? Are they proud of their bodies? Ashamed?

What do you notice about the emotional state of each person? Is he: shy, compliant, aloof, proud, fearful, mad, suspicious, introspective, superior, confused, happy, anxious, angry, weak, pained, suffering, bright, curious, sexy, distant, blank, bored, rigid, arrogant, content, lonely, trusting, strong, crazy, involved, frustrated, attractive, docile, bemused, correct, friendly, hurt, spontaneous, satisfied, depressed?

Can you visualize how those emotions are expressed by facial dynamics and body movement?

If there is more than one person in the photo, what do you notice about the group mood-the gestalt of the group? Is there harmony or chaos? How do the people relate? Are they tense or relaxed? What are their messages towards each other? Who has the power? The grace? Do you see love present?

What do you notice about the various parts of each person? Look carefully at the general body posture, and then at the hands, the legs, the arms, the face, the eyes, the mouth. What does each part tell you? Are the parts harmonious or are their inconsistencies?

Pay particular attention to the face...

...Go over it [the photograph] again and again...trying to pick up something you have missed.

Ask yourself more general questions...

What is obvious and what is subtle?

Where is the sense of movement? (Or, is there any?)

What memories and experiences does the photo stir in you?

How do you identify with the people in the photo? How are you alike...different?

What moves you most about the photo? What do you find distasteful about it? Is there anything that disturbs you?

Try to define the social and economic class of the people photographed. What is their cultural background?

If it is a family, would you want to be a member of it?

Would you want your children to play with theirs?

If the photos are personal – of you, your family, friends, or associates – try to remember the exact circumstances of the photo session.

How have you changed since then?' (pp. 35, 36).

Assignments

1. Select two or more photographs from your personal photograph album and evaluate them in terms of Akeret's questions. Do the same for two or more images that have appeared in the mass media. At least one photograph in each set must be of a group.

2. Select two photographs from two different genre that do not feature people, for example a landscape and still life. To what extent can Akeret's questions help you evaluate them?

Roland Barthes *The Rhetoric of the Image*

In this essay, written in 1964, Barthes 'deconstructs' an advertisement for Panzani pasta. A lack of space prevented a summary of this essay being presented in this book, but a simple outline of how Barthes analysed the advertisement should help the reader in their evaluation of images.

The colour advertisement shows a string bag that has fallen open. In, and falling out of the bag, are tomatoes, peppers, onions and mushrooms as well as Panzani products; pasta, sauce and cheese. Apart from the tinned sauce, the Panzani products are in transparent packaging and all have green, red and white labelling. He sees three levels of message in the advertisement;

- **The linguistic message:** these are the words in the advertisement. The word 'Panzani' denotes the name of the product but also sounds Italian and along with word 'L'Italienne' which appears in the text at the bottom of the advertisement both have connotations of 'Italianicity'.

- **The coded iconic message:** these are the connotations a particular society will draw from the visual elements. The string bag has connotations of returning from a market, which has connotations of freshness as do the vegetables. The tri-colours of the vegetables and the labels suggest the Italian flag.

- **The non-coded iconic message:** these are the objects that are literally denoted, irrespective of the societies codes, the vegetables, net etc.

The advertisement has words at the bottom of the page he calls them 'anchorage' and they can give information about what the product is.

'Deconstruction' is linked to semiology/semiotics, however Barthes's association with these theories is not unqualified, see for example Section 36, *Authentication* of *Camera Lucida*

Assignment

1. Find two photographs, one an advertisement and one that is not an advertisement and 'deconstruct' them in the way Barthes has.

C. VERY USEFUL BOOKS

The books listed below have been selected in terms of someone starting the critical evaluation of photographs who wants a clear overview of the subject.

1. Baldwin, G.: *Looking at Photographs*
 A very interesting useful little book that defines and explains '...the techniques, processes, and materials used in...making photographs...'.
 An essential aid to understanding photographic images.

2. Barrett, T.: *Criticising Photographs*
 Barrett aims to give a comprehensive overview of the many approaches to photographic criticism. His writing is clear and concise. This is an excellent book that will give the student a clear understanding of the key principles of the various approaches.

3. Langford, M.: *Story of Photography*
 Langford gives a very clear, concise and comprehensive overview of the history of photography. An excellent introduction to the subject's history.

4. The Icon Books *Introducing* series
 Covering everything from Barthes to Semiotics, these books explain the
 essential elements of key thinkers/theories/movements using cartoons and humour.
 Their aim is, however, very serious. They are marketed in the USA by Totem
 Books.

The books listed above have very little overlap and used together should give
the student a good overview of photography and theory relating to it.

Glossary

Alienation To be divorced or separated from something. Usually used in a negative sense often implying that there should be greater empathy or understanding.

Allegorical A **narrative** description of a subject under the guise of another subject. **Surrealism** could be described as allegorical as opposed to **Dada** which could be described as **dialectical**.

Appropriation To use other people's work in your own, either by copying it or physically using it. Arguably this can be dated back to about 1913 in the use of collage by the cubists Braque, Picasso and Gris who used pieces of newspaper in their images as a comment on the relationship between illusion and reality in their work (Synthetic Cubism). It is seen as one of the characteristics of post-modern art. Not to be confused with **Derivative**.

Aesthetic To do with art and how (well) something works visually. Aesthetics is the philosophy of art.

Angst A state of anxiety resulting from an awareness of the complexities of life.

Auteur The author of a work of art.

Avant-garde In art forms these are the artists, photographers, writers etc. who are at the forefront of changes.

Banal Ordinary, uninteresting or boring.

Bourgeois (from the French) Middle class, but often a negative rather than a neutral term. To label some one bourgeois is to emphasise their conservative tastes, conformist approach to life and possibly their financial status.

Candid photograph An un-posed, more or less spontaneous photograph.

Chiaroscuro The use of light and shadow in an image. An Italian term borrowed from painting often used to describe the use of light and dark by such artists as Caravaggio and Rembrandt.

Chromatic Of, or relating to colour.

Circa Means roughly or about, when used before the date of a photograph it indicates that the photograph's exact date is not known. Abbreviated as; c., cir., circ. and ca.

Cliché A way of showing or saying something that has been done so often before that it now has no real value.

Colonise In political terms this is when one country or culture denies another the right to its own independent identity and tries to impose its will on, or rule the weaker one. In photography, it generally refers to individuals from rich nations photographing people of (often) poorer nations and imposing their values on the subjects of the photographs.

Colour, spot The addition of colour to a monochrome image usually at the photomechanical printing stage. Early use at times tried to give the impression of full colour reproduction but in general one or more colours is used without shading to give emphasis to particular parts of the image. Excellent examples of its use can be seen in issues of *USSR in Construction* and contemporary use can be seen in Barbara Kruger's work.

Consumerist A consumerist society is one where the consumption or buying of products becomes, to some extent, the measure of a person's worth and identity.

Context The context within which a photograph is taken and then viewed is regarded as crucial to understanding it. To understand the context one would ask questions such as when, where, why and how the photograph was taken. For example, how it was distributed and viewed; what reaction there was to the image; to what extent the photographer was a free agent and to what extent he or she was controlled by others such as business interests, governments and social and/or cultural constraints?

Critical/Criticism The words 'criticism', 'critical' etc. can be ambiguous. They can mean a negative statement about something, or they can mean to examine art in detail without implying positive or negative conclusions, as in this book.

Crop To cut off parts of the image at the edge of the frame either when taking the photograph, when making the final print or when publishing it. In all cases, the photographer or editor is excluding information either for aesthetic reasons or to emphasise a particular point or to do both.

Corny (colloquial) Something that has been done so often that it is unoriginal and not worth repeating. Related to **Cliché** and **Kitsch**.

Culture The two meanings most relevant to this book are the general values, attitudes and customs of a society; and the arts.

Dada Like **Surrealism** Dada was an art movement which started in the first part of the twentieth century, and like Surrealism it often uses the unreal **juxtaposition** of visual elements for its impact. The movements are however fundamentally different. Dada is **didactic** or **dialectical**, arguing for a particular point of view, usually political – as typified by the work of John Heartfield, Surrealism is poetic and **allegorical**.

Decisive moment, The A phrase (and in translation the title of his classic book – however it does not have the same meaning in French as in English) used by Henri Cartier-Bresson to describe his approach to photography in which he takes the photograph at the precise time that the geometric pattern and action within the frame come together to reveal the most telling image. It is **not** simply an action shot.

Deconstruction An method of analysing ideas advocated by the French philosopher Jacques Derrida. Ideas and words are carefully analysed to find multiple or even contradictory meanings that may not have been apparent even to the author. In this respect it seems very similar to Practical Criticism, however it is associated with Structuralism, a philosophy of language in which words are signs that only have an arbitrary relationship to the things they represent and their meaning is to be found in the differences between words. As a result it can be argued that it impossible to know what anything means. Derrida's theories are very controversial. Conceived as a means of analysing language it is applied to photography, although in doing so an extra layer of complexity is introduced as a photograph does not have an arbitrary relationship to the thing it represents.

Democratise Photography is considered a democratic medium for two reasons, firstly it accepts anything as a subject for photographing and secondly it is something that everyone can participate in unlike other art forms which require a fairly high degree of skill to produce acceptable images. Historically, it is also seen as democratic in that it allowed ordinary, and not particularly wealthy, people to have portraits of their family members, when prior to photography the cost of paintings meant only the rich had such portraits.

De-mystify In theories dealing with issues, such as those covered in this book, someone whom 'mystifies' an aspect of knowledge makes it hard to understand or obscure and so avoids or hides the truth. It does not necessarily mean there is a conspiracy to hide the truth. To de-mystify is to present a logical case to refute or clarify the original argument.

Derivative In general a negative term in art criticism, used to describe work that copies another artist's style or approach. Such work could also be described as unoriginal. See **Appropriation**.

Dialectical A logical debate that attempts to resolve issues between opposing points of view. This does not involve disproving one of them. See **Dada**.

Didactic Intended to teach or inform. See **Dada**.

DIN A measure of film speed. It is the second part of the ISO rating. The first part increases arithmetically, while DIN increases logarithmically so is a lower number e.g. ISO 400/27.

Document To document something is to make a record of it. Documentary photography covers a wide range of activities from the objective recording of things to potentially controversial activities such as recording people's lives. Although intended to inform it can also be used to persuade, and be used as **propaganda** so weakening its documentary value. Related concepts are **reportage** and 'photojournalism'.

Eclectic Something that is not pure, but uses elements from various sources.

Editorial images Images in a magazine or newspaper that have been chosen, by the publication concerned, to illustrate its stories and/or point of view as opposed to advertising images which the advertiser selects. Very occasionally publications will refuse to carry certain advertising images. In general it is accepted that the advertiser not the publication is responsible for the advertising images.

Emulsion The light sensitive layer on photographic film or paper (the base). Oftenconfused with the base itself, which historically has been paper, metal, glass and film.

Ethics Relating to moral decisions, i.e. telling right from wrong. In photography, ethical considerations are often raised in social documentary work and the depiction of women, amongst other issues.

Farm Security Administration (FSA) A US government agency set up during the great Depression to help struggling farmers. Its talented photographic section, headed by Roy Stryker, produced over 200 000 photographs. One of the most important bodies of work in documentary photography. This book is illustrated with numerous FSA photographs.

Film and Photo League A photographic group that had its roots in international left wing workers' movements. Committed to both straight

photography and social and political issues, it included many of the US's leading photographers. It was destroyed as a result of the right wing Senator Joseph McCarthy's witch hunts.

Flâneur Somebody who wanders the streets observing in a **voyeuristic** way as photographers sometimes do.

Formal A formal evaluation of a photograph would concern itself with concepts such as composition, depth of field, tonal range etc. Usually this leads to an explanation of how these aspects of the image emphasise what the photographer is trying to show or say. See **Aesthetic**.

Human Interest Stories Stories, not necessarily news stories, intended to increase the viewer/reader's understanding of other people's lives.

Humanism A philosophical system that dates from the fourteenth century. In photography, humanist photographers are associated with social documentary photography and could be described as those who see common bonds and experiences between all humanity. Also known as 'concerned' photographers they wish to improve peoples' lives through their work. Cornell Capa championed their cause in the latter half of the twentieth century and Sebastião Salgado could be regarded as one of the most prominent contemporary humanist photographers.

Icon In normal English use this is an image or symbol that represents something else, a cross for Christianity, for example. Originally the word had religious connotations, but now it has much broader use. Dorothea Lange's 'Migrant Mother' photograph is regarded as iconic both in several senses; of representing the work of the FSA; of representing the rural poor; and of representing an aspect of motherhood (see Fig. 32). Relatively few photographs are regarded as iconic. Taschen have published two volumes entitled *Photo Icons* in which they reproduce the photographs they feel are iconic and they give the reasons for their selection. In **semiotics**, icon has a slightly different meaning. It is a sign that has no direct link to the thing it represents but which is made to look like the thing it represents. For example, a painting and certain road signs would be icons.

Index In **semiotics** this is a sign that has a direct link (causal, sequential or special) to the subject.

Illustrative In art criticism this is usually a negative term, implying the artist has not interpreted the subject, only copied it or shown it in a predictable way.

Imperious As in 'imperial', used in photographic criticism this has a similar meaning to **'colonise'** and the same negative connotations.

Irony (also 'easy irony') The use of something to convey its opposite meaning and often mocking the subject used. See **Kitsch**.

Juxtaposition The placing together of two or more things, this is used quite widely by photographers, often creating a relationship between things when one does not normally exist.

Kitsch Shallow, generally cheap items that are often marketed as art, may be sentimental and/or pretentious but are easily understood. Related to **'corny'** and **cliché** . Sometimes photographed in great detail by photographers as an **ironic** comment on the item owners' tastes. Very different approaches to such items can be seen in the work of Walker Evans and Martin Parr.

Large format camera A camera that uses a negative of 4 × 5 inches (approximately 101 × 127 mm) or larger. Although awkward to use the large negative gives the highest quality image in terms of tone and detail. Edward Weston commonly used a 8 × 10 inch camera.

Mandala A Hindu, Buddhist or Jain pictorial symbol, usually a circle divided into four, used to aid meditation.

Marxism The political and economic teachings of Karl Marx, seen as an alternative to capitalism. Although communism is based on Marxism they are not interchangeable terms; many would argue that most communist states corrupted Marxist principles.

Magnum Photos A photographic agency run as a cooperative (one that is owned by its member photographers). Founded in 1947 by Robert Capa, Henri Cartier-Bresson, George Rodger and David Seymour it aimed to give photographers greater control over the use of their work. Although strongly identified with reportage, its member photographers work in a range of fields. There are numerous Magnum photographs in this book.

Mass media Television, radio, newspapers, magazines and, increasingly, the web.

Medium This is the material the artist or other person uses, for example oil paint, sculpture or photography. For much of the twentieth century, artists were concerned with being true to their medium and in photography these photographers are known as **straight photographers**. Throughout the twentieth century there were, however, photographers and artists who mixed media and this became increasingly common towards the end of the century.

Metaphysics The branch of philosophy that attempts to inquire as to what the nature of reality is and as to what is real.

Metonym The use of one aspect of something to refer to the whole thing, for example to use the word 'crown' to refer to the monarchy.

Miniature camera A 35 mm camera. Introduced in the 1920s one of the first photographers to exploit the camera's ease of use and inconspicuousness was Henri Cartier-Bresson.

Monograph A book devoted to the work of one photographer.

Muckraking Originally a term used in the early 1900s in the USA to describe social reforming journalists and writers who exposed political and commercial corruption. Confusingly, also used to describe unprincipled and sensationalist journalism undertaken to boost circulation irrespective of the social or private cost to those exposed. Care must be taken not to allow this more modern use of the word to distort the understanding of images described using the original sense of the word.

Mystification/Mystify See **de-mystify**.

Narcissism Excessive love of oneself.

Narrative A story. In photography this often refers to a sequence of photographs, for example W. Eugene Smith's *Country Doctor*, Picture Post's *Day in the Life* series, much of Duane Michal's work and Nan Goldin's *Ballad of Sexual Dependancy*. See **Reportage**.

New Objectivity A movement dating from the mid 1920s, centred in Germany, in which things (often ordinary manufactured items) were photographed with accuracy. See **straight photography** and **medium**.

Nihilistic Extreme scepticism, believing in nothing, to the extent (in the extreme) of wanting to destroy everything.

Objectify To objectify someone is to turn them into an object, to deny their individuality as a person, and so reduce them to being an object for someone else's pleasure or use. Often used to criticise the way women are depicted as nudes. Not to be confused with 'objectivity' which is to look at something without prejudice.

Oeuvre All the work produced by an artist/photographer or writer. It is arguable that it is a more useful word than the commonly used 'repertoire', but it is widely used.

Palinode A poem that retracts the thoughts and feelings of an earlier poem.

Paradigm A basic framework around which a theory can be built.

Pathos A quality that arouses pity or sadness.

Pictorialism One of the first movements in photography. It defined good photography in terms of fine art and the images were often manipulated to achieve a softer effect. It was romantic in its approach. **Straight photographers** rejected it.

Phenomenology A philosophical theory that holds that we only ever have direct experience of sense data (sight, sound, touch) not the 'real' world. When an aspect of the world is not being observed, it exists as a possible sensory experience.

Polemic Hostile and/or controversial argument.

Positivism A philosophy that developed at about the same time as photography in which it is argued that all observable facts could be recorded and quantified by scientists providing complete knowledge allowing for the solution of many, if not all, of humanities problems. Photography, because of its ability to record accurately, was seen as a good tool for positivists. It is not the same as **reductionism** although the two standpoints are not incompatible.

Primitive To describe a photographer's or artist's work as 'primitive' is to say it has a simplicity, innocence or naivety. Although this is a neutral description it is often used positively, Sontag, for example, describes Atget's work as primitive.

Propaganda Information, often knowingly false, given to the public in a sustained way to get them to think or act in a particular way. Often coupled with censorship to prevent any alternative views being given. It is common in authoritarian states, but possible in democracies if one person or persons with common goals control the mass media.

Publicity In Berger's *Ways of Seeing* it means Advertising, and in general the word 'advertising' would be used.

Quote Just as words can be quoted so can images, this can be literal, i.e. copying or using a copy of the original image, or more indirect. Unlike written quotes, visual quotes are often not credited and rely on the viewer's knowledge to recognise them.

Realism A philosophical theory that holds that things exist irrespective of what we think or know about them. Most people are realists when it comes to physical facts about the world.

Reductionism A theory in which one area of knowledge is absorbable into another, for example the various sciences (e.g. biology and chemistry) can be explained by, or reduced to physics. In philosophical terms reductionism relates to particular

areas of knowledge, however in general terms many use it to mean that all knowledge is ultimately reducible to fundamental physics.

Religiosity This does not necessarily mean to give something religious attributes, it can also mean to make it special and something that should not be criticised.

Reportage A style of photography that attempts to tell a story, reveal things or explain the lives of people generally through a series of related images. Associated with European news magazines that started in the 1920s and 1930s, it is generally a European term and is closely related to documentary photography. Henri Cartier-Bresson gives a description of it in his introduction to *The Decisive Moment*. See **Decisive Moment** and **Narrative**.

Rhetorical question A question that is more a statement and does not anticipate an answer. Assignment no. 5 in Sontag's *In Plato's Cave* is based on answering a rhetorical question, something one would not normally do.

Sabattier effect The partial reversal of tones in an image caused by fogging the negative part the way through development. Often used by Man Ray. Frequently, but incorrectly, called **Solarization**.

Sceptic Someone who doubts or questions things.

Semiology/Semiotics These are two similar theories of language, Semiology being the European branch based on the teachings of Ferdinand de Saussure and Semiotics, the North American branch based on the writings of Charles Sanders Peirce. The theories are used in many photography courses, as they are perceived to help understand images. While most would agree they have provided some valuable insights many philosophers regard them as obscure and ultimately inadequate as a theories of language. In this book, Chapter 7 summarises the first chapter of Clive Scott's book *The Spoken Image: Photography and Language*, and Scott makes extensive use of aspects of these theories. See **Deconstruction**, **Icon**, **Index**, **Sign** and **Structuralism**.

Secular Not religious or governed by religious considerations.

Sign In the linguist Ferdinand de Saussure's theory of language, a unit of language, a sign, is composed of two things: the signified, which is a mental component or concept and the signifier, which is a sound-image or written word. For de Saussure there was no natural connection between the two, so different languages will use different words for the same thing. The philosopher C.S. Peirce also developed a theory of signs in order to understand language. Peirce has three semiotic categories the indexical, the iconic and the symbolic. In his system of semiotics the

index is a sign that has a direct link (causal, sequential or spatial) with its subject e.g. smoke and fire; the **icon** resembles the subject; and the symbol is only linked by convention, like a word. The symbol is essentially the same as de Saussure's signifier in that their relationship to the subject is arbitrary and they need to be interpreted. de Saussure's signs are *dyads* in that they only have two components, the signified and the signifier, Peirce's are *triadic* having three components.

School In art and photography a school can be a teaching institution. It can also be a group of people who have the same approach to the subject. These people can be closely or loosely bound together.

Solarization The reversal of tones in an image due to gross over exposure when taking a photograph, e.g. the sun appears black as in Ansel Adams' *The Black Sun, Owens Valley, California,* 1939. Commonly, but incorrectly, used to describe the **Sabattier effect**.

Solipsism A philosophical view that holds that the only thing a person can know with certainty is that they exist, the existence of everything else can be doubted. Can be used more generally to describe, for example, an isolated or **alienated** individual.

Straight photography A pure approach to photography in which the photographer exploits the essential characteristics of photography to the fullest. Typified in terms of detail and tonal range by photographers like Edward Weston and Ansel Adams, who generally used **large format cameras**; and in terms of capturing the fleeting moment, by Henri Cartier-Bresson, who used a 35 mm camera (**miniature camera**). Initially US-based, there was a similar but independent movement in Europe known as **The New Objectivity**. Both schools rejected **Pictorialism**. This straight approach dominated twentieth century photography and is still very influential today. Although seen as a twentieth century movement there are many nineteenth century photographers (even pictorialists) whose work would be considered as 'straight'.

Structuralism A theory of language developed by Ferdinand de Saussure in which language is made up of signs and the signs have two parts, the mental concept (the 'signified') and the written, spoken or image form (the 'signifier'). See **Semiology**.

Surrealism An approach to art that to some extent depends on the subconscious and often results in dream like images. Man Ray and Jerry Uelsmann's work are explicitly surreal. The work of photographers like Bill Brandt and Diane Arbus may not be as explicitly surreal but also depend on surrealism to a greater or lesser

extent for their impact. Susan Sontag however argues that all photography is 'natively surreal'. See **Dada** and **Allegorical**.

Surrogate Something that stands in for something else, for example Hans Bellmer and Laurie Simmons use dolls to stand in for people.

Symbol Something that represents something else, e.g. a sign.

Tautological A statement that is of necessity, true and as such is not very useful, for example 'Jo may, or may not be a photographer'.

Temporal Of time.

Tourist In normal use, this is someone on holiday in a foreign country. In photographic criticism, the term often has negative connotations suggesting a shallow and exploitative interest in something they are not part of.

Third World A term used to describe poorer countries, mostly in Africa, Asia and South America. The term was regarded by some to be derogatory and now the phrase 'developing nations' tends to be used. It however can also be misleading. While nations such as Brazil, China, India and South Africa are undoubtedly developing, nations such as the Congo and Zimbabwe are getting poorer. Terms such as 'non-Western' can be used but Japan, for example, is a very rich country, while seeing the divide between rich and poor nations in terms of which hemisphere they are in i.e. 'North' and 'South' is also misleading.

Vantage point The point from which something is looked at, for example from above, below or eye level etc. Rodchenko was a photographer particularly noted for his use of vantage. See **view point**.

Vernacular Ordinary, in common use. Vernacular photography is not the same as amateur photography, it refers to an approach dating from the mid-1960s in which ordinary things were photographed in straight forward ways as in Ed Ruscha's *Every Building on the Sunset Strip*.

View point A person's opinion, their 'point of view'. The phrase can be used to describe the (physical) point from which they see or photograph something but the use of the phrase '**vantage point**' would make this clearer.

Vintage Print One made at the time the photograph was taken or shortly afterwards. A key characteristic of photography is its reproducibility, making it a very **democratic** medium. Yet, many photographers limit the number of prints they make so pushing up their value, and the market will always pay more for a vintage print than for a later but identical print.

Visual literacy Somebody who is literate understands and uses words well and is well read. A person who is visually literate has a good understanding of images.

Voyeur Strictly speaking a voyeur is someone who gets pleasure from secretly watching others involved in sexual activities. In photographic criticism it has a broader, but still negative, meaning; as someone who photographs or looks at images of others, often of the poor or disadvantaged without any involvement or intention of improving the situation.

Index

248

Also available from Focal Press

Langford's Starting Photography

A guide to better pictures for film and digital camera users

Michael Langford
Philip Andrews

- Practical, user-friendly guide to get you started fast, whether using film or digital photography for your image making

- Packed full of lavish color illustrations to stimulate your imagination and show you what can be achieved

If you are taking your first step into photography you really can't ask for more than this classic guide to ensure it is a memorable experience for you!

With this authoritative update of the best-selling start-up guide you will embark on a learning adventure, exploring the fundamentals of photography, both creative and technical, to acquire the skills to take inspirational pictures, whether using a film or digital camera.

Updated for the 'starting photographer today', core basics include: how to select and compose a good picture; how to use the camera's controls – shutter speed, focus, zoom, flash etc.; advice on how best to tackle different subjects – people, places, animals, landscapes, or close-ups, as well as invaluable scanner and printing techniques; troubleshooting tips.

To master the art and technique of photography, take advantage of the experimental projects provided to put your new skills to the test and use the examples of professional photographers' work to develop your ideas and enhance your creative mind.

March 2005: 189 × 246 mm: 500 color illustrations: Paperback:

0 240 51967 1

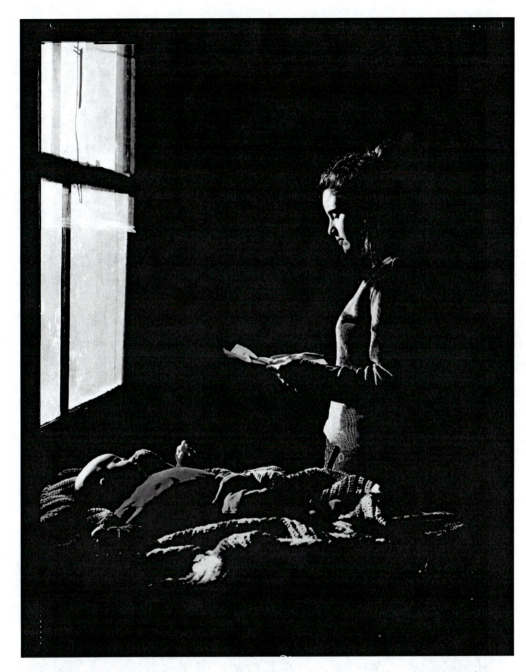

Figure C1 Woman reading a possession order, 1997 © Tom Hunter. Courtesy Jay Jopling/White Cube(Londan).

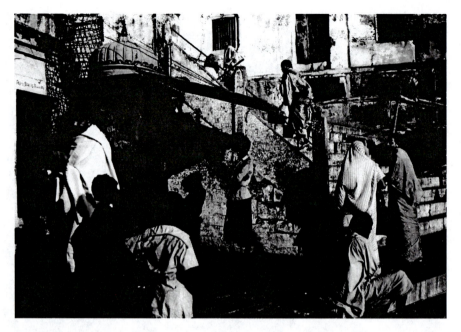

Figure C2 Morning on Panchganga Ghat, Benares, Uttar Pradesh, 1985 © 1998 by Raghubir Singh/Succession Raghubir Singh.

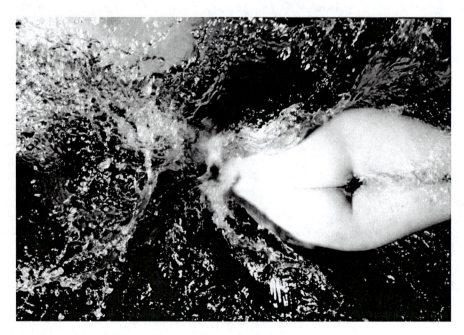

Figure C3 Untitled – 1985 © Ashley la Grange. Ashley la Grange, 1985.

Figure C4 2003 GB. ENGLAND. Ascot Races, 2003. © Martin Parr/Magnum Photos.

Figure C5 Untitled – 1994/Liz shaking her fist at Ray © Richard Billingham. Courtesy Anthony Reynolds Gallery Ltd.

Figure C6 Robert Mugabe campaigning near Bindura in 2000 © Rob Cooper.